Rick Steves

EUROPE'S TOP

100

MASTERPIECES

ART FOR THE TRAVELER

Rick Steves & Gene Openshaw

CONTENTS

ART
MATTERS

Art can carbonate your travels, swizzle your history, and open eyes you didn't realize were shut. It gets you intimate with genius and high on beauty. That's why we wrote this book.

Since the beginning of time, humans have expressed their deepest urges, desires, and aspirations by creating beautiful things. And beauty can take many forms: pretty, arresting, erotic, thought-provoking, disturbing, funny, or exhilarating.

Tour guides love to share a favorite piece of art, make it meaningful, and make it fun. This book is that—multiplied by 100. Together, we have five decades of experience between us leading tour groups around Europe, and it was a joy to assemble our favorite works of art into this grand tour of Europe. And taken together, they give a quick sweep through Europe's entire history.

As a bonus, many of the masterpieces are featured in short TV clips, excerpted from the *Rick Steves' Europe* public television series. With the Rick Steves Classroom Europe program (classroom.ricksteves.com), you can enjoy three- to five-minute segments that give context and dimension to the art. It's quick and easy, fun and free. For a key of the featured art, see page 260.

You don't need to be a scholar to get excited about art. But the more you understand the context in which a work of art was created—what was going on at the time, the patron's agenda, and the artist's goal—the more you can enjoy it. We hope this collection helps you better enjoy each of these individual works and appreciate the wonderful world of art.

And now, we invite you to travel with us—one beautiful creation at a time—through our vote for Europe's top 100 masterpieces.

Rich & Gene

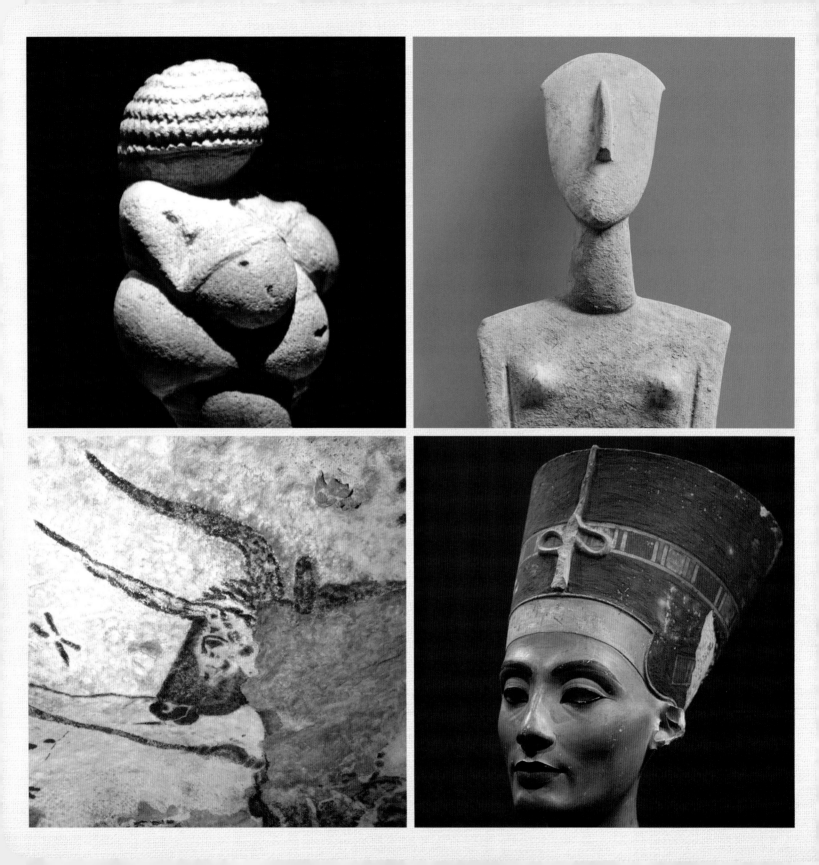

PREHISTORY

Europe's first artists were already hard at work 30,000 years ago. These Homo sapien virtuosos—despite their Stone Age technology and nomadic lifestyle—produced surprisingly powerful art. Their specialty was carving tiny statues, mostly of women, possibly representing the awesome force of "Mother Nature" and her life-giving traits. Artists also painted on the walls of caves. As hunter-gatherers, it's little wonder they focused on subjects they knew best— the animals they stalked.

Over the millennia, Europe evolved. Tool-making technology went from hard rock (the Paleolithic era) to heavy metal (Neolithic). Solitary hunters settled down to become farmers in villages. Soon they had the prosperity and leisure time to invent writing, government, organized religion, and art—what we call "civilization."

So to complete the picture, we'll also see art from one of the world's first great civilizations, Egypt. Egyptians made statues of themselves thinking it would preserve their souls to live on after death.

In fact, as we'll see throughout this book, the primeval art produced so many years ago has lived on. Prehistoric statuettes set the tone for later artists who used the human (mainly female) form to express deeper emotions and ideas. Cave paintings influenced how artists reimagined the world around them. And as in Egypt, artists ever since have been determined to create timeless art built for eternity.

VENUSES THROUGH HISTORY

Beauty can take many forms. But since the very beginnings of the human species, the most popular subject for artists has always been the female body. Long before the end of the Ice Age, Europeans were fashioning small statues of women.

The chubby *Venus of Willendorf* (c. 25,000 BC), found in modern-day Austria, is shown resting her spindly arms on her ample breasts. At just 4.4 inches high, this statue is like many such statues of the day. Most are no bigger than a smartphone. They're carved out of stone or bone, or molded from clay. They're generic females, with no face or feet. The hips are wide, and the breasts and butt are exaggerated, with a prominent vaginal slit. This focus on women's life-giving attributes has led scholars to suggest they're symbols of fertility. Living at the mercy of the elements, the early Europeans who created these may have worshipped Mother Nature. Scholars have dubbed them "Venus figurines."

During the long journey from Paleo- to Neo-lithic times, statuettes of Stone Age women shed some 20,000 years of fat to become so-called "Cycladic figures" (c. 3,000 BC). These ladies from the Greek Isles are skinny. They're always naked, with stylized breasts and folded arms. Because they lack distinct features, it's suggested that they may represent the Everywoman. But no one knows the exact purpose: Was she a fertility goddess, funereal figure, good-luck charm, spirit guide, prehistoric Barbie doll, caveman Playboy Bunny . . . or just art?

These "Venuses" were only the start of a 25,000-year tradition of using the beauty of women—yes, you could say objectifying women—to express society's deepest-held values.

The word "beauty" can apply to harmonious concepts as well as physical beauty. During the days of classical Greece and Rome, a statue of a perfectly-proportioned person—like the *Venus de Milo*—epitomized the harmony and geometrical order they found in the divine cosmos.

(continued)

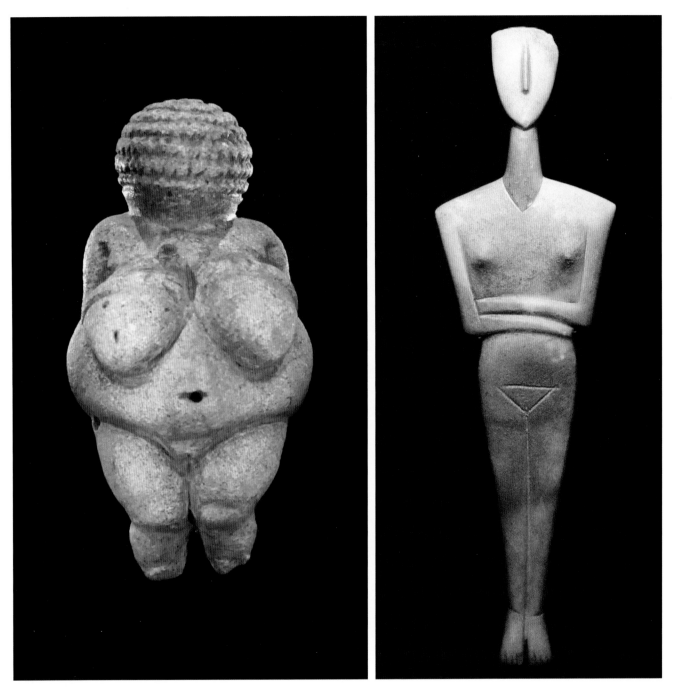

Venus of Willendorf (c. 25,000 BC), Natural History
Museum, Vienna

Cycladic Figure (c. 3,000 BC), National Archaeological
Museum, Athens

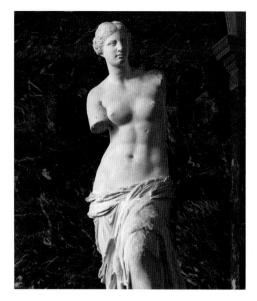

Venus de Milo (c. 100 BC),
Louvre Museum, Paris

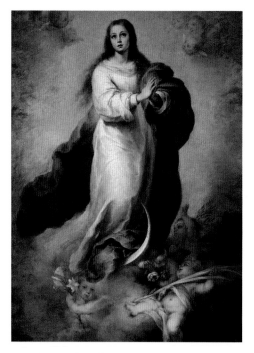

The Immaculate Conception of El Escorial,
Bartolomé Murillo (c. 1665),
Prado Museum, Madrid

In Christian times, "Venus" became "Mary." Just as Venus represented earthly love to pagans, the Madonna was venerated by Christians as a symbol of divine love. Images of Mary welcomed worshippers into the church, promising love and forgiveness. Because medieval art was rather rudimentary, artists used symbolism to communicate this. A vase of lilies might represent Mary's chastity, and Baby Jesus might hold a symbol of his prophesied death. By Renaissance times, artists could portray Mary with such human realism that she radiated her spirituality through her physical beauty.

And so it went, as each era created images of beautiful women to express abstract concepts. *Mona Lisa* is not merely a portrait of a businessman's wife; it's a visual treatise on a geometrically perfect universe. Botticelli's *Birth of Venus* embodied the Platonic ideal of the quest for enlightenment. In more modern times, a secular Venus nicknamed "Marianne" (in Delacroix's *Liberty Leading the People*) carried the torch of France's revolutionary spirit.

Throughout art history, artists have used beautiful women as a way to convey deeper meanings. The women of art, which you'll see featured throughout this book—whether in their role as life-givers, warriors, sensuous vixens, perfect models, symbols of an era, or forthright workers—have always represented the "beauty" of humanity's greatest ideals.

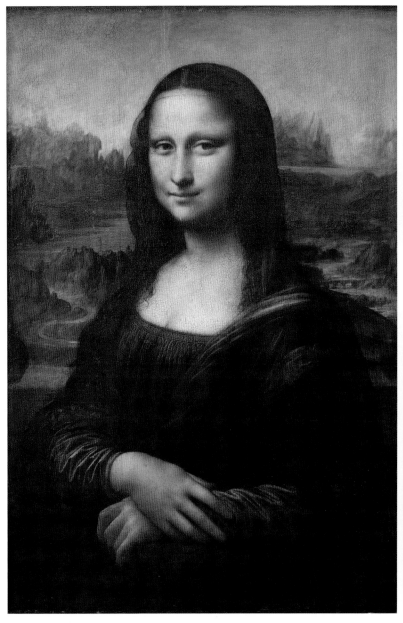

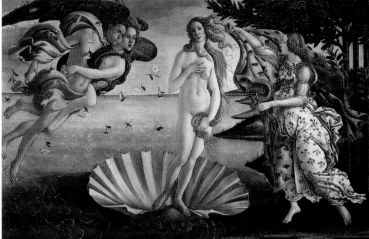

The Birth of Venus (c. 1485), Sandro Botticelli,
Uffizi Gallery, Florence

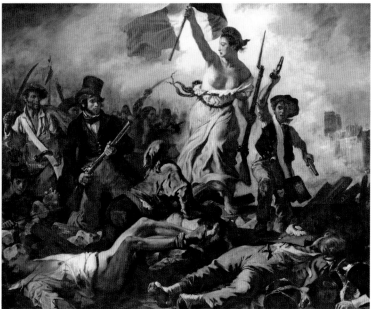

Liberty Leading the People (1830), Eugène Delacroix,
Louvre Museum, Paris

Mona Lisa (1506), Leonardo da Vinci,
Louvre Museum, Paris

PREHISTORIC CAVE PAINTINGS OF LASCAUX

This caveman man cave is startling for how fashionably it's decorated. The walls are painted with animals—bears, wolves, bulls, horses, deer, and cats—and even a few animals that are now extinct, like woolly mammoths. There's scarcely a Homo sapiens in sight, but there are human handprints.

All this was done during the Stone Age nearly 20,000 years ago, in what is now southwest France. That's about four times as old as Stonehenge and Egypt's pyramids, before the advent of writing, metalworking, and farming. The caves were painted not by hulking, bushy-browed Neanderthals but by fully-formed Homo sapiens known as Cro-Magnons.

These are not crude doodles with a charcoal-tipped stick. The cave paintings were sophisticated, costly, and time-consuming engineering projects planned and executed in about 18,000 BC by dedicated artists supported by a unified and stable culture. First, they had to haul all their materials into a cold, pitch-black, hard-to-access place. (They didn't live in these deep limestone caverns.) The "canvas" was huge—Lascaux's main caverns are more than a football field long, and some animals are depicted 16 feet tall. They erected scaffolding to reach ceilings and high walls. They ground up minerals with a mortar and pestle to mix the paints. They worked by the light of torches and oil lamps. They prepared the scene by laying out the figure's major outlines with a connect-the-dots series of points. Then these Cro-Magnon Michelangelos, balancing on scaffolding, created their Stone Age Sistine Chapels.

The paintings are impressively realistic. The artists used wavy black outlines to suggest an animal in motion.

They used scores of different pigments to get a range of colors. For their paint "brush," they employed a kind of sponge made from animal skin. In another technique, they'd draw the outlines, then fill it in with spray paint—blown through tubes made of hollow bone.

Imagine the debut. Viewers would be led deep into the cavern, guided by torchlight, into a cold, echoing, and otherworldly chamber. In the darkness, someone would light torches and lamps, and suddenly—*whoosh!*—the animals would flicker to life, appearing to run around the cave, like a prehistoric movie.

Why did these Stone Age people—whose lives were probably harsh and precarious—bother to create such an apparent luxury as art? No one knows. Maybe because, as hunters, they were painting animals to magically increase the supply of game. Or perhaps they thought if they could "master" the animal by painting it, they could later master it in battle. Did they worship the animals?

Or maybe the paintings are simply the result of the universal human drive to create, and these caverns were Europe's first art galleries, bringing the first tourists. While the caves are closed to today's tourists, carefully produced replica caves adjacent give visitors a vivid Stone Age experience.

Today, visiting Lascaux II and IV, as these replica caves are called, allows you to share a common experience with a caveman. You may feel a bond with these long-gone people . . . or stand in awe at how different they were from us. Ultimately, this art remains much like the human species itself—a mystery. And a wonder.

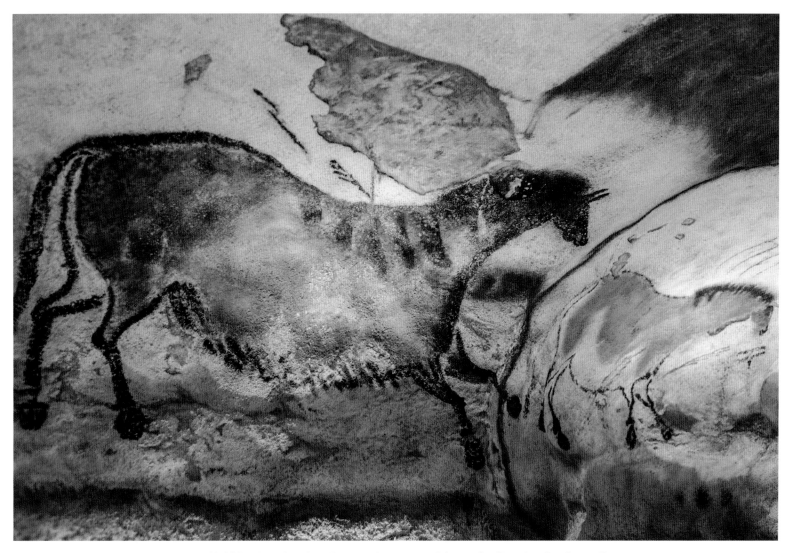

Lascaux cave paintings (c. 18,000 BC), replica from Lascaux International Center for Cave Art, Dordogne, France

BUST OF NEFERTITI

The most famous piece of Egyptian art in Europe is this 3,000-year-old bust of a Queen of Egypt named Nefertiti.

This woman has all the right features of a classic beauty: long slender neck, perfect lips, almond eyes, symmetrical eyebrows, pronounced cheekbones, and a perfect spray-on tan.

Her pose is perfectly symmetrical from every angle—front, back, and side. From the side, her V-shaped profile creates a dynamic effect: She leans forward, gazing intently, while her funnel-shaped hat swoops up and back. Her colorful hat is a geometrically flawless, tapered cylinder.

And yet, despite her seemingly perfect beauty, the real person shines through. In real life, Nefertiti was born a commoner and renowned for her beauty. Her name means "the beautiful one has come." She married the pharaoh, Akhenaton, and soon became the most powerful woman in the land. The newlyweds moved into a large palace and had six daughters. (Nefertiti became the mummy-in-law of Tutankhamen, the famous "King Tut" whose tomb was unearthed in 1922, sparking a worldwide fascination with Egypt.) During the reign of the dynamic power couple, Egypt's 1,000-year-old traditions were challenged, and the once-stiff art styles broke out of the rigid mold.

Unlike earlier statues of generic gods, Nefertiti's bust has unique human details. Looking close, you can make out fine wrinkles around the eyes—these only enhance her beauty. She has a slight Mona Lisa smile, pursed at the corners. Her eyebrows are so delicately detailed, you can make out each single hair. From the back, the perfection of her neck is marked with a bump of reality—a protruding vertebra. And because she's missing the quartz inlay in the left eye, it gives the impression she's winking at you. Her look is meditative, intelligent, lost in thought. Like a movie star discreetly sipping a glass of wine at a sidewalk café, Nefertiti seems somehow more beautiful as a real person with real flaws.

The bust is made out of limestone, with a stucco surface. This bust served as the master model for countless other portraits of the queen scattered across the kingdom.

Today Nefertiti's bust is displayed in a room all her own in a museum in Berlin. How the queen arrived in Germany is a tale straight out of Indiana Jones. A German archaeologist uncovered the bust in the Egyptian desert in 1912 and spirited it out under questionable circumstances. Since her arrival in Berlin, she's been surrounded by controversy. Some scholars condemned the bust as a fake. Meanwhile, the masses adored Nefertiti and made her a virtual symbol of Germany itself—Germany's "queen." Hitler promoted her as a pagan symbol of his new non-Christian Reich. When Germany was split in the Cold War, both sides fought to claim her. Today Nefertiti's timeless beauty has come to represent the aspirations of the reunited German people. And around the world, her intriguing allure has made her Egyptology's cover girl.

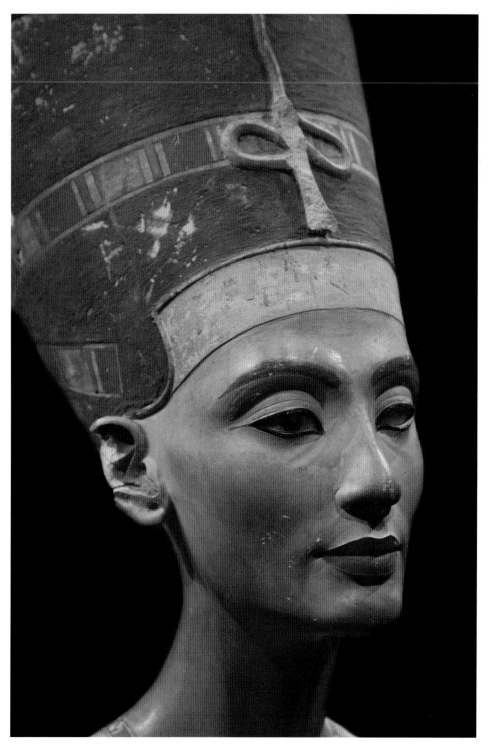

Bust of Nefertiti (1345 BC), Neues Museum, Berlin

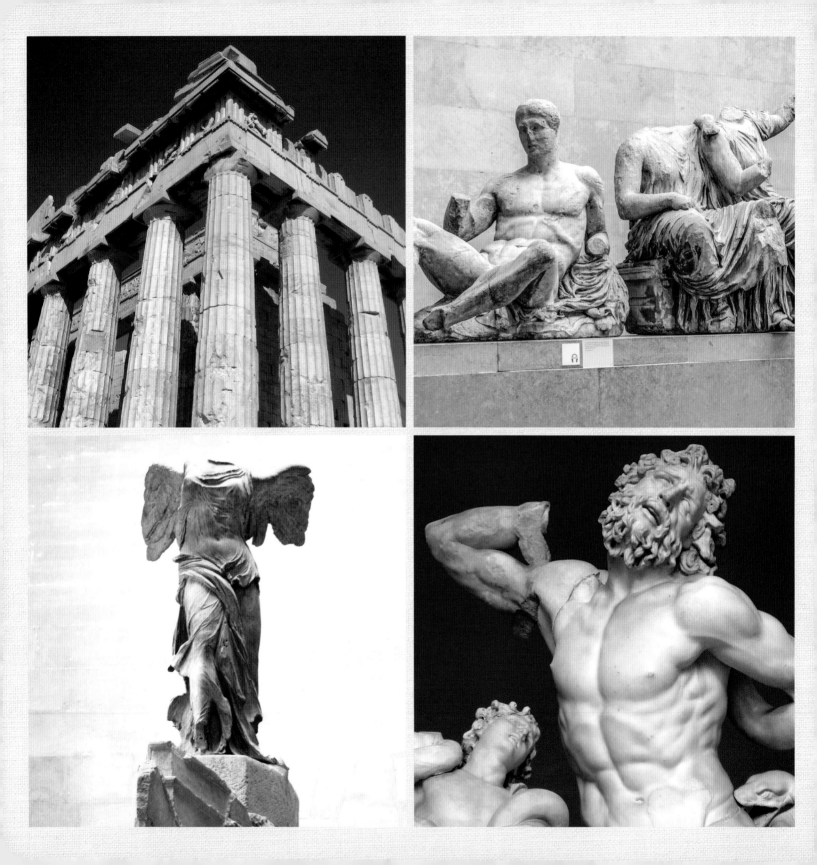

ANCIENT GREECE

Our lives today would be quite different if it weren't for a few thousand Greeks who lived in a small city about 2,500 years ago: Athens. Democracy, theater, literature, mathematics, science, philosophy, and art all flourished in Athens during its 50-year Golden Age. It set the template for the rest of the West.

But Classical Greece didn't just pop out of nowhere. Cursed with rocky soil, isolated by a rugged landscape, and scattered by invasions, the Greeks took centuries to unify. Eventually, they came to dominate the ancient world—through brain, not brawn. They prided themselves on creating order out of chaos.

Greek artists strove to create a harmonious balance between warring opposites. They built temples with perfect geometrical proportions and well-balanced columns and crossbeams. Their statues—of radiant Apollo, sensuous Venus, and powerful Poseidon—showed the gods as glorified human beings with perfect anatomy. The balanced proportions echoed the order and stability of the Greek cosmos. For the Greeks, the human form seemed to symbolize their highest ideals.

MINOAN BULL-LEAPING FRESCO

This colorful fresco—painted in about 1450 BC, a thousand years before the Parthenon was created by Golden Age Greeks in Athens—is a reminder that the incredible civilization known as Classical Greece grew from an also-enlightened earlier society of Greek sea traders called the Minoans.

This painting radiates the joie de vivre of the easy-goin' Minoan. It shows Minoans at play in the sport of bull-leaping. As the bull charged, an athlete would grab it by the horns (like the figure on the left). The bull would fling him upward, somersaulting heels-over-head (like the guy in the middle). Then he'd spring off the bull's back, hoping to stick the landing upright (like the figure on the right), with a smile on his face and a *"ta-da!"* pose.

Skeptical scholars point out that the feat of gymnastics depicted here is pretty improbable. Regardless, the Minoans likely had some kind of bull-leaping sport. Frescoes everywhere showed them jumping over these wild long-horned creatures—just as daredevils still do today in some Mediterranean lands. For the Minoans, bull-leaping may have been a ritual, metaphorically demonstrating how these civilized people had mastered brute nature. Or it could have been a spectator sport, performed in their palace courtyard. Or it may have simply been high-spirited youths doing what they've done since the beginning of time: showing off their bravery by courting danger—a kind of ancient Running of the Bulls.

The fresco is dynamic. It's made of plaster that's been molded by hand to make the bull and humans actually rise cameo-like from the surface. The artist painted the plaster while it was still wet. This locked the pigments inside, giving it those translucent colors—airy blue, rich brown, and deep red—that are still radiant after all these years. The artist captured the heady sense of motion: the bull stretches out in full gallop, his tale flicking behind him. The athlete tumbles nimbly, his legs splayed apart, curly locks waving in the breeze.

This rare pre-Classical fresco decorated the Minoans' Knossos palace on the Greek isle of Crete. Unlike most early peoples, the Minoans were traders, not fighters. They'd grown rich exporting wine, olive oil, and jewelry, giving them the wealth to build beautiful palaces and the leisure to enjoy pastimes like bull-leaping. The palace was not a heavily fortified citadel with stern propaganda of conquering kings and avenging gods. It was open and airy, with sprawling rooms, open-air courtyards, and brightly painted columns. The palace's many wall paintings showed off tanned, curly-haired, happy, and well-dressed Minoans dancing, fishing, strolling through gardens, or cavorting with exotic animals—beauty for its own sake.

Shortly after this fresco was painted, the Minoan civilization collapsed. No one knows why. The Minoans were then overrun by more warlike tribes invading Crete from the mainland. But these later Greeks inherited the Minoans' cultural savvy and love of art. Because of this, some scholars hail the Minoans as the first truly "European" civilization. They were an essential ingredient in that stew of peoples that cooked up Classical Greece.

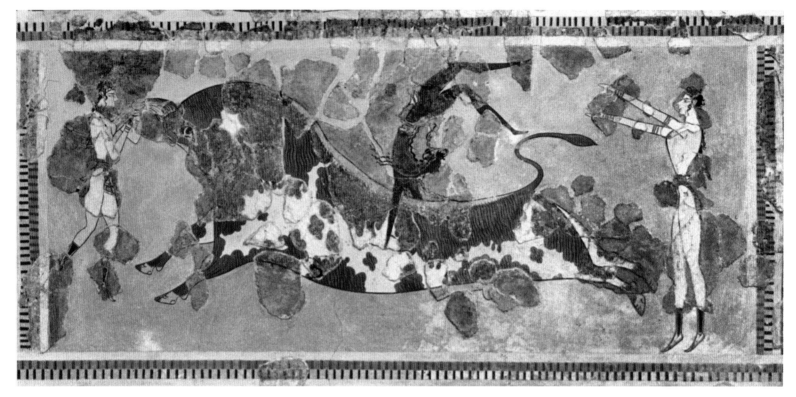

Bull-Leaping Fresco (c. 1450 BC), Heraklion Archaeological Museum, Crete

ARTEMISION BRONZE—ZEUS OR POSEIDON

One of the jewels of the ancient world is this perfectly posed bronze statue of a god at war.

The god steps forward, raises his arm, sights along his other arm at the distant target, and prepares to hurl his weapon. (Or is he about to serve a tennis ball? Or pound a nail? Or maybe he's riding a surfboard?)

If the statue is meant to be Zeus (as some think), he'd be throwing a thunderbolt—if Poseidon, a trident. When the statue was discovered—in a sunken ship off the coast of Greece (Cape Artemision) in 1928—no weapon was found, so no one knows for sure who it represents. (For simplicity, I'll call him Poseidon, and hope jealous Zeus doesn't strike me down with a thunderbolt.)

Poseidon stands 6 feet 10 inches tall, and has a physique like—well, like a Greek god. He's trim, graceful, and muscular.

His hair is curly and tied at the back. His now-hollow eyes were once white, made with inset bone. He plants his left foot and pushes off with the right. Even though every limb moves in a different direction, the overall effect is one of balance.

The statue's dimensions are a study in Greek geometry. His head is exactly one Greek foot in length. He stands 6 Greek feet tall, or exactly one Greek fathom. The entire figure has an "X" shape that would fit into a perfect circle—his navel at the center, and his fingertips touching the rim.

The unknown artist has frozen Poseidon's movements in time, so we can examine the wonder of the physical body. He's natural yet ideal, twisting yet balanced, moving while at rest. With his geometrical perfection and godlike air, this figure sums up all that is best about the art of the ancient world.

Sculpted around 460 BC, this statue is an example of the so-called Severe style, describing the style of Greek art between 500 and 450 BC. Historically, this is when Greece battled the Persians. During this time of horrific war, the Greeks made art that was serious and unadorned, and expressed naked, muscular strength. Severe-style statues celebrate the nobility of the human form and the heroism of the individuals who carried them through these tough times.

Shortly after this statue was created, the Greeks emerged victorious from their wars, shook off tyrants at home, and took control of their own destiny through democracy. This Poseidon shows Greece poised at the dawn of that new era of prosperity and enlightenment, his gaze fixed on the coming future. That future would be known as the Golden Age . . . an age that would inspire Western civilizations to come.

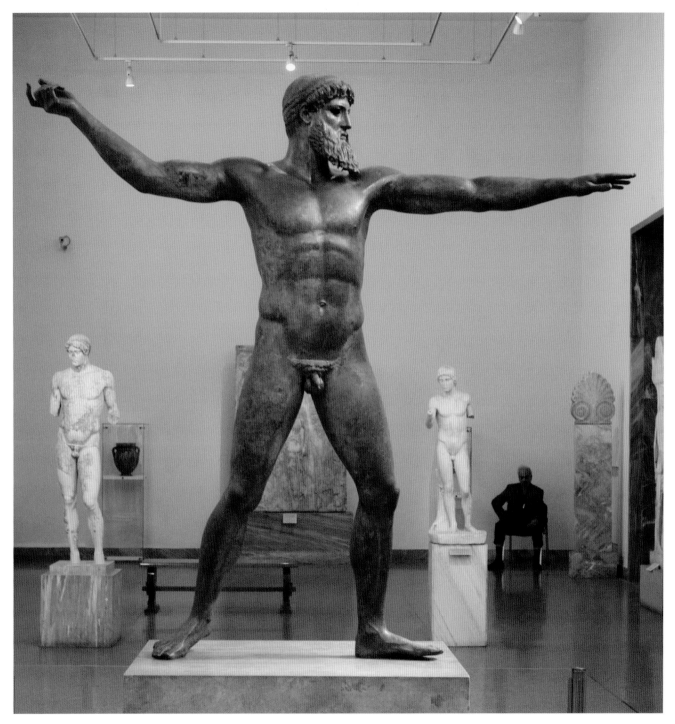

Artemision Bronze (c. 460 BC), National Archaeological Museum, Athens

THE PARTHENON

Rising up from the teeming heart of modern Athens, this gleaming temple shines from the top of the Acropolis hill like a beacon . . . a beacon of civilization.

The temple—dedicated to the goddess Athena, the patron of Athens—was the crowning glory of the city's enormous urban-renewal program during its Golden Age in the fifth century BC. After the Persian War, Athenians set about rebuilding the Acropolis, creating a vast and harmonious ensemble of temples and monuments with the Parthenon as the centerpiece.

Climbing the fabled hill, you reach the summit and, of everything there, bam: the Parthenon is the showstopper—the finest temple in the ancient world, standing on the highest point, 500 feet above sea level. Constructed about 440 BC, it's massive, the largest Doric temple in Greece—about 230 feet long and 100 feet wide. It's surrounded by 46 white-marble columns, each 34 feet high, 6 feet in diameter, and capped with a 12-ton capital.

But even more impressive than its sheer size is the building's sheer beauty. The columns are in the classically simple Doric style—lightly fluted, with no base, and topped with plate beneath a square slab. In its heyday, the pure white structure was adorned with colorful statues and reliefs painted in vivid colors. Inside was a legendary 40-foot-tall statue of Athena (though now lost to history). All in all, the temple was a model of balance, simplicity, and harmonious elegance. It epitomized the goddess of wisdom, Athena, as well as the enlightenment of the Athenian people.

The architects achieved that harmonious effect with some clever optical illusions. For example, the Parthenon's steps subtly arch up in the middle—to compensate for the sagging effect a flat line makes to the human eye. Similarly, the columns lean slightly inward to appear parallel, and they bulge imperceptibly in the middle to give a pleasing sturdiness as they support the stone roof.

The Parthenon's builders used only the finest white Pentelic marble—100,000 tons of it, brought in from a quarry 15 miles away. Unlike ancient structures constructed by the Egyptians and Romans, the Parthenon was not built by slaves, but by paid workers. The columns were made from huge marble drums, stacked like checkers, and fixed with metal pins in the center. Each piece of the Parthenon was unique—individually sized and cut to fit—then assembled on the spot like a giant 70,000-piece jigsaw puzzle.

The Parthenon, then and now, stands as *the* symbol of Athens' Golden Age—that 50-year era of prosperity and enlightenment when the city laid the foundations for what came to be known as Western civilization. It's one of the most influential works ever created by humankind. For 2,500 years, it's inspired architects, sculptors, painters, engineers . . . and visitors from across the globe.

For more of the Parthenon's glory, turn the page.

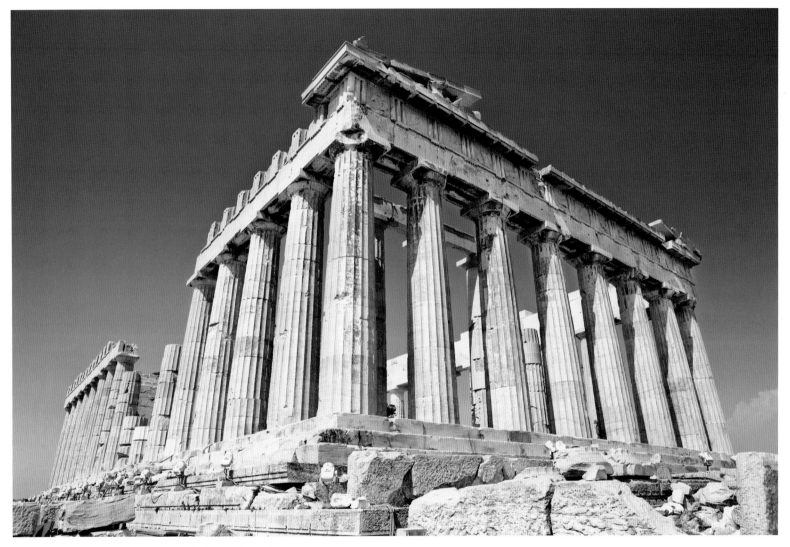

Parthenon (447–432 BC), Acropolis, Athens

ELGIN MARBLES—THE PARTHENON SCULPTURES

For 2,000 years, the Parthenon temple in Athens remained almost perfectly intact. But in 1687, with Athens under siege, the Parthenon was used to store a huge cache of gunpowder. (See where this is going?) *Pow!* A massive explosion sent huge chunks of the Parthenon everywhere. Then in 1801, the British ambassador, Lord Elgin, carted the most precious surviving bits of carved stone off to London, where they wow visitors to this day—the "Elgin Marbles."

London's British Museum shows off the statues and relief panels that once decorated the top of the Parthenon's now-bare exterior.

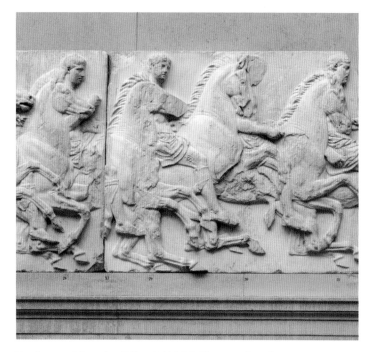

Parthenon frieze (c. 430 BC), British Museum, London

The reliefs, carved in about 430 BC, are part of the 500-foot-long frieze that once ringed the temple. They show 56 snapshots from ancient Athens' most festive occasion: a grand parade up the Acropolis hill to celebrate the city's birthday.

The parade begins with men on horseback, struggling to rein in their spirited steeds. Next come musicians playing flutes, while ladies dance. Distinguished citizens ride in chariots, kids scamper alongside, and priests lead ceremonial oxen for sacrifice.

At the heart of the procession is a group of teenage girls. Dressed in elegant pleated robes, they shuffle along carrying gifts for the gods, like incense burners and jugs of wine.

The girls were entrusted with the parade's most important gift: a folded-up robe. As the parade culminated inside the Parthenon, the girls symbolically presented the robe to the temple's 40-foot-tall gold-and-ivory statue of Athena.

The realism is incredible: the men's well-defined muscles, the horses' bulging veins. The girls' intricately pleated robes make them look as stable as fluted columns, but they step out naturally—the human form emerging from the stone. These panels were originally painted in bold colors. Amid the bustle of details, the frieze has one unifying element—all the heads are at the same level, headed the same direction, creating a single ribbon of humanity around the Parthenon.

(continued)

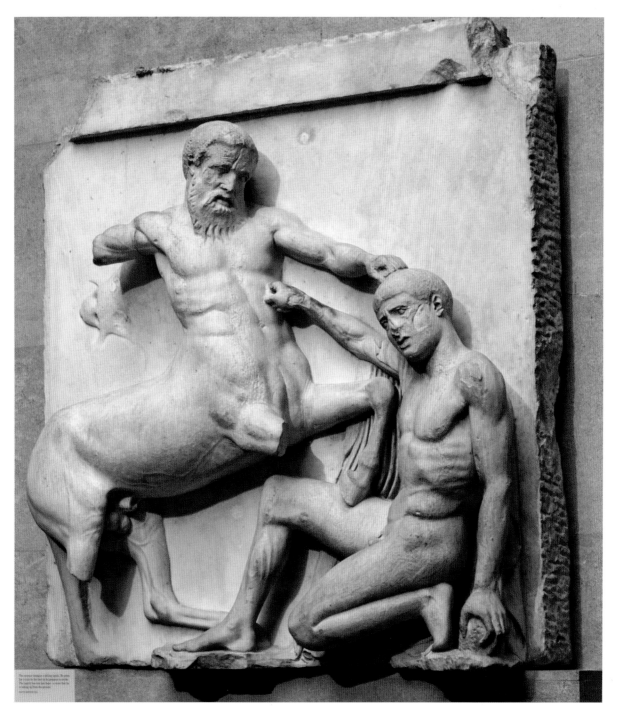

Parthenon metope (c. 430 BC), British Museum, London

The Parthenon's main entrance was decorated with a grandiose scene depicting the moment when the city of Athens was born. These statues nestled inside the triangular-shaped pediment over the door. It shows the Greek gods lounging around at an Olympian banquet. Suddenly, there's a stir of activity. The gods turn toward a miraculous event: Zeus has just had his head split open to reveal Athena, the symbol of the city. (Unfortunately, that key scene is missing—it's the empty space at the peak of the triangle.)

These pediment statues are realistic and three-dimensional, reclining in completely natural and relaxed poses. The women's robes cling and rumple naturally, revealing their perfect anatomy underneath.

A final set of relief panels (the so-called metopes) depict a Greek legend that sums up the entire Parthenon. They show the primeval Greek people brawling with brutish centaurs. It's a free-for-all of hair-pulling, throat-grabbing, kicks to the shin, and knees to the groin. Finally, the humans get the upper hand—symbolizing how the civilized Athenians triumphed over their barbarian neighbors.

In real life, the Greeks rallied from a brutal war, and capped their recovery by building the Parthenon. The treasured Elgin Marbles represent the cream of the crop of that greatest of Greek temples. And they capture that moment in human history when civilization triumphed over barbarism, rational thought over animal urges, and order over chaos.

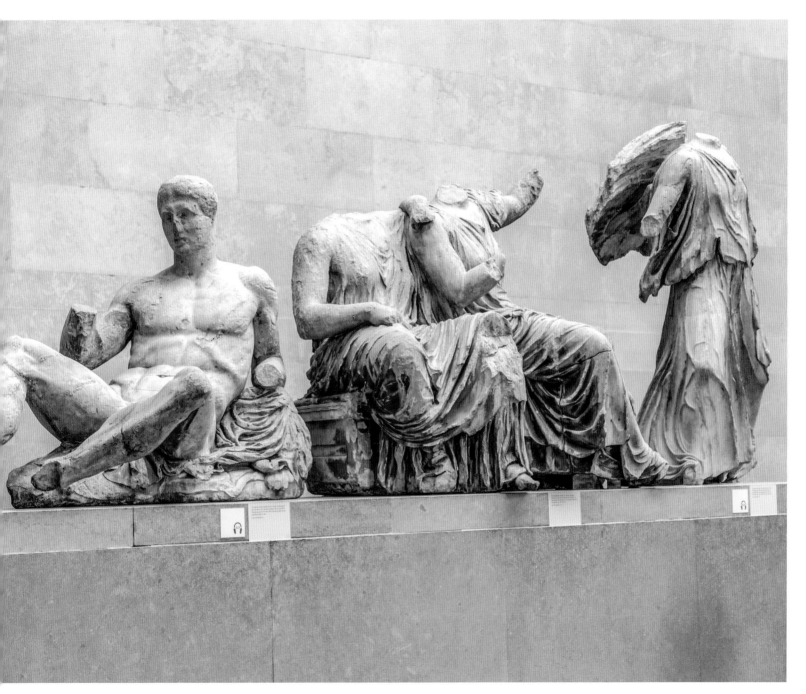

Parthenon pediment sculptures (c. 430 BC), British Museum, London

APOLLO BELVEDERE

Apollo—the radiant Greek god of the sun and of music—is running through the woods. In the distance, he spots his prey. Keeping an eye on the animal, he slows down and takes aim. He throws his cape over his shoulder, draws a (now-missing) arrow from his quiver, and raises his (also-missing) bow. The sculptor freezes the fleeting moment in mid-step for all to see.

Apollo embodies all that was good about Classical Greece. It fully captures the beauty of the human form. The optimistic Greeks conceived of their gods as perfect humans, and usually showed them buck naked. Apollo's anatomy is perfect, and his smooth-skinned face is gorgeous, with curly hair tumbling down in flowing locks. Wearing only a cloak (on top) and sandals (below), it sets off his lithe nakedness.

The Greeks loved balance. A well-rounded man was both a thinker and an athlete, a poet and a warrior. *Apollo Belvedere* is also a balance of opposites. He's moving, but not out of control. He eyes his target, but has yet to attack. The smoothness of his muscles is balanced by the rough folds of his cloak. And he's both realistic, like a living, breathing human being, as well as idealized, with godlike features.

Apollo's pose is natural. Instead of standing at attention—face-forward with his arms at his sides, like earlier primitive statues—he is on the move. His elfin body seems to float just above the pedestal, as it gently comes to rest. Apollo's stance is called *contrapposto,* or "counter-poise." He plants his right foot while the left trails behind, almost dangling in mid-air. Meanwhile, he raises his left arm while the right trails down. His body faces forward while his head turns stage left. All the body parts are in contrary motion, yet they rest in perfect balance around his genital center of gravity.

The beauty of Apollo's face, the perfection of the muscles, the balance of elegant grace and masculine power . . . these represent the full ripeness of the art of ancient Greece.

The *Apollo Belvedere* is 2,000 years old, but it's actually based on a much earlier statue. It's likely a high-quality copy made by the Romans, who considered Greek statues like Apollo to be the height of classiness. After being lost for a thousand years, Apollo was unearthed in the 15th century and ensconced in the pope's "Belvedere" palace (now the Vatican Museums), where it became instantly famous. Thanks to the new-fangled printing press, an engraving of the statue was spread all across Europe. By the 1700s, *Apollo Belvedere* was considered the most perfect work of art in the world. His idealized face and eternal youth made this pagan god a symbol of all things divine, even for devout Christians. The statue inspired artists from Dürer to Canova, and writers from Byron to Nietzsche. When Michelangelo was painting the face of Jesus for his Last Judgment in the Sistine Chapel, his model was none other than the noble features of this pre-Christian Greek god, the *Apollo Belvedere.*

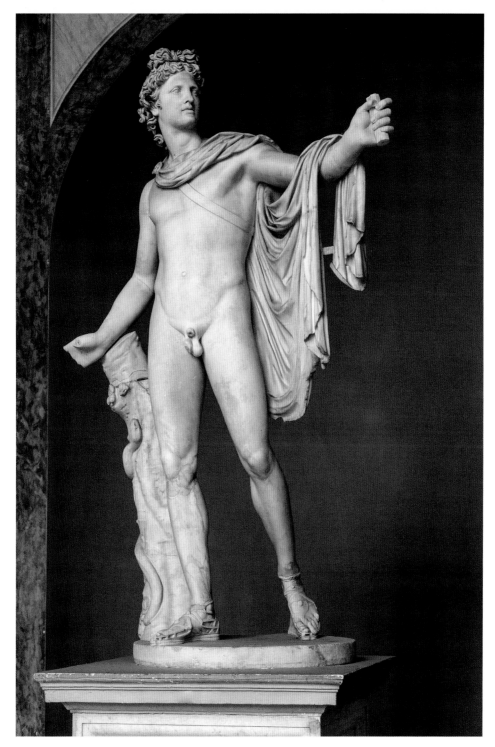

Apollo Belvedere (c. AD 130), Vatican Museums, Rome

VENUS DE MILO

The *Venus de Milo*—the goddess of love, from the Greek island of Milos, sculpted in about 100 BC—created a sensation when it was discovered in 1820. Europe was already in the grip of a classical fad, and this statue seemed to sum up all that ancient Greece stood for. The ancient Greeks pictured their gods in human form—which meant that humans are godlike. Venus' well-proportioned body embodied the balance and orderliness of the Greek universe.

Split Venus down the middle from nose to toes and see how the two halves balance each other. Venus rests on her right foot (that *contrapposto* pose so popular with classical sculptors). She then lifts her left leg, setting her whole body in motion. It's all perfectly realistic: As the left leg rises, her right shoulder droops down. And as her knee points one way, her head turns the other. Despite all this motion, the impression is one of stillness, as Venus orbits slowly around a vertical axis. The twisting pose gives a balanced S-curve to her body. The balance between fleeting motion and timeless stability made beauty.

Other opposites balance as well, like the smooth skin of the upper half of her body that sets off the rough-cut texture of her dress. She's actually made from two different pieces of stone plugged together at the hips (you can see the seam). The face, while realistic and anatomically accurate, is also idealized—like a goddess, she's too generic and too perfect. This isn't any particular woman, but Everywoman—all the idealized features that appealed to the Greeks.

The statue became famous for a number of reasons. Venus' classic beauty was seen as the ideal of female grace. The statue is a rare Greek original, not a Roman copy. Its sudden discovery (by a humble Greek farmer) made great news copy.

Most of all, Venus brought with her an air of mystery. Who was this beautiful woman? She's probably Venus, but no one knows for sure. What is she thinking? Her expression is alluring yet aloof. Her dress dangles suggestively; she's both modestly covering her privates but hinting at more.

And what were her arms (which were never found) doing? No one knows. Some say her right arm held her dress, while her left arm was raised. Others think she was hugging a statue of a man or leaning on a column. I say she was picking her navel.

Regardless, though Venus' arms have been lost over the centuries, her eternal beauty remains intact.

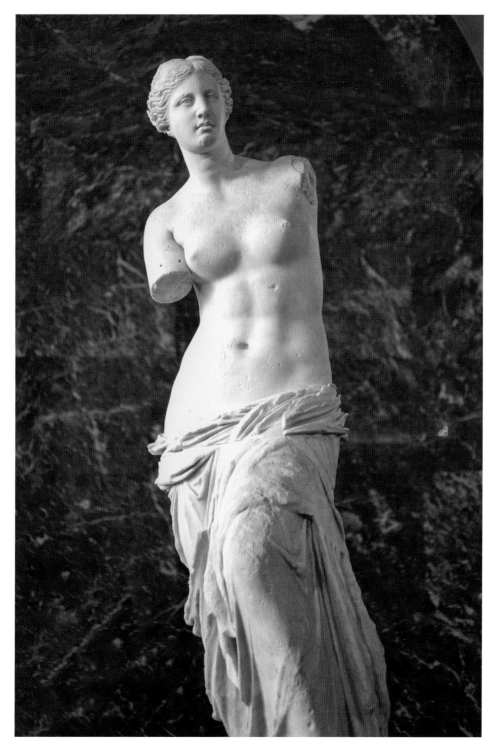

Venus de Milo (c. 100 BC), Louvre Museum, Paris

WINGED VICTORY OF SAMOTHRACE

Nike, the Greek goddess of victory, has flown to earth to congratulate the Greeks on their naval victory over Rhodes, and she now touches down on the prow of their flagship.

The statue is a rare original (not a Roman copy), unearthed on the Greek island of Samothrace in 1863. In ancient times, Samothrace was a major pilgrimage destination for pagans, including Alexander the Great and his Hellenistic successors. The statue (sculpted around 190 BC) stood in a temple dedicated to victory, high on a hilltop.

These days, the statue is displayed in the Louvre with a similar dramatic flair, atop a staircase. As you ascend, the statue seems to burst with life. Nike's clothes are windblown and sea-sprayed, the folds of her dress whipping dramatically around her, curving down her hips. As she strides forward, the wind blows her and her wings back, yet she remains a pillar of vertical strength. These opposing forces create a feeling of great energy, making her the lightest two-ton piece of marble in captivity. Metaphorically, Nike is battling against the strong headwinds of adversity, but perseveres to emerge victorious.

Scholars have long speculated about her missing arms. Most likely, she had her left arm pointing down, while her right arm was thrust high, celebrating the victory like a Super Bowl champion.

Compared with more sedate and balanced statues from Golden Age Greece, this Hellenistic work (from two centuries later) ripples with excitement. The statue's off-balance pose, like an unfinished melody, leaves you hanging. But the artist has captured a moment of stillness in the midst of all the fury. Flapping her wings to steady herself against the swirling winds, the goddess hovers for a second in mid-air, as she slowly touches down onto the ship.

The fame of Winged Victory in ancient times had a powerful effect on later artists. When Rome conquered Greece, Romans copied Greek statues for their own villas. Sure, they liked the balance and intellectual purity of Golden Age art, but they absolutely loved exciting Hellenistic statues like Winged Victory. Thanks to art like this, Greek culture was preserved by the Romans, and lived on.

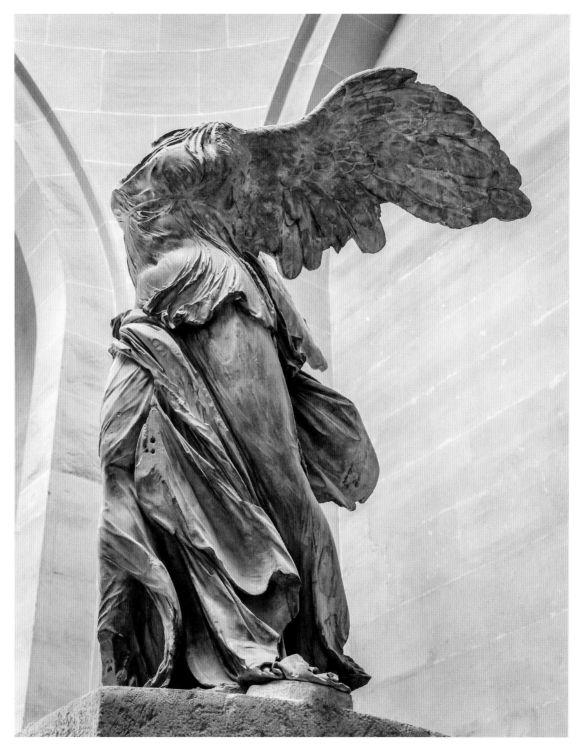

Winged Victory of Samothrace (c. 190 BC), Louvre Museum, Paris

LAOCOÖN

A man and his two sons wrestle with snakes. Their agony captures the dramatic climax of the Trojan War.

The Greeks have sent the original Trojan Horse full of soldiers as a trick to get into the city of Troy. Laocoön (pronounced lay-OCK-oh-won), the high priest of Troy, tries to warn his people. So the Greek gods have sent snakes to crush him to death. The sculptor captures the scene at its most intense moment—Laocoön is struggling to survive, but he's just now realizing that the snakes are too much for them. Look at his face—his agonized expression says it all: "I and my people are doomed." (Or, perhaps, "Snakes! Why did it have to be snakes?")

The figures were carved from four blocks of marble pieced together seamlessly. The poses are as twisted as possible, accentuating every straining muscle and bulging vein. Follow the line of motion. It starts with Laocoön's left foot, then continues up his leg, running diagonally through his body and out his right arm. It's a dramatic scene, rippling with motion and emotion.

Laocoön was one of the most famous statues in the ancient world. But after the fall of Rome, the statue was lost for a thousand years. Then, in 1506,

it was unexpectedly unearthed in Rome. It was cleaned off and paraded through the streets before an awestruck populace.

One of the first to lay eyes on *Laocoön* was the young Michelangelo. He was hired by the pope to help reassemble the fragments. Look closely at Laocoön's right arm. In Michelangelo's day, that arm was completely missing. Many thought that Laocoön originally had his arm extended straight out, holding the snakes off at arm's length. But Michelangelo thought the arm must have been bent at the elbow, because he had studied cadavers and knew just how the muscles worked. In the early 1900s, archaeologists excavated the original elbow, and proved Michelangelo right.

The discovery of *Laocoön* in 1506 had a considerable impact on art history. It inspired Michelangelo to amp up his figures with more motion and more emotion. Just two years later, he started work on the Sistine Chapel, and used what he'd learned from the ancients—filling that ceiling with twisted and muscular bodies, pulsing with motion and emotion—and took the Renaissance to a whole new level.

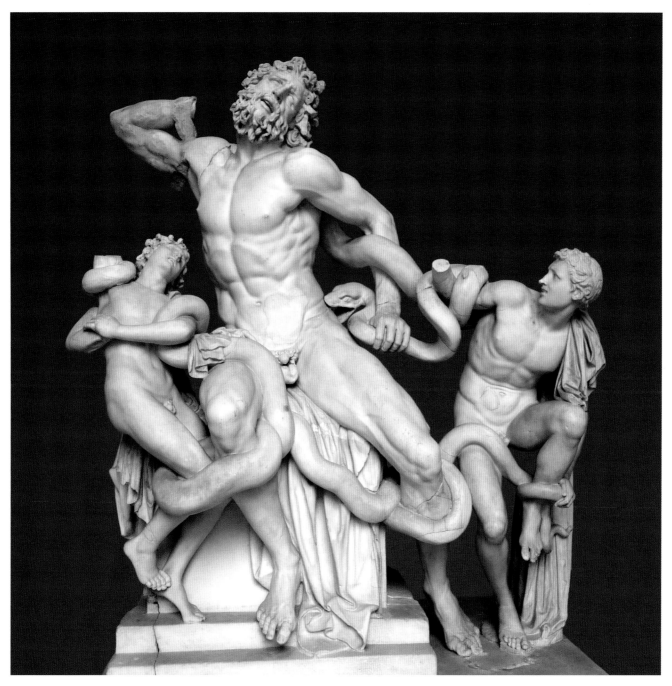

Laocoön (c. first century BC), Vatican Museums, Rome

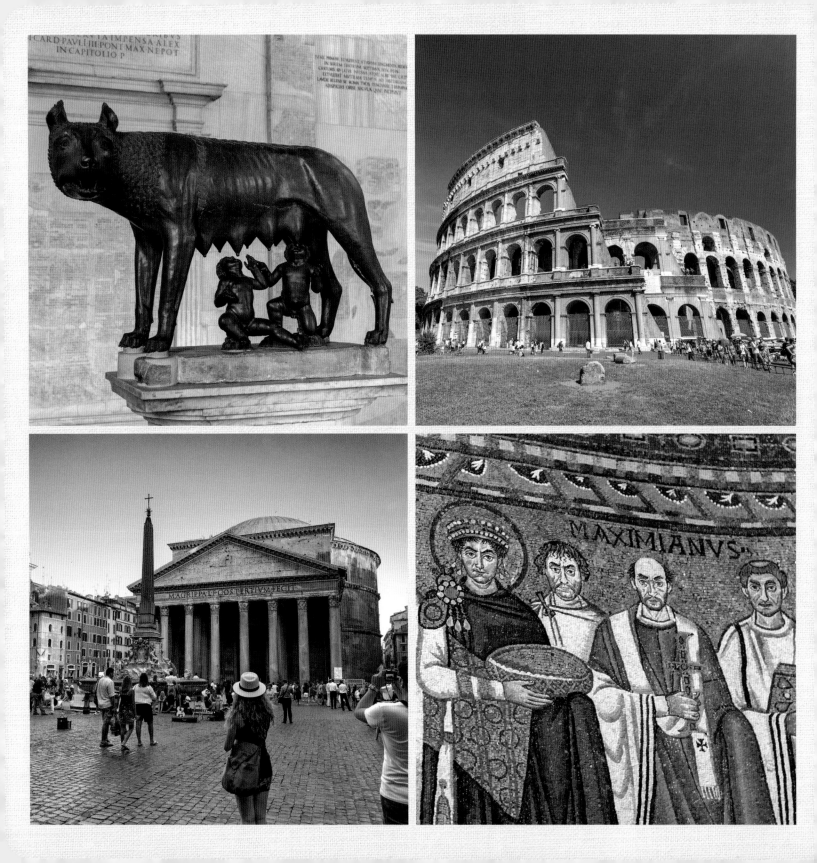

ANCIENT ROME

Rome is history's supreme success story. By conquest, assimilation, and great administration, Rome grew from a tiny village to become the capital of a vast empire.

In a nutshell, classical Rome lasted for a thousand years, from 500 BC to AD 500. It grew for 500 years, peaked for 200, and fell for 300. Today, legions of tourists march across Europe to see the triumphal arches, ruined temples, gladiator arenas, and armless statues left behind by the grandest of civilizations.

The Romans were great engineers. They built on a scale grander than any civilization before them, thanks to two innovations: the arch and concrete. Though great engineers, they weren't great artists. Because of that lack of originality, the Romans copied Greek statues to decorate their villas, baths, and public buildings. They used Greek-style columns and crossbeams to adorn their arch-and-concrete buildings. They took sophisticated Greek culture and spread it all across Europe and beyond. By the time Rome fell, it had established a legacy of classical grandeur that would be revived again and again through the centuries.

ROMAN SHE-WOLF STATUE

Rome conquered the ancient world, and it all started with these little suckers.

According to legend, twin brothers Romulus and Remus were orphaned in infancy and set adrift on the Tiber River. They were rescued by a she-wolf, who raised them as her own. The boys grew up to found the city of Rome, traditionally in the year 753 BC.

As the Roman empire expanded, the she-wolf (shown with or without babies) became the instantly recognizable logo for the Roman brand. It was soon all over their empire: on coins, statues in the Forum, in mosaic floors, engraved on lamps, even carved on people's tombstones. The image helped unite the growing empire. And it symbolized how the fierce Romans could have risen from feral roots to dominate the world.

This particular statue is the most revered version of the ancient image. It's powerful, standing larger than life. The mama wolf looks out protectively, keeping watch while her babies blithely drink up. Look into the wolf's eyes. An animal looks back. She has jagged teeth, ragged ears, and merciless eyes. This wild animal, teamed with hungry babies, makes a powerful symbol for the tenacious empire of Rome.

The statue is old, but no one is sure how old. It may have been made by the Romans' even-more-ancient ancestors, the Etruscans, from the fifth century BC. But Professor Carbon Fourteen suggests it's more likely medieval, and the little boys were added in the 15th century. The wolf was cast out of bronze in a single piece, likely made as a high-quality replacement for a prominent ancient statue.

The ancient Romans fervently believed in the myth of the she-wolf. They honored the wolf's cave on Palatine Hill, called the Lupercale, as well as the spot where Romulus and Remus supposedly grew to manhood. Every February 15, they celebrated the Lupercale festival, where men dressed up in animal skins, sacrificed goats, and whipped women who wanted to become more fertile. This all seemed like just a quaint legend until modern times, when—lo and behold—archaeologists discovered some ancient huts and a nearby cave on Palatine Hill, and the legend became history.

Over the centuries, the she-wolf logo has spread all over the world. It's the symbol of the city of Rome, seen on everything from flags to taxis to police cars. It's the symbol of Rome's soccer team, and souvenir stands everywhere sell she-wolf keychains, mouse pads, and ashtrays. The wolf is often accompanied by the letters "S.P.Q.R.," which was Rome's ancient motto. It stands for *Senatus Populusque Romanus*—the "Senate and People of Rome."

The famous bronze statue pictured here stands today in a museum atop Rome's Capitoline Hill—the venerable spot where Rome has been governed almost since Romulus and Remus were in diapers.

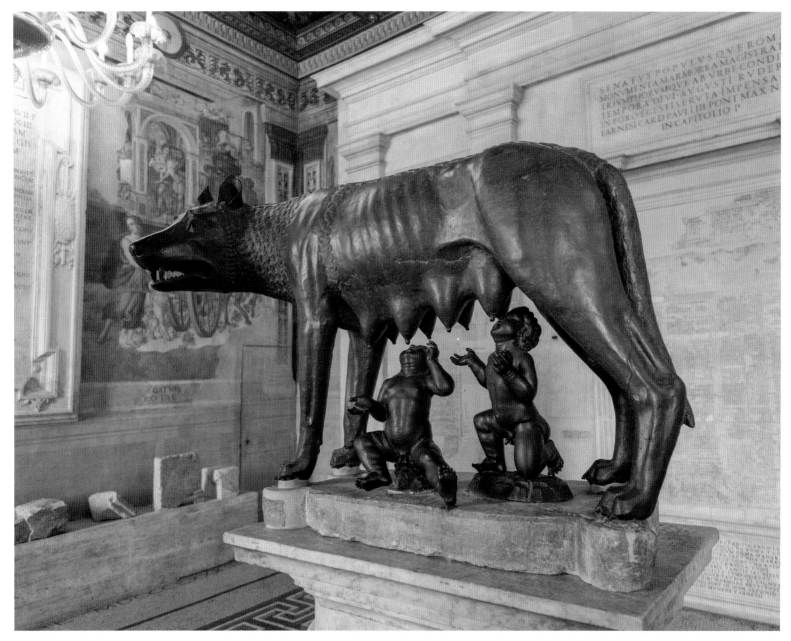

Capitoline She-Wolf (fifth century BC or medieval), Capitoline Museums, Rome

ROMAN COLOSSEUM

To connoisseurs of sports stadiums, spectacle, and homicide, the Colosseum is a thing of beauty.

Built when the Empire was at its peak in AD 80, the Colosseum is Rome at its grandest. It was the Empire's biggest gladiator arena. In fact, at 160 feet high and about a third of a mile around, it was the biggest man-made structure Romans had ever seen.

As spectators arrived for the games, they'd be greeted at the door by a *colosso* (hence the name of the arena) bronze statue of Nero 100 feet tall, gleaming in the sunlight. The stadium was a brilliant white, with painted trim and monumental statues. Across the top stretched a vast awning to shade spectators—the first domed stadium. The Colosseum could accommodate 50,000 roaring fans.

The Romans built it using the round Roman arch, but faced it with decorative elements borrowed from Greece: sturdy Doric columns on the bottom, scroll-shaped Ionic on the second tier, and leafy Corinthian at the top. These added a veneer of sophistication to this no-nonsense arena of death.

Entering the stadium, fans would file past fast-food joints and souvenirs of their favorite gladiator. They'd take their seat—there wasn't a bad seat in the house—and look out at the staggering expanse: an oval-shaped playing surface, surrounded by rows of bleacher seats.

Let the games begin!

The trumpets would blare, the drums pound, and the gladiators enter. They'd parade around, wave to the Vestal Virgins in their special box seat, stop before the emperor, and shout: "*Ave Caesar!* Hail Caesar! We who are about to die salute you!"

(continued)

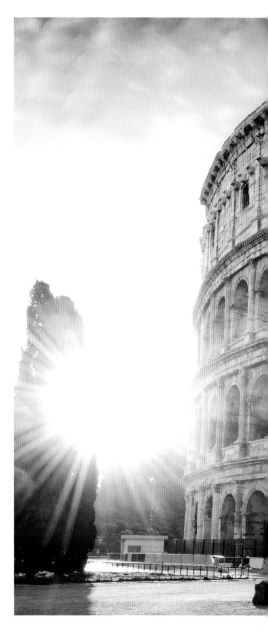

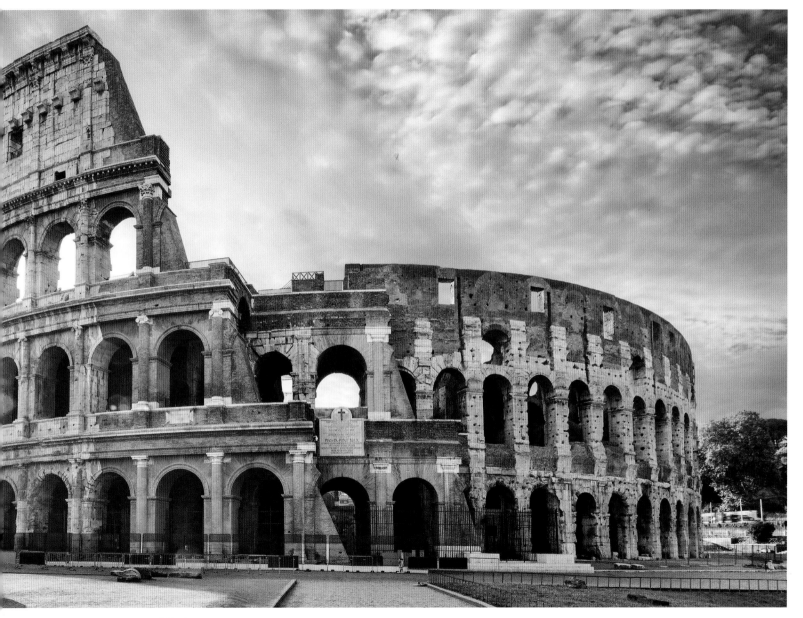

Colosseum (AD 80), Rome

First came the warm-up acts: dogs fighting porcupines, or condemned criminals thrown to lions, or maybe hunters prowling through stage-set forests looking for tigers. Beneath the arena floor, stagehands could raise combatants up on elevators, through trap doors, where they'd pop out from behind a blind. Between rounds, fans were treated to palate-cleansing gimmicks, like female gladiators, or a dwarf battling a one-legged man.

Then came the main event—two trained gladiators squaring off *mano a mano* in a battle to the death. Some carried swords, others specialized in javelins, nets, or tridents. The dead were dragged off by a man dressed like the Roman Grim Reaper.

The Colosseum was inaugurated in AD 80 with a 100-day festival, during which 2,000 men and 9,000 animals were killed. Colosseum employees squirted perfumes to mask the stench.

Why were the Romans so barbaric? Well, public spectacles like these allowed everyday citizens the chance to witness the kind of conquest that generated their plunder-based wealth.

The Colosseum was built at Rome's peak, but as Rome fell, the Colosseum declined. With the coming of Christianity, the games became politically incorrect, and by AD 523—after nearly 500 hundred years of games—the Colosseum closed.

Over the centuries, the structure was inhabited by squatters, battered by earthquakes, and pillaged by scavengers for pre-cut stones.

But today, the Colosseum still stands. It links Rome's past with its vital present. It's the dramatic backdrop for political events and papal appearances, broadcast everywhere.

As the legend goes, so long as the Colosseum shall stand, so shall stand the city of Rome. For nearly 2,000 years, the Colosseum has been the enduring symbol of Rome—the Eternal City.

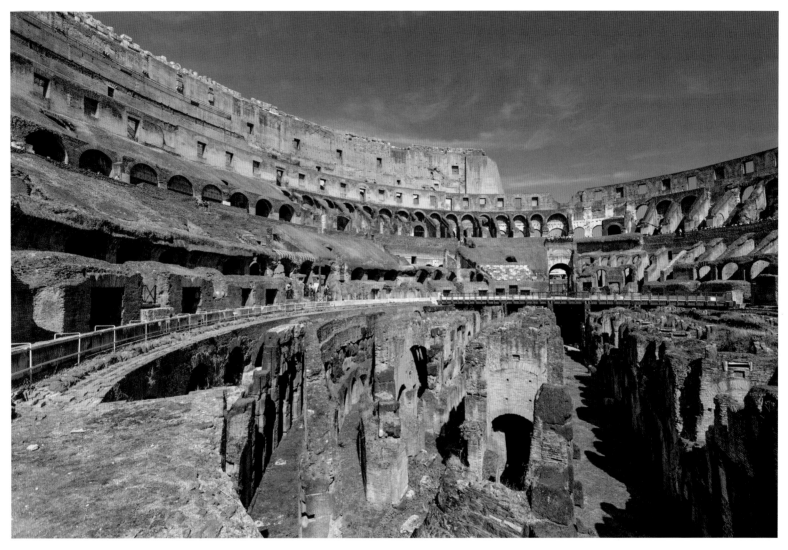

Colosseum interior (AD 80), Rome

ROMAN PANTHEON

The Pantheon gives you a feel for the magnificence and enlightened spirit of ancient Rome better than any other monument.

The Pantheon was a Roman temple dedicated to all *(pan)* of the gods *(theos)*. It was a one-stop-worship place for ancient pagans who could come here to honor Jupiter, Venus, Mars, or any of the thousands of other Roman gods—the god of bread-making, of fruit trees, even the god of manure.

The temple was built by the Emperor Hadrian around AD 120. Hadrian was a voracious traveler, sophisticated scholar, and amateur architect, and he may have personally helped design it. Hadrian loved Greece, and gave the Pantheon the distinct look of a Greek temple—columns, crossbeams, and pediment.

The facade's enormous columns—40 feet tall, 15 feet around, and 55 tons—are each made of a single piece of red-and-gray granite. They were quarried in faraway Egypt, shipped across the Mediterranean, then carried overland to this spot, where they were lifted into place using only ropes, pulleys, and lots of sweaty slaves. It's little wonder that the Romans—so organized and rational—could dominate their barbarian neighbors.

But what makes the building so unique is what's on the inside—a soaring interior dome. Stepping inside, your eye is drawn upward, where the dome completely fills your field of vision. The dome was the ancient world's largest, a testament to Roman engineering. It's exactly as high as it is wide—142 feet from floor to rooftop, 142 feet from side to side. You can put it into an imaginary box that's a perfect cube. Even if you're not a mathematician, the perfection and symmetry of the building makes a strong subconscious impression. Modern engineers still admire how the Romans built such a mathematically precise structure without computers, fossil fuels, or electricity.

The dome is made from concrete, a Roman invention. The dome gets lighter and thinner as it rises to the top—from 20-foot-thick walls at the bottom to five feet thick at the top, made with light volcanic stone. The square indentations, or coffers, reduce the weight as well. At the top of the dome is an opening 30 feet across. This sunroof is the building's only light source. So what happened when it rained? They got wet.

With perhaps the most influential dome in art history, the Pantheon was the model for Brunelleschi's dome in Florence, Michelangelo's at St. Peter's, and even the Capitol Building in Washington, DC.

As ancient Rome crumbled, the Pantheon was spared. This pagan temple to "all the gods" was converted to a Christian church to "all the martyrs." Over the centuries, it became a revered burial spot for "secular saints" like the artist Raphael and Italy's first modern king.

The Pantheon is the only ancient building in Rome continuously used since its construction. Visitors from around the world pack the place to remember the greatness of classical Rome. And the Pantheon contains the world's greatest Roman column. There it is—the pillar of light, shining through the sunroof, spanning the entire 142 feet, connecting heaven and earth.

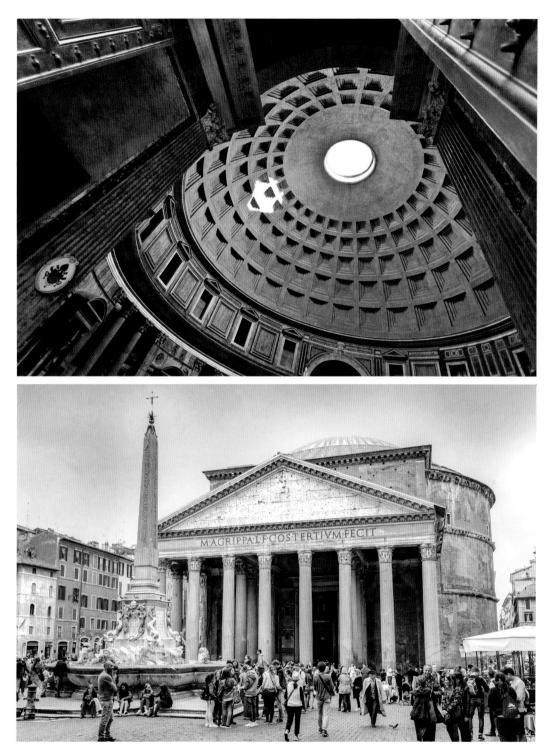

Pantheon (AD 120), Rome

RAVENNA'S MOSAICS

It's AD 540. The city of Rome has been looted, Italy is crawling with barbarians, and Rome's thousand-year empire is crumbling fast. Into this chaotic world comes the emperor of the East—Justinian. In these tranquil mosaics (which he commissioned), he reassured everyone that he was restoring order and stability—that his rule would be a beacon of civilization.

Emperor Justinian—wearing the imperial purple robe and jeweled crown—leads a dignified procession of men into the church. The other mosaic (on the opposite wall) is a mirror image: Empress Theodora leads her entourage of well-dressed women and courtiers.

Justinian is flanked by soldiers (left) and priests (right), demonstrating how he was reuniting the empire both politically and religiously. He carries a golden bowl of Communion wafers, while Theodora has the chalice of wine, as they file in to consecrate their new church. Justinian and his supportive wife had brought peace to Italy and briefly revived the glory of ancient Rome.

But aside from the symbolism, these mosaics give a behind-the-scenes glimpse at these remarkable people.

Justinian has his legendary curly hair and round handsome face. At age 43, he married his twenty-something girlfriend, the commoner Theodora—renowned for her beauty and notorious for her checkered past as an actress and prostitute. Despite opposition, Justinian made Theodora his queen and most capable adviser. Theodora gets equal billing with her own mosaic.

(continued)

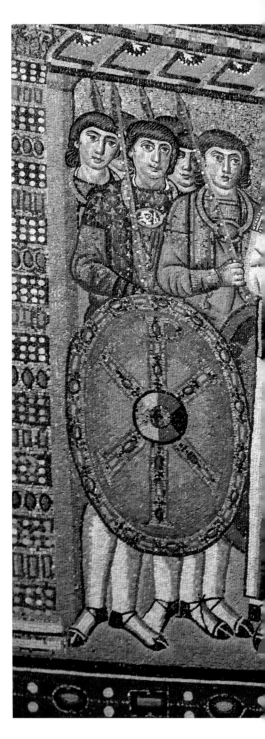

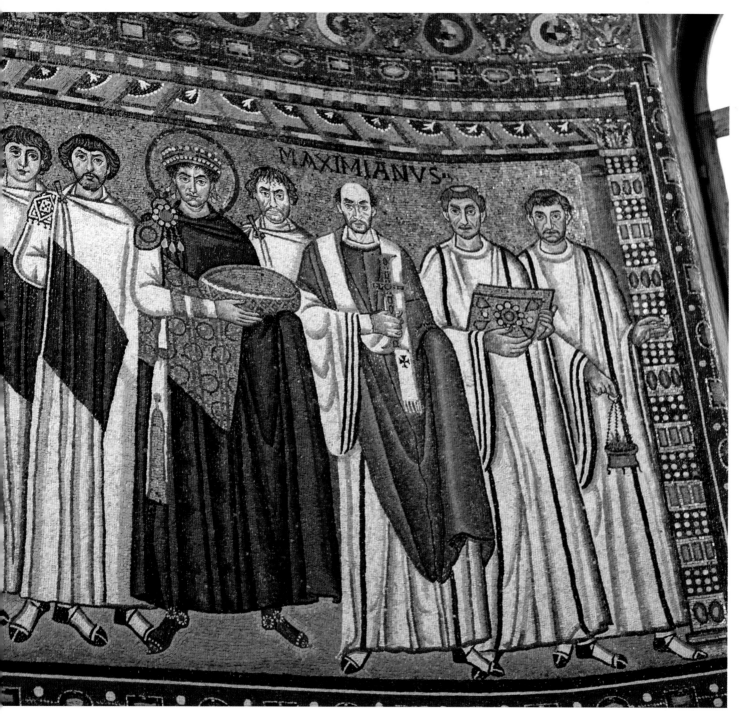

Justinian Mosaic (AD 547), Basilica of San Vitale, Ravenna

In the mosaic, Theodora is joined by her best friend Antonina (right), a fellow actress. Justinian stands alongside his trusty general Belisarius (left), who secured Italy for Justinian. Narses (right) was the palace eunuch who became a ballsy general. The bald guy (labeled "Maximianus") was the bishop Justinian appointed to enforce the three-gods-in-one Trinity doctrine that most Christians follow to this day.

These high-quality mosaics—made from thousands of tiny chips of gold, glass, and stone the size of your fingernail—capture the majesty of this long-lost world. Justinian wears a stunning robe pinned at the shoulder with a jeweled brooch, and accessorizes with an elaborate diagonal-shaped chest-piece that all the big shots wore. Theodora rocks a gown with a brocaded hem embroidered with the Three Magi. Her head and shoulders drip with rubies, emeralds, and pearls. Both Theodora and Justinian wear something else—halos—marking them as divine rulers, in the same god-on-earth tradition of Roman emperors that stretched back to Caesar Augustus.

But now Rome was fading, and these flesh-and-blood human beings were crystallizing into icons. Everyone faces forward, with solemn faces and almond eyes making a line across the mosaic. Any sense of a 3-D setting is dissolving into the gold-mosaic background.

Despite Justinian's efforts, the Roman Empire eventually broke in two and Italy descended into Dark Age chaos. Theodora died young of breast cancer. Justinian retreated to Constantinople (modern Istanbul). For the next thousand years, that eastern half of the Roman Empire—the Byzantine Empire—would be the center of European civilization. And through the dark centuries that followed the collapse of Rome in the West, people could stand in this church—the Basilica of San Vitale in Ravenna—before these glittering mosaics to get a glimpse of the grandeur of what had been . . . and the glory of what was to come—the Renaissance.

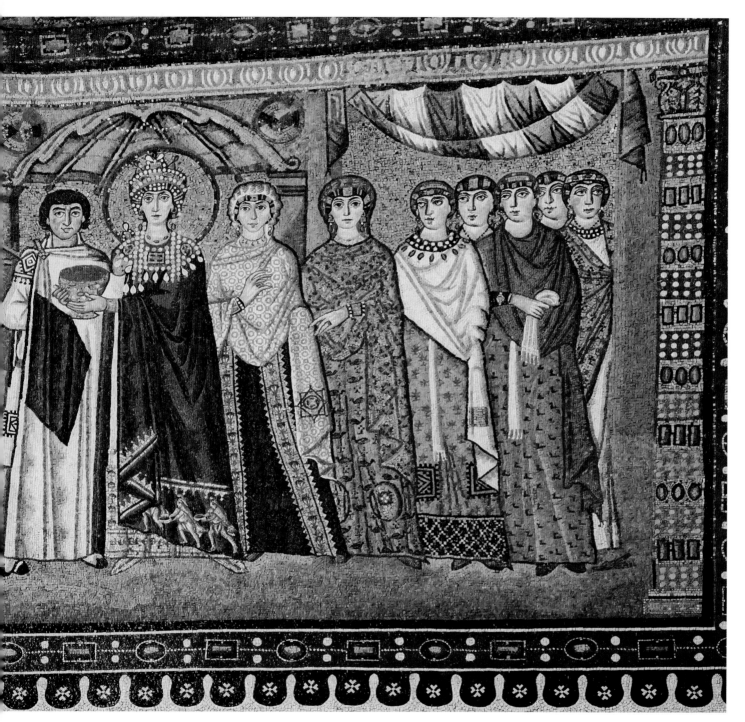

Theodora Mosaic (AD 547), Basilica of San Vitale, Ravenna

MEDIEVAL ERA

A thousand long years separate ancient and modern Europe. These "Middle Ages" lasted from about 500 to 1500. The first half is often called the Dark Ages (500-1000), because, after Rome's fall, Europe crumbled into poverty, war, and cultural stagnation.

There were a few beacons of light: Monks preserved classical learning in hand-copied books. Christian churches were built in the Romanesque style, mimicking the grandeur of ancient Rome. From Europe's fringes came new influences: the Muslim Moors brought exotic splendor to Spain, and the Byzantines of Constantinople (Istanbul) inspired majestic churches in Italy.

After the year 1000, a flood of light shone through stained glass and lit up Dark Age Europe. Thus began the "High" Middle Ages, a time of increased trade, prosperity, and a rising level of culture.

Artists served the wealthy Christian Church. They erected soaring Gothic cathedrals filled with stained glass and adorned with stately statues and dazzling golden altarpieces of the Virgin Mary.

Eventually, secular thought blossomed in universities, and kings stood up to popes. The Europe we know today was taking form, and the Renaissance loomed on the horizon.

BOOK OF KELLS—*CHRIST ENTHRONED*

Jesus Christ sits on a throne and solemnly cradles something very important—a book, the holy word of God. He has a lush head of curly flaxen hair and a thoughtful expression. Seated under an arch, he's surrounded by a labyrinth of colorful, intricately woven designs.

This illustration from an old Bible tells the story of Jesus. This particular drawing came right at the point in the story (Matthew 1:18) where this heavenly Jesus was about to be born as a humble mortal on earth.

It's just one page of the remarkable 1,200-year-old gospels known as the Book of Kells. Perhaps the finest piece of art from the so-called Dark Ages, this book is a rare artifact from that troubled time.

It's the year 800. The Roman empire has crumbled, leaving Europe in chaos. Vikings were raping and pillaging. The Christian faith—officially embraced during the last years of the empire—was now faltering, as Europe was reverting to its pagan and illiterate ways. Amid the turmoil, on the remote fringes of Europe, lived a band of scholarly Irish monks dedicated to tending the embers of civilization.

These monks toiled to preserve the word of God in the Book of Kells. They slaughtered 185 calves and dried the skins to make 680 cream-colored pages called vellum. Then the tonsured monks picked up their swan-quill pens and went to work. They meticulously wrote out the words in Latin, ornamented the letters with elaborate curlicues, and interspersed the text with full-page illustrations—creating this "illuminated" manuscript. The project was interrupted in 806 when Vikings savagely pillaged the monastery and killed 68 monks. But the survivors fled to the Abbey of Kells (near Dublin) and finished their precious Bible.

Christ Enthroned is just one page—1/680th—of this wondrous book. On closer inspection, the page's incredible detail work comes alive. To either side of Christ are two mysterious men holding robes, and two grotesque-looking angels, with their wings folded in front. Flanking Christ's head are peacocks (symbols of Christ's resurrection), with their feet tangled in vines (symbols of his Israelite roots). Admittedly, Christ is not terribly realistic: He poses stiffly, like a Byzantine icon, with almond eyes, weirdly placed ears, and E.T. fingers.

The true beauty lies in the intricate designs. It's a jungle of spirals, swirls, and intertwined snakes—yes, those are snakes, with their little heads emerging here and there. The monks mixed Christian symbols (the cross, peacock, vines) with pagan Celtic motifs of the world around them (circles, spirals, and interwoven patterns). It's all done in vivid colors—blue, purple, red, green, yellow, and black—meticulously etched with a quill pen. Of the book's 680 pages, only two have no decoration.

As Christianity regained its footing in Europe, monasteries everywhere began creating similar monk-uscripts—though few as sumptuous as the Book of Kells. In 1455, Johann Gutenberg invented the printing press, books became mass-produced . . . and thousands of monks were freed from being the scribes of civilization.

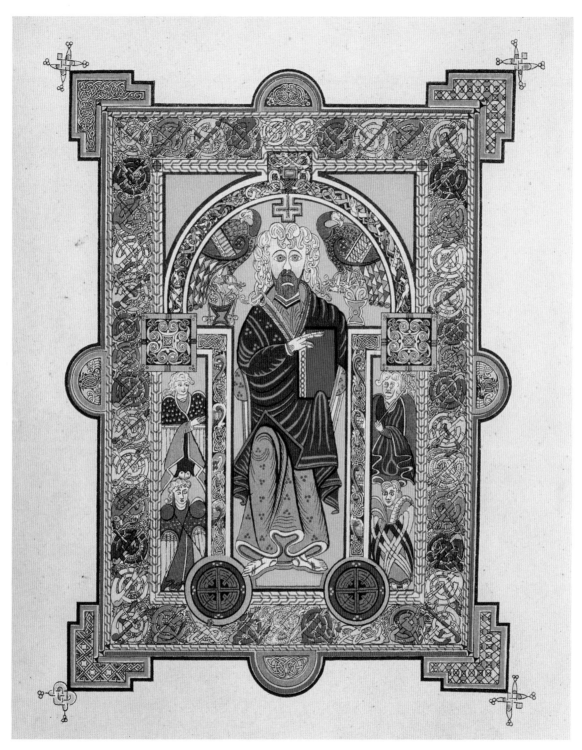

Christ Enthroned, Book of Kells (AD 800), Trinity Old Library, Dublin

ARLES' ROMANESQUE TYMPANUM

The Europe we know today emerged shortly after the year 1000. They'd survived their Y1K crisis, the Viking raids subsided, trade increased, and an energized Christendom fueled a period aptly called the Age of Faith. An unprecedented boom in church building swept Europe. Eager to rekindle the grandeur of ancient Roman structures, these medieval people adopted a knockoff style known as "Romanesque." One of the best surviving examples is in southern France—an 800-year-old church in the city of Arles: St. Trophime.

Like a Roman triumphal arch, the church's main entrance introduced worshippers to a world of classical splendor—with a twist. All of the classical features—round arches, triangular pediment, leafy columns, toga-wearing statues, and intricate reliefs—were filled with Christian imagery.

The damned

In the tympanum (the semicircular area above the door), Christ presides like a Roman emperor over the scene. He's seated majestically on a throne, radiating an oval-shaped aura. One hand is raised in blessing while the other cradles a Bible, in the classic pose of the Pantocrator, or Ruler of All. He's serene, stable, and symmetrical, reassuring everyone that a firm hand is on the tiller.

It's Judgment Day. Christ has come at the end of time to judge men's souls. He brings along the winged creatures of the Apocalypse (Revelation 4). They clutch books and scrolls, identifying them as the four evangelists: Matthew (the winged angel), Mark (the lion), Luke (the ox), and John (the eagle). Below Jesus, the 12 apostles line up on their thrones to dispense justice to the 12 Tribes of Israel. The righteous are permitted to file off to the left toward heaven. But the sinners (on the right) join a chain gang doing a sad conga line over the fires of hell. This entire portal was painted in vivid colors, like a neon billboard overlooking the town square. Illiterate peasants were drawn to it, learning Bible messages through pictures—reassuring, frightening, and inspiring all at the same time.

Stepping inside St. Trophime, you'll notice now dark it is, with heavy stone walls, few windows, and a barrel-arch ceiling—textbook Romanesque. It's no surprise that medieval artists in Arles drew inspiration from the Romans. They were surrounded by ancient monuments—a Roman arena, theater, and baths. They even scavenged the Roman ruins for carved stones to decorate the church.

St. Trophime's fortress-of-God style would later give way to the lighter Gothic style of pointed arches and bright windows. But this church was clearly built to last. It began life as a way station for humble pilgrims on their long trek to Santiago de Compostela, Spain. For 800 years pilgrims paused here to meditate on the solemn Christ, winged creatures, pious apostles, and lightly-toasted sinners . . . and they still do today.

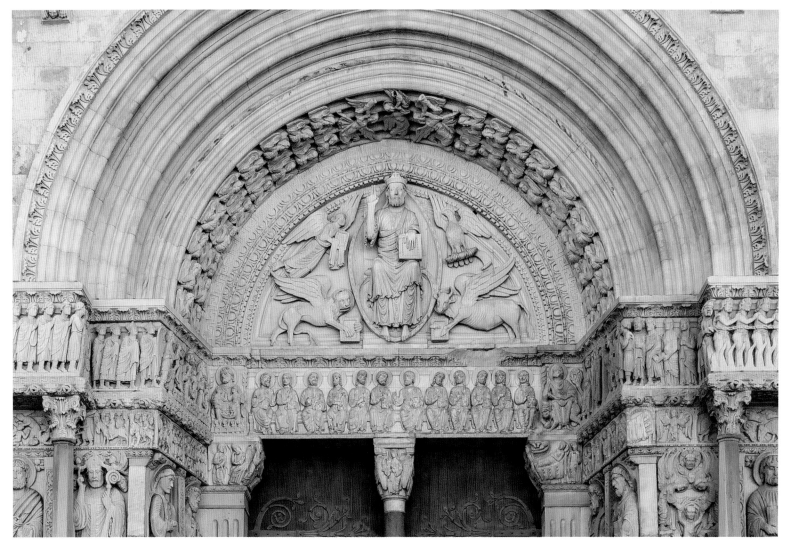

Tympanum (c. 12th century), St. Trophime Church, Arles, France

CROWN OF THE HOLY ROMAN EMPEROR

In a darkened, high-security room of a palace in Vienna lie the crown jewels of a lost empire. These are Europe's oldest and most venerated royal objects—the sacred regalia used to crown the Holy Roman Emperor. These precious objects set the tone for nearly a thousand years of coronations.

The star of the collection is the Imperial Crown. Compared with more modern crowns, it's a bit clunky—oddly shaped and crusted with uncut (not faceted) gems. But it's more than 1,000 years old, and is a true Dark Age bright spot. It was probably made for Otto the Great, the first king to call himself Holy Roman Emperor (r. 962–973). Otto saw himself as the successor to the ancient Roman emperors, as well as King Charlemagne who revived the empire in the year 800. Like Charlemagne, Otto made sure he was crowned personally by the pope in St. Peter's—thus legitimizing both his "Roman" birthright and his "holy" right to rule.

The Imperial Crown swirls with symbolism. The cross on top says this man is a divine monarch, ruling with Christ's blessing. The Roman-style arch over the top recalls the feathered crests of legionnaires' helmets. And the sheer opulence of the crown—made of 22-carat gold, elaborate filigree, and 144 precious stones—attests that this king rules over many lands: a true emperor.

After Otto, future rulers were crowned with this same crown. Many were just minor dukes who called themselves emperors. (Voltaire quipped that the Holy Roman Empire was "neither holy, nor Roman, nor an empire.") But under the dynamic Austrian Habsburg family, it truly became an empire, covering much of Europe and the New World. The Habsburgs' 60-acre palace in Vienna (the Hofburg) was the epicenter of European culture, and their time-worn coronation rituals became Europe's standard.

Picture the crown along with the other royal regalia in action for a coronation. First, the emperor-to-be would don the royal mantle, a 900-year-old red-and-gold silk cloak, embroidered with exotic lions, camels, and palm trees threaded from thousands of tiny white pearls. Next, the entourage entered the church, bearing the 11th-century jeweled cross, complete with a chunk of the (supposed) actual cross of Jesus. The emperor was given a royal orb (modeled on Roman orbs), an oak-leaf scepter, and a sword said to belong to Charlemagne himself (but probably not). The emperor placed his hand on a gold-covered Bible and swore his oath. Then he knelt, the jewel-studded Imperial Crown was placed on his head, and—*dut dutta dah!*—you had a new Holy Roman Emperor.

By the 19th century, the Habsburg Empire was fading. "Holy Roman" rulers were forced to tone down their official title, and once-powerful emperors were reduced to hosting ribbon-cutting ceremonies and white-gloved balls. In 1914, the heir-apparent, Archduke Ferdinand, was assassinated. This kicked off World War I, Austria fell, and by 1918, the 1,000-year Holy Roman Empire was history. The crown ended up in a glass display case where its jewels still sparkle with the glory of a once-great empire.

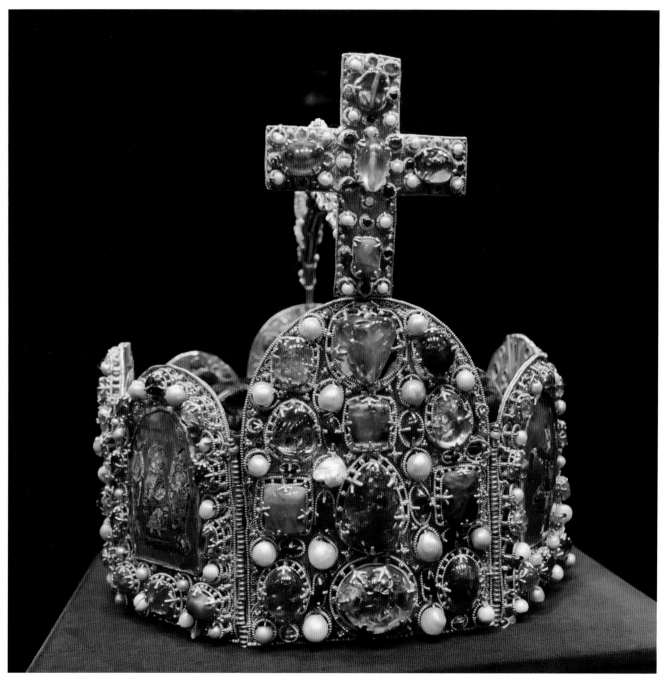

Imperial Crown of the Holy Roman Emperor (c. 960), Hofburg Treasury, Vienna

FLORENCE BAPTISTERY'S HELL

Life in the Middle Ages was "nasty, brutish, and short," leaving medieval people obsessed with what came after: Will I go to heaven or hell?

This mosaic made it crystal clear what the fate of the wicked would be. You'd be sent to hell, where souls were devoured by horned ogres, chomped on by snakes, harassed by Spock-eared demons, and roasted in eternal flames. This particular view of hell, from the Baptistery in Florence, seared itself into the European consciousness.

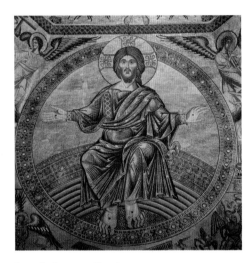

Last Judgment, Baptistery

Florence's Baptistery is even older than this 13th-century mosaic. Built atop Roman foundations, it's the city's oldest surviving building—nearly 1,000 years old. The Baptistery is best known for its bronze Renaissance doors (including Ghiberti's "Gates of Paradise"), but its interior still retains the medieval mood. It's dark and mysterious, topped with an octagonal dome of golden mosaics of angels and Bible scenes.

Dominating it all is the mosaic of Judgment Day. Christ sits on a throne, spreads his arms wide, and gives the ultimate thumbs-up and thumbs-down. The righteous go to heaven, the others to hell.

Of course, no one in medieval times knew exactly what hell was. Even the Bible lacked specifics, describing only a place that's dark, underground, fiery, unpleasant, everlasting, and segregated from the realm of the blessed.

The mission of the artists who did this mosaic: to bring hell to life. It's a chaotic tangle of mangled bodies, slithering snakes, and licking flames. In the center squats a bull-headed monster, with his arms outstretched like Christ's demonic doppelgänger. He gorges on one poor soul, grabs the next course with his hands, and stomps on two more souls, while snakes sprout from his ears and tail to grab more victims.

(continued)

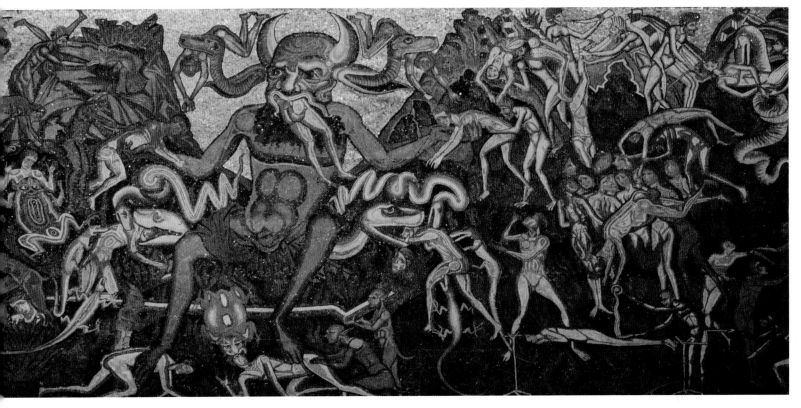

Hell (c. 1225), Baptistery, Florence

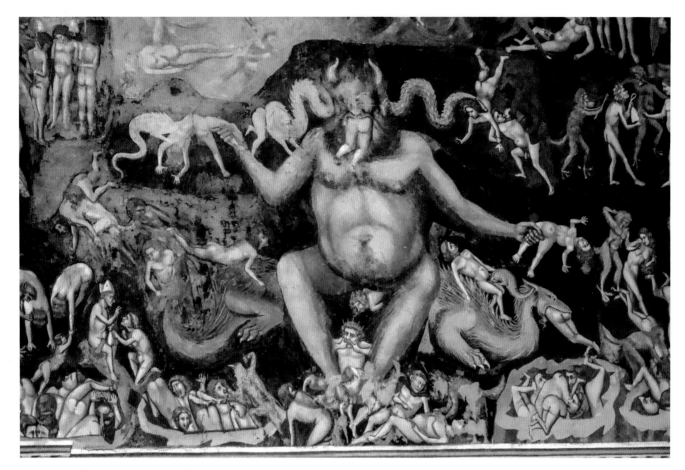

Hell (c. 1305), Giotto, Scrovegni Chapel, Padua

Graphic details like these were groundbreaking in pre-Renaissance times. We see the beast's six-pack abs, braided beard, and wrinkled red robe that echoes the flickering flames. The damned have naturalistic poses—crouching, twisting, gesturing—and their anguished faces tell a sad story of eternal torment.

This mosaic's realism proved to be hugely influential for proto-Renaissance artists like Giotto, and the building itself inspired Renaissance architects like Brunelleschi. And shortly after this mosaic was completed, a little baby named Dante Alighieri was dipped into the baptismal font just beneath it. Dante grew up well aware of this hellish scene. When he wrote his epic poem, *Inferno* ("Hell"), he described it with the same vivid imagery: craggy landscapes, mobs of naked wretches, a Minotaur in the center, and so on. Dante's motifs inspired other artists over the centuries (such as Giotto and Signorelli) who created Europe's altarpieces, paintings, novels, and illustrations. These shaped the imaginations of people around the world. And much of it can be traced to Florence's Baptistery, and to those anonymous artists who labored here in the 13th century, determined to give 'em hell.

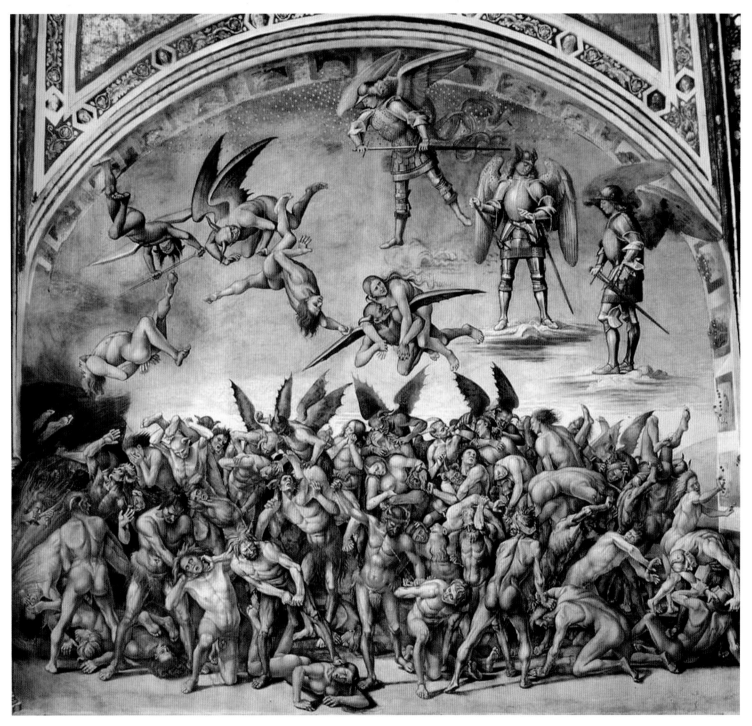

The Damned Cast into Hell (1503), Luca Signorelli, Orvieto Cathedral

VENICE'S ST. MARK'S

Stand in the center of St. Mark's Square—the center of Venice—and take in the scene: the historic buildings, the cafés with their dueling orchestras, the sheer expanse of the square, and all the people—Italians on holiday, Indians in colorful saris, and Nebraskans in shorts and baseball caps. Overseeing it all is a church that's unlike any other in the world—the Basilica of St. Mark.

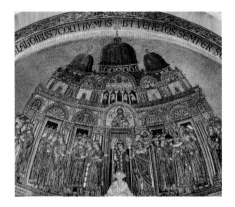

Facade mosaic: St. Mark is buried

St. Mark's is a treasure chest of wonders acquired during Venice's glory days. The facade shows off the cosmopolitan nature of this sea-trading city that assimilated so many different cultures. There are Roman-style arches over the doors, Greek-style columns alongside, Byzantine mosaics, French Gothic pinnacles on the roofline, and—topping the church—the onion-shaped domes of the Islamic world. The gangly structure has been compared to "a warty bug taking a meditative walk" (Mark Twain) or "a love-cluster of tiara-topped ladybugs copulating" (unknown).

One of the facade mosaics depicts the scene when the body of St. Mark—the author of one of the four gospels in the Bible—was interred on this spot. In 1063, this church was built over Mark's bones. As Venice expanded, the church was encrusted with precious objects—columns, statues, and mosaics—looted from their vast empire. Their prize booty was four bronze horses, placed in the center of the facade. It's little wonder that the architectural style of St. Mark's has been called "Early Ransack."

(continued)

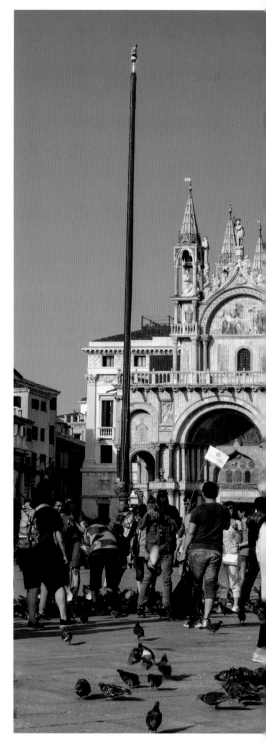

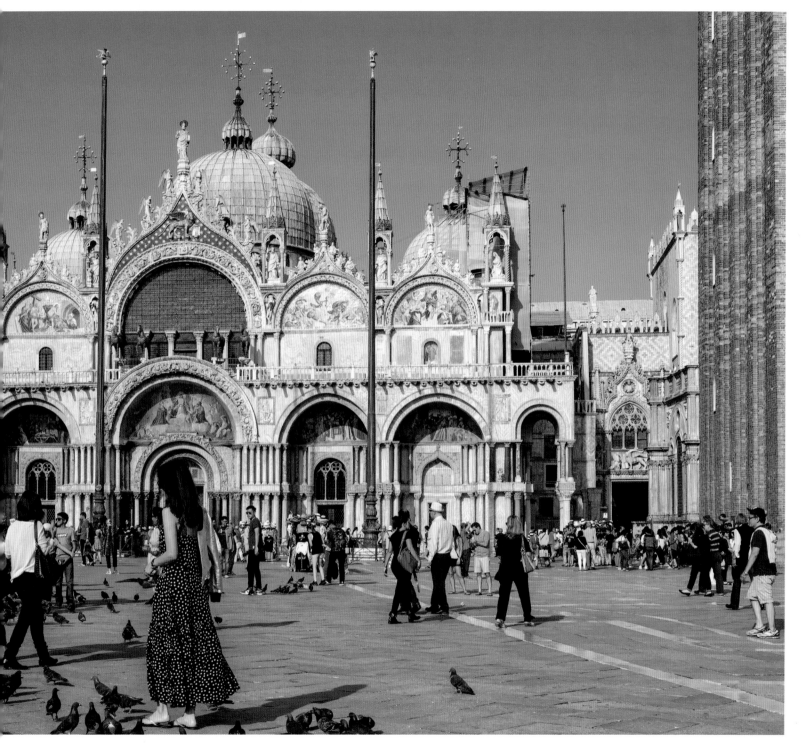

St. Mark's Basilica (1063), Venice

When you step inside St. Mark's Basilica, the entire atmosphere takes on a golden glow as your eyes slowly adjust to the dark. The church is decorated, top to bottom, with radiant mosaics. It's as intricate as it is massive. (Imagine paving a football field with contact lenses.) They tell the entire story of Christ and the saints in pictures made from thousands of tiny cubes of glass (with gold baked inside) and colored stone. The reflecting gold mosaics help light this thick-walled, small-windowed, lantern-lit church, creating a luminosity that symbolizes the divine light of heaven.

Dome of St. Mark's

As you explore deeper, you'll discover the church is filled with precious and centuries-old objects: jewel-encrusted chalices, silver reliquaries, and monstrous monstrances (for displaying the Communion wafer). An urn holds the (supposed) holy DNA of St. Mark. The priceless 1,000-year-old Golden Altarpiece is a towering wall of handcrafted enamels set in a gold frame and studded with 15 hefty rubies, 300 emeralds, and 1,500 pearls. Exotic objects like these date from an era when Venice was almost as oriental as it was European.

The church's symbolic message culminates at the very heart of the church. There, up in the central dome, Christ reigns in the starry heavens, riding on a rainbow. This isn't the agonized, crucified Jesus featured in most churches, but a vibrant, radiant being gazing solemnly down, raising his hand in a blessing, as the Pantocrator, or Ruler of All. His grace radiates through a ring of saints to the altar below. As the central spot in the church, the Pantocrator dome is the symbolic center of the Venetian universe itself, with Christ blessing it all. God's in his heaven, the faithful are on earth, Venice is central, and all's right with the world.

Standing under the dome of St. Mark's, it becomes clear: Among Europe's churches, there are bigger, more historic, and even holier churches. But none are more majestic than St. Mark's Basilica.

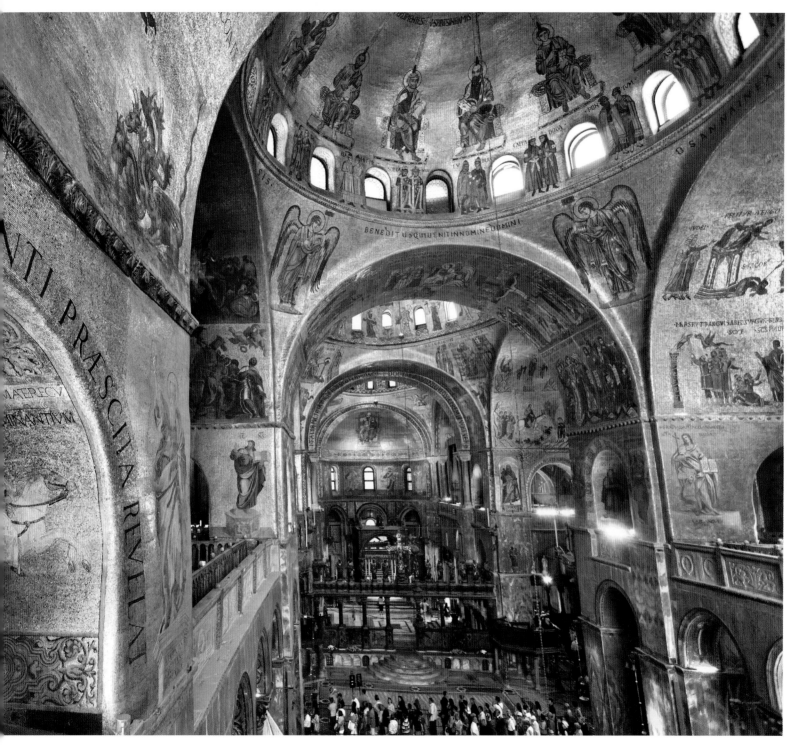

St. Mark's Basilica (1063), Venice

VENICE'S BRONZE HORSES

Stepping lively in pairs and with smiles on their faces, these four bronze horses exude a spirited exuberance. They long stood in the most prominent spot in the city of Venice—above the main door of St. Mark's Basilica, overlooking St. Mark's Square.

The horses are old—much older even than Venice. They're likely from Greece and made in the fourth century BC. Originally they were part of a larger ensemble shown pulling a chariot, Ben-Hur style.

The realism is remarkable: the halters around their necks, the bulging veins in their faces, their chest muscles, and the creases in their necks as they rear back. With flashing eyes, flaring nostrils, erect ears, and open mouths, they're the picture of equestrian energy.

They are clearly teammates. Each raises its hoof at the same time and same height. They cock their heads to the side, seemingly communicating with their brothers with equine ESP.

These bronze statues are rare survivors of that remarkable ancient tech-

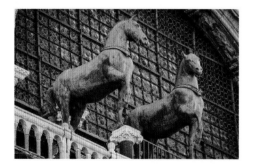

Bronze Horses (copy) on St. Mark's facade

nology known as the lost-wax method. They were not hammered into shape by metalsmiths, but cast—made by pouring molten bronze into clay molds. Each horse weighs nearly a ton. During the Dark Ages, barbarians melted most metal masterpieces down for re-use, but these survived. Originally gilded, they still have some streaks of gold leaf. Long gone are the ruby pupils that made their fiery eyes glisten in the sun.

Their expressive faces seem to say, "Oh boy, Wilbur, have we done some travelin.'" That's because megalomaniacs through the ages have coveted these horses not only for their artistic value, but because they symbolize Apollo, the god of the sun . . . and symbol of power.

Legend says they were made in Greece during the time of Alexander the Great. They were then taken by Nero to Rome. Constantine brought them to his new capital in Constantinople (modern-day Istanbul) to adorn the chariot racecourse. In 1204, during the Fourth Crusade, the Venetians stole them. They placed them on the balcony of St. Mark's Basilica from where the doge would speak to his people—the horses providing a powerful backdrop. Six centuries later, Napoleon conquered Venice and took the horses. They stood atop a triumphal arch in Paris until Napoleon fell and they were returned to their "rightful" home in Venice.

In the 1970s, the horses made their shortest and final journey. With the threat of oxidation from polluted air, they were replaced by modern copies. The originals galloped for cover inside the church, where they are displayed today.

For all their travel, this fearsome foursome still seems fresh. They're more than just art. They stand as a testament to how each civilization conquers the previous one, assimilates the best elements from it, and builds upon it. And when visitors come to Venice today and admire these horses, they're looking at a lot of history.

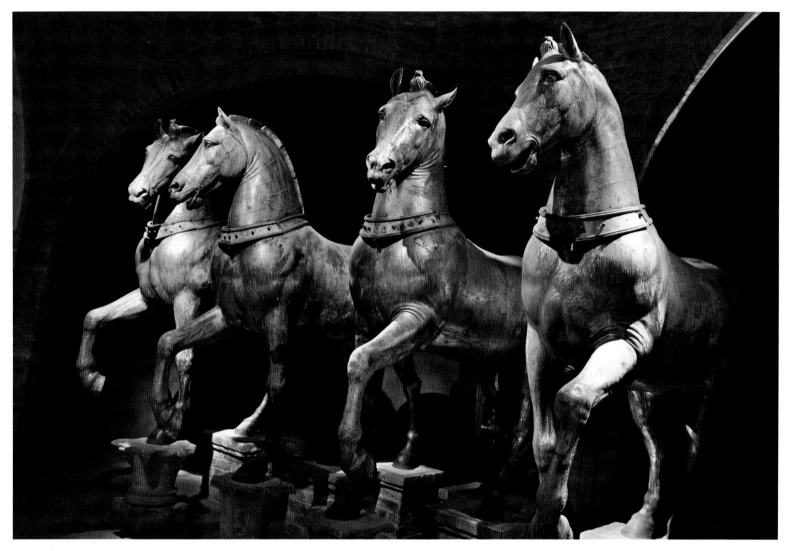

Bronze Horses (fourth century BC), St. Mark's Basilica, Venice

BAYEUX TAPESTRY

This skinny, 70-yard-long strip of cloth depicts a crucial historical event that helped shape the Europe we know. Like a graphic novel, it tells the mesmerizing story of how William the Conqueror and Harold of England competed for the English crown. The tale culminates in one of the most pivotal battles in history: The Battle of Hastings in 1066.

SCENES 1, 2, AND 3: The story begins in London. In the opening scene—the first of about 60 in the tapestry—we see the reigning King of England. King Edward (labeled in Latin *Edward Rex*) is presiding on the throne in his palace. He orders his brother-in-law Duke Harold *(Harold Dux)* to ride off to France. At that time, Normandy (northern France) was under English rule. Harold was to announce to all the subjects that Edward had decided who his successor as king would be—a seemingly illegitimate duke called "William the Bastard," known today as "William the Conqueror."

This colorful scene introduces us to some of the tapestry's artistic elements. First, it's realistic enough that even an illiterate peasant could understand what's happening. The Latin titles reinforce the main characters and key events. Down-to-earth details like the king's jaunty pose and Harold's hunting dogs keep you "reading." The narrative is framed by a border (top and bottom) with more eye candy—some related to the story, some mere decoration.

(continued)

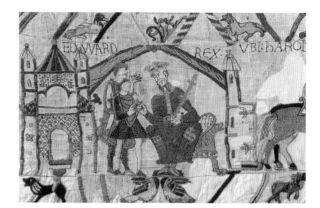

1: King Edward on his throne . . .

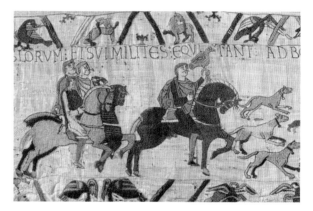

2: . . . sends Duke Harold to France . . .

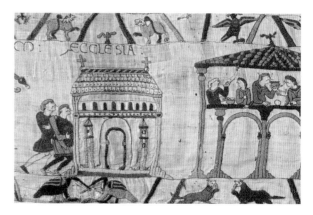

3: . . . where William lives.

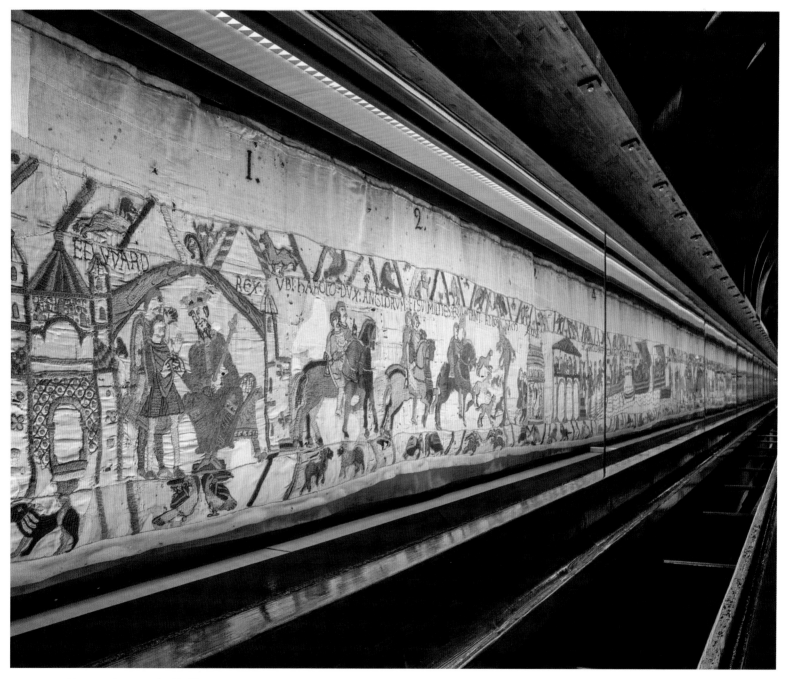

Bayeux Tapestry (c. 1070), Bayeux Tapestry Museum, Bayeux, France

Let's fast-forward a few scenes.

SCENE 23: Here, Harold (in the flowing cape) has located William (seated, cradling a sword). Harold tells William he'll be the future king of England, and places his hand on a casket of holy relics, and swears his undying loyalty.

This was a key scene. It shows that Harold knew full well that William was the rightful heir. The Latin title clearly says: "Harold made a holy oath to William." But look—even while Harold is publicly pledging allegiance, privately he's scowling.

SCENE 25: In a later scene, Harold has returned to England, where he tells King Edward he's faithfully done as instructed. The king's gesture looks like he's not so convinced. Harold cringes obsequiously, like the slimy scum he is.

Look closely at the raised surface of the king's rich robe. You can practically feel the texture with your eyes. This so-called "tapestry" was actually made by embroidering—that is, using a needle-and-thread to stitch the figures onto a white linen cloth.

SCENE 28: Next, we see King Edward (top, among friends) as the picture of health. But suddenly (bottom), he was *defunctus,* and laid out for burial. That very day, Harold seized power.

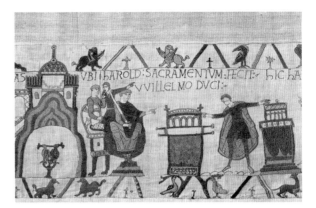

23: Harold (in cape) swears loyalty to William.

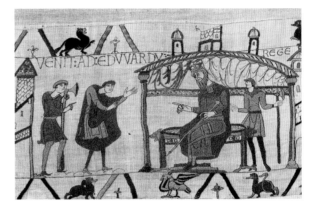

25: Harold slinks back to King Edward.

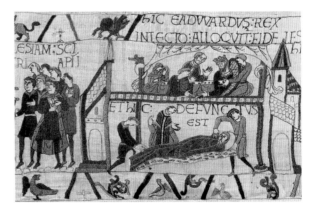

28: Edward (reclining in green) dies.

SCENES 30–32: Next, we see Harold on the throne in Westminster Abbey, where the archbishop gives him the scepter, crown, and orb, making him "King of the English." Courtiers to the left and right applaud. Harold is at the peak of his power. But wait—what's this?! Farther to the right, there's a stir in the crowd. Everyone looks up and points at something. It's a new star (stella) in the sky. It's none other than Halley's Comet racing across the heavens in the year 1066. It must surely be an omen of Harold's future—but would it be good, or bad?

Keep in mind as you read the Bayeux tapestry: It was Norman propaganda. Harold's the villain, William is the good guy. The English have barbaric long hair, while the Normans are clean-cut. Normans of the day actually called their English cousins *"les goddamns,"* after a phrase they kept hearing them say.

The tapestry was probably made in the 1070s—that is, shortly after the events depicted. It was made by the Normans to hang in the nave of Bayeux's cathedral to remind locals of their ancestors' courage.

Let's continue the story. As you recall, Harold of England had seized William of Normandy's rightful throne. How would William respond?

SCENE 38: The tapestry shows William in northern France, boarding his army onto ships. He's determined to win his rightful crown. They set out across the English Channel in dragon-prowed ships reminiscent of the Vikings. No wonder—these "Normans" (as their name reminds us) are descendants of the "Norse-men," with the Vikings' seafaring skills and weaponry. The Normans arrive in England at the coastal town of Hastings and prepare for battle.

(continued)

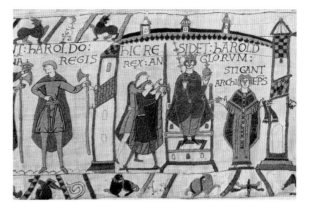

30: Harold (on throne) is now King.

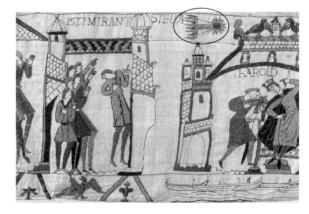

32: People point to a comet.

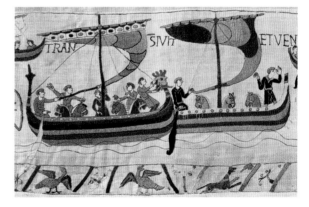

38: William sails to England.

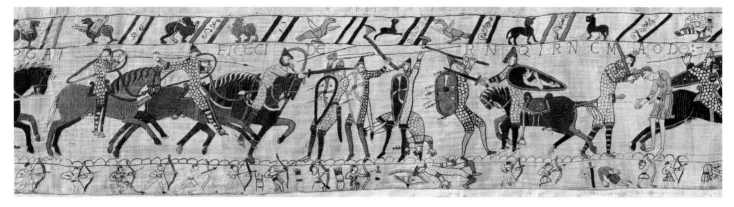

56: Soldiers, horses, swordsmen, and archers fight the pivotal Battle of Hastings.

SCENES 56–57: We fast-forward to the climax of the whole tapestry: the Battle of Hastings, which pitted the invading Normans of France against the Anglo-Saxons of England. It was a fierce, 14-hour battle. Knights on horseback charge, swordsmen clash, and archers launch arrows, leaving the battlefield strewn with mangled corpses. Amid the chaos, we see Harold—he's standing right below his title, *Haro-l-d: Rex,* holding his shield. According to historical accounts, Harold had fallen from his horse. He lifted his visor to shout to his men, when suddenly—shoop!—Harold gets hit with an arrow, right in the eye. (It's yellow and a bit hard to see.) Finally, an enemy horseman bends down to finish Harold off with a sword. The title above says it all: "Here King Harold is slain."

The Battle was won by William. The Normans now ruled England. This illegitimate child, until then known as "William the Bastard," could now call himself "William the Conqueror." As the tapestry continues, it shows the victorious Normans riding off to . . . to . . . to . . .

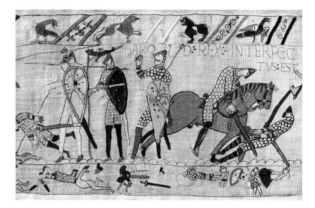

57: Harold (standing in center) gets shot . . .

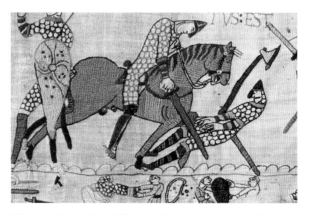

57 (detail): . . . then falls, finished off with a sword.

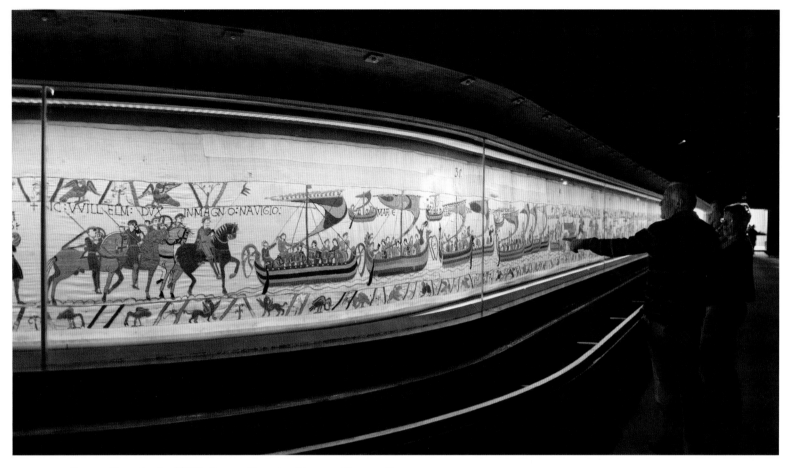

Bayeux Tapestry (c. 1070), Bayeux Tapestry Museum, Bayeux, France

Unfortunately, that's where the Bayeux tapestry ends, because the final scene is missing, lost to history.

But we know the rest of the story. William marched to London, claimed his throne, and (though he spoke no English) became king of England. This set in motion 400 years of conflict between England and France—not to be resolved until the 15th century. However, on the plus side, the Norman conquest of England brought that country into the European mainstream.

Because of the events depicted on the Bayeux tapestry, England got a stable government, contact with the rest of Europe, and a chance to eventually grow into a great European power.

And today, historians and tourists alike can stand in the presence of this precious document, stroll slowly along, and see those momentous events from nearly a thousand years ago unfold before their eyes.

THE ALHAMBRA

Nowhere else does the splendor of Moorish civilization shine so beautifully than at the Alhambra—this last and greatest Moorish palace in Europe.

For seven centuries (711–1492), much of Spain was Muslim, ruled by the Islamic Moors from North Africa. While the rest of Europe was slumbering through the Dark Ages, Spain blossomed under Moorish rule. The culmination was the Alhambra—a sprawling complex of palaces and gardens atop a hill in Granada. And the highlight is the exquisite Palacios Nazaríes, where the sultans and their families lived, worked, and held court.

You enter through the fragrant Court of the Myrtles, into a world of ornately decorated rooms, stucco "stalactites," filigreed windows, and bubbling fountains. Water—so rare and precious in the Islamic world—was the purest symbol of life. The Alhambra is decorated with water, water everywhere: standing still, cascading, masking secret conversations, and drip-dropping playfully.

As you explore the labyrinth of rooms, you can easily imagine sultans smoking hookahs, lounging on pillows and Persian carpets, with heavy curtains on the windows and incense burning from the lamps. Walls and ceilings are covered with intricate patterns carved in wood and stucco. (If the Alhambra's interweaving patterns look Escheresque, you've got it backward: The artist M. C. Escher was inspired by the Alhambra.) Because Muslim artists avoided making images of living creatures, they ornamented with calligraphy—by carving swoopy letters in Arabic, quoting poetry and verses from the Quran. One phrase—"only Allah is victorious"—is repeated 9,000 times.

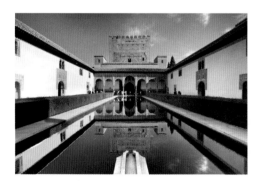

Courtyard of the Myrtles

The Generalife gardens—with manicured hedges, reflecting pools, playful fountains, and a breezy summer palace—is where sultans took a break from palace life. Its architect, in a way, was the Quran, which says that heaven is like a lush oasis, and that "those who believe and do good, will enter gardens through which rivers flow" (Quran 22.23).

(continued)

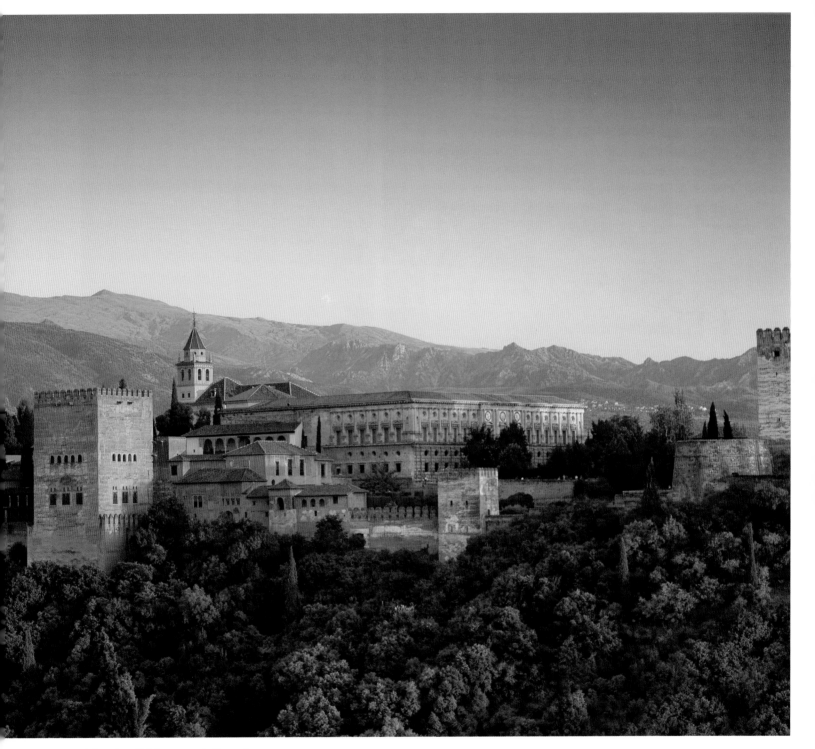

Alhambra (14th century), Granada

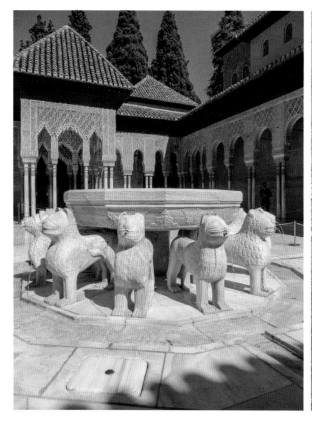

Courtyard of the Lions

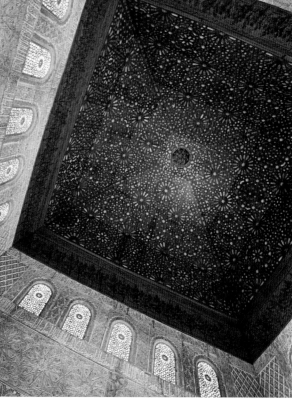

Grand Hall of the Ambassadors ceiling

The Alhambra's much-photographed Courtyard of the Lions is named for its fountain of 12 marble lions. Four channels carry water outward—figuratively to the corners of the earth and literally to the sultan's private apartments. As a poem carved onto the Alhambra wall says, the fountain gushes "crystal-clear water" like "the full moon pouring light from an unclouded sky."

The palace's largest room is the ornate throne room—the Grand Hall of the Ambassadors. Here the sultan, seated on his throne beneath a domed ceiling of stars, received visitors. The ceiling, made from 8,017 inlaid pieces of wood (like a giant jigsaw puzzle), suggests the complexity of Allah's infinite universe.

The throne room represents the passing of the torch in Spanish history. It was here in the year 1492 that the last Moorish king surrendered to the Christians. And it was here that the new monarchs, Ferdinand and Isabella, said *"Sí, señor"* to Christopher Columbus, launching his voyage to the New World that would make Spain rich. But the glory of the Alhambra lived on, adding an elegance and grace to Spanish art for centuries to come.

Today, the Alhambra stands as a thought-provoking reminder of a graceful Moorish world that might have flowered throughout all of Europe—but didn't.

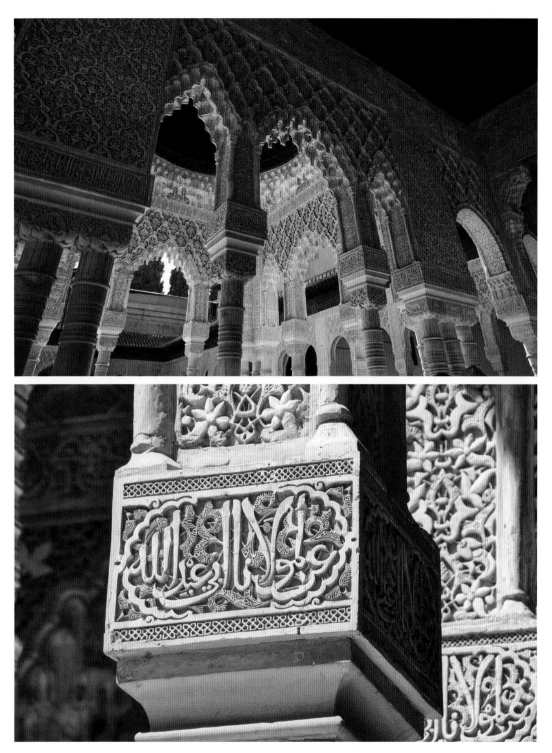

Above: Intricate stucco work in the Alhambra
Below: The name of Allah (which looks like a "W") carved throughout

DUCCIO'S *MADONNA*

Often called the last great medieval altarpiece, this painting capped the era with unprecedented size, skill, and opulence.

During the Middle Ages—also known as the Age of Faith—most every church in Europe had a painting like this one. Mary sits on a throne, with Baby Jesus in her lap, flanked by angels, amid the golden radiance of heaven. Mary was a cult figure, adored for bringing Jesus into the world. During troubled times, a maternal figure like Duccio's majestic Madonna—nearly 10 feet tall (sitting down) and enthroned in a golden world—reassured worshippers that everything would be okay.

The painting is not terribly realistic by modern standards: There's no background. The angels are just stacked on top of each other, floating in gold, kneeling on air. Mary's throne is crudely drawn, with the left side turned at a three-quarters angle while the right points straight out. Mary herself is a wispy cardboard cutout that seems to float just above the throne.

These were time-worn formulas stretching back centuries. The faces are as somber as icons and ancient mosaics. Mary's almond eyes and super-long fingers heighten her otherworldly elegance. These elements were in every church in every century. Like the universal use of Latin for Mass, this gave the Christian faith a predictable, reassuring uniformity and consistency.

On the other hand, that long tradition was about to change . . . and Duccio was the man who started it. In fact, this "last medieval altarpiece" has also been called the "first great Renaissance painting."

Duccio pioneered Renaissance 3-D. He draped a curtain on the back of Mary's throne. With that simple act, suddenly Mary is no longer floating in the golden ether, she's clearly "in front of" the drape, existing somewhere in the same real space we inhabit.

The painting is alive with brilliant colors. Mary's dress is deep blue, framed with gold trim, and highlighted with pink where her undergarments show through at the neck, wrists, and feet. Jesus' delicate shirt and red robe are tied up with a neat golden bow. Every angel wears a different robe—pink, purple, lilac, green. The gold background is made of real gold, making this altarpiece glow in a dim church. Follow the exquisite line of gold in Mary's trim: it frames her face, then snakes down to Jesus, then curves across her lap and down to the labyrinthine hem. This level of realistic detail was unheard of in medieval times.

What was truly innovative was how Duccio made these heavenly folks seem human. He gives Mary a human tenderness and Jesus a childlike playfulness, as he reaches out to give the congregation a cute "blessing." Notice that everyone looks in a different direction: The angels gaze adoringly at Mary and Jesus, Jesus looks somewhere offstage, and Mary stares out at the viewer. It turns a symbolic formula into a scene, an ensemble of interacting characters. And it means that the worshipper, returning Mary's gaze, is now part of this intimate episode.

What Duccio started, Giotto and other artists continued, and the rest became Renaissance history. Duccio pointed the way as art became more realistic, beautiful, and human.

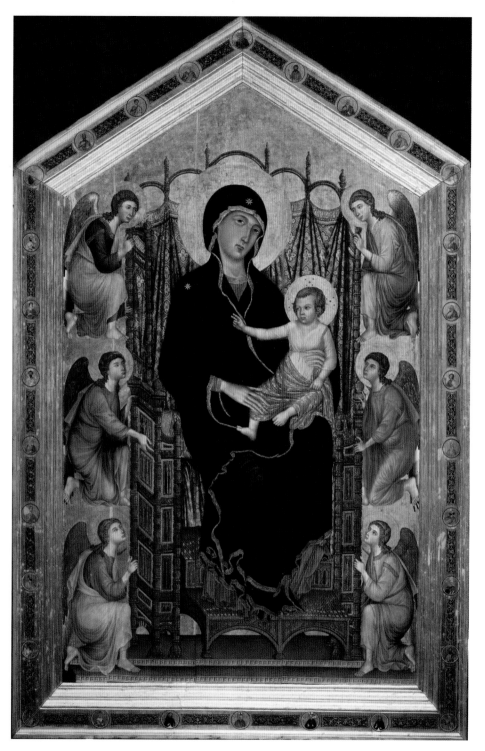

Rucellai Madonna (1285), Duccio, Uffizi Gallery, Florence

GIOTTO'S SCROVEGNI CHAPEL

Wallpapered with Giotto's beautifully preserved cycle of 38 frescoes, the glorious Scrovegni Chapel depicts the life of Jesus with unprecedented realism. Painted around 1305, two full centuries before the High Renaissance, it's considered to be the first piece of "modern" art. Europe was breaking out of the Middle Ages, and Giotto was painting real people in real scenes, expressing real human emotions.

The walls of this long, narrow chapel in Padua were Giotto's canvas to tell the three-generation history of Jesus. Giotto's storytelling style is straightforward, and anyone with knowledge of the episodes of Jesus' life can read the chapel like a comic book.

Detail of *Betrayal of Christ (The Kiss)*

It begins in the chapel's upper corner with a heartbreaking episode that draws the viewer right in. Jesus' grandpa, Joachim, is humiliated because he can't produce a child. He returns dejectedly home, where miraculously, his wife gives birth to Mary, the mother of Jesus.

From this humble start, the story spirals clockwise around the chapel, from top to bottom: We see Jesus being born in a manger, baptized by John the Baptist, performing miracles, and so on. "Turning the page" to the chapel's other wall, Giotto begins Jesus' traumatic final days: the Last Supper, Jesus' arrest, and the Crucifixion. The story concludes on the rear wall with a giant fresco of Jesus reigning at the Last Judgment. And all this unfolds beneath a blue, starry sky overhead on the chapel ceiling.

Jesus' life was so eventful that Giotto had to crystalize the story into just a few evocative scenes. He captures all the drama of the Passion in the *Betrayal of Christ* panel—a.k.a. *Il Bacio,* or "The Kiss." Amid the chaos of battling soldiers, Giotto directs your eye to the crucial action in the center. There, Judas ensnares Jesus in his yellow robe (the color symbolizing envy), establishes meaningful eye contact, and kisses him. Jesus' stone-faced response to his supposed friend says it all.

At age 35, at the height of his powers, Giotto tackled the Scrovegni, painting the entire chapel in 200 working days.

His frescoes were groundbreaking: more realistic, 3-D, and human than anything seen in a thousand years. Giotto set his religious scenes in the everyday world of rocks, trees, and animals. So, when Joachim returns home, his faithful dog leaps up to greet him, frozen realistically in mid-air. Giotto's people, with their voluminous, deeply creased robes, are as sturdy and massive as Greek statues. They exude stage presence. Their gestures are simple but expressive: A head tilted down says dejection, clasped hands indicate hope.

Giotto's Scrovegni Chapel represents a turning point not only for European art, but also for a whole new way of thinking. It was Humanism—away from scenes of heaven and toward a more down-to-earth view, with man at the center.

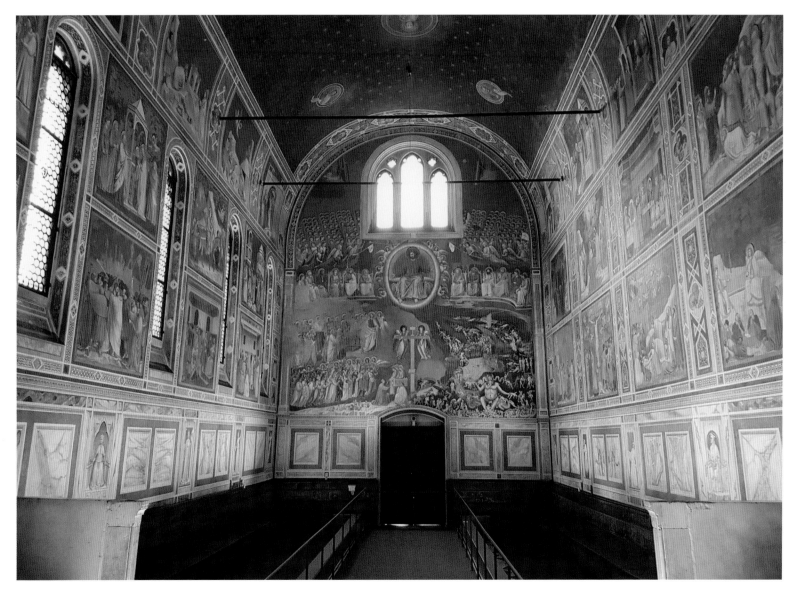

Scrovegni Chapel frescoes (c. 1305), Giotto, Scrovegni Chapel, Padua

PARIS' NOTRE-DAME CATHEDRAL

On an island in the center of Paris—on the spot dubbed "point zero"—stands the world's best-known Gothic cathedral. Notre-Dame's facade is instantly recognizable: the twin rectangular towers, the circular rose window, the three arched doorways, the rows of statues . . . and the impish gargoyles that line the roof.

The round rose window frames a statue of "Our Lady" (Notre Dame) to whom this church is dedicated. For centuries, Mary, the mother of Jesus, has symbolized the Christian faith's compassionate heart. And here she stands at the heart of the facade, surrounded by the halo of the rose window. And this church stands at the heart of Paris, where the ancient Parisii tribe settled, where Romans built their pagan Temple of Jupiter, and where the Franks replaced it with a Christian church.

Imagine the faith of the people who built this massive cathedral. Countless people of high and low standing dedicated their lives to building this church, knowing it wouldn't be finished until long after they were dead. They broke ground in the year 1163 with the hope that someday their great-great-great-great-great-great grandchildren might attend the dedication Mass. Two centuries later, in 1345, they did.

Over the centuries, the cathedral continued to evolve and undergo renovation. Recently it suffered a devastating fire (2019), requiring yet another makeover, and adding another chapter to its long history.

Stepping inside, put on a medieval pilgrim's perspective as you soak in the ambience of this centuries-old space. Follow the slender columns up 10 stories to where Gothic arches come together like praying hands.

Take in the subtle, mysterious light show that God beams through the stained-glass windows.

This is Gothic. Taller and filled with light, this was a new design needing only a few load-bearing columns, topped by crisscrossing pointed arches to support the weight of the stone roof. No longer did walls have to be thick and fortress-like to provide support—instead they could be filled with windows.

Back outside Notre-Dame, you see the gangly architectural elements of Gothic: pointed arches, tall windows, lacy stone tracery, and statues.

Most distinctive of all are the flying buttresses, the 50-foot-long stone beams that stick out from the church. They were the key to the Gothic structure. With pointed arches supporting the roof, the weight of the roof pressed outward, not down (as with earlier round arches). Flying buttresses supported that weight by pushing back in. This Gothic technology, with its skeletal structure mostly protruding on the outside, was invented in Paris in the 13th century. It enabled architects to erect lofty cathedrals with roofs supported by thin columns, allowing for "walls" of glorious stained glass.

The church's roofline is dotted with statues of grotesque winged creatures. These bizarre beasts represented tormented souls caught between heaven and earth. They also functioned as drain spouts. When it rained, they made a gargling sound, giving us their name—gargoyles. Or maybe that's the sound of Quasimodo as he limps along the roofline, grunting and grimacing with appreciation at this, the wonder of the High Middle Ages.

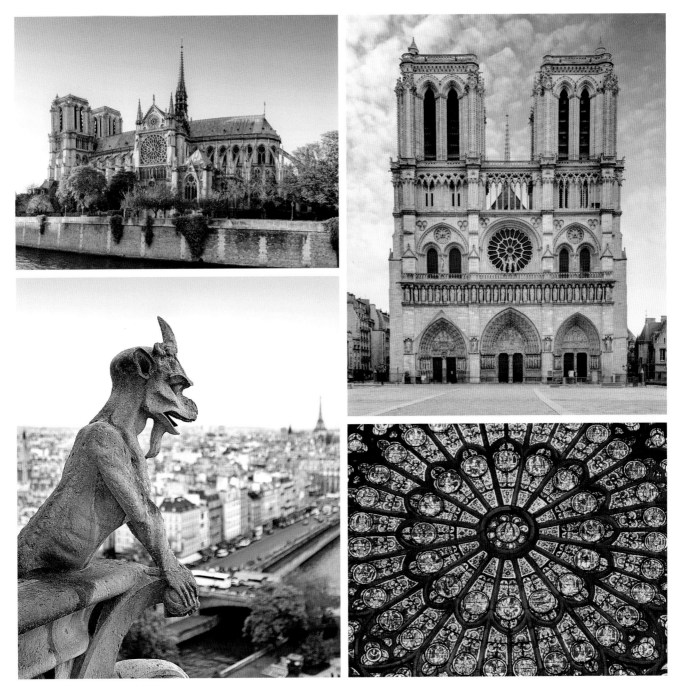

Notre-Dame Cathedral (1163–1345), Paris

SAINTE-CHAPELLE

This tiny jewel of Gothic architecture is a cathedral of glass like none other. It was purpose-built by King Louis IX—the only French king who is also a saint—to house Jesus' supposed Crown of Thorns.

Louis came upon the crown in Constantinople while on Crusade. Convinced he'd found the real McCoy, he spent a fortune to build a suitable chapel to hold it—and paid triple that for the precious crown. Today, the supposed Crown of Thorns is not on display, but the church is, along with its star attraction: stained glass.

You enter Sainte-Chapelle on the somber ground floor, wind your way up a tight spiral staircase, and then pop out—*wow!*—into a cathedral that seems to be made of nothing more than glowing colors and radiant light.

Fiat lux. "Let there be light."

From the first page of the Bible, it's clear: Light is divine. In Sainte-Chapelle, the sunlight shines through the stained glass like God's grace shining down to earth. The dazzling glory of Gothic glows brighter here than in any other church.

Gothic architects used new technology to turn dark stone buildings into lanterns of light. Sainte-Chapelle has only the slenderest of structural columns becoming ribs that come together to make pointed arches to hold up the roof, leaving "walls" of glass. Sainte-Chapelle was completed in a mere six years (Notre-Dame, just a few steps away, took 200), creating a harmonious structure that's the essence of Gothic.

Worshippers are surrounded by 15 big window-panes, with more than 1,000 different scenes. These cover the entire Christian history of the world, from the Creation to Christ to the end of the world—6,500 square feet of glass in all. Each individual scene is interesting, and the whole effect is overwhelming.

Craftsmen made the stained glass—which is, essentially, melted sand—using a recipe I call "Stained Glass Supreme": Melt one part sand with two parts wood ash. Mix in rusty metals to get different colors—iron makes red, cobalt makes blue, copper makes green, and so on. Blow glass into a cylinder shape, cut lengthwise, and lay flat to cool. Cut into pieces. Fit pieces together by drizzling molten strips of lead to hold them in place. The artist might use, say, blue glass for background, green for clothes, brown for hair. More intricate details—like folds in the robes or the line of a mouth—are created by scratching or painting the glass. Put it all together, and—*voilà!*—you've created a picture. Imagine the painstaking process of making the glass, fitting the pieces together to make a scene . . . and then multiply it by a thousand.

In Sainte-Chapelle, medieval worshippers could stand immersed in radiant light. They'd gaze upon the crown, ponder Christ's sacrifice, see the sunlight pouring in like God's grace as it illuminates Bible lessons in glass . . . and get a glimpse of the divine.

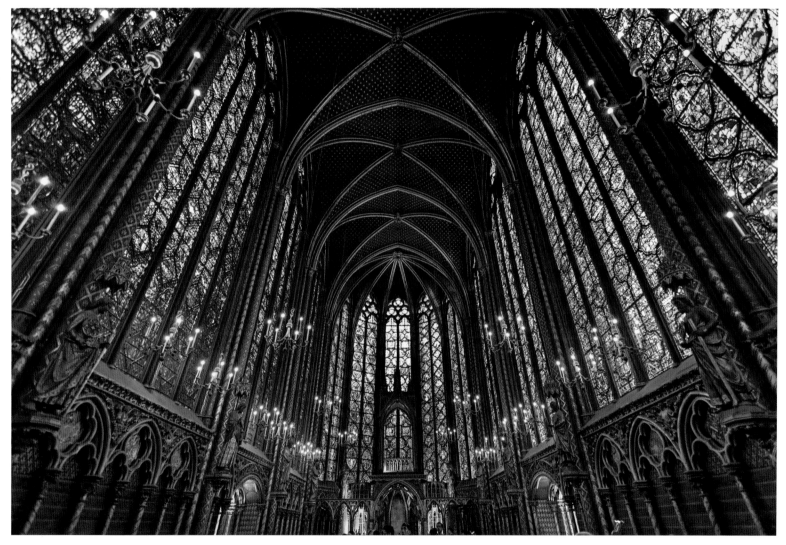

Sainte-Chapelle (1242–1248), Paris

FRA ANGELICO'S *ANNUNCIATION*

This is really big news. The archangel Gabriel enters, crosses his arms in greeting, fans his colorful wings, and announces to Mary that she's about to give birth. Mary does not exactly look overjoyed.

Annunciation scenes like this were popular throughout European art history because they captured that crucial moment of incarnation . . . the moment when God became Man. Annunciations were a Fra Angelico specialty. His unique contribution was placing the scene outdoors in a casual and realistic setting.

Fra Angelico created this for a monastery in Florence. He was himself a monk here, even serving as prior. He decorated the monastery with religious scenes for the contemplation of his fellow brothers in Christ. In fact, this particular scene would have looked remarkably familiar to the monks. The painting's columns and arches look much like their own monastery. Fra Angelico brought the heavenly scene home to his monks quite literally.

The *Annunciation* was placed at a well-traveled spot—at the top of the main staircase. Monks would come face-to-face with the painting, pause to say a "Hail Mary" prayer, then continue on to their solitary cells. Paintings like these, while world-famous today, were meant only for the private eyes of a few humble monks.

Painted around the year 1450, the painting captures that glorious time when medieval piety seemed to dovetail perfectly with the budding humanism of the Renaissance. In traditional fashion, this *Annunciation* is filled with medieval symbolism, and everyone dutifully wears their gold-plate haloes.

On the other hand, Fra Angelico was exploring the Renaissance revolution in 3-D. There's a clearly defined foreground (the columns), background (the trees), and middle ground where Fra Angelico places his figures. There's also a clear vanishing point: the line of columns leads the eye to the tiny window in the back, giving a glimpse of a wider world beyond. Fra Angelico has brought this holy scene into our real world of grass, flowers, and trees. Though an ascetic monk, Fra Angelico refused to renounce one earthly pleasure—his joy in the natural beauty of God's creation.

Fra Angelico's colors are a harmonious blend of pink, blue, gold, and green. In person, if you sway back and forth . . . Whoa! The angel's wings actually sparkle! That's because Fra Angelico added multi-colored glitter to the fresco.

When Fra Angelico joined the Dominican order, he was given the nickname of Fra Angelico—meaning "Angelic Brother." He earned a reputation for sweetness, humility, and compassion. In 1984, he was beatified by the pope—just one step from sainthood.

For Fra Angelico, painting was a form of prayer. He created an ethereal world that's perfectly lit, with no moody shadows . . . one that seems to glow from within, like a stained-glass window. He shows us the miraculous, but it seems completely real—like it's happening before our very eyes. Or, to put it another way: He shows us the beauty of everyday things, and makes it seem miraculous.

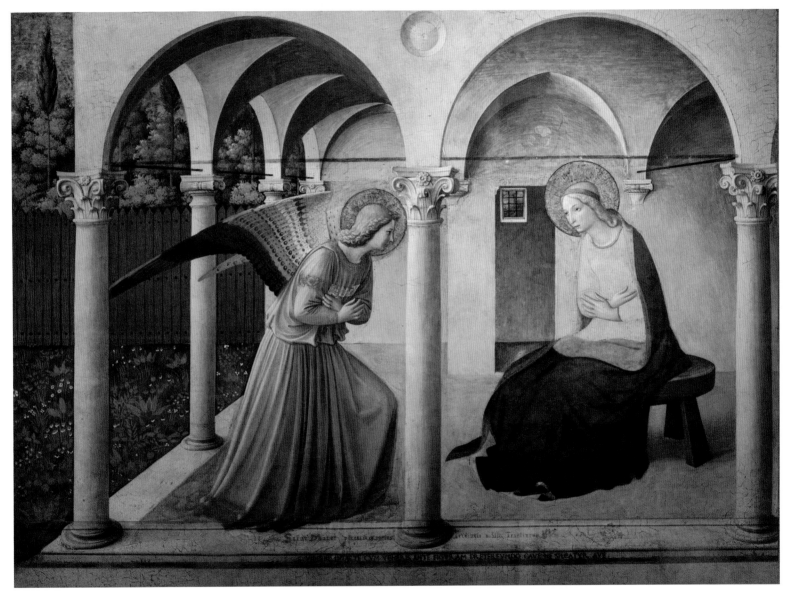

Annunciation (c. 1450), Fra Angelico, San Marco Museum, Florence

CHARTRES CATHEDRAL'S STATUES

Many of the children who watched construction begin on Chartres Cathedral in the year 1194 were around to attend the dedication Mass in 1260. That's astonishing, considering that other Gothic cathedrals, such as Paris' Notre-Dame, took literally centuries to build. Having been built so quickly, the cathedral has a unity of architecture, statuary, and stained glass that captures the spirit of the Age of Faith like no other church.

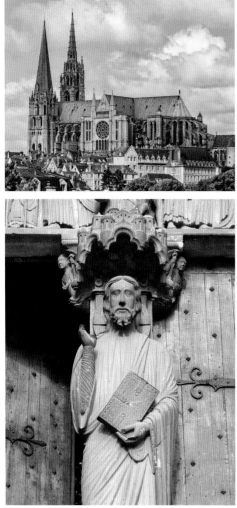

Chartres' facade with its soaring steeples testifies to the long history of this church. For 1,700 years there had been a church on this spot dedicated to Mary, the mother of Jesus. But in 1194, an intense, lead-melting fire incinerated the old church, leaving only this facade. Compare the steeples—they don't match. The shorter tower, which survived the fire, is in the older Romanesque style. The other one was damaged and rebuilt in the style of the time—Gothic.

The new church became a textbook example of the Gothic style. It's an exoskeletal structure made of flying buttresses (along the church's sides) that pushed inward to reinforce the vertical pillars, which in turn supported the roof. This was the miracle of Gothic design, allowing a taller-than-ever structure with ribbed walls and lots of stained-glass windows.

Historian Malcolm Miller calls the church the "Book of Chartres," telling the entire Christian story through its statues, stained glass, and architecture.

Chapter 1 is the statues decorating the north door. They show the beginning of history (at the peak of the entrance arch) when God creates Adam. Next, there are the solemn, bearded statues (flanking the doors) representing the Old Testament. Like robed columns, these wise-looking men seem to be supporting the church. Melchizedek (farthest left) has the cap of a king and the cup of communion, symbolizing how secular rule and religious faith came together in medieval times. Abraham (next to Melchizedek) is preparing to sacrifice his son, when suddenly he hears something. He turns his head to see God's angel, who stops the bloodshed. This kind of screen-capture drama anticipates Renaissance naturalism by 200 years.

The Book of Chartres continues on the south doors with the coming of Christ. Jesus holds a book and raises his arm in blessing. His face is among the most noble in all of Gothic sculpture. Chartres' sermon-in-stone climaxes above the door with the final event in Christian history—the Last Judgment.

The glory of Chartres Cathedral shines greatest when you go inside. For that, turn the page.

Chartres Cathedral, with statue of Jesus

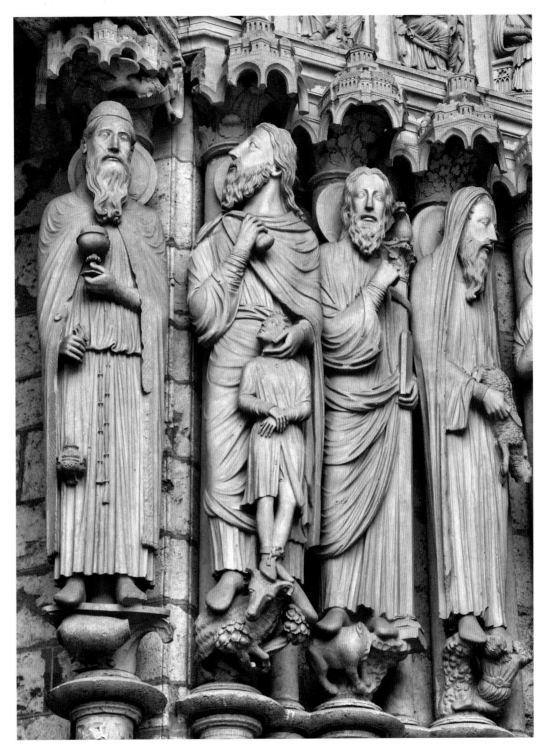

Statues of Old Testament (1194-1260), Chartres Cathedral, Chartres

CHARTRES CATHEDRAL'S STAINED GLASS

Stepping inside Chartres Cathedral, you become a medieval pilgrim entering a mysterious space. As your eyes adjusted to the dark, you'd take in what seem to be enormous panels of light floating in empty space like holograms. These are Chartres' crown jewels—its stained-glass windows. (In the "Book of Chartres," these would be the color illustrations.) Chartres has 28,000 square feet of stained glass. To the Chartres generation, the church—with the way light animates the stained glass—was a metaphor for how God brings his creation to life.

The vast nave is more than 400 feet long. The support pillars soar as if heaven-bound, and then branch out into the lacy crisscross Gothic arches. In medieval times, the place would have been packed with pilgrims. (The sloping floor made for easy cleaning after dirty pilgrims camped out here.)

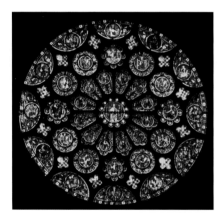

South Rose window

The faithful were inspired by the stained-glass windows. The huge rose windows hang high over the entrances like God's jeweled brooches. Even illiterate peasants could "read" Chartres' windows. Each window told a story. And each was "brought to you by" one of Chartres' merchant brotherhoods, who financed them in exchange for an "ad" in the window—a wheel for the wheelmakers, a barrel for the coopers, and so on.

Chartres' oldest window is the majestic Blue Virgin, showing Mary seated on a throne. The colors glow like embers in the dark. Mary is wearing a deep "Chartres blue" dress, cradling a lavender-robed Jesus, set against a ruby-red sky, while the brilliant dove descends from above. The Blue Virgin was one of the most popular stops for pilgrims—especially pregnant ones.

The entire cathedral—officially called "Our Lady of Chartres Cathedral"—was dedicated to the lady who gave birth to Jesus. Images of Mary are everywhere—in the windows, ringing the choir, and as a venerable statue-on-a-pillar. But the church's biggest attraction was an ancient relic that was kept deep in the holiest chapel—the veil of Mary.

This tiny 2,000-year-old fragment of cloth is said to be part of the veil Mary wore when she gave birth to Jesus. When the old church burned in 1194—lo and behold—the veil miraculously survived. This was seen as a sign from Mary that she wanted a new and grander church. With that, money poured in and construction began.

Chartres Cathedral has become the physical embodiment of the Age of Faith. Its architecture is as mathematically perfect as God's Creation, the sculpture is a sermon, and the stained glass is lit by the light of God. Its imagery depicts a web of heaven and earth, angels and demons, prophets and martyrs, and rich symbolism—that is, the complex Christian universe.

Imagine that day in 1260 when the church was completed and the dedication ceremonies were held. Those who broke ground could finally watch as their great-grandchildren, carrying candles, entered the cathedral.

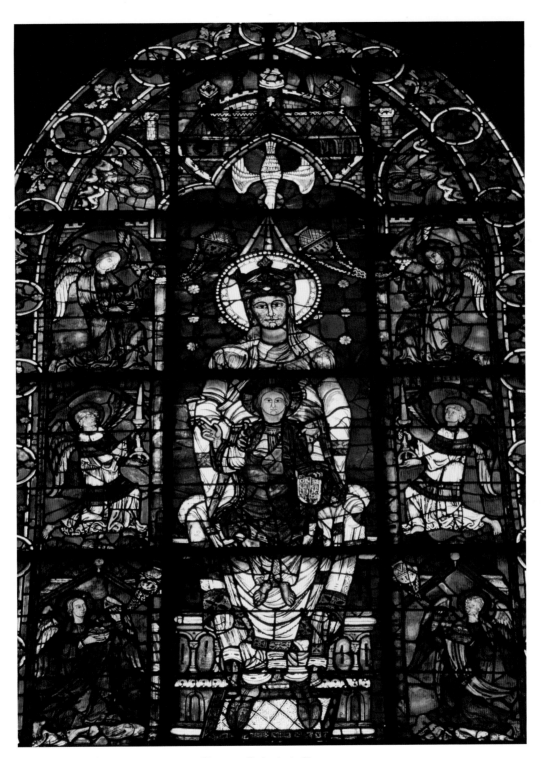

Blue Virgin window (12th century), Chartres Cathedral, Chartres

THE LADY AND THE UNICORN TAPESTRIES

The Middle Ages doesn't sound quite so boring as I sink deeper into middle age myself. Not all medieval art is stuffy, moralistic, and focused on heaven. As Europeans began awakening from their 1,000-year slumber, they were rediscovering the beauty of the world around them—and that included sensuality.

These mysterious tapestries deal with the pleasures of the five senses, with a unicorn as your guide. In medieval lore, unicorns were solitary creatures, so wild that only virgins could tame them. Religiously, the unicorn symbolized Christ—pure, but somewhat remote—who is made accessible to humankind by the Virgin Mary. In secular society, unicorns symbolized how a feral man was drawn to his lady love. This set of tapestries draws inspiration from all these traditions.

The first tapestry (on opposite page) deals with "Taste." A graceful blonde lady in an elegant dress takes candy from a servant's dish and feeds some to her pets. The unicorn looks out to the viewer like "Hmm, maybe I should try some." This was the dawn of the Age of Discovery, when overseas explorers were spicing up Europe's bland gruel with new fruits, herbs, and spices. In the tapestry on "Smell," the lady weaves flowers into a sweet-smelling wreath. In "Sound," she plays sweet music on an organ, soothing the savage beasts around her. In "Sight" (this page), the once-wild unicorn begins to cuddle up on the lady's lap.

(continued)

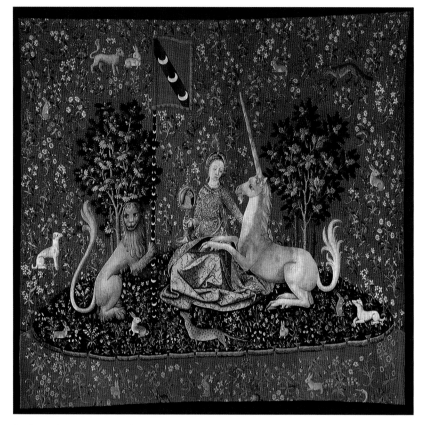

Lady and the Unicorn: Sight

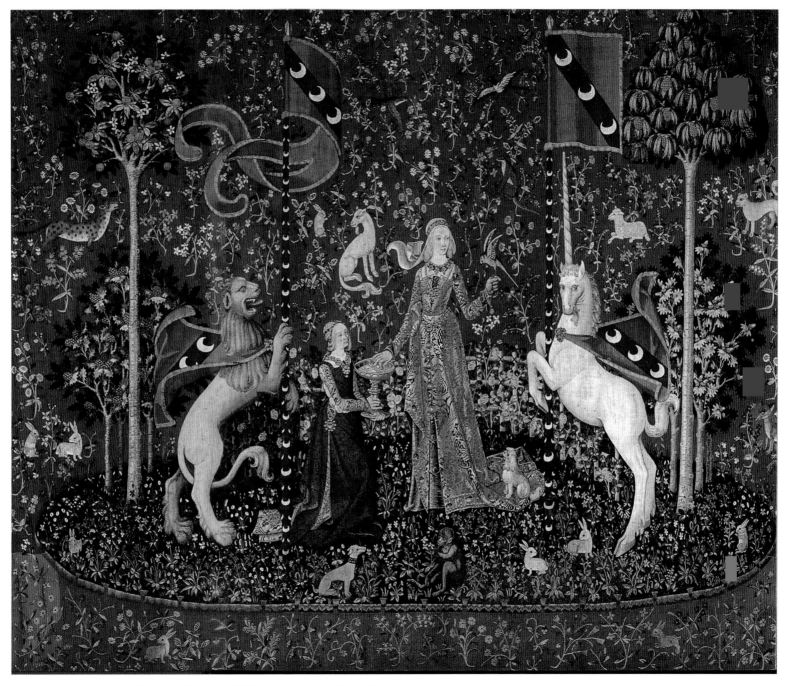

Lady and the Unicorn: Taste (c. 1500), Anonymous, Cluny Museum, Paris

Next comes "Touch"—that most basic and dangerous of the senses. Amid a jungle of wild animals, the unicorn now stands docile at the lady's feet, letting her "stroke the unicorn's horn"—if you know what I mean. (The nearby lion gets the double entendre.) Medieval Europeans were exploring the wonders of love and the pleasures of sex.

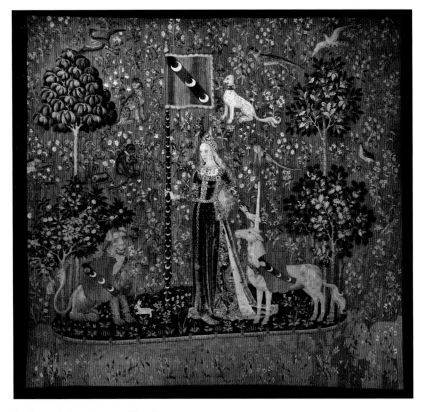

Lady and the Unicorn: Touch

The design (from around 1500) may seem crude by Renaissance 3-D standards (no perspective, weird-looking animals), but the detail work is incredible (the patterns in the lady's dresses, her necklace, the many exotic plants). Each detail is exquisite by itself, and if you step back they blend together into pleasing patterns.

The most-talked-about sixth tapestry gets its name from the words on our lady's tent: *A Mon Seul Désir* ("To My Sole Desire"). What is her only desire? Our lady has tried all things sensual and is now prepared to follow her one true impulse. Is it jewelry, as she grabs a necklace from the jewel box? Is she shunning the jewels? Or is it love? Her friends, the unicorn and lion, open the tent doors. The tent is decorated with flickering flames, a symbol of passion. Is she going in to meet the object of her desire? Or has she already been there?

Human sensuality is awakening. An old dark age is ending. Europe is aroused with anticipation, and the Renaissance is coming.

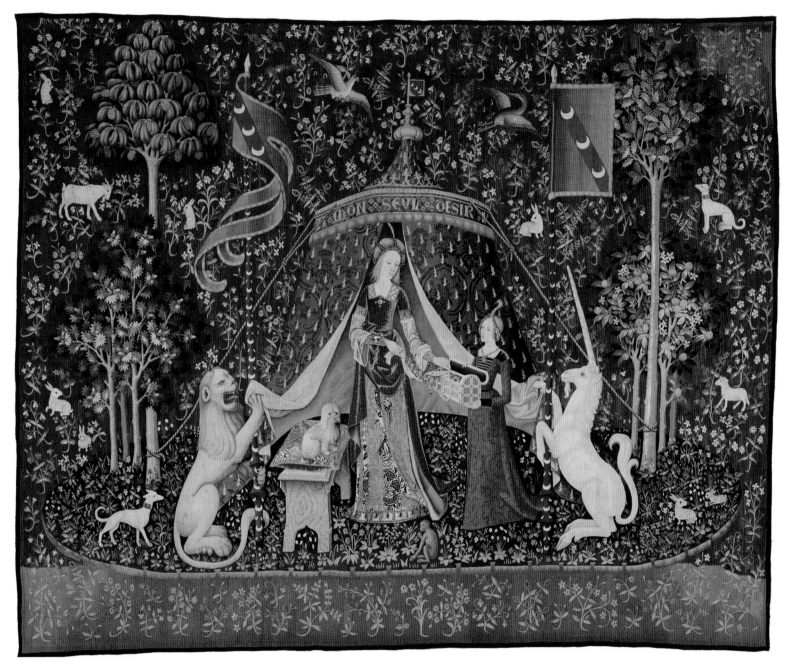

Lady and the Unicorn: To My Sole Desire (c. 1500), Anonymous, Cluny Museum, Paris

RENAISSANCE

"Renaissance" means rebirth. A thousand years after Rome fell (plunging Europe into medieval darkness), the Renaissance revived the classical values of ancient Greece and Rome. Powered by a new humanistic attitude, there was an explosion of original thinking and creativity.

In politics, it meant budding democracy. In science, secular learning was revived after centuries of superstition. It was the era of Columbus and global exploration. In architecture, it meant buildings with Greek-style columns, Roman-style arches, and towering domes, all paired symmetrically, with geometrical perfection. Sculptors chiseled sturdy balanced statues that looked like Greek gods and mythological warriors but were actually the heroes of the Bible.

In painting, Renaissance artists rediscovered realism, and they spelled that "3-D." They mastered how to portray the spacious three-dimensional world on a two-dimensional canvas. They brought the Madonna down from her golden heaven and into the real world of rocks, trees, and sky, with a human realism that radiated her spirituality through her physical beauty. Soon artists were painting not just saints and popes but also sensuous nudes and real-life people, in all their human glory.

The Renaissance began in Italy with the likes of Michelangelo and Leonardo da Vinci, but it grew into a Europe-wide phenomenon. For a century-plus, Europe reveled in a cultural golden age that not only revived the ancient world but helped birth the modern one.

GHIBERTI'S BRONZE DOORS

Some say that the cultural explosion called "the Renaissance" began precisely in the year 1401, with two bronze panels.

These panels were the two finalists in Florence's citywide competition to find the best artist to create a set of bronze doors for the beloved Baptistery. That octagonal building in front of Florence's main church was dear to the hearts of Florentines. It was the city's oldest structure, nearly 1,000 years old, where venerable citizens from Dante to Machiavelli to the Medici were baptized.

All the great Florentine artists entered the contest. There was the promising young sculptor Donatello, the goldsmith Lorenzo Ghiberti, and the all-around Renaissance man, Filippo Brunelleschi. They were asked to submit their take on the Bible story of the Sacrifice of Isaac. This was the crucial moment when Abraham, obeying God's orders, was about to kill his only son as a sacrifice.

The two finalists were Ghiberti and Brunelleschi. It was a tough call. Before reading on, look at each entry panel as if a critic. Decide which one you'd favor.

Brunelleschi (left), put the boy Isaac at center stage, creating a balanced composition. Ghiberti (right) focused on Abraham. Abraham's face is intense. He pulls the knife back, ready to strike. But just then, the angel swoops in—coming straight out of the panel, right at you, like a 3-D movie—to save the boy in the nick of time. Now that's drama.

The winner was—drum roll, please—Ghiberti.

That simple contest started a historic chain of events. Ghiberti made the Baptistery doors, which proved so successful that he was asked to make another set for another entrance. These were the famous Gates of Paradise that revolutionized the way Renaissance people saw the world around them. Ghiberti added a whole new dimension to art—depth. In the *Jacob and Esau* panel, Ghiberti set the scene under a series of arches. The arches appear to recede into the distance, as do the floor tiles and banisters, creating a 3-D background for a realistic scene. The figures in the foreground stand and move like real people, telling the Bible story with human details. Ghiberti made the viewer part of this casual crowd of holy people. Amazingly, this spacious, three-dimensional scene is made from bronze only a few inches deep. Ghiberti's work in perspective would inspire the next generation of painters, who learned to create three-dimensional scenes on a two-dimensional surface.

Meanwhile, Brunelleschi—after losing the Baptistery gig—went to Rome. He studied the Pantheon, and returned to build the awe-inspiring dome crowning the cathedral (or Duomo) of Florence. And Donatello went to work for Ghiberti, learning the skills that would soon revolutionize sculpture. All three of these artists inspired Michelangelo, who built on their work and spread the Florentine Renaissance all across Europe.

You could say that a simple art contest in 1401 started an artistic revolution. And it all began with two bronze panels.

Competition panels: *The Sacrifice of Isaac* (1401), **Filippo Brunelleschi** (left) and **Lorenzo Ghiberti** (right), Bargello, Florence

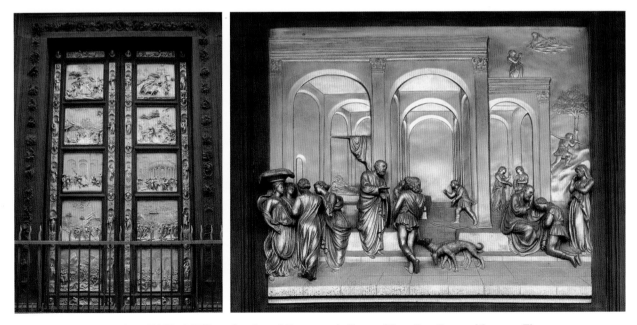

Gates of Paradise, replica (1425–1452), Lorenzo Ghiberti, Baptistery, Florence

Jacob and Esau panel, Gates of Paradise, Duomo Museum, Florence

BRUNELLESCHI'S DOME

The distinctive red-and-white-ribbed dome of Florence's cathedral sits at ground zero of that cultural explosion we call the Florentine Renaissance.

As a bustling center of banking, trading, and cloth-making, Florence was practicing the art of civilized living while the rest of Europe was still wearing hand-me-down leotards.

Meanwhile, their cathedral (or Duomo), built in medieval times, didn't match their budding Renaissance society. Though huge—nearly 500 feet long—the Duomo was still unfinished, with a gaping 140-foot hole in the roof (a drag on rainy Sundays). It's as if those medieval people had started the church not knowing how to cap it, but knowing a fix was on the way.

Non c'è problema. In 1420 Filippo Brunelleschi was hired to complete the task that earlier architects could not.

Brunelleschi was uniquely qualified. He'd visited Rome, where he studied the famed ancient Pantheon. He dissected that dome's dimensions, mathematics, and engineering, and visualized placing it atop Florence's Duomo.

Brunelleschi oversaw every aspect of the project. He personally designed new technology—pulleys to lift the stone, brick molds, and scaffolding for the workers.

Brunelleschi's biggest challenge was constructing a dome that spanned a hole too wide for the wooden scaffolding that traditionally supported a dome under construction. (An earlier architect suggested supporting it with a great mound of dirt inside the church . . . filled with coins, so peasants would later cart it away for free.)

Brunelleschi's dome was so big it would have to be self-supporting as it was built. The solution was a dome within a dome. Brunelleschi left a hollow space between the outer dome (which we see from outside) and the inner shell (seen from inside the church). (Today's tourists walk between them as they climb to the cupola.) This made the entire dome lighter. It rose in rings like an igloo, supporting itself a ring at a time as it proceeded up from the base. They built vertical ribs of white marble, then filled them in with a ring of interlocking red bricks. When each ring was complete, they'd move the scaffolding up and do another section. As they approached the top, Brunelleschi arched the ribs in and fixed them in place with the lantern. The dome was completed in just 16 years, an astonishingly short period of time for the day.

Brunelleschi's 330-foot dome was a feat of engineering that was both functional and beautiful, putting mathematics in stone. Though the dome weighs an estimated 80 million pounds—as much as the entire population of Florence—it feels lofty, appearing to almost float above the white, green, and pink cathedral.

Brunelleschi's dome was the wonder of the age, the largest dome built in a thousand years. People gave it the ultimate compliment, saying, "Not even the ancients could have done it." It was the model for many domes to follow. When Michelangelo designed St. Peter's dome, he said he could build "the Duomo's sister—bigger, but not more beautiful."

Even today, Brunelleschi's dome calls to mind the confidence of the Florentines, who, six centuries ago, rose from medieval roots to host the blossoming of the Renaissance. And it stands as a proud symbol of man's ingenuity, proving that art and science can unite to make beauty.

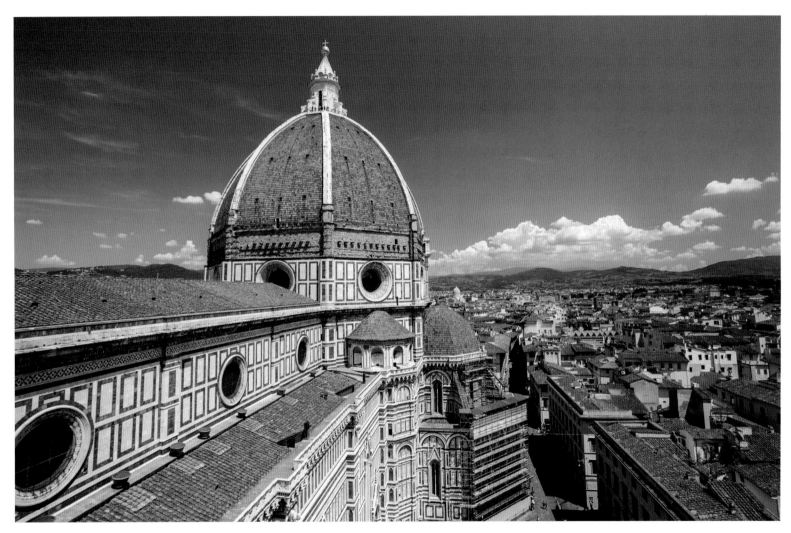

Dome of Florence Cathedral (1420–1436), Filippo Brunelleschi, Florence

MASACCIO'S *TRINITY*

In his short but influential career, Masaccio (1401–1428) became the first painter since ancient times to portray a spacious three-dimensional world. With *The Trinity*, it was almost like he'd blown a hole in a church wall, creating a window onto the real world.

The subject was traditional—the three members of the Christian Trinity. Masaccio painted it on the wall next to the place where worshippers would dip their fingers in the font, cross themselves, and mumble, "Father, Son, and Holy Ghost."

Masaccio gave that heavenly scene an earthly reality that made it seem tangible. With simple pink and blue paint, Masaccio created the illusion that we're looking into an actual chapel—rather than at a church wall. It's topped with an arched ceiling and framed at the entrance with classical columns. Inside the chapel, the Trinity appears. There's a crucifix with Christ. Behind him, God the Father stands atop an altar, seemingly holding up the cross. The dove of the Holy Spirit's in there somewhere. (Hint: It's God's white "collar.")

Other figures heighten the sense of reality. The disciple John looks up at Christ while Mary looks down at us. Note the realism in the face of Mary, now a 50-year-old mother. The two donors (husband and wife, most likely) kneel on the front step outside the chapel, their cloaks spilling out of the niche. Below this illusionary chapel sits an illusionary tomb with the skeleton of Adam, looking just like real tombs elsewhere in the church.

Masaccio's great innovation was painting a 3-D scene on a 2-D surface. The checkerboard-coffered ceiling creates a 3-D tunnel effect. The rows of panels appear to converge at the back, as the panels get smaller, lower, and closer together. Earlier painters had played with tricks like this, but Masaccio understood the mathematics involved and nailed it. The row of coffers all lead to the distant horizon. Lay a mental ruler along them, and you'll find the vanishing point. Having fixed where the distant horizon is, Masaccio draws a checkerboard grid in between, then places the figures on it like chess pieces. Masaccio leads your eye deeper and deeper into the chapel, from the donors, to Mary and John, and then Christ, God, and the back wall. Masaccio gave such thought to the proper perspective that we, as viewers, know right where we stand in relation to this virtual chapel.

Masaccio (along with his contemporary Brunelleschi) developed these mathematical laws of perspective. Soon, artists everywhere were drawing Masaccio-like chessboards, creating spacious, perfectly lit 3-D scenes filled with chess-piece humans.

By placing this heavenly trio in such an earthly realistic setting, Masaccio gave the faithful a chance to commune with the Godhead—to connect with the divine nature of God—like no artist before him.

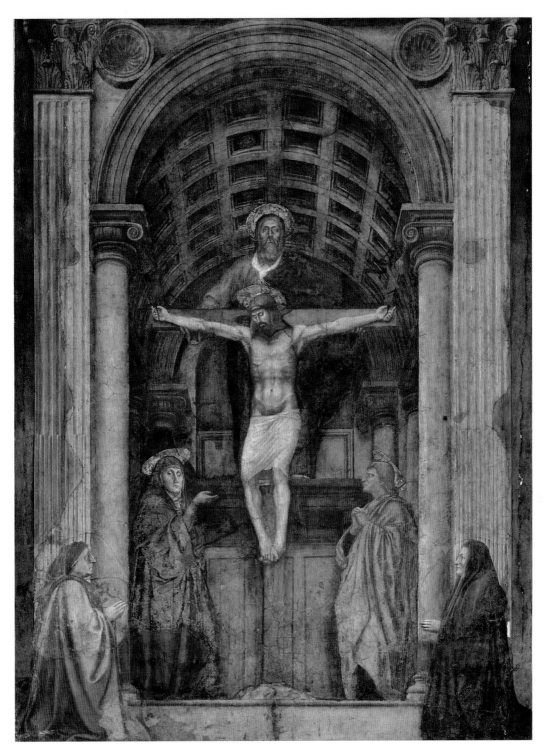

The Trinity (1427), Masaccio, Santa Maria Novella, Florence

DONATELLO'S *DAVID*

The shepherd boy, David, has just slain the giant, Goliath. He's taken the giant's oversized sword, decapitated him, and now places his foot triumphantly on the severed head and pokes playfully at it.

He's naked. Donatello portrays David as a nude teenager. He's wearing only a helmet and boots. His skin is smooth and he sways gracefully. David plants his left leg firmly, in the same *contrapposto* stance so popular in ancient statues.

When Donatello sculpted this, around 1440, this first large-scale cast-bronze statue made since ancient times broke new ground in many ways.

This was the first freestanding male nude Europe had seen in a thousand years. That was extremely bold. In the Middle Ages, the human body was considered a dirty thing, a symbol of man's weakness, something to be covered up in shame. But with the Renaissance, the body was celebrated. Donatello made David's nakedness stand out even more by giving him a hat and boots.

Rather than showing David in his traditional role as a powerful Old Testament king, Donatello boldly chose to focus on the giant-slaying episode.

Countless later sculptors and painters would follow Donatello's lead, including Michelangelo. This statue stood in the courtyard of the Medici Palace, where a young Michelangelo grew up admiring it (and perhaps dreaming of a *David* of his own).

In the Bible story, David is a mere shepherd boy. The statue's child-like muscles and small stature compared with the oversized sword are clearly those of a young man. Compared with, say, Michelangelo's older and sturdier Renaissance man, this statue is a mere Renaissance Boy. In fact, with his soft belly, smooth muscles, long hair, coy eyes, and swishy pose, he looks more girlish than boyish.

This *David* is more than risqué. It drove home the statue's point: that even a naked, effeminate boy could slay a heavily armed giant . . . if he was powered by God. The statue matched how Florentines saw themselves—as a plucky little city-state battling the brutish tyrants around them—and Donatello's statue became a symbol of a city that saw itself blessed by God and free to succeed . . . boldly.

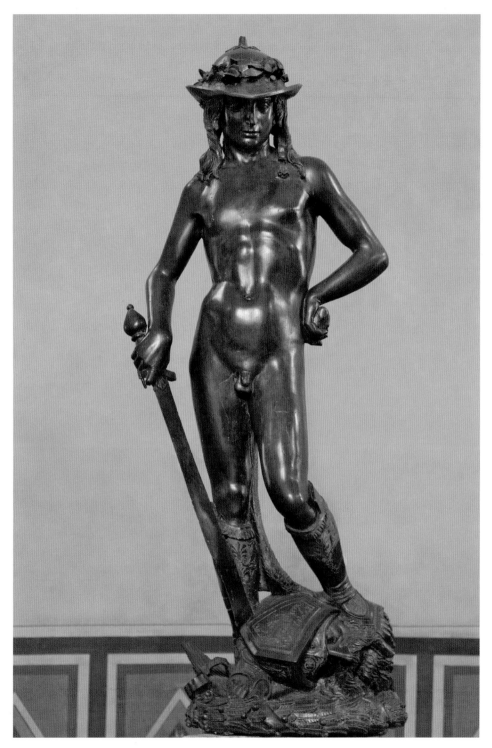

David (c. 1440), Donatello, Bargello Museum, Florence

DAVID, DAVID, AND DAVID

In the Bible, it's an epic battle: Philistines against the Israelites. And it's fought by one warrior from each tribe. The Philistines send up the brutal giant Goliath. And the Israelites go with the ultimate underdog, the shepherd boy, David. Of course, David has God on his side, and—*bop*—he beans the giant with his slingshot, knocks him dead with the original "right between the eyes," and the Israelites are victorious. David has been featured countless times throughout art history, as if those who embrace him were empowered by God to slay the giants oppressing their world. Several Italian masters produced iconic sculptures of David—all of them different. Compare and contrast the artists' styles. How many ways can you slay a giant?

DONATELLO'S *DAVID*

Casually gloating over the head of Goliath, Donatello's *David* is young and graceful, almost Gothic in its elegance and smooth lines. While he has a similar weight-on-one-leg (*contrapposto*) stance as Michelangelo's later version, Donatello's David seems feminine rather than masculine.

MICHELANGELO'S *DAVID*

Michelangelo's *David* is pure Renaissance: massive, heroic in size, and superhuman in strength and power. The tensed right hand, which grips a stone in readiness to hurl at Goliath, is more powerful than any human hand. It's symbolic of divine strength. A model of perfection, Michelangelo's *David* is far larger and grander than we mere mortals. We know he'll win. Renaissance man has arrived.

GIAN LORENZO BERNINI'S *DAVID*

Flash forward more than a century. In this self-portrait, 25-year-old Bernini is ready to take on the world, slay the pretty-boy *David*s of the Renaissance, and invent Baroque. Unlike Michelangelo's rational, cool, restrained *David,* Bernini's is a doer: passionate, engaged, dramatic. While Renaissance David is simple and unadorned—carrying only a sling—Baroque Dave is cluttered with a braided sling, a hairy pouch, flowing cloth, and discarded armor. Bernini's *David,* with his tousled hair and set mouth, is one of us; the contest is less certain than with the other *David*s.

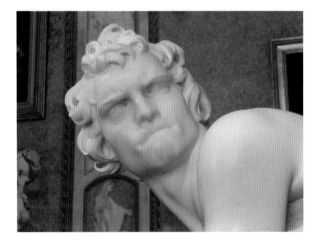

Bernini's face of **David**

To sum up: Donatello's *David* represents the first inkling of the Renaissance; Michelangelo's is textbook Renaissance; and Bernini's is the epitome of Baroque.

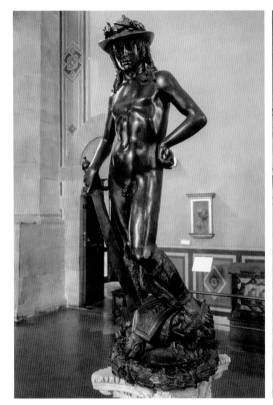

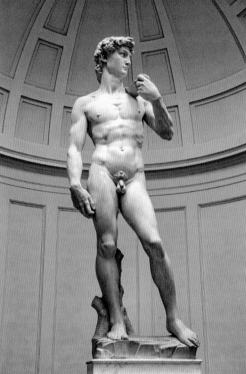

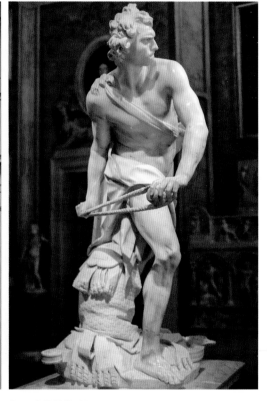

David (c. 1440), Donatello,
Bargello Museum, Florence

David (1504), Michelangelo,
Accademia Gallery, Florence

David (1623), Bernini,
Borghese Gallery, Rome

DONATELLO'S *ST. GEORGE*

George—the legendary dragon-slayer and early Christian saint—appears here as a proud warrior. He plants both feet firmly on the ground. He stands on the edge of his niche looking out, alert. He tenses his powerful right hand and scans the horizon. He's the picture of confidence—calm, but ready to attack. The cross on his shield makes it clear he's Christian—just the sort of righteous warrior that proud Florentines could rally around as they battled nearby cities. George represented how they—powered by God—could slay dreaded dragons . . . rival city-states like Milan, Pisa, and Siena.

Donatello carved the statue around 1417. It was designed for a niche at Orsanmichele Church, where a copy stands today. While earlier medieval statues stand obediently inside their niche, Donatello's *St. George*—as restless as man on the verge of the Renaissance—is stepping out from the protection of the Church.

The relief panel below the statue shows George actually doing what he's been pondering—charging with his lance raised to slay the dragon and save the poor maiden.

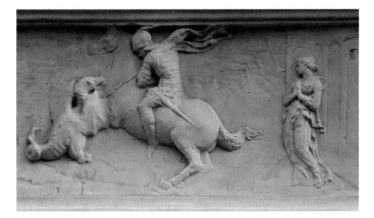

Relief panel below statue: George kills the dragon

Donatello's drama and realism carved into this small panel were groundbreaking: the dragon-slayer frozen in mid-kill, the maiden in a classic *contrapposto* pose, and the sketchy arches and trees in the background that gave a believable illusion of depth. Donatello had apprenticed for Ghiberti, the man who did the famous reliefs for Florence's Baptistery doors, and they pioneered the hallmark of Renaissance art: 3-D realism.

Donatello (1386–1466) was the first great Renaissance genius, a model for Michelangelo and others. He mastered realism, creating the first truly lifelike statues of people since ancient times. In person, Donatello was a moody loner, focused only on his art. He developed the role of the "mad genius" that Michelangelo would later perfect. In a way, Donatello was like his St. George—a bold warrior paving the way to a Renaissance future.

Donatello's statue stood right in the heart of Renaissance Florence, decorating a niche in a prominent church along the main drag. No wonder the statue came to be the unofficial symbol of a proud Florence on the rise. Nearly a century later, Michelangelo would be inspired to create his own proud symbol of Florence—*David*. Note the similarities. Both are Christian warriors overcoming brute enemies. Both have powerful right hands. And both exude an air of relaxed intensity and intelligent determination. This was the spirit of the Renaissance. And Florence was its capital.

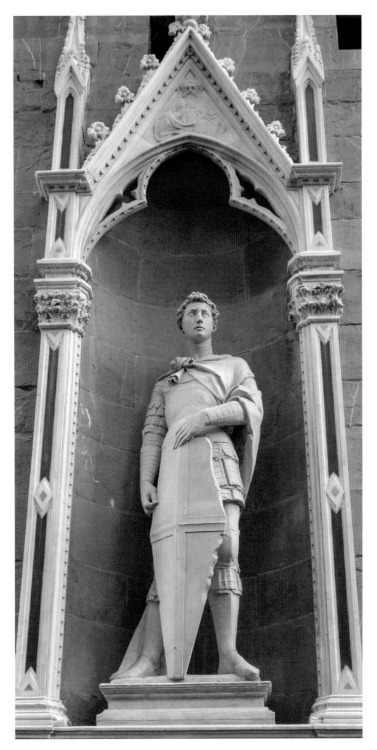

St. George (c. 1417), Donatello, copy at Orsanmichele Church (original in Bargello), Florence

BOTTICELLI'S *SPRING*

It's springtime in an orange grove. The winds of March blow in (that's "Mr. Blue," on the right), causing an April nymph to sprout May flowers from her lips. She then morphs into the goddess of Spring, who scatters blossoms as she goes. (Modern botanists have identified over 100 species of flowers in this garden.) The god Mercury lifts his baton to disperse the last remaining clouds. And the Three Graces, dressed in sheer see-through nighties, celebrate the end of winter with a delicate maypole dance. In the center stands Venus, the goddess of love. Above her flies a blindfolded Cupid, happily shooting his arrows of love without worrying whom they'll hit.

This classical allegory of springtime (a.k.a. *La Primavera*) is also a celebration of the budding "spring" of the Renaissance. Florence in the 1480s was in a Firenz-y of activity. There was a can-do spirit of optimism in the air, expressed in public monuments and art. The guiding force was the prosperous Medici family, led by a charismatic Renaissance man, Lorenzo the Magnificent. He regularly hosted an enlightened Florentine circle of artists, poets, thinkers, and bon vivants at the Medici Palace, in a lush garden much like in this painting. There, among statues of Greek gods and heroes, they'd sip wine, read philosophy, recite poetry, and hobnob mentally with the great minds of antiquity. One of this circle was Sandro Botticelli. Having recently returned from Rome inspired by the ancient statues he saw there, he captured the humanistic spirit of the times.

La Primavera became a celebration of the created world in all its fertility. This is a return to the pre-Christian world of pagan Greece, where things of the flesh were not sinful. Rather, the beauty of the world was a reflection of the loving God who created it.

Venus—the goddess of earthly love—becomes the earthly counterpart to the Christian Mary—representing divine love. She's framed by a "halo" of leaves, wearing the tender expression of a Botticelli altarpiece, and presiding over a scene of pure love.

La Primavera was painted to adorn a Medici pleasure villa. It was soon joined by an even more sensual Botticelli painting. Venus would cast off her robes completely for a full-frontal celebration of the goodness of the naked human body.

For that painting, turn the page.

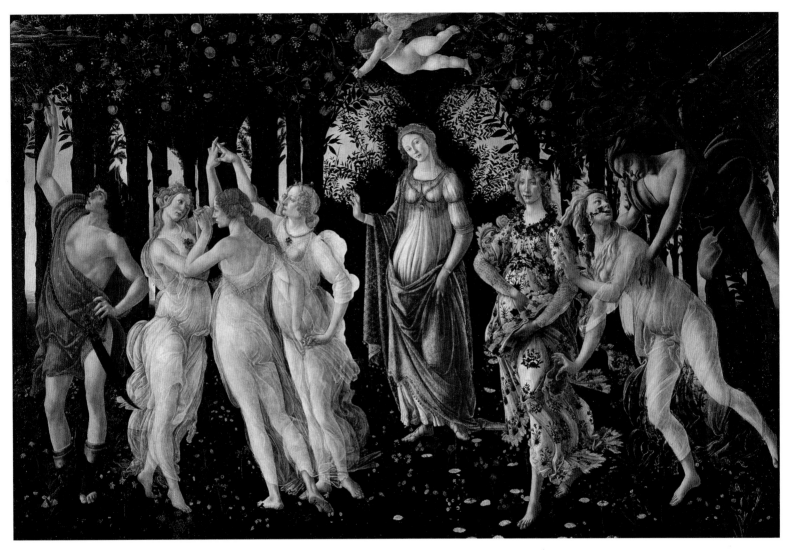

Spring, a.k.a. *La Primavera* (c. 1482), Sandro Botticelli, Uffizi Gallery, Florence

BOTTICELLI'S *BIRTH OF VENUS*

This work was revolutionary: the first large-scale painting of a naked woman in a thousand years. It summed up the growing secular culture of Renaissance Florence.

Venus—the goddess of love and beauty—was born from the foam of a wave. Still only half awake, this fragile newborn, blown by the god of wind, floats ashore on a scallop shell, where her maid waits to dress her in a rich robe fit for a goddess.

Botticelli, painting innocent beauty, did everything possible to please the eye. His pastel colors make the world itself seem fresh and newly born. Botticelli (who was trained as a goldsmith) mixed real gold into the paints to highlight Venus' radiant hair, the scallop shell, the Wind's wings, and even the sun-sparkled grass.

The god of wind sets the scene in motion. Everything—Venus' flowing hair, the waves on the water, the swirling robes, even the jagged shoreline—ripples like the wind. Venus' wavy hair mirrors the undulating line of her body. Mrs. Wind holds on tight, as their bodies, wings, and clothes intertwine. In the center of all that wavy motion stands the still, translucent form of Venus, looking like she's etched in glass.

In good Renaissance style, Botticelli poses Venus with the same S-curve body and modestly placed hands as a classical statue. But whereas Botticelli's Renaissance contemporaries insisted on ultra-realism, Botticelli's anatomy is impossible. Venus' neck is too long and she stands off-kilter. Venus' maid seems to float above the ground. And how exactly does Mrs. Wind wrap that leg around her man?

With *The Birth of Venus* (a.k.a. *Venus on the Half-Shell*), Botticelli was creating a more ideal world, with a more ethereal beauty. It's a perfectly lit world, where no one casts a shadow. The bodies curve, the faces are idealized, and their gestures exude grace.

Venus' nakedness is not so much erotic as innocent. Botticelli thought that physical beauty was a way of appreciating God. Venus' beauty could arouse and uplift the soul of the viewer, giving him a spiritual longing for heavenly things.

Gaze into the eyes of Venus. She's deep in thought . . . but about what? Around her, flowers tumble in the slowest of slow motions, suspended like musical notes, caught at the peak of their brief life. Venus' expression has a tinge of melancholy, as if knowing how quickly beauty fades and that innocence will not last forever.

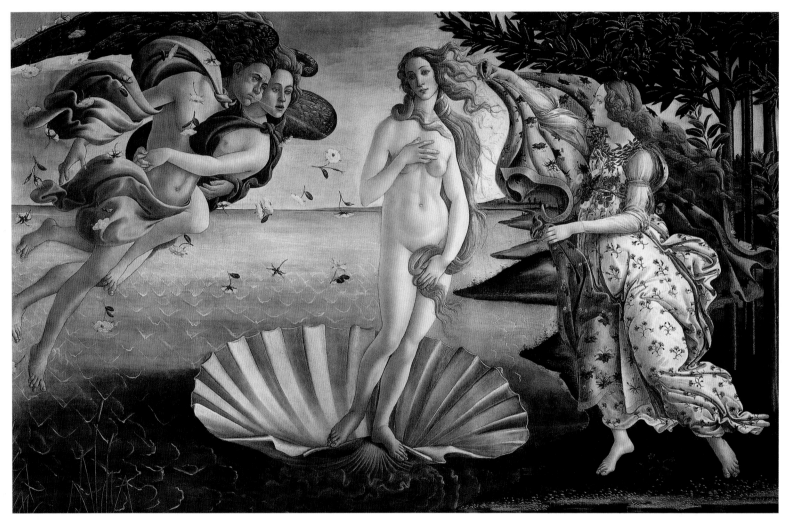

The Birth of Venus (c. 1485), Sandro Botticelli, Uffizi Gallery, Florence

LEONARDO'S *LAST SUPPER*

"One of you will betray me."

Leonardo da Vinci captures the dramatic moment just as Jesus dropped this stunning accusation, and the words ripple through his 12 disciples. They huddle in stressed-out groups, wondering, "Lord, is it I?" Some are scandalized at such a thought, raising their hands in horror. Others want more information and turn to question their friends. Simon (on the far right) seems to have no answer at all. The beloved disciple John (next to Jesus) simply faints. The apostles move like waves, surging toward and away from Jesus. In this agitated atmosphere, there's one figure (fourth from left) who's almost overlooked: Judas. With his face in shadow and clutching his 30 pieces of silver, he's trying to act nonchalant. Jesus knows full well who the traitor is, but his expression is not angry—he's sad, wise, and seemingly resigned to his fate.

In good Renaissance style, Leonardo blends this probing insight with mathematical perfection. The lines of the walls and ceiling all converge (following the laws of perspective) at the painting's center—Christ's face. (In fact, restorers found a tiny nail hole in Jesus' left eye, which anchored the strings Leonardo used to establish these lines.) Subconsciously, it feels like everything leads directly to Christ. For more Christian symbolism, Leonardo arranged the twelve into four groups of three: 3 (symbolizing the Trinity) × 4 (the Gospels) = 12 (the apostles). But despite this complex composition, the picture is not forced or sterile, but an insightful depiction of real human beings. There are no halos.

The Last Supper decorates one entire end of a former monastery dining hall. Leonardo made his scene seem like an extension of the hall. Monks could eat their supper, feeling like they were sharing the Last Supper in the physical presence of Jesus.

Leonardo spent years laboring over *The Last Supper*. He worked meticulously, adding layer upon layer of paint to get the subtle expressions just right. Unfortunately, that proved to be the painting's undoing. Leonardo had chosen to paint on a dry wall rather than the more durable method of wet-plaster fresco.

Deterioration began almost immediately. Within a few decades it was flaking and faded. A door was cut in the wall, leaving a blank space beneath Jesus. In the 1700s, it was restored (badly), only to have rude anti-church revolutionaries vandalize it. The church was bombed in World War II, but—miraculously, it seems—the wall holding *The Last Supper* remained standing. A 21-year restoration project (completed in 1999) peeled away 500 years of touch-ups, and visitors were again allowed to see it.

To minimize damage from humidity, only 30 visitors are allowed in every 15 minutes for exactly 15 minutes. The door opens, you take a step, you look right, and . . . there it is—hazy but still powerful.

Leonardo was the consummate Renaissance man: a musician, sculptor, engineer, scientist, and sometime painter. While the image may have become faint today, Leonardo's *Last Supper* combines knowledge from all these fields to create a timeless beauty that cannot fade.

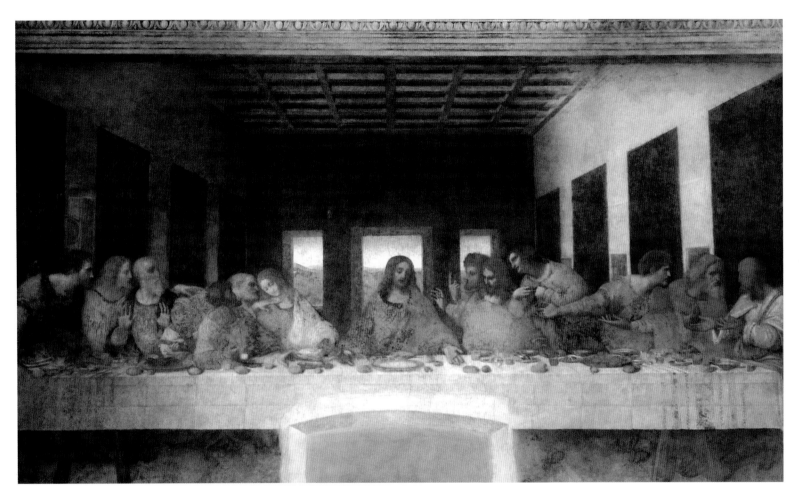

Last Supper (1498), Leonardo da Vinci, Church of Santa Maria delle Grazie, Milan

LEONARDO'S *MONA LISA*

Earth's most famous painting sits alone behind bullet-proof glass, mobbed by six million heavy-breathing tourists every year. Given the paparazzi scene, many visitors leave underwhelmed. But on closer inspection, *Mona Lisa*'s universal appeal is undeniable.

Leonardo da Vinci has painted a portrait of Lisa del Giocondo, the wife of a wealthy Florentine merchant. She sits in a chair on a balcony that overlooks a sweep-

ing landscape. Her life-size body is surprisingly massive and statue-like, a perfectly proportioned pyramid turned at three-quarter angle to show off its full volume. The folds of her sleeves and her gently clasped hands are remarkably realistic and relaxed. Lisa's arm rests lightly on the arm-rest, almost on the level of the picture frame itself, as if she's sitting in a window, looking directly at you with an intense gaze you can't ignore.

The landscape behind her seems endless, getting hazier and hazier. It leads your eye deep, deep, deep into the painting, to a fantasy realm of misty mountains, until you reach the distant horizon line . . . and then get bounced right back to Lisa's penetrating eyes, placed at the same level. With the landscape behind, the painting's viewer in front, and Lisa in between, the painting creates a deep 3-D world.

Like a Renaissance architect (which Leonardo also was), he carefully composed the scene into a geometrical pattern that reflects the order seen in nature. It creates an overall mood of balance and serenity, with a twist of mystery.

Lisa's enigmatic smile comes from Leonardo's trademark hazy technique called *sfumato,* which blurs the edges, so you can never quite see the corners of her mouth. Is she happy, melancholy, or is it a supermodel's smirk? Everyone reads it differently, projecting their own moods onto this Rorschach inkblot.

Leonardo began the painting at the height of his powers. Ever the perfectionist, Leonardo kept tweaking this beloved painting for years, and it was really only "finished" with Leonardo's death.

Mona Lisa was innovative and influential. It was done in new-fangled oil-based paint, rather than the traditional tempera, or egg yolk. The three-quarter pose and landscape backdrop set the standard for later portraits. And Leonardo had pioneered a new psychologically probing style, showing not just the outer features but also the inner personality.

Mona Lisa has a powerful ability to be loved. Leonardo kept it in his personal possession until he died. King François I fell in love with it and made it the centerpiece of the royal collection. Louis XIV took it to Versailles, and Napoleon hung it in his bedroom, before it eventually became enshrined in the Louvre. In 1911, the painting was stolen, making it even more famous. Since then, *Mona Lisa* has become perhaps the most-recognized image in the world: parodied by Duchamp, Dalí, Warhol, and Banksy, and used by advertisers to sell everything from perfume to pizza. If you go to the Louvre, *Mona Lisa* is not hard to find. With all the mobs, it's the only painting you can actually hear. When you finally muscle your way to her presence, she'll smile . . . and you will, too.

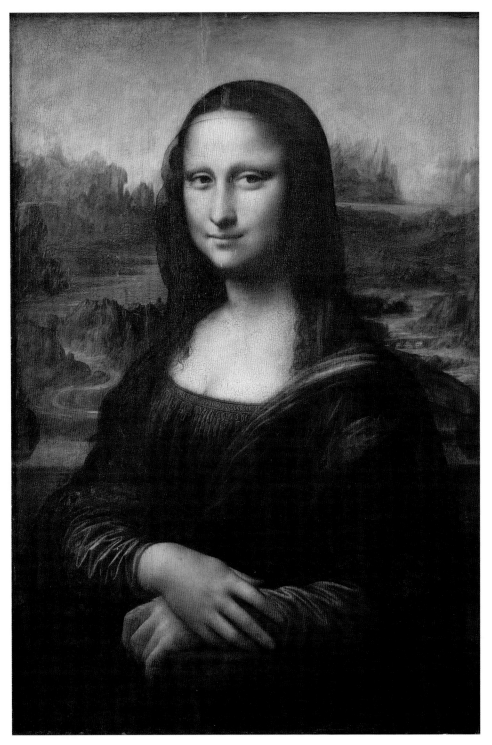

Mona Lisa (1506), Leonardo da Vinci, Louvre Museum, Paris

BOSCH'S *GARDEN OF EARTHLY DELIGHTS*

Five centuries of scholars have puzzled, pondered, and pontificated over the meaning of this cryptic triptych. Whatever it ultimately means, the large three-panel painting, with its wonderland of eye-pleasing details, is a garden of artistic delights.

The basics are pretty similar to other more traditional altarpieces. Hieronymus Bosch painted the story of mankind, from the innocence of creation (left panel), to the sensual pleasures of life on Earth (center), to the fate of sinners in hell after the Last Judgment (right panel).

The left panel is a fantasy Garden of Eden. The world is fresh, everything is in its place, the animals behave virtuously, and even God looks young. Adam and Eve—naked and innocent—get married, with God himself performing the ceremony.

The central panel depicts the Garden of Earthly Delights (that gives the whole work its name). It's a riot of naked men and women, black and white, on a perpetual spring break—eating exotic fruits, dancing, kissing, cavorting with strange animals, and contorting themselves into a Kama Sutra of sensual positions. In the background rise the fantastical towers of a medieval Disneyland. It's seemingly a fantasy land of pleasures and earthly delights. But where does it all lead? Men on horseback ride round and round, searching for but never reaching the elusive Fountain of Youth. People frolic in earth's "Garden," seemingly oblivious to where they came from (left) and where they may end up . . .

Now, go to hell (right panel). It's a burning Dante's Inferno-inspired wasteland where genetic-mutant demons torture sinners. Everyone gets their just desserts, like the glutton who is eaten and excreted into the bowels of hell, the musician strung up on his own harp (a symbol of lust), the gamblers with their table forever overturned, and the sexual harasser hit on by a pig-faced nun. In the center, hell is literally frozen over. Dominating it all, a creature with a broken eggshell body and tree-trunk legs stares out—it's the face of Bosch himself.

(continued)

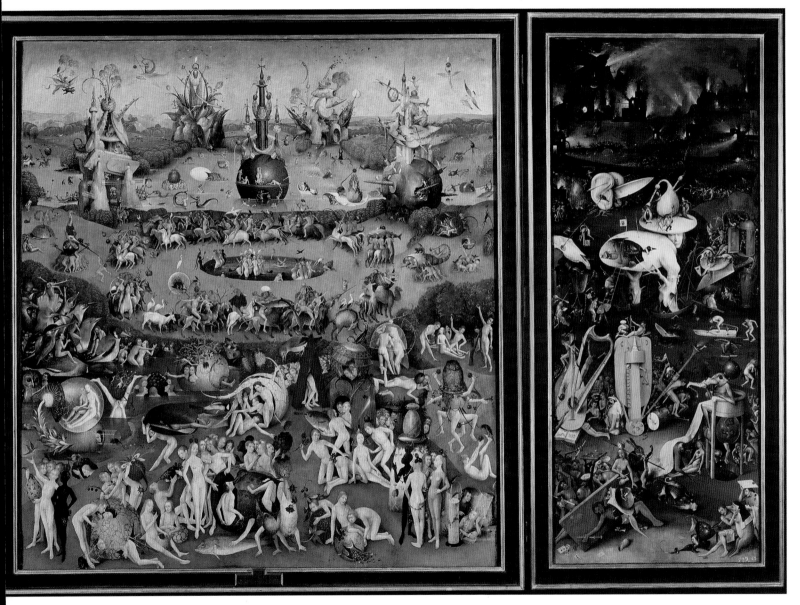

The Garden of Earthly Delights (c. 1505), Hieronymus Bosch, Prado Museum, Madrid

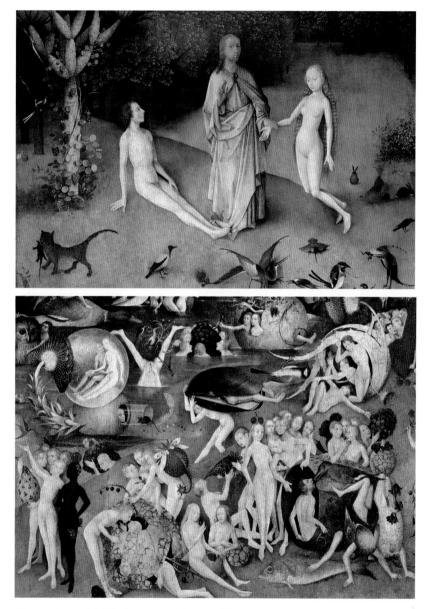

Above: A youthful God marries Adam and Eve.
Below: People frolic in earth's "Garden."

So what does it all mean? So little is known about the Flemish painter Hieronymus Bosch (c. 1450–1516) that it's hard to guess his intent. The basic message is that the pleasures of earthly life are fleeting. But if so, is it a condemnation of those "earthly delights" (which lead to hell) or a celebration (to enjoy them while you can)? The frolicking figures of the central panel sure look like they're having a great time, like innocent kids at play, exploring their bodies and the wonders of the world with no sense of shame. Even the gruesome imagery of hell has a certain black humor to it. It could be that Bosch, who painted numerous standard altarpieces, made this as a kind of secular altarpiece for his sophisticated Burgundian patrons. Or, with its infinitely imaginative innovations, it could be nothing less than an 85-square-foot window into the strange mind of Hieronymus Bosch.

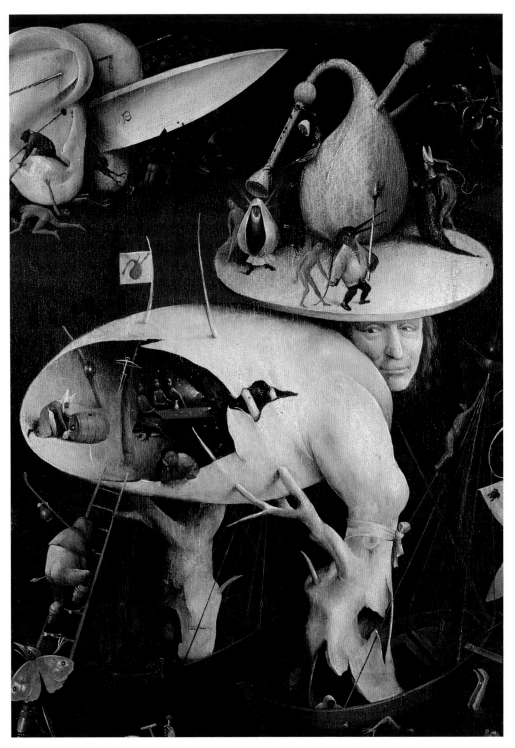

The face of Bosch (on eggshell body) in hell

MICHELANGELO'S *PIETÀ*

This was the statue that made Michelangelo famous. He was only 24 years old when his *Pietà* debuted in St. Peter's in Rome for the Holy Year of 1500. Thousands of pilgrims filed by and were amazed by what appeared to be a miraculous event carved out of marble yet unfolding before their eyes.

The word *pietà* means "pity," and is the name of any work showing Mary tenderly mourning her dead son, Jesus.

Michelangelo, with his total mastery of the real world, captures the sadness of the moment. Mary gazes down on her crucified son. Christ's lifeless right arm droops down, letting us know how heavy his corpse is. Christ's bunched-up shoulder and rigor-mortis legs show that Michelangelo learned well from his studies of cadavers. The vulnerability of Christ's smooth skin is accentuated by the rough folds in Mary's robe. As Mary supports the body with her right hand, she turns her left hand upward, asking, "How could they do this to you?"

It's hard to believe that this supple, polished statue is carved from one of the hardest of stones—Carrara marble. Michelangelo didn't think of sculpting as creating a figure, but as simply freeing the God-made figure already in the marble. He'd launch himself into a project like this with an inspired passion, chipping away to find what God had put inside.

As realistic as this work is, its true power lies in the subtle "unreal" features. Life-size Christ looks childlike compared with larger-than-life Mary. Unnoticed at first, this makes a subliminal impression of Mary enfolding Jesus in her maternal love. Mary—the mother of a 33-year-old man—looks like a teenager, emphasizing how Mary was the eternally youthful "handmaiden" of the Lord, always serving him, even at this moment of supreme sacrifice. Mary always accepts God's will, even if it means giving up her son.

Mary is a solid pyramid of maternal tenderness. Yet within this, Christ's body tilts diagonally down to the right and Mary's hem flows with it. Subconsciously, we feel the weight of this dead Savior sliding from her lap to the ground.

To appreciate the full impact of this scene, Michelangelo hoped you'd view his *Pietà* from close up, looking up at Mary's face. Sadly, on May 23, 1972, a madman with a hammer entered St. Peter's and began hacking away at the *Pietà*. The damage was repaired, but it changed forever how people interact with this object of beauty. It now sits behind a shield of bullet-proof glass and is viewable only from a distance.

This is Michelangelo's only signed work. The story goes that he overheard some pilgrims praising his *Pietà*, but saying it was done by a second-rate sculptor from a lesser city. Michelangelo was so enraged he grabbed his chisel and chipped an inscription in the ribbon running down Mary's chest. It said, "This was made by Michelangelo Buonarroti of Florence."

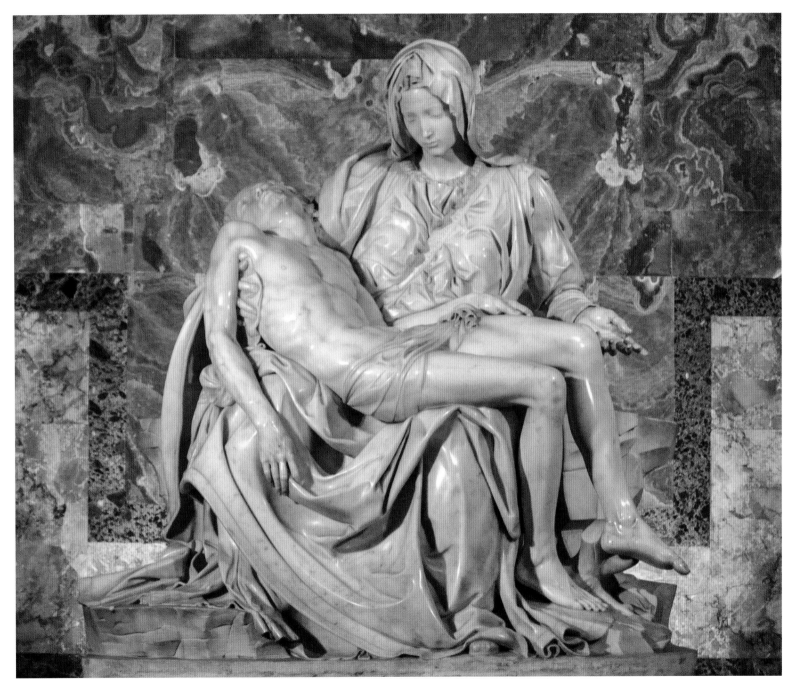

Pietà (1499), Michelangelo, St. Peter's Basilica, Rome

MICHELANGELO'S *DAVID*

When you look into the eyes of Michelangelo's *David*, you're looking into the eyes of Renaissance man. This six-ton, 17-foot-tall symbol of divine victory over evil represents a new century and a whole new Renaissance outlook. It's the age of Columbus and Classicism, Galileo and Gutenberg, Luther and Leonardo—of Florence and the Renaissance.

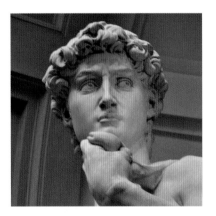

In 1501, Michelangelo Buonarroti, a 26-year-old Florentine, was commissioned to carve a large-scale work for Florence's cathedral. He was given a block of marble that other sculptors had rejected as too tall, shallow, and flawed to be of any value. But Michelangelo picked up his hammer and chisel, knocked a knot off what became David's heart, and started to work.

He depicted a story from the Bible, where a brave young shepherd boy challenges a mighty giant named Goliath. David turns down the armor of the day. Instead, he throws his sling over his left shoulder, gathers five smooth stones in his powerful right hand, and steps onto the field of battle to face Goliath.

Michelangelo captures David as he's sizing up his enemy. He stands relaxed but alert, leaning on one leg in the classical *contrapposto* pose. In his left hand, he fondles the handle of the sling, ready to fling a stone at the giant. His gaze is steady—searching with intense concentration, but also with extreme confidence. Michelangelo has caught the precise moment when David is saying to himself, "I can take this guy."

David is a symbol of Renaissance optimism. He's no brute. He's a civilized, thinking individual who can grapple with and overcome problems. He needs no armor, only his God-given physical strength and wits. Look at his right hand, with the raised veins and strong, relaxed fingers—many complained that it was too big and overdeveloped. But this is the hand of a man with the strength of God on his side. No mere boy could slay the giant. But David, powered by God, could . . . and did.

Though the statue was intended to stand atop the cathedral, it long stood in an even more prominent spot—guarding the entrance of Town Hall. Renaissance Florentines identified with David. Like him, they considered themselves God-blessed underdogs fighting their city-state rivals. In a deeper sense, they were civilized Renaissance people slaying the ugly giant of medieval superstition, pessimism, and oppression. They were on the cusp of our modern age.

Today, *David* is displayed safely indoors, under a glorious dome at the end of a church-like nave lined with other statues by Michelangelo. You can approach as a camera-toting tourist or as a pilgrim finding inspiration in this "cathedral of humanism." *David* stands as the ultimate symbol of the Renaissance—of optimism, humanism, and all that's good in the human race.

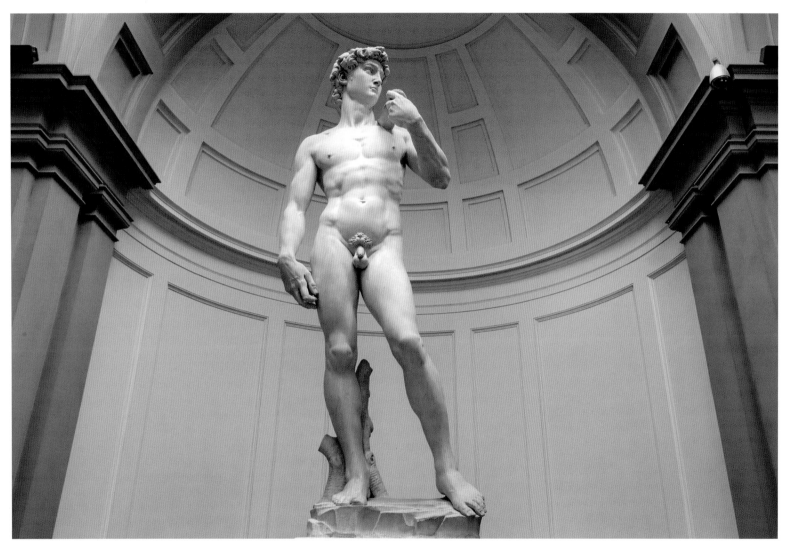

David (1504), Michelangelo, Accademia Gallery, Florence

MICHELANGELO'S SISTINE CEILING

Having recently completed his *David* and *Pietà,* Earth's greatest sculptor was now asked to put down his chisel and pick up a brush. The pope wanted him to paint the ceiling of the inner sanctum of the Vatican—the Sistine Chapel. And when the pope calls, it's hard to say no.

For the next four years, Michelangelo perched six stories up on scaffolding, laboring to cover this vast blank canvas. His subject? No less than the entire history of the world from creation to the coming of Christ.

In the center of the ceiling is the central image of creation. God swoops in with his entourage of angels, in a bundle of energy. Adam, newly formed in the image of God, lounges dreamily in perfect naked innocence. The two reach toward each other. Adam's hand is limp and passive; God's is strong and forceful, his finger twitching upward with energy. The synapse in between the two is the center of the work. Here is the very moment of creation—God passes that spark of life to man, the crowning work of his creation.

With this massive fresco, Michelangelo captures the spirit of the Renaissance. It was the era of humanism, which stressed the goodness and rational power of man. So here, God is not a terrifying giant reaching down to a puny and helpless man from way on high. He's like a loving father passing the baton to the next generation. God and man are on an equal plane, with the two exchanging meaningful eye contact. They're a team—God creating man in his image, to do his will on earth, working together to further the divine process of creation.

This central scene is only a fraction of the ceiling. The spine of the ceiling chronicles the busy week of Creation: God creating light, the earth, man, woman, and so on. Flanking this are robed prophets, each with a different personality: restless, thoughtful, angry, somber. In the triangles (or "lunettes") are distant ancestors who foresaw the coming of Christ. Finally, interspersed throughout are nude young men posing to show off their buff physiques. These all had a symbolic meaning, all part of Michelangelo's complex theological vision.

(continued)

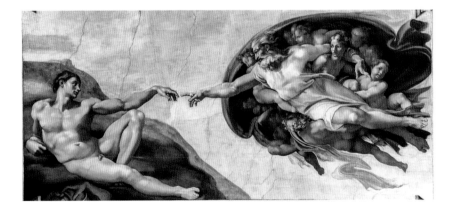

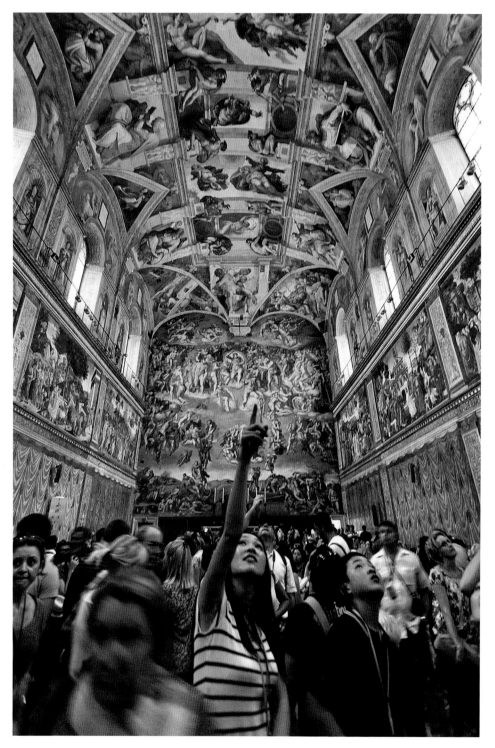

Sistine Chapel, Vatican Museums, Rome

In sheer physical terms, the ceiling is an astonishing achievement: 5,900 square feet—like painting an entire football field. Michelangelo painted standing up, not lying down, as is commonly thought. He painted in fresco—that is, painting on wet plaster. So the plaster had to first be hauled up and troweled on, and Michelangelo had to work quickly before it dried. The physical effort, the paint dripping in his eyes, and the mental stress from a pushy pope combined to almost kill Michelangelo.

But when he was done and the scaffolding came down—it just blew 'em away. Michelangelo's ceiling both capped the Renaissance and turned it in a new direction. In Renaissance style, it mixed Christian with classical pre-Christian figures. But the style was more dramatic and emotional than anything seen before. The ceiling's imagery has become part of the collective human consciousness. And in the opinion of many people—from art scholars to humble tourists—the Sistine ceiling is the single greatest work of art by any one human being.

(Wow. Who could possibly follow that? Only Michelangelo himself. For that, turn to the next featured work of art . . .)

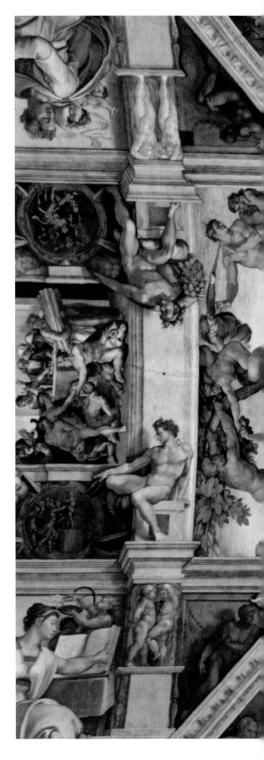

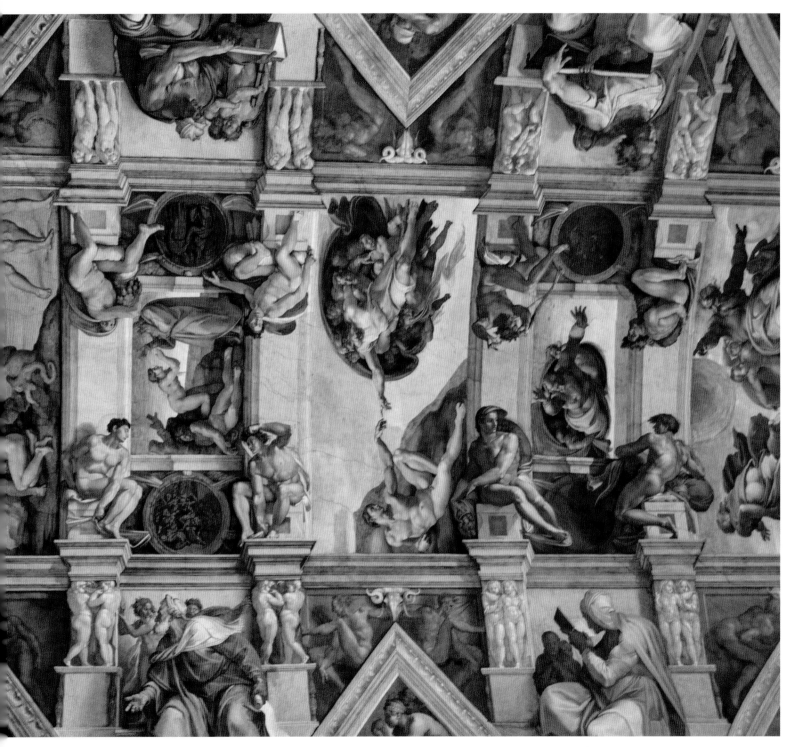

Sistine ceiling (1508–1512), Michelangelo, Vatican Museums, Rome

MICHELANGELO'S *LAST JUDGMENT*

Twenty-three years after doing the Sistine ceiling, another pope asked Michelangelo to return to the Sistine to paint the wall behind the altar. He had painted the story of creation on the ceiling. Now, he set out to complete his Christian history of the world by painting the world's final event—the end of time.

The mood of Europe was completely different from when Michelangelo had last painted here. Conflict between Catholics and Protestant Reformers was raging across Europe, and the Renaissance spirit of optimism was fading. Michelangelo himself—once the champion of humanism—was questioning the innate goodness of mankind.

It's Judgment Day, and Christ has come down to find out who's been naughty and who's been nice. Christ is a powerful figure in the center, raising his arm to smite the wicked. Beneath him, a band of angels blows its trumpets Dizzy Gillespie-style, giving a wake-up call to the sleeping dead. The dead—in the lower left—leave their graves and prepare to be judged. The righteous ones, on Christ's right hand, are carried up to the glories of heaven. The wicked, on the other hand, are hurled down to hell, where demons await to torture them.

It's a grim picture. No one is smiling, not even the saved souls in heaven. Meanwhile, over in hell, the wicked are tortured by gleeful demons. One of the damned (the crouched-down guy to the right of the trumpeting angels) has an utterly lost expression, like, "Why did I cheat on my wife?!" Two demons grab him around the ankles to pull him down to the bowels of hell, condemned to an eternity of constipation.

Overseeing it all is the terrifying figure of Christ dominating the scene. This is not your "love-thy-neighbor" Jesus anymore. He's come for justice. His raised arm sends a ripple of fear through everyone. Even his own mom, Mary, crouched beneath his arm, turns away. When *The Last Judgment* was unveiled in 1541, the pope is said to have dropped to his knees and cried, "Lord, charge me not with my sins!"

This fresco changed the course of art. The complex composition, with more than 300 figures swirling around Christ, was far beyond traditional Renaissance balance. The tumbling bodies made it a masterpiece of 3-D illusion. And the sheer over-the-top drama of the scene was unheard of for the time. Michelangelo had "Baroque-en" all the rules of the Renaissance, signaling a new era of emotional art.

The Last Judgment also marks the end of Renaissance optimism. In the Sistine ceiling's *Creation of Adam,* he was the wakening man-child of a fatherly God. Here, in *The Last Judgment,* man cowers in fear and unworthiness before a terrifying, wrathful deity.

Michelangelo himself must have wondered how he'd be judged— had he used his God-given talents wisely? Look at St. Bartholomew, the bald, bearded guy at Christ's foot. Bartholomew holds a flayed skin. In the flayed skin you can see a barely recognizable face—the twisted self-portrait of a self-questioning Michelangelo.

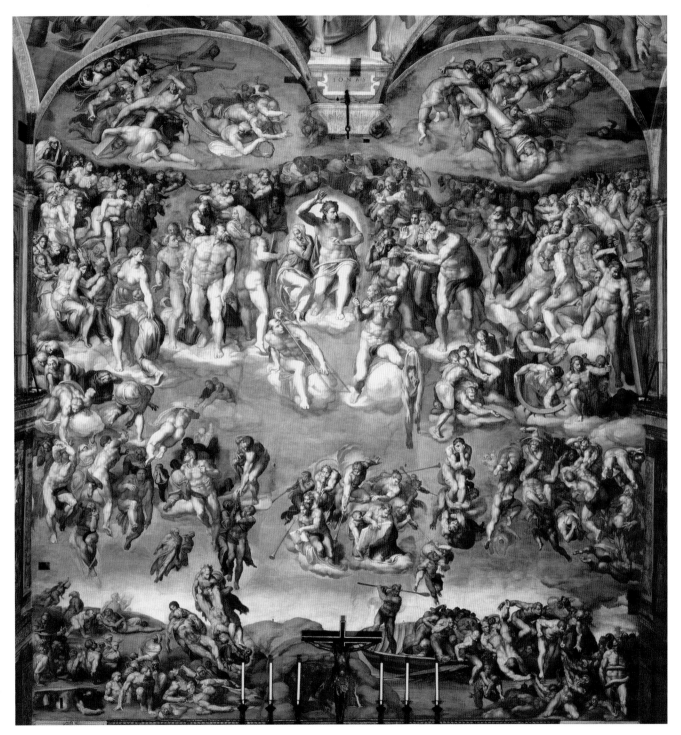

The Last Judgment (c. 1535–1541), Michelangelo, Vatican Museums, Rome

MICHELANGELO'S FLORENCE *PIETÀ*

Fifty years after he sculpted his famous *Pietà* in St. Peter's, Michelangelo tackled the subject again. This time, the mood is darker, as Michelangelo intended this work to decorate his own tomb.

Christ's broken body is being lowered from the cross. His grief-stricken loved ones struggle to support the heavy corpse. His mother Mary (the shadowy figure on the right) cradles him. She was with her son at his birth and now at his death ... still supporting him. On the left, Mary Magdalene turns away from the horrible scene. Christ's polished body zig-zags down to the grave. He's massive—his arm alone is almost the size of the Magdalene. You feel the dead weight of the body pulling down, and the heavy weight of sorrow these survivors struggle to bear.

At the peak of the pyramid is the hooded figure of Nicodemus, who helped bury Christ. Look closely at the face of Nicodemus—it's a self-portrait of Michelangelo. Nicodemus had special significance for Michelangelo, who belonged to a Bible study group called the Nicodemists. Like the converted Pharisee of the Bible (and like Protestants of the day), the Nicodemists were exploring the concept of being "born again." In the statue, Nicodemus looks down at Christ, seemingly wondering how someone so dead could ever be born again. The answer? Because Christ died for us, we can all live eternally.

The statue is clearly unfinished. Mary is still shrouded in stone, and there are raw chisel grooves near the base. Scholars speculate why Michelangelo never finished it.

First, he was old—a man in his seventies, tackling a physically demanding medium. He was trying to retire, turning down lucrative sculpting jobs—this one was a personal project. The optimistic Renaissance world he once knew was devolving into the bitter wars between Catholics and Protestants. Michelangelo was depressed, anticipating his own death. By sculpting this statue, he was essentially writing his own obituary.

For eight years Michelangelo labored over the *Pietà*. He hoped to chisel these four figures from a single block of marble, a sculpting tour de force. But as he worked, the marble proved to be hard, grainy, and flawed. It came off in unpredictable chunks and sparked when he hit it. Meanwhile, as the years ticked on, he was continually bugged by his closest companions asking, "When will you finish that thing?"

Pushed to the edge, one night Michelangelo grabbed a hammer and attacked the statue. He hacked away, breaking off Christ's left arm, smashing his nipple, and completely demolishing the left leg. You can still see cracks where the surviving fragments were later pieced back together by another sculptor. Regardless, Michelangelo turned his back on the *Pietà* and never touched it again.

Michelangelo had spent a lifetime bringing statues to life by "freeing" them from the stone. Now, as Nicodemus, he looks down at what could be his final creation—the once-perfect body of Renaissance man ... twisted, disfigured, and dead.

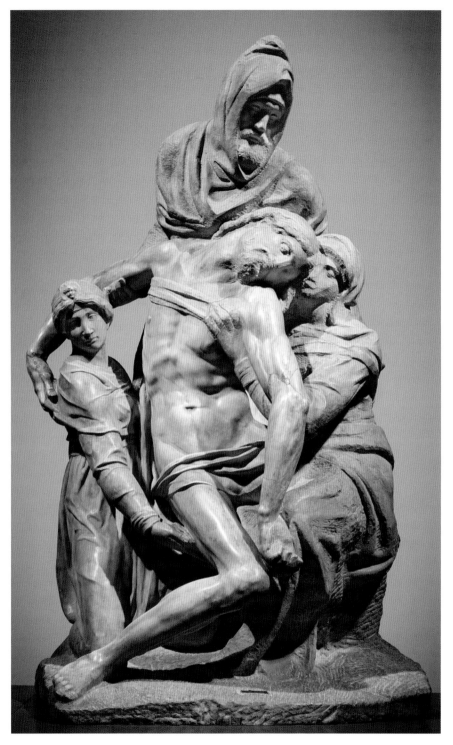

Florence *Pietà*, or *The Deposition* (1555), Michelangelo, Duomo Museum, Florence

RAPHAEL'S *SCHOOL OF ATHENS*

In 1508, the great Pope Julius II decided to redecorate his Vatican apartment. He hired a 25-year-old who came with a reputation as a one-of-a-kind prodigy: Raphael Sanzio. For the pope's library, Raphael painted this scene highlighting secular knowledge. Raphael imagines all the great scientists and philosophers from the ancient world gathered together in a kind of rock and roll heaven.

In the center stand Plato and Aristotle. Plato points up, indicating his philosophy that mathematics and pure ideas are the source of truth. Aristotle gestures down, showing his preference for hands-on study of the material world. Their master, Socrates (midway to the left, in green), debates the meaning of it all. In the lower left, the great mathematician Pythagoras sits and ponders his famous formula: $a^2 + b^2 = c^2$. In the lower right, the bald Euclid bends over to draw a geometrical figure.

There's another way to look at this Who's Who of great minds. You see, Raphael thought that Renaissance thinkers of his generation were as enlightened as the ancients. So he cast many of his contemporaries in the role of these enlightened people of the past. Plato, for example, with his long beard and receding hairline, is clearly Leonardo da Vinci, Raphael's hero. And Euclid is the architect Donato Bramante. In fact, the entire scene is set amid the arches and pillars of Bramante's work-in-progress—St. Peter's Basilica. Raphael even photobombed his own painting. Find his self-portrait on the far right—the young man wearing a black beret and peering out.

Self-portrait of Raphael
(in black beret)

Now take in the whole scene. Raphael balances everything symmetrically. He places a couple dozen figures to the left, a couple dozen to the right, with Plato and Aristotle dead center. Focus on the square floor tiles in the foreground. If you laid a ruler over them and extended the line upward, it would run right to the center of the picture. If you put your ruler on the tops of the columns, those lines all point down to the middle. All the lines of sight draw your attention to Plato and Aristotle, and to the small arch over their heads. It's almost like a halo over these two secular saints who dedicated their lives to the divine pursuit of knowledge.

Finally, focus on the guy sitting right up front and center, leaning on a block of marble. He was a last-minute addition to the scene. While Raphael was working here, another painter was at work for the same pope down the hall in the Sistine Chapel. Raphael happened to get a sneak peek at that artist's work. He was astonished. He returned to *The School of Athens*, scraped off a section of fresco, replastered it, and added this final figure: none other than the great painter, sculptor, and poet—Michelangelo Buonarroti.

With this fresco, Raphael's message was clear: The enlightened ancient world had been reborn in the Renaissance.

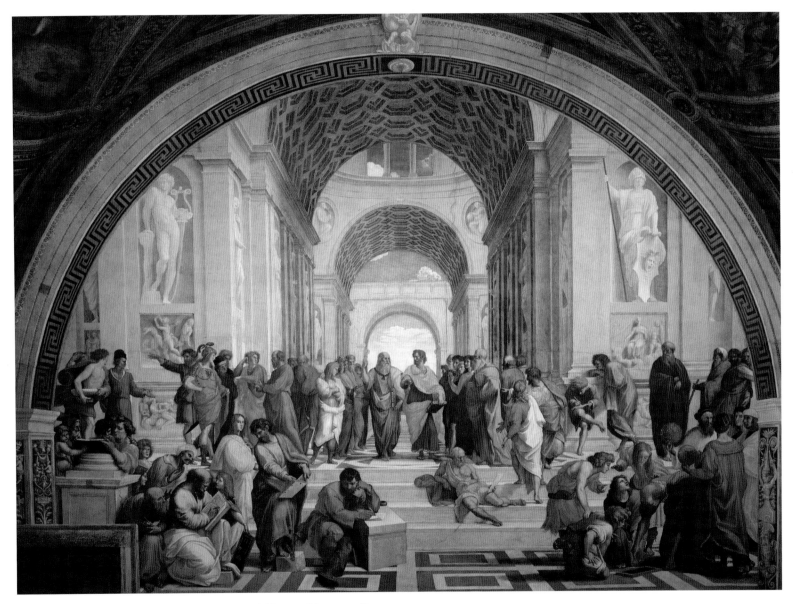

The School of Athens (1511), Raphael, Vatican Museums, Rome

RAPHAEL'S *MADONNA OF THE GOLDFINCH*

Mary, dressed in red and blue, gazes down at the two chubby little kids at her feet. It seems she's been reading to her toddler, Jesus, when suddenly little Johnny the Baptist rushes in to show his cousin what he's just found: a bird. Jesus, standing *contrapposto* like a chubby Greek statue, leans across Mary's lap to pet the bird.

Raphael has brought Mary and Bambino down from their traditional heavenly realm and placed them in the same world as you and I—the real world of trees, water, rocks, flowers, and sky. This Madonna radiates tenderness and holiness, the divine embodied in human form.

Raphael's idol was the great Leonardo da Vinci. He captures Leonardo's graceful style, painting a family scene with warm colors and a hazy background that matches the golden skin of the children. The painting is bathed in an even light, with few shadows. The seamless brushwork varnishes the work with an iridescent smoothness.

Also like Leonardo, Raphael gives his painting a carefully planned structure. He poses the figures into a pyramid, with Mary's head at the peak. Mary is a mountain of maternal tenderness enfolding the two kids within her loving embrace. Mary's face is a perfect oval, and her shoulders form a perfect Renaissance arch. The two halves of the painting balance perfectly. Draw a line down the middle, through Mary's nose and down through her knee. John the Baptist on the left is balanced by Jesus on the right. Even the trees in the background balance each other, left and right, and Mary wears a "halo" of fluffy clouds. These things aren't immediately noticeable, but subconsciously they create the feeling that God's created world is geometrically perfect. And it reinforces the calm atmosphere of maternal security.

Despite the geometric template, Raphael lets a bit of messy reality spill over the lines so the painting isn't static. Mary eyes John with a knowing look. Meanwhile, John looks across at Jesus, and Jesus looks back. The interplay of gazes adds a sense of motion and tension to the balanced scene.

Then Raphael gives the painting a psychological kidney punch. The center of the composition is the tiny goldfinch. (Because of the finch's appetite for thistles, it represents the Crown of Thorns, symbolizing the Passion.) The kids play with it innocently, unaware that it is a portent of what lies ahead—Jesus' Crucifixion.

All of these elements come across as simple and unforced—much like Raphael himself. Raphael lived a charmed life. Handsome and sophisticated, he painted masterpieces by day and partied by night. His love affairs were legendary. With his debonair personality and lavish lifestyle, he epitomized the worldly spirit of the Renaissance. Both in his life and art, he exuded what his contemporaries called *sprezzatura*—an effortless, unpretentious elegance.

Raphael is considered the culmination of the Renaissance, perfectly blending realism, balance, beauty, and human emotion. When he died—just 37 years old—his work spawned many imitators who cranked out sappy Madonnas that fill today's museums. It's easy to take Raphael for granted. Don't. He's the real thing.

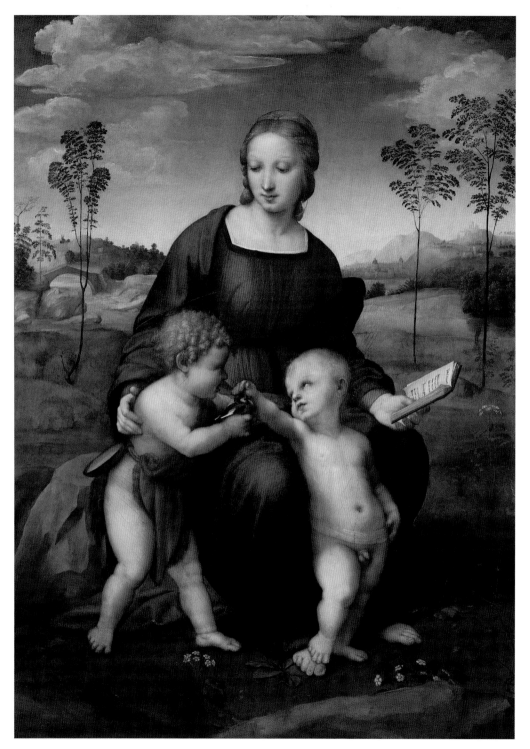

Madonna of the Goldfinch (c. 1506), Raphael, Uffizi Gallery, Florence

RAPHAEL'S *TRANSFIGURATION*

Raphael is one of the holy trinity of Renaissance artists (with Michelangelo and Leonardo), and this is his last and greatest painting. Raphael used every arrow in his artistic quiver in this complex masterwork, summing up all he'd learned and setting the tone for artists to come.

The face of Christ

At the top, a luminous Jesus floats in a heavenly vision, backlit by an aura of incandescent clouds. It's the miraculous event described in the Bible, where Jesus ascends a mountain and converses with the prophets Moses (right) and Elijah (left). Beneath Jesus' feet, his three closest disciples cower in awe, blinded by the light, as their leader is "transfigured before them, his face shining as the sun, his clothes white as light" (Matthew 17).

As ethereal as the painting's top half is, the bottom is dark, stormy, and emotional. While Jesus is away being transfigured, the rest of the disciples struggle with a troubling event. A boy (right) is having a seizure—his body contorts, his mouth is agape, and his eyes roll up. His poor father (behind him in green) is terrified, and his mother kneels before the disciples and pleads, "Heal him." The disciples turn to each other for advice. Some point upward, explaining that the only one who can save the boy is away on business. It's a dramatic episode, and (sitting at bottom left) Matthew takes notes for a best-selling book he's writing. As it turned out, when Jesus finally came down from the mountain, he healed the boy. Raphael juxtaposes both events into one painting—heavenly and earthly—emphasizing how the divine power of God can come down from above to heal the troubled world.

Stylistically, Raphael combines the soft-focus grace of Leonardo (in the upper half) with Michelangelo's beefy bodies, twisting poses, and emotional power (lower half). The composition is a series of interlocking triangles and circles set inside the rectangular (13-foot-tall) frame. Jesus, with outstretched arms, is an inverted triangle, standing within a larger triangle formed by the two prophets. In the lower half, the disciples' upstretched arms group them into another triangle with the mom as the axis. The boy, though possessed, seems to instinctively know where help lies, and his upward-pointing gesture unites the painting's two halves.

Raphael's final days working on *The Transfiguration* are a microcosm of his life. On the one hand, he was creating a powerful spiritual statement. But meanwhile, he was living the high life with Rome's glitterati and carrying on a torrid love affair with the "baker's daughter," La Fornarina. On April 6, 1520, Raphael—only 37—died suddenly, after a night of wild sex. For his funeral, *The Transfiguration* made its debut.

The painting was incredibly influential. Its squirming figures filling the picture-plane inspired the Mannerists. Its dark shadows and over-the-top emotions influenced Baroque. And its intense spirituality spoke to believers. The last thing Raphael painted before he died was the beatific face of Jesus, perhaps the most beautiful Christ in existence.

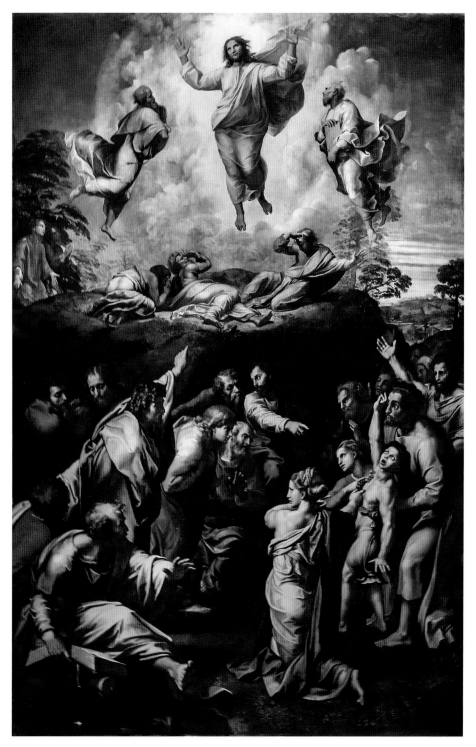

The Transfiguration (1520), Raphael, Vatican Museums, Rome

TITIAN'S *VENUS OF URBINO*

A luscious strawberry blonde, wearing nothing but earrings and a bracelet, reclines across her bed. The sheets are rumpled, her hair spills seductively down her shoulder, and she lounges luxuriously, unabashedly naked.

The title identifies her as Venus, the Goddess of Love, painted to celebrate the Duke of Urbino's wedding. She brings along her symbolic dog (representing fidelity), bouquet of roses (passion), and ladies-in-waiting (with the bride's hope chest).

Others maintain this "Venus" is actually a full-monty portrait of a very well-known woman of the day—a renowned Venetian call girl who once serviced the naughty Duke.

Clearly, the painting is flat-out sexy. This is not some otherworldly goddess (like Botticelli might paint), but a sensuous flesh-and-blood woman. She stares straight at the viewer with a heavy-lidded gaze. There's no coy pretense of girlish flirtation. The hand on her privates is not so much modest as suggestive. This isn't a Venus, it's a centerfold—a Renaissance Miss August—with no purpose but to please the eye (and other organs). The bed is used.

This nude in her sumptuous setting epitomized the luxury-loving, cosmopolitan, edgy world of Titian's hometown: the city of casinos, bordellos, and publishers of banned books—Venice.

When Titian painted this, he was in his mid-40s, the most famous painter of his day—perhaps even more famous than Michelangelo. Titian the Venetian (it rhymes) was cultured and witty, a fine musician and businessman—an all-around Renaissance kind of guy. He traveled throughout the Continent to paint portraits of Europe's movers and shakers and sexy scenes for their bedrooms. He excelled equally in stately portraits, racy nudes, solemn altarpieces, and raucous pagan scenes from Greek mythology.

Titian reinforces the painting's eroticism. Venus' rich, luminous flesh stands out from the dark background and white (and mussed-up) sheets. Titian splits the canvas down the middle with a curtain, connecting the two halves with a diagonal slash of luminous gold—the nude woman. The place where the vertical line of the curtain meets the horizontal of the bed is the undeniable center of the composition: her genitals.

When the *Venus of Urbino* was first displayed in the Uffizi (in 1736), it had to be secretly kept behind a more modest painting. With this painting, Titian had pioneered the reclining female nude, and it would inspire countless later artists, from Goya to Velázquez to Manet. Over the years, it's said that many visitors swooned before it—the poet Byron called it "The Venus." With her sensual skin, hey-sailor look, and unapologetic nudity, she must have left them blithering idiots.

Now turn to the n-n-n-n-next painting.

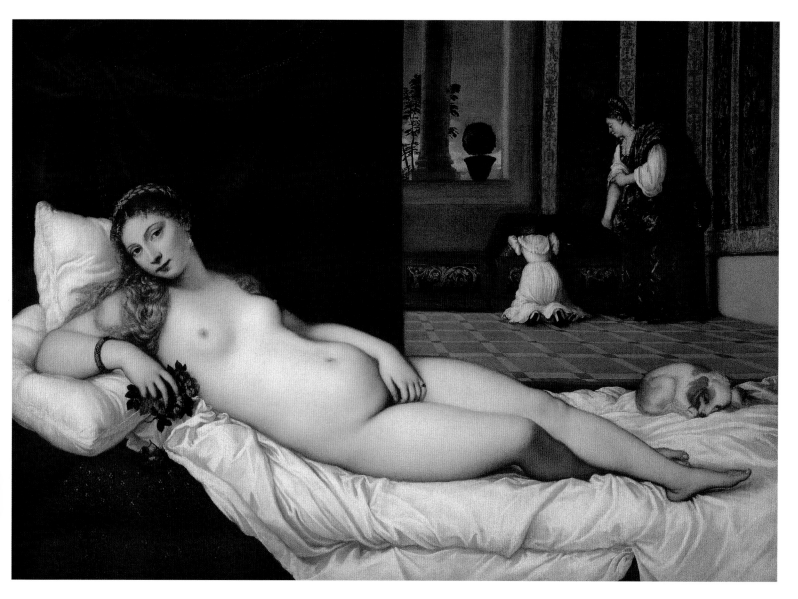

Venus of Urbino (c. 1534), Titian, Uffizi Gallery, Florence

EL GRECO'S *BURIAL OF COUNT ORGAZ*

A simple chapel in the Spanish city of Toledo holds El Greco's most beloved painting, which couples heaven and earth in a way only "The Greek" could. It just feels right to see a painting in the same church where the artist placed it 400 years ago. This 15-foot-tall masterpiece, painted at the height of El Greco's powers, is the culmination of his unique style.

Self-portrait of El Greco

The year is 1323. Count Don Gonzalo Ruiz of Orgaz, the mayor of Toledo, has died. You're at his funeral, where he's being buried right here in the chapel that he himself had ordered built. The good count was so holy, even saints Augustine and Stephen have come down from heaven to be here. Toledo's most distinguished citizens are also in attendance. The two saints, wearing rich robes, bend over to place Count Orgaz, dressed in his knight's armor, into the tomb. (Count Orgaz's actual granite tombstone was just below the painting.) Meanwhile, above, the saints in heaven wait to receive his blessed soul.

The detail work is El Greco at his best. Each nobleman's face is a distinct portrait, capturing a different aspect of sorrow or contemplation. The saints' robes are intricately brocaded and have portraits of saints on them. Orgaz's body is perfectly foreshortened, sticking out toward us. The officiating priest wears a wispy, transparent white robe. Look closely. Orgaz's armor is so shiny, you can actually see St. Stephen's reflection on his chest.

The serene line of noble faces divides the painting into two realms—heaven above and earth below. Above the faces, the count's soul, symbolized by a little baby, rises up through a mystical birth canal to be reborn in heaven, where he's greeted by Jesus, Mary, and all the saints. A spiritual wind blows through as colors change and shapes stretch. With its metallic colors, wavelike clouds, embryonic cherubs, and elongated forms, heaven is as surreal as the earth is sober. But the two realms are united by the cross at right.

El Greco considered this to be one of his greatest works. It's a virtual catalog of his trademark techniques: elongated bodies, elegant hand gestures, realistic faces, voluminous robes, and an ethereal mix of heaven and earth. He captures a moment of epiphany with bright, almost fluorescent colors that give these otherwise ordinary humans a heavenly aura.

The boy in the foreground points to the two saints as if to say, "One's from the first century, the other's from the fourth . . . it's a miracle!" The boy is El Greco's own son. On the handkerchief in the boy's pocket is El Greco's signature, written in Greek. One guy (seventh from the left) in this whole scene doesn't seem to be completely engaged in the burial. Looking directly out at the viewer is the painter, El Greco himself.

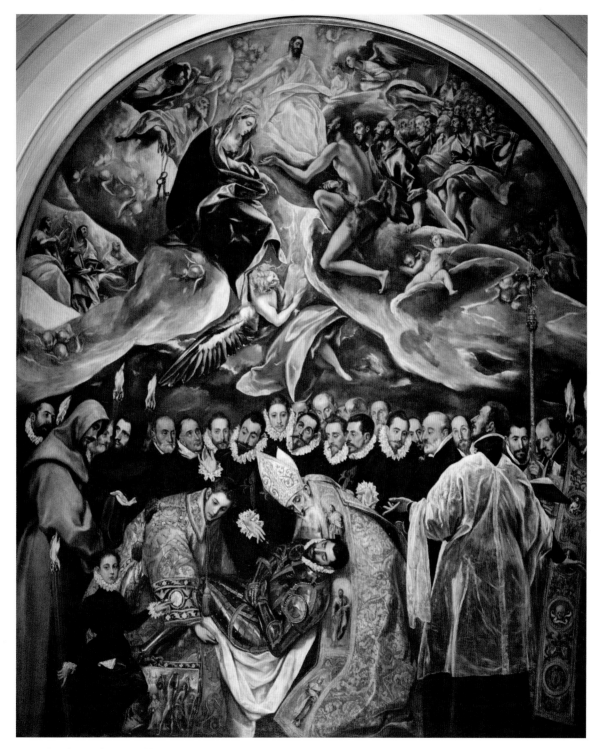

Burial of Count Orgaz (1588), El Greco, Santo Tomé Chapel, Toledo, Spain

VAN EYCK'S *ARNOLFINI WEDDING*

Sometimes dubbed "The Shotgun Wedding" (for the bride's seemingly pregnant state), this painting depicts a well-heeled Italian businessman and his wife in their upscale apartment in the cosmopolitan city of Bruges, Belgium. It's likely a wedding portrait.

Mirror on back wall

Jan Van Eyck (c. 1390–1441) meticulously paints their rich trappings: their brass chandelier, Oriental carpet, canopied bed, and imported oranges on the windowsill. He highlights their incredibly expensive clothes—made of luxurious fabrics, with rich colors, and trimmed with rare fur. No wonder. Giovanni Arnolfini was a cloth merchant, living in the city that was Europe's main producer and exporter of high-fashion couture.

The realism is astonishing. It's a masterpiece of down-to-earth details. Van Eyck has built a virtual dollhouse, inviting us to linger over the furnishings. Feel the texture of the fabrics, count the hairs of the couple's terrier, trace the shadows generated by the window. Each object is painted at an ideal angle, with the details you'd see if you were standing right next to it. The string of beads hanging on the back wall are as crystal clear as Mrs. Arnolfini's bracelets.

To top it off, look into the round mirror on the far wall—the whole scene is reflected backward in miniature, showing the loving couple and a pair of mysterious visitors. Is one of them Van Eyck himself at his easel? Has the artist painted you, the home viewer, into the scene?

This seemingly simple picture was groundbreaking in the world of art. It's (arguably) the first modern oil painting, made by dissolving pigments in vegetable oil, rather than tempera (which uses egg yolk). Van Eyck could lay down, say, a patch of brown, then apply a second layer of translucent orange, then another. The colors bleed through to create the figure—like the Arnolfinis' meticulously detailed terrier.

This portrait of a Bruges power couple is one of history's first paintings that wasn't of a saint, king, pope, or miraculous event. Van Eyck was glorifying ordinary people, signaling the advent of humanism. He created the first slice of everyday life.

The exact meaning of the portrait isn't clear. Van Eyck left clues that lead people to conclude this represents a marriage vow of some sort. The chandelier with its one lit candle likely symbolized love—how it keeps shining even in daylight. The fruit on the windowsill was fertility, and the dangling whisk broom was the new wife's domestic responsibilities. And the terrier? He'd be Fido—fidelity.

Van Eyck proudly signed the work (above the mirror) "Jan van Eyck was here, 1434." It's as if he was asserting to be an eyewitness to the event, and he captured that exact moment, just as it was, for posterity.

By the way, the woman likely was not pregnant. The fashion of the day was to gather up the folds of one's full-skirted dress. At least, that's what they told her parents.

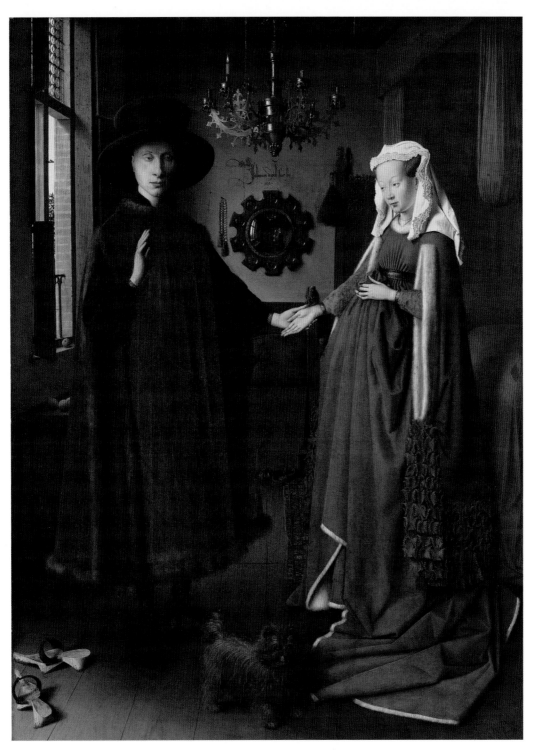

The Arnolfini Wedding, a.k.a. *The Arnolfini Portrait* (1434), Jan Van Eyck, National Gallery, London

CRIVELLI'S *ANNUNCIATION*

An angel kneels alongside his saintly companion as they arrive to give Mary the good news that she'll bear Jesus. Mary, in green, is visited by the dove of the Holy Spirit, who beams down from the distant heavens in a shaft of light.

The striking thing about this traditional Annunciation scene is the setting: in a bustling city on a street that seems to stretch forever. The floor tiles and building bricks recede sharply into the distance. We're sucked right in, from the fruits in the foreground, past the angel, accelerating through the alleyway, under the arch, and off into space. Your eye goes way, way back, then you focus back out and bam!—you have a giant pickle in your face. The Holy Spirit spans the entire distance, connecting heavenly background with earthly foreground.

The scene is colorful, beautiful, and airy, with every detail crisp and clear. It seems to be the epitome of Renaissance three-dimensional perspective . . . but there's something odd about that 3-D.

In fact, Carlo Crivelli was on the cusp between the new Renaissance style and the older Gothic style. Following traditional tastes, he paints immaculate details: the hanging Oriental rug, the peacock (with his faint shadow), and the elaborate friezes on the buildings. He includes traditional Christian symbols like the clear flask on Mary's shelf (purity), the peacock (immortality), and Adam's forbidden apple.

But the painting is also an exercise in Renaissance "one-point perspective," where—if you laid a ruler along the painting's lines—they would all converge at a single "vanishing point" on the horizon. But on closer inspection, Crivelli's lines don't match up. The street's pavement tiles lead to one point on the horizon, Mary's ceiling coffers lead to another, and the upper room coffers lead to still another. Also, the people at the far end of the street are bigger than they should be at that distance. And the Holy Spirit's laser beam comes in at a completely impossible angle—it should start high in the sky directly above the angel. Though Crivelli explored one-point perspective, his 3-D ended up more like 2¾-D.

Crivelli's defenders insist he purposely did this for artistic purposes. By playing with the relative sizes of people, they say, he was able to give distant figures their due, with perfect clarity. By tweaking the vanishing points, he made the upper balcony appear spacious and airy, while Mary's room is (appropriately for a virgin) small and intimate. With multiple perspectives, Crivelli created a rich, Escheresque labyrinth of rooms and walkways that the viewer can wander through, around, and into, appreciating all the colorful details within. Crivelli's world is simultaneously real and unearthly—just the kind of place where God can suddenly intervene with a miraculous annunciation.

In Crivelli's day, Renaissance artists became almost obsessed with 3-D space. Perhaps they were focusing their spiritual passion away from heaven and toward the physical world. With such restless energy, they needed lots of elbow room. Space, the final frontier.

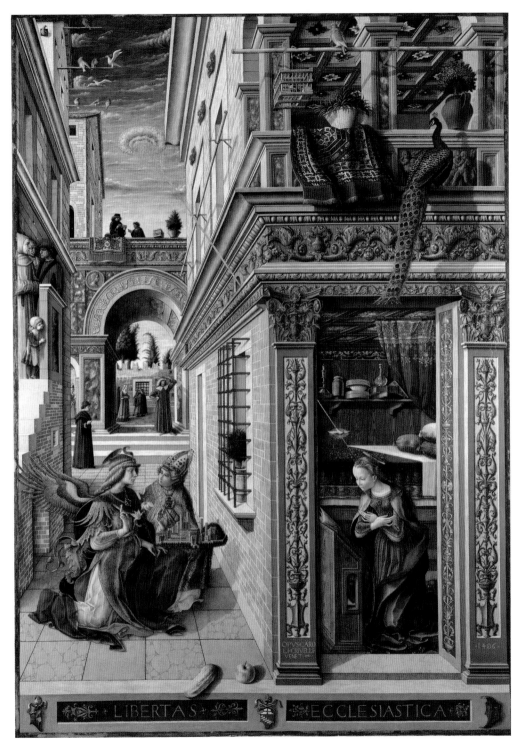

The Annunciation, with Saint Emidius (1486), Carlo Crivelli, National Gallery, London

DÜRER'S *SELF-PORTRAIT*

Albrecht Dürer was the first artist to paint a self-portrait. Here he stares out intensely—you can't avoid his gaze. He's decked out in a fancy fur-lined coat and perfectly permed hair. Dürer had recently returned from Italy and wanted to impress his fellow Germans with his sophistication. Dürer wasn't simply vain. He'd grown accustomed, as an artist in Renaissance Italy, to being treated like a prince.

Dürer marks this snapshot with an exact place and time. To the left of his face is the year—"1500." To the right is a Latin inscription saying "I, Albrecht Dürer from Nuremburg, painted myself with indelible colors at XXVIII years" (age 28).

Though still a young man, Dürer was now the most famous artist in Europe. His woodcut prints and engravings had been shared with thousands, thanks to the newly invented mass medium of the printing press. This painting has an engraver's attention to detail. The hair is intricately braided into cascading ringlets. The skin texture is shaded just right. His well-cropped beard and finely curved lips are those of a handsome man. In the fur collar, you can see every individual hair. Dürer's eyes radiate intelligence. It's a very personal portrait of a real flesh-and-blood human being.

Portraits of real people were just coming into their own. During medieval times, only Christ and the saints were worth painting. Oh, a few kings and dukes got portraits, but these were usually photoshopped to show them in the best light. Artists never painted themselves. They were low on the societal totem pole, anonymous, considered blue-collar craftsmen who worked with messy paints.

But Dürer had visited Renaissance Italy, where he saw a revolution underway. Ordinary citizens were now deemed worthy to be depicted in all their everyday glory, warts and all. And artists—like Botticelli, Michelangelo, and Titian—were rock stars.

Dürer returned to Germany and created Europe's first true selfies. This is a life-size, stand-alone portrait of himself, as rich and monumental and serious as any saint or king. In fact, look closely at Dürer's intense, full-frontal gaze and raised hand. He looks exactly like a Christ from a medieval altarpiece, raising his hand in solemn blessing. This was the ultimate humanist statement. It focused on a man, not a saint, portraying him almost like Christ on earth—the artist as an instrument of God, carrying on his creation.

After Dürer, self-portraits became a thing. Raphael photobombed his own masterpiece, *The School of Athens*. Michelangelo painted his twisted self-portrait in *The Last Judgment*. Rembrandt's self-portraits show the artist's evolution—from unsure young man, to confident careerist, to brooding old man. Van Gogh added even more psychological intensity, and Picasso gave a backstage peek at his work process. Each artist's self-portrait shows his emotional state, a glimpse at how beauty is born.

But ultimately, Dürer's self-portrait is not a statement or a symbol, but just what it appears to be—a photo-realistic snapshot of a very remarkable man. To hammer home his personal imprint, the artist signed the work with his distinct signature—a letter A arching over a D: Albrecht Dürer.

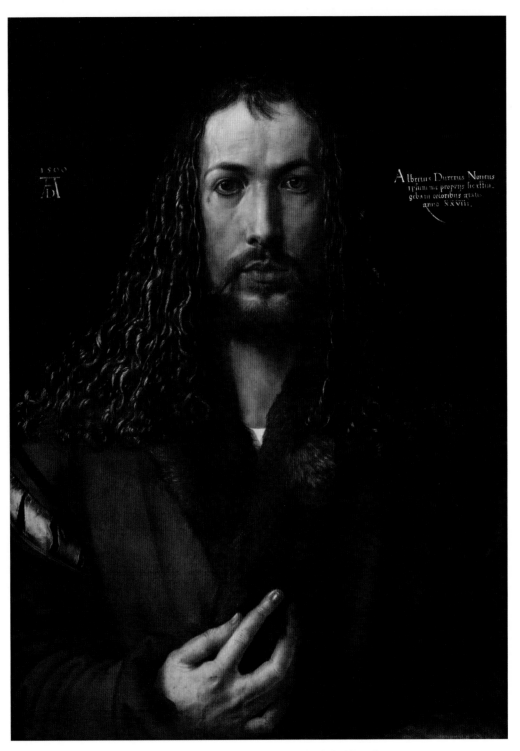

Self-Portrait in Fur Coat (1500), Albrecht Dürer, Alte Pinakothek, Munich

RIEMENSCHNEIDER'S ALTAR OF THE HOLY BLOOD

In a loft-like chapel lit by stained glass, in Germany's best-preserved medieval town, Rothenburg, stands an extraordinary sculpture carved entirely out of wood—the Altar of the Holy Blood.

Tilman Riemenschneider, the Michelangelo of German woodcarvers, sculpted this from 1500 to 1504—about the same time Michelangelo was working on his *David*.

The entire 35-foot-tall carving is designed to display the tiniest of relics—a single drop of Christ's "holy blood." In the very center, in a cross held up by angels, was a small rock-crystal capsule containing the blood. The relic (brought to Rothenburg around 1270) had drawn so many pilgrims that they had to build an entirely new church. Then they hired Riemenschneider to create a glorious altarpiece to properly show off the relic.

Riemenschneider's carvings are all about Christ's blood. He tells the story of the Passion, from Christ's arrival in Jerusalem (left panel), to his arrest in Gethsemane (right panel), his torture (the statue at top), to his crucifixion (at bottom)—when he shed his "holy blood."

Altar of the Holy Blood

Riemenschneider puts the main focus on the critical central scene—the Last Supper. The 12 disciples are gathered around a table to share one last meal together. Riemenschneider freezes the moment just as Jesus (third figure from left, facing directly out) stands to make a historic announcement: "This is my body,"

he says, "and this is my blood," as he gives the bread and wine of Communion to his disciples. Meanwhile, the disciples look at each other warily, knowing that one of them will betray their master. The traitor is Judas, standing right in the center, sucking up to Christ.

Think of the countless pilgrims through the ages who've knelt here before this altar. They'd ponder the story of Jesus' Passion: How he sacrificed his own blood. And a drop of that "Holy Blood" was displayed on this very altarpiece.

Riemenschneider was not just a backwoods whittler—his realism and attention to detail are astonishing. The altarpiece is a lacy web of intertwining vines. In the Last Supper scene, Riemenschneider faithfully creates flesh-and-blood human beings, with expressive faces, curly locks, sharp-folded robes, and weathered hands. As Christ turns to Judas, he gives him a psychologically probing look—simultaneously accusing and tender.

For his medium, Riemenschneider chose wood from the linden tree—a much venerated tree that lives for centuries and is found all over Germany. Riemenschneider chose not to paint over the wood,

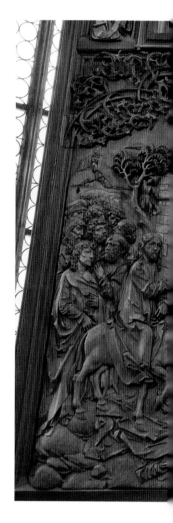

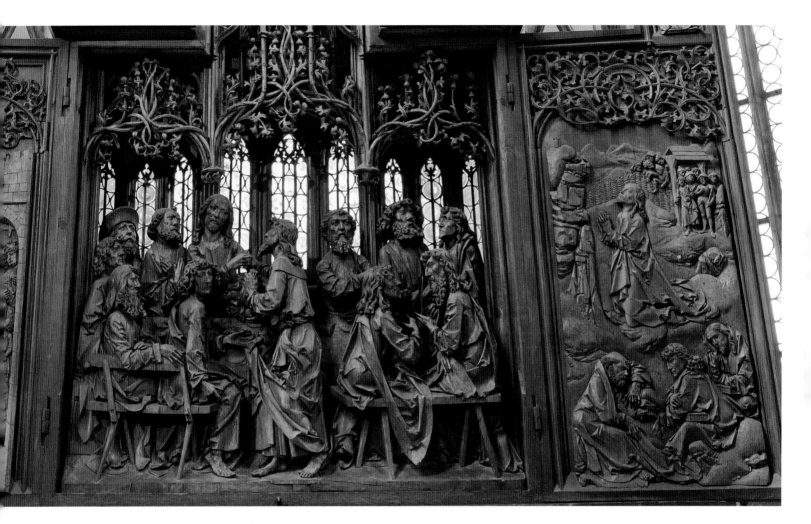

wanting to show off the natural beauty of this beloved national tree.

For five centuries Riemenschneider's altarpiece has inspired the faithful. Locals use it to celebrate time-honored traditions in the days leading up to Easter. Year round, believers can come here, relive Christ's agony, and appreciate the Holy Blood—the sacrifice that brings them eternal life.

Altar of the Holy Blood: The Last Supper (1504), Tilman Riemenschneider, St. Jakob's Church, Rothenburg, Germany

GRÜNEWALD'S ISENHEIM ALTARPIECE

Take in this panel as if you were a humble peasant, and feel the agony of Jesus being crucified. Christ's body is twisted and emaciated, with a deathly pallor. The crown of thorns is a swarm of torment, as Jesus gasps for air. The crossbar bends down—not so much from the weight of Jesus' body as from his anguish. Christ's stretched, extended arms are pulled from their sockets, his fingers grotesquely contorted, his feet broken and swollen. The blood drips down. And look at Christ's skin: It's covered with thorns, wounds, and sores.

This Crucifixion was painted for a medieval hospital, which specialized in patients suffering from horrible skin diseases (specifically a kind of shingles called St. Anthony's Fire). Before the age of painkillers, suffering patients could gaze on this scene and feel that Jesus understood their distress.

The artist, Mattias Grünewald, makes this an intimate drama. Mary turns pale and swoons, as a grieving John the Evangelist tries to support her. She is draped in the white shroud that will cover the body of her dead son. Mary Magdalene, overcome by anguish, drops to her knees and pleads for some way out of this tragedy. On the right, John the Baptist stands alongside a symbolic lamb, reminding all that Jesus was fated to make this terrible sacrifice. All of the gestures—John's finger, Mary Magdalene's outstretched arms, and Mary's clasped hands—direct the eye upward to the focus of the composition: Jesus.

This dark, gruesome, troubling Crucifixion could not be more bleak.

But it wasn't the end of the story. The patients lying in this hospital needed some hope that their suffering had a purpose.

See that tiny seam running down the middle of the painting? It reminded everyone that there was a better world lying beyond.

Grünewald's Crucifixion is just one panel of many, all part of a polyptych, or multipaneled altarpiece. The panels were attached by hinges that could pivot like shutters. Most of the time, the altarpiece was closed, showing the Crucifixion. But on feast days, the priest opened the Crucifixion up at the seam, to reveal the panels within.

To open up the painting, turn the page.

(continued)

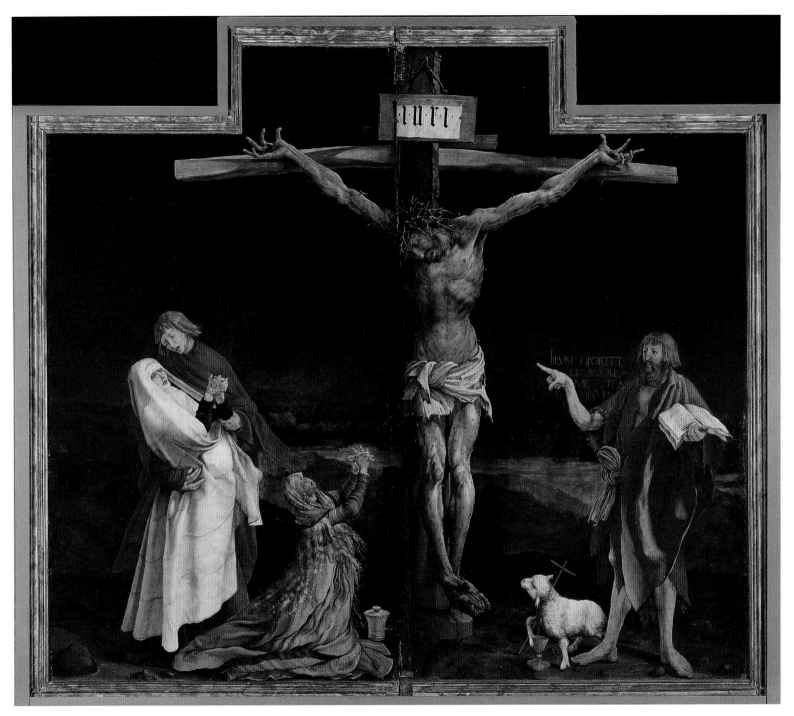

Isenheim Altarpiece: **Crucifixion** (c. 1516), Mattias Grünewald, Unterlinden Museum, Colmar, France

Wow! We're not in medieval Kansas anymore. The darkness parts, and Grünewald shows a more expansive, more colorful, and cheerier world. These inner panels put Christ's seemingly tragic death in the wider context of his blessed birth and radiant resurrection.

In the Annunciation panel (left), a brilliantly dressed angel flutters in to tell a humble Mary she will give birth to a Savior. In the central scene, Mary beams as she looks down on her baby boy, while a celestial band of angels serenades them. Jesus has come down into the world—the real world—as seen by the castle in the background. His joyous mission is to defeat death, just as God the Father is doing in the shower of light.

Though Jesus came to be crucified, he overcame death. And that's what we see in the Resurrection panel on the right. Jesus rockets out of the tomb, as this once-mortal man is now transformed into God.

Grünewald's depiction of this popular Bible scene is unique in art history. Grünewald was a mysterious loner who had no master, no students, and left behind few paintings. But with his genius, he reinvented the Resurrection. Christ—the self-proclaimed "Light of the World"—is radiant. His once-plain burial shroud is now the colors of the rainbow (painted, legend says, by Grünewald's assistant, Roy G. Biv). Jesus has undergone the "resurrection of the flesh," and now look at his skin: His perfect white epidermis would have offered hope to all the patients who meditated on the scene. They had hope that the suffering they now endured was all part of God's grand plan, and a loving God would reward them in the hereafter. Grünewald's happy finale is a psychedelic explosion of Resurrection joy.

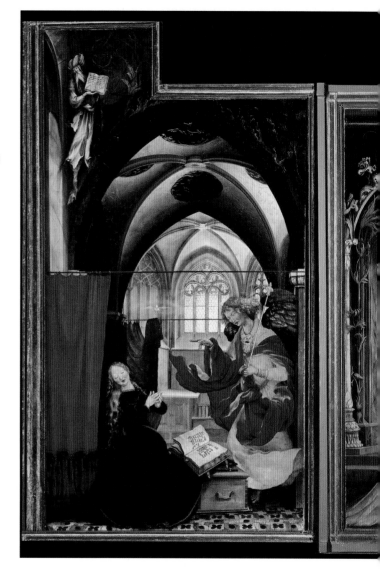

Isenheim Altarpiece: Annunciation, Concert of Angels, Nativity, and Resurrection (c. 1516), Mattias Grünewald

BAROQUE ERA

In the 17th century, Catholics and "divinely ordained" kings preferred the over-the-top art style called Baroque. Churches were draped in gold leaf, marble, mosaic, statues, painting, and stained glass—giving worshippers a glimpse of the heaven that awaited them. Palaces were designed to impress, with glittering ballrooms and vast manicured gardens.

Cultured aristocrats adorned their palaces with colorful paintings. The Baroque style meant drama, bright colors, large canvases, lots of flesh, rippling motion, wild emotions, grand themes . . . and the sure sign of Baroque—pudgy winged babies. Baroque art overwhelms. Ornamentation abounds. Abundance abounds. It plays to the heart, titillates the senses, and carries us away. Some of this stuff—featuring rapes, seductions, and decapitations—is definitely R-rated for nudity and violence.

In contrast, the industrious seafaring country of Holland appreciated a more straightforward style—portraits, landscapes, and slice-of-life scenes that appealed to the pragmatic tastes of upwardly mobile businessmen.

By the 18th century, the center of European culture had shifted north from Italy to France. Louis XIV's breathtaking palace at Versailles inspired palaces by Louis-wannabes everywhere. But while the rich sat idly in their frilly palaces, the world was changing around them, and revolution was in the air.

REMBRANDT'S *NIGHT WATCH*

The Night Watch is Rembrandt's largest and most famous—though not necessarily his greatest—painting. Created in 1642, when he was 36, it came from his most important commission: a group portrait of a company of Amsterdam's Civic Guards to hang in their meeting hall.

It's an action shot. With flags waving and drums beating, the guardsmen spill onto the street from under an arch. It's "all for one and one for all" as they rush to Amsterdam's rescue. The soldiers grab lances and load their muskets. In the center, the commander (in black, with a red sash) strides forward energetically with a hand gesture that seems to say, "What are we waiting for? Let's move out!" His lieutenant focuses on his every order.

Why is *The Night Watch* so famous? Well, it's enormous, covering 170 square feet. The guards are almost life-size, so it seems like they're marching right out of the frame and into our living room.

In its day, *The Night Watch* was completely different from other group portraits. Until then, subjects were seated in an orderly group-shot pose with each face well-lit and flashbulb-perfect. The groups commissioning the work were paying good money to have their mugs preserved for posterity, and it was ego before artistic freedom.

By contrast, Rembrandt got the Civic Guards off their duffs and showed them doing their job—protecting the city. He added less-than-heroic elements that gave it a heightened realism, like the dwarf and the mysterious glowing girl holding a chicken (the guards' symbol). Rembrandt's trademark use of a bright spotlight to highlight the main characters made it all the more dramatic. By adding movement and depth to an otherwise static scene, he took posers and turned them into warriors, and turned a simple portrait into high art.

OK, some *Night Watch* scuttlebutt: First off, the name "Night Watch" is a misnomer. It's actually a daytime scene, but Rembrandt finished his paintings with a preserving varnish. Eventually, as the varnish darkened and layers of dirt built up, the sun set on this painting. During World War II, the painting was rolled up and hidden for safekeeping. Over the years, this stirring painting has both inspired people and deranged them. In 1911, a madman sliced it with a knife, in 1975, another lunatic cut the captain's legs, and in 1990, it was sprayed with acid.

The Night Watch was a smashing success in its day. Rembrandt had captured the exuberant spirit of Holland in the 1600s, when its merchant ships ruled the waves, and Amsterdam was the center of the first global economy. These guardsmen on the move epitomized the proud, independent, and upwardly mobile Dutch. On an epic scale, Rembrandt created the definitive "portrait" of that single generation of people that reinvented the world—the era we call the "Dutch Golden Age."

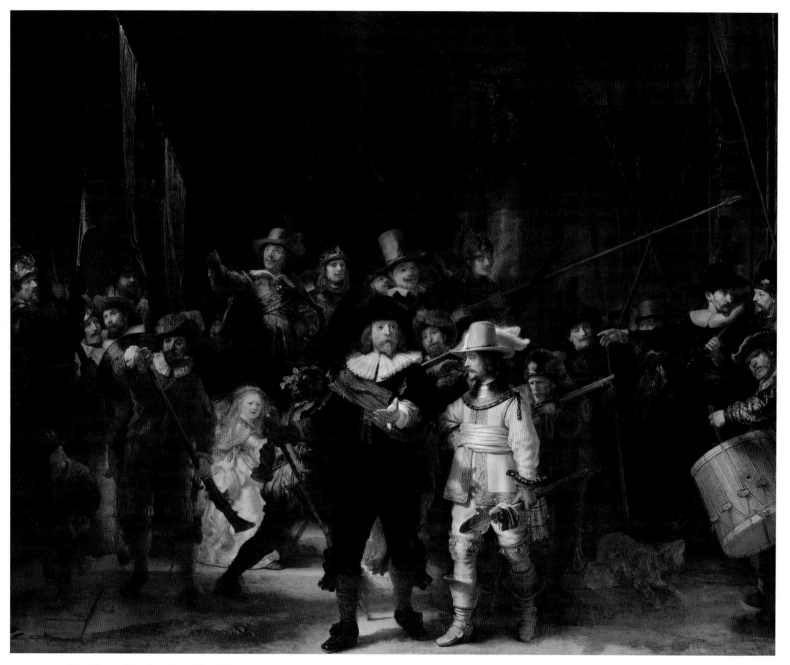

The Night Watch, a.k.a. *The Militia Company of Captain Frans Banninck Cocq* (1642), Rembrandt, Rijksmuseum, Amsterdam

REMBRANDT'S SELF-PORTRAITS

Rembrandt's many self-portraits show us the evolution of a great painter's style, as well as the progress of a genius' life. For Rembrandt, the two were intertwined.

EARLY SELF-PORTRAIT

In an early self-portrait, we see the young, 22-year-old small-town boy who's just arrived in big-city Amsterdam. His blue-collar father insisted he become a lawyer, and his mother hoped he'd be a preacher, but precocious Rembrandt was determined to pursue art. He would end up combining the secular and religious worlds by becoming an artist, showing us the spiritual through the beauty of the created world. This self-portrait shows him as being divided—half in light, half hidden by hair and shadows—open-eyed, but wary of an uncertain future.

THE PRODIGAL SON IN THE BROTHEL

Rembrandt became wealthy by painting portraits of Holland's well-to-do businessmen (including his famous *Night Watch*). He married his beloved Saskia. They moved to an expensive home (today's Rembrandt House Museum) and decorated it with their collection of art and exotic furniture. At the peak of his happy life, he painted himself as the Prodigal Son—laughing it up, toasting with a glass of Heineken, in the company of a woman with the face of Saskia.

Unfortunately, shortly after the *Prodigal Son* was painted, Rembrandt's fortunes changed. His wife died, his children died young, and commissions for paintings dried up as his style veered from the popular style of the day. He had to auction off paintings to pay his debts.

As Rembrandt aged and his fortunes darkened, his self-portraits reflect the changing times. For that, turn the page.

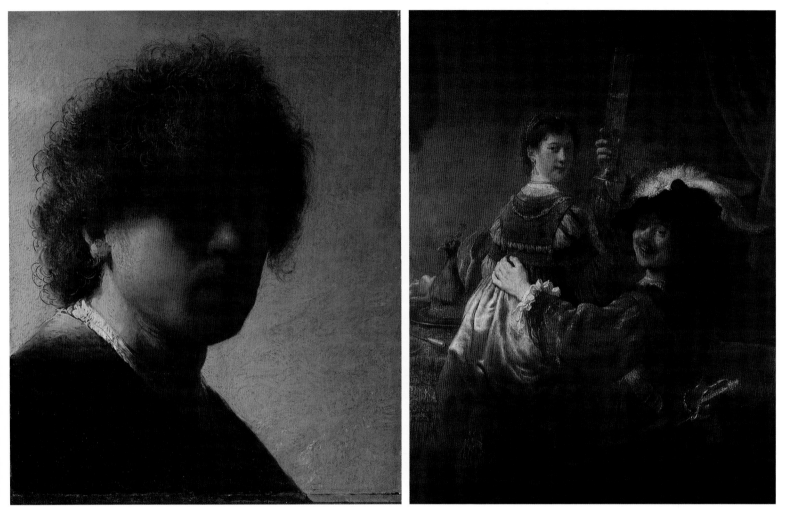

Self-Portrait (1628), Rembrandt, Rijksmuseum, Amsterdam

The Prodigal Son in the Brothel (1637), Rembrandt, Gemaldegalerie Alte Meister, Dresden

LATE SELF-PORTRAIT

The late self-portrait shows a more circumspect man. Rembrandt is in his 50s but he looks 70. He's seen it all—success, love, money, fatherhood, loss, poverty, death. With a lined forehead, a bulbous nose, and messy hair, he peers out from the darkness. In typical Rembrandt style, most of the canvas is a dark, smudgy brown, with only the face lit clearly. His later works were darker in color and in subject, as he explored the "darker" side of human experience.

Though Rembrandt's fortunes faded, he continued to paint masterpieces. He took his bitter experiences and wove them into a wiser type of art. Free from the dictates of patrons, he painted what he wanted, how he wanted it, and if you didn't like it, tough. He turned to personal themes—family members, down-to-earth Bible scenes, and self-portraits like this. He went beyond mere craftsmanship to probe into, and draw life from, the deepest wells of the human soul.

In these last years, Rembrandt's greatest works were his self-portraits, showing a tired, wrinkled man stoically enduring life's misfortunes. His look is . . . skeptical? Weary? Resigned to life's misfortunes? Or amused? As Rembrandt surveyed the wreckage of his independent life, he painted himself as a disillusioned, well-worn, but proud old genius—his own man to the end.

Rembrandt had become wealthy by painting portraits of Holland's rich. He ended his life poor but painting where his artistic spirit led him. His greatest subject? Himself.

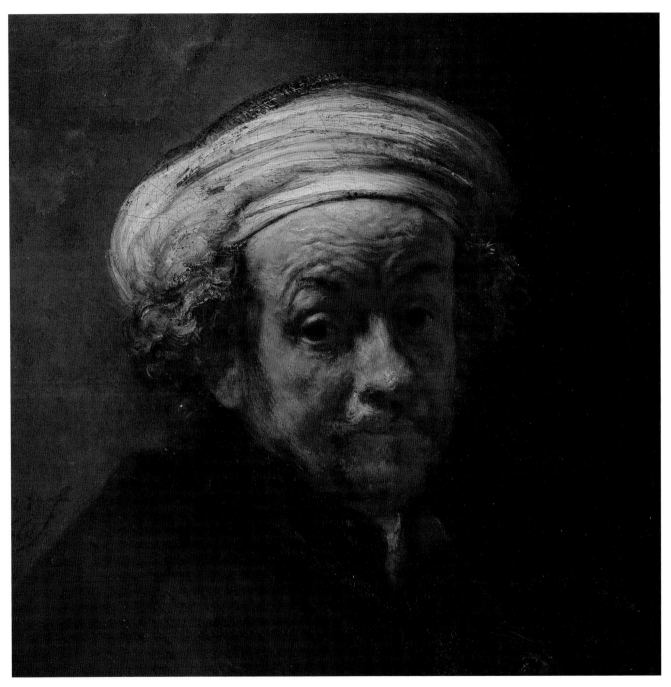

Self-Portrait as the Apostle Paul, detail shown (1661), Rembrandt, Rijksmuseum, Amsterdam

VERMEER'S *KITCHEN MAID*

A maid pours milk from a pitcher into a bowl. She looks down, focused intently, performing this simple task as if it's the most important thing in the world. Vermeer has captured a quiet moment in Holland.

In Vermeer's day, maids were generally portrayed as luscious objects of desire surrounded by mouth-watering foods. Though Vermeer keeps some of that conventional symbolism—cupids in the baseboard tiles, uterine jugs, erotic milk-pouring, and a heat-of-passion foot warmer—the overall effect here is quite the opposite. Rather than a Venus, this is a blue-collar maid, a down-to-earth working girl . . . working. She's broad-shouldered and thick, balanced on a sturdy base. Because of the painting's lines of perspective, we the viewers are literally looking up at her. Vermeer's maid embodies that most-prized of Dutch virtues: the dignity of hard work.

While the painting's subject is ordinary, you could look for hours at the tiny details: the crunchy crust of the loaves of bread, the broken window pane, the shiny brass basket, even the rusty nail in the wall with its tiny shadow.

Vermeer frames off a little world in itself. Then he fills that space with objects for our perusal. Vermeer silences the busy world, so that every sound, every motion is noticed. It's so quiet you can practically hear the thick milk hitting the bowl. You can feel the rough crust of the bread, the raised seams of her blouse, and the thick material of her apron.

Vermeer (1632–1675), from the picturesque town of Delft, was only 25 when he painted this, but it set the tone for his signature style: interiors of Dutch homes, where Dutch women engage in everyday activities, side-lit by a window. While Vermeer's Baroque contemporaries painted Greek gods and idealized Madonnas, he specialized in the daily actions of regular people.

Like many Vermeer paintings, there's an element of quiet mystery. Is the faint smile of this "Dutch *Mona Lisa*" happy or sad? The portrayal subtly implies a more complicated story than we'll ever know.

Vermeer was a master of light. His luminous paintings radiate with a diffuse lighting, with minimal shadows. He makes simple objects glow. He could capture reflected light with an artistry that would make the Impressionists jealous two centuries later.

Vermeer presses the pause button on daily life and gives us the time to really see it. He invites you to slow down, probe deep into the canvas, and immerse yourself in his world. Through Vermeer, we can learn to appreciate the beauty of everyday things.

In all, only 37 Vermeer paintings survive each is a small jewel worth lingering over.

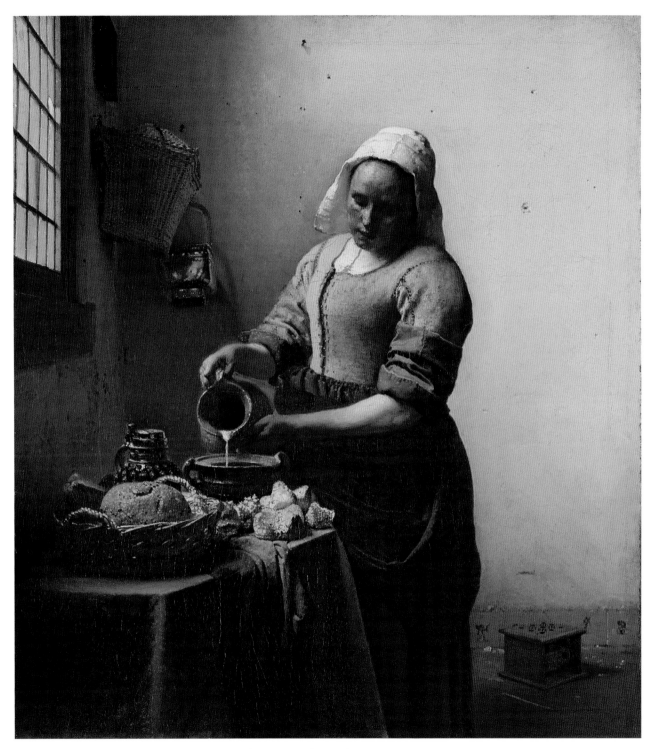

Kitchen Maid (c. 1658), Johannes Vermeer, Rijksmuseum, Amsterdam

BERNINI'S *APOLLO AND DAPHNE*

In a palace in Rome's leafy Borghese Gardens stands this dramatic statue, displayed in the very room Bernini sculpted it for. When you visit the Borghese Gallery in person, the statue reveals itself exactly as Bernini intended.

Daphne's fingers sprout leaves.

Starting from behind, you see only a man's backside. But as you begin circling around the side, you realize it's the god Apollo, running at full speed, his cloak whipping behind him. He's chasing after a beautiful woman, the nymph Daphne. Apollo is starry-eyed, having been struck by Cupid's arrow, making him crazy in love with Daphne. But Daphne's running away, horrified. Apollo is catching up—he reaches out to grab her by the hip. Desperate, Daphne calls out to her father, a river god, to save her.

It's only when you circle around to the front that Bernini reveals the story's surprise ending. Magically, Daphne is saved from Apollo's embrace by turning into a tree. In good Baroque fashion, Bernini captures the dramatic split second when the terrified nymph's fingers begin to sprout leaves, her toes become roots, and Apollo is in for one rude surprise.

This striking statue by the twenty-something Bernini was a tour de force of sculpting. He was a master of marble, carving supple flesh out of hard stone: you can see Daphne's love handles, and Apollo's fingers press in as if it were real skin. Bernini used only the finest Carrara marble—renowned for its softness and creamy, ivory hue. Bernini chipped away to reveal the most delicate of features—the statue is almost more air than stone. Apollo's back leg defies gravity. The exquisitely carved marble leaves at the top ring like crystal when struck.

The statue is just one of a handful of works Bernini did for the luxury-loving cardinal who owned the Villa Borghese. This palace-in-a-garden was a showcase for his fine art while wining and dining the VIPs of his age. It was a multimedia, multi-era extravaganza of great art: Baroque frescoes on the ceiling, Greek statues lining the walls, Roman mosaics on the floor . . . and Bernini's statues in the center.

With his chisel, young Bernini—who virtually invented the Baroque style—was establishing some of its early features: He makes this supernatural event seem realistic. He captures the scene at its most dramatic, emotional moment. The figures move and twist in unusual poses. Apollo's cape billows behind him. It's not just a statue you stand and look at. It's interactive—you have to walk around it to fully experience it. With *Apollo and Daphne*, Bernini turned a static sculpture into a charged scene—a piece of theater-in-the-round.

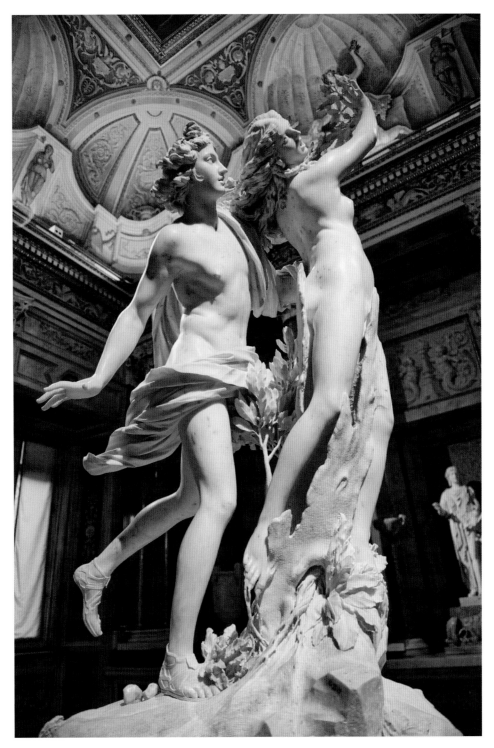

Apollo and Daphne (1625), Bernini, Borghese Gallery, Rome

VELÁZQUEZ'S *LAS MENINAS*

Diego Velázquez spent 30 years painting formal portraits of the Spanish king. Then, deciding to switch things up, he painted his most famous and greatest painting. Instead of showing the king, *Las Meninas* captures the behind-the-scenes action as the king's portrait is being painted.

Velázquez stands at his easel, flicks his Dalí moustache, raises his brush, and looks directly out toward the people he's painting—the king and queen. They'd be standing right where the viewer stands. In fact, you can even see the royal couple reflected in the mirror on the back wall. We're seeing what the king and queen would have seen: their little blonde-haired daughter Margarita and her "maids," or *meninas,* who've gathered to watch the sitting.

Velázquez (1599–1660) was a master of candid snapshots. Trained in the unflinching realism of his hometown of Seville, he'd made his name painting wrinkled old men and grimy workers in blue-collar bars.

Here, he catches the maids in an unguarded moment. Margarita is eyeing her parents, while a maid kneels to offer her a drink and another curtsies. To the right is one of the court dwarves, and a little boy playfully pokes the family dog. Just at that moment, in the background, a man pauses at a doorway to look in on the scene. The moment is frozen, but you can easily imagine what these people were doing 30 seconds before or 30 seconds later.

This seemingly simple painting was revolutionary in many ways. Velázquez enjoyed capturing light, and capturing the moment, just as the Impressionists would two centuries later. Also, if you look close, you'll see that the girls' seemingly detailed dresses are nothing but a few messy splotches of paint—the proto-Impressionist use of paints that Velázquez helped pioneer.

Velázquez creates a kind of 3-D dollhouse world and induces you to step inside. The figures are almost life-size, and the frame extends the viewer's reality. The eye unconsciously follows the receding lines of the wall on the right to the far wall, and the painting's vanishing point—the lighted doorway. The painting's world stretches from there all the way back to the imaginary space where the king and queen (and the viewer) would be standing. And you are part of the scene, seemingly able to walk around, behind, and among the characters. Considered by many to be the greatest painting ever, this is art come to life.

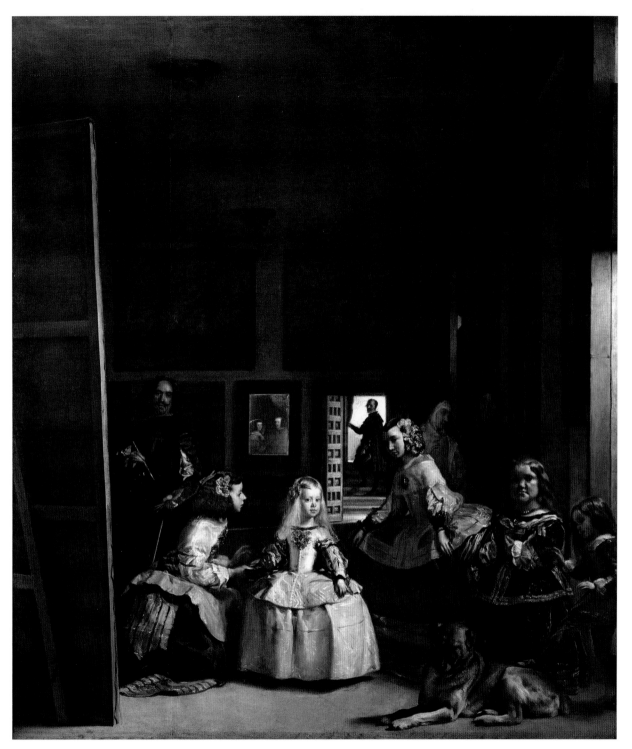

Las Meninas (c. 1656), Velázquez, Prado Museum, Madrid

WIESKIRCHE, BAVARIA'S ROCOCO CHURCH

Germany's greatest Rococo-style church, this "Church in the Meadow" looks as brilliant now as the day it floated down from heaven. It's a divine droplet, a curly curlicue, as overripe with decoration as this sentence, but—bright and bursting with beauty—it's an exquisite example of the final flowering of the Baroque movement.

The church was constructed around a crude wooden statue of Christ being whipped. No sooner was the statue made (1738) than it miraculously began to shed tears. Amazed pilgrims came from all around. They, too, wept and were miraculously healed. The statue became a celebrity, pilgrims donated lots of money, and two of Bavaria's top Rococo architects (the Zimmermann brothers) were hired to give the statue a proper home.

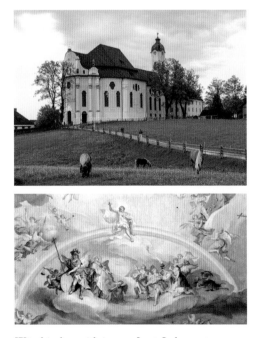

As the church's name suggests, the Wieskirche stands literally in a meadow in the middle of the Bavarian countryside. You approach up a pathway, walking through fertile fields where cows graze peacefully and the scent of cut hay, fresh cow pies, and an alpine breeze saturates the air the way the Holy Spirit permeates the created world.

Stepping inside the small church, you're greeted with curvaceous decor that looks like it came out of a heavenly spray can. The walls are whitewashed, and clear windows flood the church with light. Surrounded by a riot of colorful columns, golden pulpits, an over-the-top altarpiece, and a frescoed ceiling that seems to open up to the sky, your eyes hardly know where to rest.

The Wieskirche's ornate style, called Rococo, is like Baroque that got shrunk in the wash—lighter, frillier, and more delicate, with whitewash and pastel colors. Where Baroque uses oval shapes, Rococo twists it even further into curvy cartouches.

The altar is a theological sermon that's all about Christ's sacrifice. It starts with his birth, moves on to his arrest and torture, and finishes with a symbol of his gruesome death: a golden sacrificial lamb.

But that's not the end of the story. The visual sermon concludes with the massive ceiling painting. There, overseeing it all, is Jesus Christ—now resurrected—riding on a rainbow, with a smile on his face. It's the most positive Last Judgment around. Jesus comes in like a friend, giving any sinner the feeling that there's still time to repent, with plenty of mercy on hand.

At the Wieskirche, all of the decoration—statues, paintings, columns, gold, colorful marble, light through the windows, and the dreamy pastoral setting—come together. Having entered the church through a meadow (representing the glories of creation), you stand inside a slice of artistic paradise. Above, the ceiling painting seems to blow open the roof, allowing you a glimpse of the celestial world beyond. For the pilgrim, the Wieskirche becomes a spiritual axis connecting both heaven and earth.

Wieskirche, with joyous Last Judgment

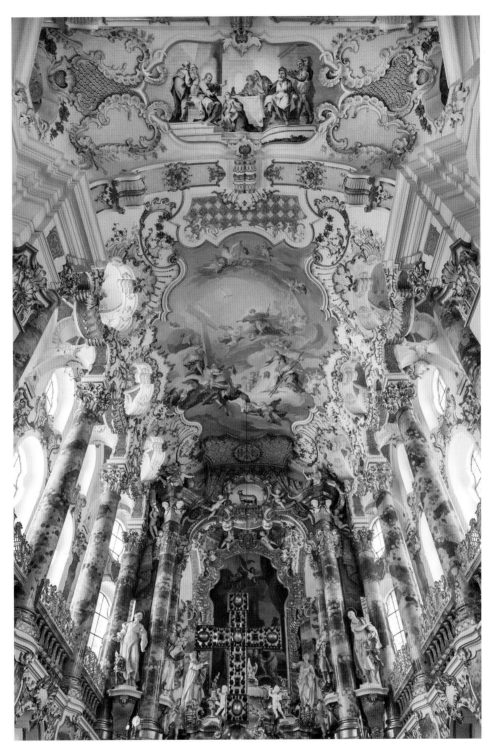

Wieskirche (late 1740s), J.B. and Dominikus Zimmermann, Bavaria, Germany

MURILLO'S *IMMACULATE CONCEPTION*

Mary appears as the teenage virgin who miraculously gave birth to the Son of God. She poses demurely, folds her hands in prayer, and gazes rapturously to heaven, her body flickering like a candle. She's dressed in luxuriant robes with her traditional colors—the white dress of purity and deep blue cloak of divinity.

With this painting, Murillo put a human face on an abstract Catholic doctrine called the Immaculate Conception. That was the idea that Mary—the pure vessel who bore Christ—was herself conceived and born free of the taint of original sin. It was a holy pregnancy with no penis, no penetration, and no orgasm. Murillo's "immaculate" virgin floats in a cloud of Ivory Soap cleanliness, radiating youth and wholesome goodness.

For centuries, the idea of the Immaculate Conception had grown in popularity, especially in Murillo's native Spain. Priests preached about Mary's goodness, poets rhapsodized over her, and everyday people prayed to Mary for help. Murillo painted nearly two dozen versions of Immaculate Conceptions. Finally, in 1661, the pope officially recognized the Immaculate Conception as dogma. Murillo set to work celebrating it with this triumphant, nearly life-size painting.

Mary seems to be floating up, her cloak rippling in the wind, borne aloft by pudgy winged babies as she rises to heaven to be received in glory. She's bathed in a cloud of radiant light, or as the Bible put it: "a woman clothed with the sun" (Rev 12:1). Previous Immaculate Conceptions had always used a stiff formula: Mary had to be a 12-year-old girl, wearing a diadem of stars, standing atop the globe of the earth, and so on. Murillo included a few such obligatory symbols: the crescent moon under her feet, the cherub's lilies representing purity, and so on. But mostly he does away with symbols and gives us a flesh-and-blood woman whose sheer grace and beauty embody the notion of purity and virtue.

Murillo was the son of a barber of Seville, at a time when the city was the wealthy gateway to the New World, and artists thrived. Murillo soaked up the photo-realism of Italian art, but added a spoonful of sugar. His sweet, sentimental, soft-focus style was perfect for the times. Europe was bitterly divided between Catholics and Protestants. Murillo's religious paintings helped make hard-to-understand Catholic doctrine accessible to the masses. Gazing on this fresh-faced Immaculate Conception, worshippers could see before their very eyes the gentle, loving Mary they'd always pictured in their minds.

Murillo's sweet naturalism was understandably popular. His depiction of Mary inspired countless artists who followed. Soon altarpieces throughout the Catholic world featured Marías like Murillo's—always receptive and ready to help. And, today, when Catholic Christians think "Immaculate Conception," this is the image that comes to mind.

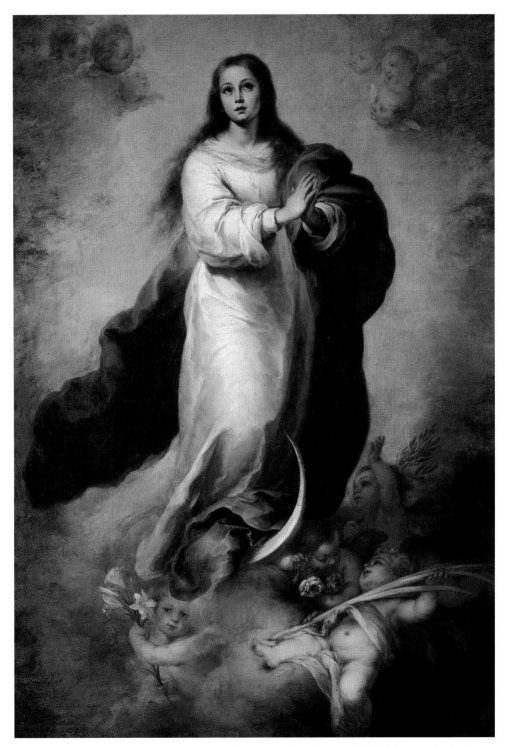

Immaculate Conception of El Escorial (c. 1665), Bartolomé Murillo, Prado Museum, Madrid

SAMMARTINO'S *VEILED CHRIST*

As you approach the altar of a small, ornate church in Naples, you run right into a dead body on a slab covered by a sheet. Getting closer, you see that the feet have nail holes in them: It's Jesus Christ. He's been crucified, and the tools of his torture—the nails and crown of thorns—lie at his side. Now he's been taken down from the cross and covered in a wispy shroud, ready for burial.

The detail work is astounding. Christ almost seems still alive. His body lies on a stone mattress, atop a gray marble bed. His head rests on two tasseled pillows.

From every angle, the statue reveals new details: Christ's left hand resting oh-so-naturally on his thigh, the delicate raised veins, the lacy fringe on the shroud. As you get closer to Jesus' face, his expression seems to change, from a look of suffering to one of peace. Circling behind, you can actually see the impression Christ's head makes in the pillow.

The most wondrous element is the shroud, or veil. It seems transparent. It's so supple, it molds itself around every part of Jesus' body, revealing every curve. You can even "look through" the veil and make out the wound in Jesus' side. The illusion of softness is startling, though it's all carved out of marble, one of the world's hardest stones.

The statue was done by the relatively obscure sculptor Giuseppe Sammartino in 1753. It's said he completed it in an astonishing 100 days. Much of the detail is too fine for even the most delicate chisel, so a lot was done in the hard work of polishing.

This uncanny *Veiled Christ* has another layer of mystery: It was part of secret initiation rituals held in this tiny church in the back streets of Naples. The prince who commissioned the statue, Raimondo di Sangro, was a member of the Freemasons. Though today's Masons are a harmless fraternal organization, back in the 1700s they had a reputation for secret pagan rituals that bordered on heresy. Raimondo boldly used the chapel as a Masonic temple. He filled it with Masonic symbolism: a Masonic triangle in the ceiling painting, a labyrinth-of-deception on the floor, and various statues symbolizing the Masonic philosophy of freedom through enlightenment.

The *Veiled Christ* was the key. Though Christ was dead and shrouded, he would eventually be resurrected. Similarly, though we mortals are shrouded in ignorance, through Masonry we can rise up, shed the veil, and reach enlightenment.

Unfortunately, Masonic imagery like the *Veiled Christ* doomed Raimondo. This highly educated man was painted as a modern Faust, who sold his soul to the devil for secret knowledge. People whispered that the *Veiled Christ*'s veil was actually made by Raimondo himself, who draped the statue with a real veil, then magically alchemized it into stone. The Church banned Raimondo's writings, he was excommunicated, forced to recant, and had to live his final days under house arrest. But his legacy of knowledge—and the remarkable *Veiled Christ*—live on, inspiring seekers and travelers alike.

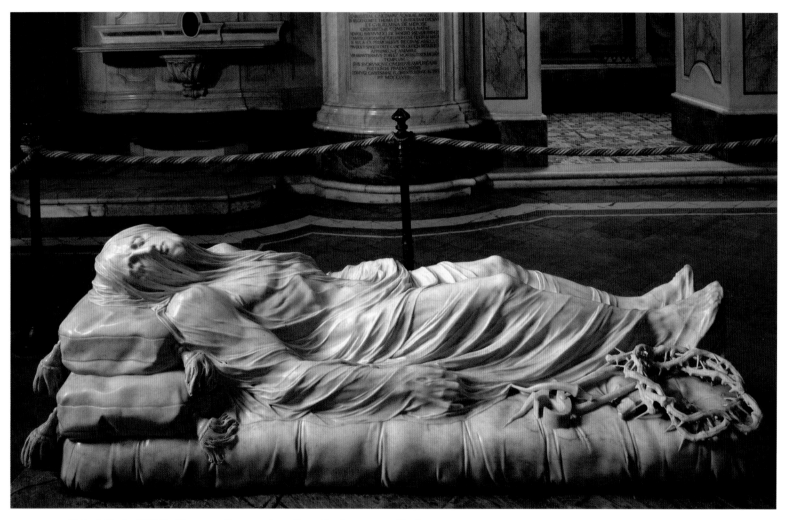

Veiled Christ (1753), Giuseppe Sammartino, Cappella Sansevero, Naples

CANALETTO'S *VIEW OF ST. MARK'S SQUARE*

Anyone who's ever visited Venice would recognize this scene: the soaring Campanile bell tower, the curious facade of St. Mark's Basilica, and the vast people-gathering expanse of St. Mark's Square. This particular view was painted in 1735, and little has changed since then. There are the same statue-topped columns, the same bronze horses on the church, and the same guy selling a dozen postcards for a dollar.

Canaletto specialized in painting scenes like this of his beloved hometown, and sold them to tourists as a souvenir "postcard" to remember their trip. Canaletto painted all the sights—the Doge's Palace, gondolas on the Grand Canal, the Rialto Bridge—plus slice-of-life scenes.

Back in the 1700s, Venice was a prime destination, especially for British tourists, on what was called the Grand Tour. Wealthy twenty-somethings completed their university education by traveling through Europe to soak up the art and culture. In Paris, they'd see Notre-Dame and take French, while in Rome they toured the Pantheon and Colosseum while networking with fellow nobles. Venice was always a highlight, not for its artifacts but for the city itself. It was the epitome of exotic Italian-ness—exuberant people, dark-eyed women, and decadent nightlife. How better to explain Venice to the folks back home than a photorealistic painting of a classic Venice moment?

In Canaletto's "postcard," it's evening on St. Mark's Square, and the setting sun is casting very long shadows. People from every walk of life stroll through—men in capes and three-cornered hats, ladies in headscarves, workers hefting baskets, and a boy and his dog. Canaletto captures it all with photographic clarity, allowing the viewer's eye to roam from detail to exquisite detail. Even the crystal-clear atmosphere seems to radiate light. Canaletto could capture the majestic spectacle of everyday Venetian life like no one else.

Canaletto painted by setting up his easel outdoors to sketch directly from nature—standard practice now, but considered a very odd thing in his day, when artists composed their scenes in the studio. But Canaletto wanted to accurately capture the moment, the light, and the colors—all things the Impressionists did a century later.

On the other hand, this wide-angle view with everything in perfect focus is a bit more than any human eye could actually take in at one glance. Canaletto, who meticulously studied the mathematics of perspective, was not above tweaking those rules to compress more of Venice into the frame.

One of the Grand Tour-ists who stopped in Venice was a British noble who ended up buying this painting— Sir John Soane. As an architect, Soane loved Canaletto's precise architectural-draftsman style. Soane went on to plaster classical Italian columns and arches (like those seen in this painting) onto the Neoclassical buildings he built back home, like the Bank of England. Canaletto's painting ended up in Soane's London townhouse, where he showed it off to his sophisticated circle of friends. Today, Soane's house is a quirky museum, chock-full of eclectic knickknacks: Roman busts, sarcophagi, coins, manuscripts, old books . . . souvenirs from his Grand Tour. And from Venice—this rich-man's postcard.

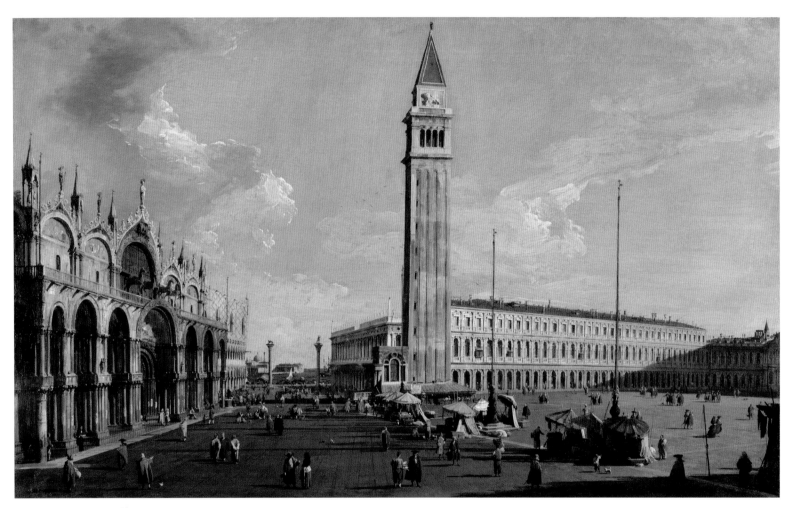

Piazza di San Marco (1735), Canaletto, Sir John Soane's Museum, London

RUBENS' *RAPE OF THE DAUGHTERS OF LEUCIPPUS*

The legendary twins Castor and Pollux ride in on their horses, crash a wedding, and steal the brides as their own. Limbs flail, horses rear, clothes are torn, hair gets mussed, and capes flutter in the wind. It's a knot of rippling flesh and passionate emotions, a violent orgy-in-the-making. In fact, this Greek myth tells not so much of a "rape" but an abduction, as the love-besotted brothers carry off the scared sisters to wed them.

Peter Paul Rubens painted anything that would raise your pulse: battles, miracles, hunts, rapes. His work runs the gamut, from Greek myths to Catholic altarpieces, realistic portraits to lounging nudes, from pious devotion to rough sex. This *Rape* has many of Rubens' distinctive elements—fleshy, dramatic, bright colors, and a classical subject. It's a freeze-frame of an action-packed moment. Rubens turns the wind machine on high, and the scene throbs with motion, billowing clouds, and steroid-juiced muscles. It's powered with an energy that people called his "fury of the brush."

Rubens' specialty was fleshy, rosy-cheeked women. These sisters' pale flesh stands out against the dark-skinned men that frame them. Rubens loved cellulite. His fascination with plus-size models and pink folds of fat give us the term "Rubensesque."

Amid all the chaos, this turbulent pig-pile of figures is all held together by a subtle X-shaped composition. The main diagonal is the women's bodies—slanting from lower left to upper right. The other diagonal starts at lower right, running up the sister's arm to Castor's face upper left and out his rippling cloak. Follow their gazes: Pollux looks lovingly down at his blonde bride-to-be, who pleads for mercy from a totally focused Castor, while the other sister twists upward, desperately looking for a way out. Like the weaving counterpoint in a Baroque fugue, Rubens balances opposites.

In his long career, Rubens was famous, wealthy, and well-traveled—a diplomat, man about town, and friend of kings and princes. He was a shrewd businessman who knew how to provide wealthy benefactors with exactly what they wanted. Rubens brought the artistic gusto of the Baroque era to great churches, palaces, and mansions throughout Europe. How can we be sure this painting is Baroque? Give it the PWB test. There it is, peeking out on the left . . . a pudgy winged baby.

In his lifetime, Rubens produced over a thousand paintings, many of them twice as big as this fully life-size work. How did he do it? He didn't. His painting studio in Antwerp (Belgium) was a virtual art factory, where the master mass-produced masterpieces. For many paintings, Rubens would do a rough, small-scale sketch. Then he'd enlist his team of experts in certain areas (horses, capes, faces, braided hair) to reproduce it on a larger scale. Rubens orchestrated the production from the studio balcony, and before a painting was carried out, he would put on the finishing touches, whipping each figure to life with a flick here and a flick there . . . his "fury of the brush."

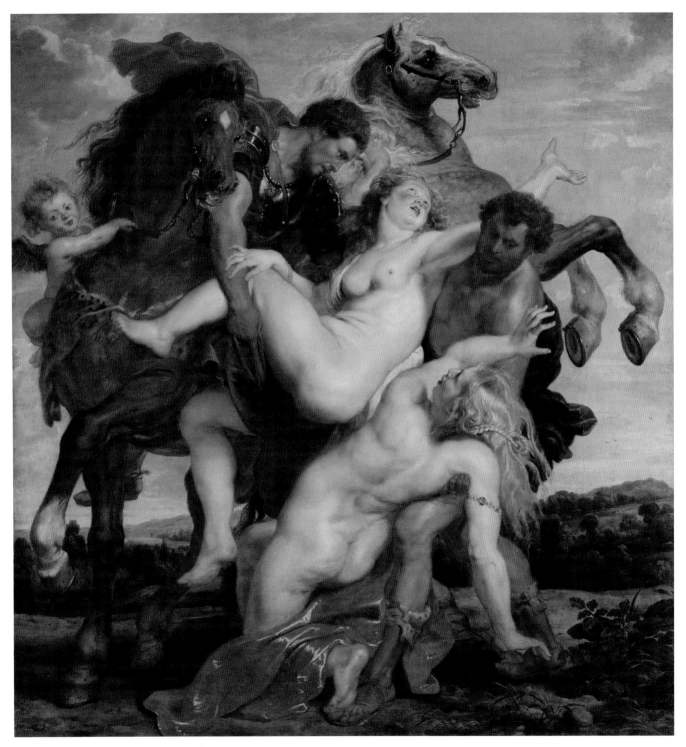

The Rape of the Daughters of Leucippus (1618), Rubens, Alte Pinakothek, Munich

ST. PETER'S BASILICA

St. Peter's Basilica is the greatest church in Christendom—the sacred head-quarters of a billion Roman Catholics. Built on the memory and grave of the first pope, St. Peter, this is where the grandeur of ancient Rome became the grandeur of Christianity.

The monumental obelisk in the square in front is a testament to the church's nearly 2,000-year history. In ancient Roman times, the obelisk stood watch over a chariot racecourse here. For halftime entertainment, the Romans killed Christians, including (around AD 65) Peter, Jesus' right-hand man. He was buried on the adjacent hill. When Christianity was finally legalized, early in the fourth century, a grand church was built on the site of Peter's martyrdom and grave. This earlier church, now known as "Old" St. Peter's, lasted until 1500, when the current structure was built.

The new church was huge—often called the largest in the world. Stepping inside is one of Europe's true "wow" experiences. The atrium alone is bigger than most churches. The nave stretches seemingly to heaven. The golden window at the far end is two football fields away. The church's footprint stomps out six acres. Plaques in the floor show where the next-biggest churches—humble chapels like St. Paul's in London and the Duomo in Florence—would fit if put inside St. Peter's.

The best way to enjoy this awe-inspiring church is to see St. Peter's Basilica on its terms. Enter as a Roman Catholic—even if only a temporary one for your visit. (Lutherans, park your Protestant swords at the door.) Standing before the tomb of St. Peter, look up and behold the Latin inscription ringing the base of the dome. In six-foot-tall letters, it's the quote from Jesus in the Bible which establishes the primacy of Peter, the first pope, and the legitimacy of the Roman Catholic Church and the more than 200 popes since Peter: "*Tu es Petrus* . . . You are Peter, and upon this rock I will build my Church."

(continued)

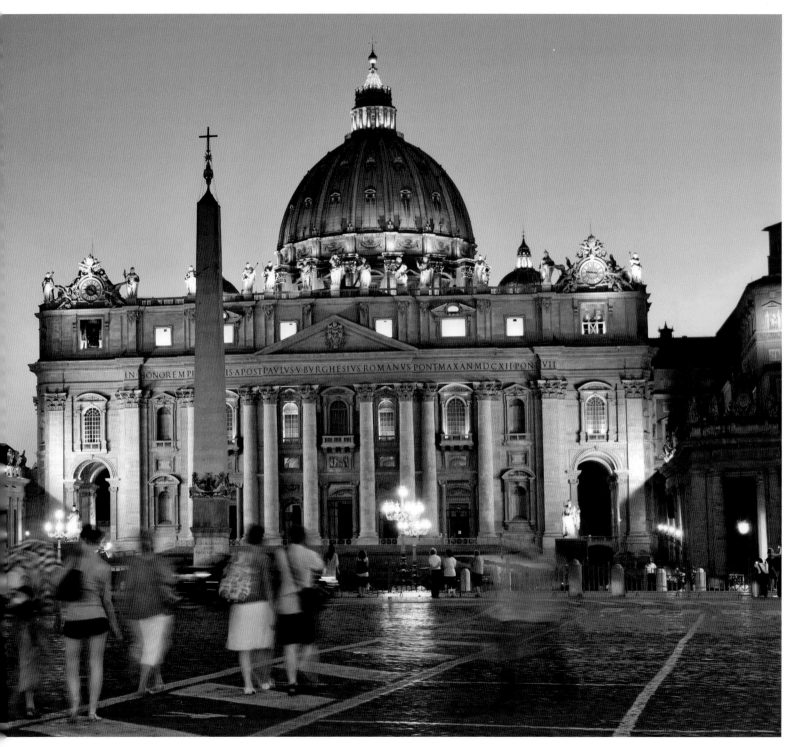

St. Peter's Basilica (1506–1667), Vatican City, Rome

The vast nave of St. Peter's Basilica, with adult-size baby statues

The interior dazzles. It's a riot of marble, gold, stucco, mosaics, columns of stone, and pillars of light. It's considered the epitome of Baroque—an ornate, mixed-media ensemble designed to fill the viewer with awe. It offered a glimpse of the heaven that awaited the faithful.

Standing before the altar, appreciate the opulence. A seven-story bronze canopy towers overhead. You're surrounded by twice-life-size statues, tombs of beloved popes, and ornate golden altarpieces. Soaring above it all is Michelangelo's 430-foot-tall dome. And under the dome, under the bronze canopy, under the altar, and 23 feet below the church's floor lies the reason this church was built—Peter's tomb.

St. Peter's today is a living church, not a museum. Mass is said daily. Pilgrims, tourists, and Roman citizens alike come here to renew their faith. Standing under Michelangelo's dome—surrounded by centuries-old statues, tombs of popes, and reminders of Peter—you really sense the continuity of the 2,000-year history.

A good way to end your visit is to hike to the top of the church—atop Michelangelo's dome. There, you can look out over all Rome, survey the Vatican grounds, and gaze down into the square at the teeny-tiny pilgrims—buzzing like electrons around this nucleus of Catholicism.

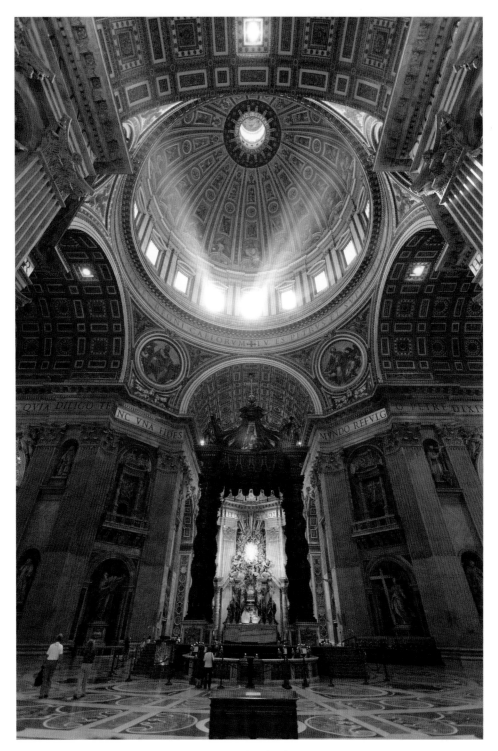

Peter's Tomb lies below the bronze canopy under the dome.

CARAVAGGIO'S *DAVID WITH THE HEAD OF GOLIATH*

In Caravaggio's take on this familiar Bible story, David the shepherd boy has killed the giant Goliath with a rock and decapitated him with a sword. Now David holds the dripping head out at arm's length, sticking it right in the viewer's face.

Like David, the artist Caravaggio loved to shove startling images in the public's face. While most artists amplified the world's prettiness, Caravaggio painted its grittiness. Here he chronicles every gruesome detail: the dripping blood, rotting teeth, bloody wound in the forehead, and Goliath's final expression of despair (or is it surprise?) frozen in death. David dangles the head by the hair and watches the life drain away. David's expression is complex. He's not gloating over his triumph, but detached, like he didn't want to kill the poor bastard, but he had to—an executioner dispensing justice.

What exactly is David thinking? Well, Caravaggio knew. He knew exactly how it felt to have just killed someone, because he had recently murdered a man with a sword. Even as he painted this, he was running from the law.

Caravaggio's life, like his art, was dark and dramatic. By his twenties, he was rich and famous for his startling talent and innovations. But he lived a reckless, rock-star existence—hanging out in dive bars, trashing hotel rooms, and picking fights. He used the low-life people he knew as models for his paintings, turning blue-collar workers into saints and prostitutes into Madonnas. Here, David is no heroic Renaissance man like Michelangelo's famous statue—he looks like a teenage runaway in a dirty shirt.

Caravaggio's specialty was stark lighting—creating a film-noir world of harsh light and deep shadows. This painting is bled of color, virtually a black-and-white crime-scene photo. Caravaggio shines the spotlight on just the details he wants to highlight: David's skinny torso and cheek, and the giant's horrified face.

The severed head of Goliath is none other than Caravaggio himself—an in-your-face self-portrait. That's led scholars to see a lot of Caravaggio's personal life in this painting. Some say David is also a portrait—of Caravaggio's young lover, symbolizing how the young man has conquered him in love, leaving him literally smitten. Others say David is another self-portrait of Caravaggio, this time in his youth—in which case, David would be the artist's youthful self reflecting on the ugly brute he'd become.

Caravaggio spent his final years wanted on murder charges. During that time, he forged a new direction in art. With his heightened realism, strong emotions, uncompromising details, and dramatic lighting, he set the tone for a new style: Baroque.

This painting—perhaps Caravaggio's last—was a gift sent to the authorities along with a request that they pardon him. He portrays himself as Goliath, a message of his own self-disgust and contrition. Caravaggio was eventually pardoned, but he died shortly afterwards—appropriately, from a stab wound. Though only 38, in his short life he'd rocked the world of art—as his paintings continue to do to this day.

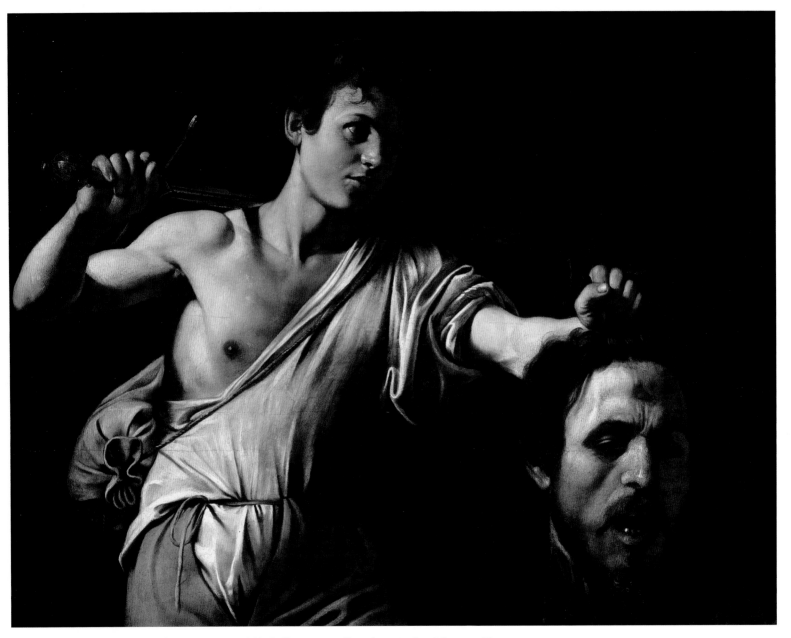

David with the Head of Goliath (c. 1607), Caravaggio, Kunsthistorisches Museum, Vienna

PALACE OF VERSAILLES

Around the year 1700, France was Europe's number-one power, and the luxurious Palace of Versailles was Europe's cultural heartbeat. For the king, money was no object and he packed it with beauty.

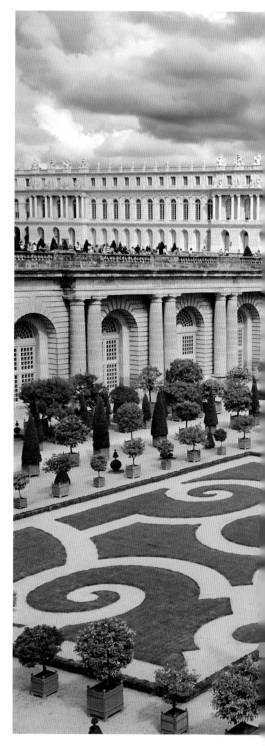

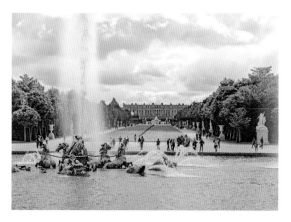

Apollo Basin

Visitors from around Europe flocked here hoping to get a glimpse of the almost-legendary king who built the palace—the great Louis XIV, known to all as the Sun King (ruled 1643–1715). They'd pass through a series of rooms, each more glorious than the last. There was the ornate Apollo Room, where the Sun King held court beneath a colorful ceiling painting depicting his divine alter-ego, the Greek god of the sun. They'd pass through the king's official (though not actual) bedroom, where, each morning, the Sun King "rose" ceremonially from a canopied bed, attended by nobles who fought over who got to hold the candle while he slipped out of his royal jammies. Here in the home of the Sun King, bedtime, wake-up, and meals were all public rituals.

(continued)

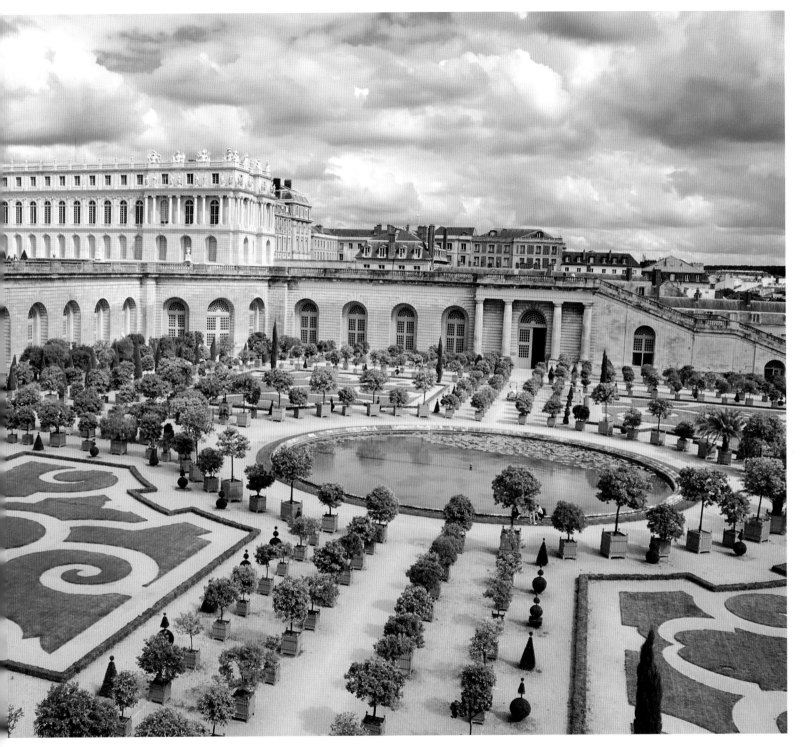

Palace of Versailles (official royal residence 1682–1789), Versailles

Finally, visitors would reach the heart of the palace: the Hall of Mirrors. No one had ever seen anything like this magnificent ballroom. It's nearly 250 feet long, dripping with glittering chandeliers, lined with gilded candelabras and classical statues, and topped with a painted ceiling showing Louis doing what he did best—triumphing. What everyone wrote home about were the 17 arched mirrors along the wall. Mirrors were a wildly expensive luxury at the time, and the number and size of these were astounding.

The sparkling Hall of Mirrors marks the center of this magnificent U-shaped palace. It's where the king's sumptuous apartments connected to the queen's equally sumptuous wing.

From the Hall of Mirrors, you can fully appreciate the epic scale of Versailles. Visitors gaze out the windows onto the palace's vast backyard. The gardens stretch, it seems, forever. It's a wonderland of trimmed hedges and cone-shaped trees, hidden pleasure groves, and hundreds of spurting fountains. The extravagant gardens drove home the palace's propaganda message: The Sun King was divine—he could even control nature, like a god. All in all, Versailles covers about 2,000 acres—twice the size of New York's Central Park—laid out along an eight-mile axis, with the Hall of Mirrors at its heart.

The Hall of Mirrors was also the heart of European culture. Imagine a party here: The venue is lit by the flames of thousands of candles, reflected in the mirrors. Elegant partygoers are decked out in silks, wigs, rouge, lipstick, and fake moles (and that's just the men), as they dance to the strains of a string quartet. Waiters glide by with silver trays of hors d'oeuvres, liqueurs, and newly introduced stimulants like chocolate and coffee. Louis was a gracious host who might sneak you into his private study to show off his jewels, medals, or . . . the *Mona Lisa,* which hung on his wall.

In succeeding generations, all Europe continued to revolve around Versailles. Everyone learned French, and adopted French taste in clothing, hairstyles, table manners, theater, music, art, and kissing. Even today, if you've ever wondered why your American passport has French writing on it, you'll find the answer at Europe's greatest palace—the Château de Versailles.

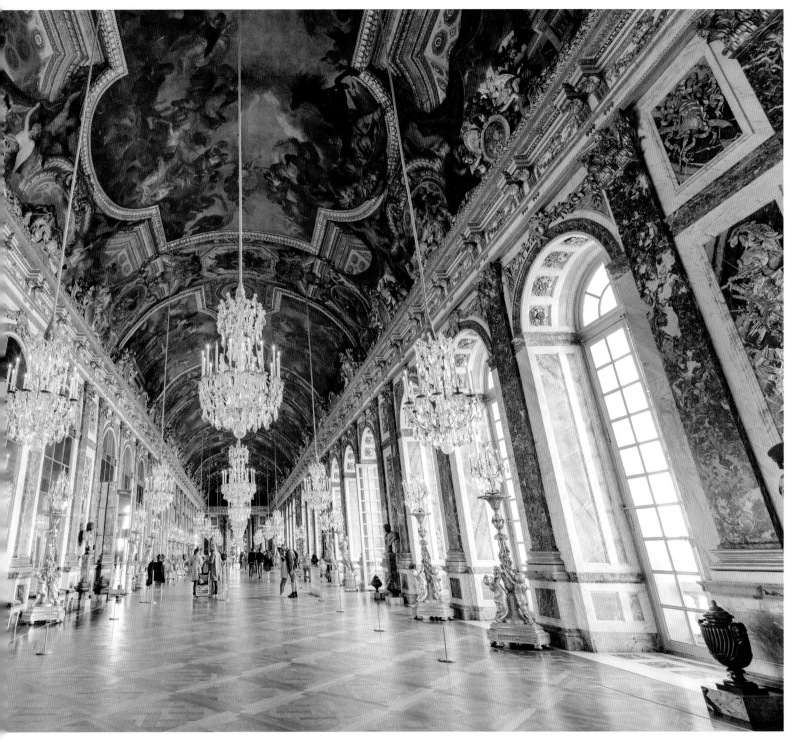

Versailles' Hall of Mirrors

RIGAUD'S *LOUIS XIV*

The official portrait of the King of France shows a 63-year-old man at the peak of his power. He wears the coronation robe—a luxuriant blue, white, and gold garment—and stands amid the royal regalia: the red-canopied throne, the crown, and the sword of Charlemagne on his hip. This is the ultimate image of a divine-right ruler—a king who could rule unchecked by the laws of man, and whose authority came directly from God.

It's the year 1701, when France was Europe's most powerful country. Louis' lavish palace of Versailles trumpets his divine power. Louis is the "Sun King," tracing his divine authority back even to the classical god Apollo. He's Europe's king of kings, the absolute example of an absolute monarch. Louis summed it up best himself with his famous rhyme, *"L'état, c'est moi!"* (lay-tah say mwah): "The state, that's me!"

Rigaud captures all the splendor, but he also gives a peek at the flesh-and-blood man beneath the royal robe. Louis, striking a jaunty pose, turns out to meet the viewer's gaze. He puts one hand on his hip and balances the other nonchalantly atop his cane—oh wait, that's actually the royal scepter, which he's playfully turned on its head. Louis tosses his robe over his shoulder, revealing his athletic legs. Louis loved to dance, and even as an old man, he looked good in tights.

In fact, Louis' subjects adored him. He was polite and approachable, and could put commoners at ease with a joke. He was everything a man could aspire to be: good-looking, an accomplished guitar player, a fine horseman, witty conversationalist, statesman, art lover, and lover of women.

Rigaud shows Louis at his best. The painting is nine feet tall, so Louis is fully life-size, and positioned so this not-so-tall man (5'5") can literally look down on us. Louis' robed body forms an imposing pyramid turned at three-quarter angle, placed in the center of a rectangular frame. Louis' face is age-appropriate: handsome, but realistically doughy and double-chinned. Every detail is immaculate, from the texture of the fabrics to the ruffled curtains to his jeweled necklace. Rigaud's painting was so realistic, it served as Louis' body-double in the throne room whenever the king was away.

Louis is dressed to kill. He was Europe's great trend-setter. His blue robe, embroidered with gold fleur-de-lis, is turned out to show off the white ermine lining. His "everyday" clothes were soon seen throughout Europe: a delicate lace cravat (on his chest), matching lace cuffs, poofy breeches for pants, silk stockings, and square-toed shoes with Louis' fashion signature—red heels.

And the hair! Louis once had flowing curls down his shoulders, but as he aged, he took to wigs—more than 300 of them. This one has twin peaks parted down the middle, and it stretched to his waist. Thanks to Louis, big-hair wigs became trendy. ("Bigwigs" everywhere wore them.)

Even this portrait by Rigaud set trends. Louis-wanna-be's in palaces throughout Europe struck similar poses with similar clothes. But none could match the original Sun King. Louis XIV was the fullest expression of the divine monarch: an accomplished man who embodied a god on earth.

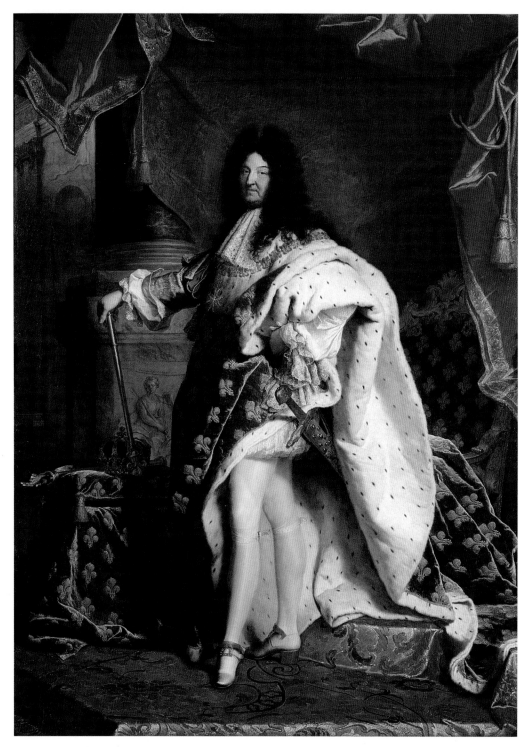

Louis XIV (1701), Hyacinthe Rigaud, Louvre Museum, Paris

19TH CENTURY

In the wake of the French Revolution, Europe was changing rapidly. Napoleon Bonaparte toppled monarchs, and the people demanded self-rule. A progressive new art style arose called Neoclassical, inspired by the rationality of ancient Greece and Rome.

Meanwhile another style was taking aim at the heart—Romanticism. With bright colors and dramatic scenes, artists captured the grandeur of untamed nature, untamed emotions, deep-rooted national pride, and the dreamy era of chivalrous knights and fair damsels.

And yet another revolution was underway—the Industrial Revolution. The iron-and-steel Eiffel Tower amazed everyone, and the steam train linked the Continent together. Europe reached new heights of prosperity, fueled by enormous wealth from overseas colonies. The belle époque (beautiful age) was a rich world of joie de vivre, cancan dancers, and progressive lifestyles. Ooh la la.

For artists, a new-fangled invention changed everything—the camera. Click! Just like that, you could capture reality better than any painting. Artists were both inspired by the camera (the unposed snapshot) and threatened by its photo-realism. They set up their easels outdoors to capture a quick "impression" with bright dabs of paint, of passing clouds, the sun on the water, or a corner café.

By century's end, Europe was at its peak, war seemed a thing of the past, and it looked like the good times would roll on forever.

DELACROIX'S *LIBERTY LEADING THE PEOPLE*

The bare-breasted Lady Liberty, carrying the French flag, represents the ongoing struggle and relentless quest for freedom. Nicknamed "Marianne," she is often seen as the symbol of the French Revolution of 1789, though this painting depicts a later revolution.

It's Paris. The year is 1830. King Charles X had just suspended civil liberties, and his subjects were angry. The Parisians have taken to the streets once again to fight their oppressors. Eugène Delacroix witnessed the events during those "Three Glorious Days" of revolution, and began composing this work.

The people have taken up arms and erected a barricade in a street near Notre-Dame (in the background). Guns blaze, smoke billows, and bodies fall. Every social class is involved: the hard-bitten proletarian with a sword, an intellectual with a top hat and a sawed-off shotgun, and even a little boy brandishing pistols. Leading them on through the smoke and over the dead and dying is the figure of Liberty, a fearless woman waving the French flag.

Delacroix packed the painting with symbols. To stir the emotions, Delacroix concentrates on the three major colors—the red, white, and blue of the French *tricolore.* Lady Liberty's pose is classic, patterned after the ancient goddess Libertas. But instead of a torch and staff, this secular goddess brandishes a flag and a gun. She sports a red "Phrygian cap," the bandana worn by 1789 revolutionaries.

Delacroix's painting epitomizes a controversial new style—Romanticism. The canvas is epic in scale ($12' \times 10'$), the colors bold, and the scene emotional, charged with rippling energy.

The July Revolution of 1830 was a success, and the people toppled their despotic king. Delacroix's painting was hailed as an instant classic, a symbol of French democracy.

However, the struggle didn't end there. They'd only replaced one despot with another less-repressive king. For the next few decades, French radicals continued to battle monarchists in pursuit of full democracy (including the 1832 revolt dramatized in *Les Misérables*). Delacroix's painting with its inflammatory message had to go underground, and was rarely exhibited in public. But it inspired his fellow lovers of liberty, like Victor Hugo. It may have influenced another French artist, Frederic-Auguste Bartoldi, in his imagery of the Statue of Liberty. Finally in 1874, the political winds were right for it to take its place in the halls of the Louvre.

The painting was born in an era when many still believed that some were born to rule, ordained by God, while others were fated to be ruled. Delacroix stirred France's passion for liberty. To this day his painting symbolizes the never-ending struggle of the common rabble who long for *"Liberté, Egalité, Fraternité"*—"Liberty, Equality, and the Brotherhood of All."

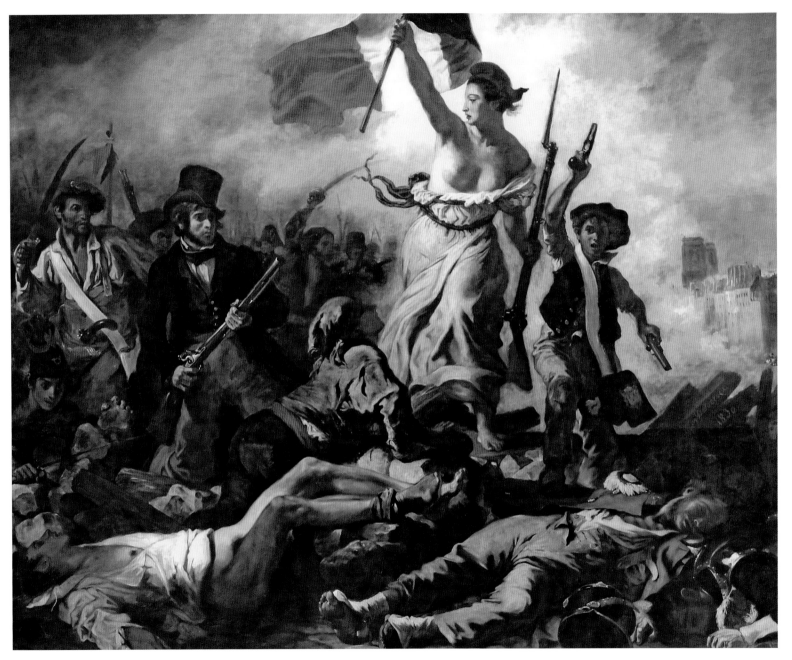

Liberty Leading the People (1830), Eugène Delacroix, Louvre Museum, Paris

ARC DE TRIOMPHE

Napoleon Bonaparte commissioned the magnificent Arc de Triomphe to commemorate his victory at the 1805 Battle of Austerlitz. Despite being vastly outnumbered, the plucky French soldiers—powered by Revolutionary fervor—won. The victory launched Napoleon—then only 36 years old—to the peak of his power, ruler of most of Europe. Napoleon wanted a monument like the triumphal arches of ancient Rome—stand-alone structures with no other purpose than to host a victory parade for the conquering general. His 165-foot-high arch would be three times the size of ancient arches, symbolically celebrating Napoleon as emperor of a "New Rome." A relief sculpture on the arch shows a toga-clad Napoleon being crowned by a goddess, while Lady Paris kneels awestruck at his imperial feet. Napoleon died before the arch's completion (1836), but his mortal remains were later allowed to pass underneath it.

The arch's decoration also honors the French Revolution of 1793. The most famous relief (*La Marseillaise,* by François Rude) depicts the female symbol of the Revolution. Lady Liberty—looking like a scary reincarnation of Joan of Arc—points the way with her sword. Her mouth is wide open, as if she's screaming the lyrics of the French national anthem: *"Allons enfants de la patrie . . . Arise, children of the Fatherland!"* The soldiers beneath her are weary and stumbling, but she rallies them to carry on the eternal fight against tyranny.

After Napoleon, this mega-arch took on new symbolism. With each French war, names and memorials were added. After World War I, French soldiers marched here in the victory parade. A victim of that War was buried here—the Tomb of the Unknown Soldier—making the arch a symbol of peace. When Hitler's Nazis goose-stepped into Paris, they hung a huge swastika on it. Then in August 1944, Paris was liberated and General Charles de Gaulle marched here along with American GIs.

Today, the Arc de Triomphe still serves as the stage for the French nation's spectacles. People gather here for Bastille Day parades, World Cup triumphs, candlelight vigils, and the finale of the Tour de France bike race.

From the top of the monument, you truly realize the central place the arch has. You're at the geographical center of Paris' 12 grand boulevards that radiate out from here in the shape of a star—an *"etoile."* You have an eye-popping view of all Paris. In one direction is the Champs-Elysées, the famed boulevard of glitzy fashion shops, celebrity cafés, and global citizens. Panning farther, you see the towers of Notre-Dame, the white dome of Sacré-Cœur, and the golden dome of Les Invalides—where Napoleon lies buried. The arch is the central link of a vast "historic axis"—a line of monuments stretching from the Louvre up the Champs-Elysées to the arch to the modern "Grande Arche" in the far distance.

A work of art? Yes. Taking in the vast expanse that radiates out from the Arc de Triomphe, you sense that you're standing at the center of that great work of art called Paris.

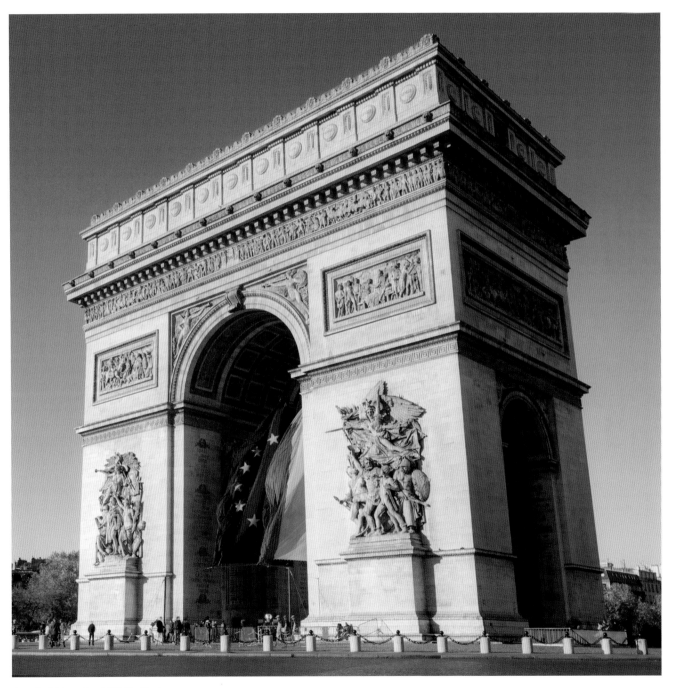

Arc de Triomphe (1836), Paris

DAVID'S *CORONATION OF NAPOLEON*

The sheer size of this canvas—32 feet long and 20 feet high—suggests the magnitude of the event it depicts.

It's the year 1804, and Napoleon Bonaparte (big ego, holding the crown aloft) is about to cement his place among the greats of history. Having conquered most of Europe, he's returned home to Paris to be crowned emperor. Dignitaries have gathered, and all eyes turn toward the man of the hour. His wife, Josephine, kneels submissively before him.

Napoleon designed the ceremony himself. With his mishmash of rituals, he hoped to unite a society fractured by the French Revolution. To appease monarchists, he used the royal regalia. To please the Church, he invited the pope (seated to the right of Napoleon). But Napoleon's main goal was to honor the new power in town—the people. Napoleon was their champion, and they'd voted overwhelmingly to make him their emperor.

The ceremony takes place at the high altar of Notre-Dame Cathedral. Napoleon and Josephine donned robes of red velvet and intricate gold embroidery. Napoleon put a laurel-wreath crown in his hair, like heroes of old. As choirs sang and a crowd of 5,000 looked on, the couple processed up the nave, where the pope awaited.

Besides nobility, the crowd also included Napoleon's crew. Napoleon was a commoner—in fact, the immigrant son of Italian-speaking parents. Now he invited his loved ones to witness his moment of triumph. Napoleon's sisters carry Josephine's train. His two brothers stand at far left (in black hats), soon to be appointed kings of Spain and Holland. To the right of the brothers are Josephine's sisters (wearing matching tiaras). They babysit a little boy—it's Josephine's son from a previous marriage. Napoleon and Josephine (who was six years older) were passionately in love. He personally insisted she be crowned empress alongside him. Standing near Josephine (holding a cushion) is Napoleon's right-hand man, General Murat. The most honored guest of all is directly behind Murat, seated in the VIP balcony. It's Napoleon's beloved mother, beaming as her little boy is about to be crowned the most powerful man in the world.

The stage was set. According to tradition, this was the point in the ceremony where Napoleon would kneel humbly before the pope to receive the crown. But times had changed. Instead, Napoleon takes the crown himself, turns his back on the pope, and faces the real authority—the people. He raises the crown high, then places it on his own head. The pope looks a little put off.

Napoleon personally asked the Neoclassical painter Jacques-Louis David to record the event, giving it the sober, heroic grandeur of ancient art. Everyone is perfectly posed, because David painted them in his studio. He gave Notre-Dame classical-style pilasters to better frame the central characters. And he even included one person who wasn't actually there—Napoleon's mother—at Napoleon's request.

After this glorious coronation, Napoleon's fate turned sour. He foolishly invaded Russia, decimating his armies. Europe's kings eventually ganged up and toppled him from power, exiling him to a remote island. There, poor and alone, Napoleon uttered his final word—"Josephine"—and died.

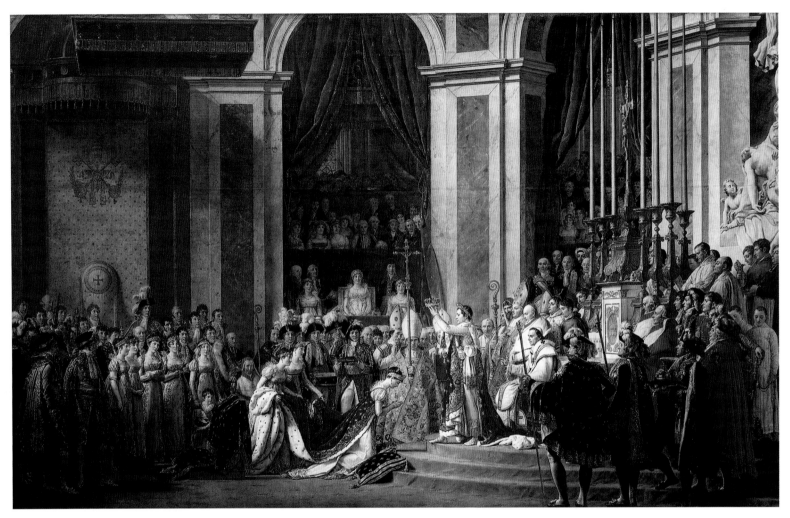

The Coronation of Napoleon (1807), Jacques-Louis David, Louvre Museum, Paris

CANOVA'S *CUPID AND PSYCHE*

Cupid flutters down to his sleeping lover Psyche. As she awakens, she stirs, and reaches back to him. Their arms intertwine, and they gaze into each other's eyes as their lips are about to meet in a kiss. With their smooth skin and lithe limbs, this youthful couple has come to represent the tenderness and innocence of pure love.

The scene is the culminating episode of a heart-tugging love story from Greek mythology (with hints of Sleeping Beauty). The boyish god of desire, Cupid (a.k.a. "Eros"), falls in love with the mortal Psyche. Jealous of Psyche's beauty, Venus separates the two lovers by sending Psyche to fetch a magical jar. Psyche foolishly opens the cursed jar, which puts her in a deep sleep. Fortunately, Cupid swoops in at the last minute like Prince Charming to awaken her with a kiss. Psyche is granted immortality, and the two live happily ever after.

The statue is the work of Antonio Canova (1757–1822), Venice's greatest sculptor. Son of a stonemason, Canova grew up in a studio along the Grand Canal. He precociously mastered the sentimental, elegant Rococo style of the late 1700s. These early works were so realistic that skeptics accused Canova of making them from plaster casts of live humans.

At 23, he went to Rome to study ancient statues, including the recently discovered ruins of Pompeii, where he sketched murals he saw of intertwined lovers. These archaeological finds inspired a revival of classical style. Called to Paris, Canova became Napoleon's court sculptor. Soon Canova's pure "neo" classical style became the rage all over Europe.

Cupid and Psyche has all the elements of Canova's Neoclassicism. Canova created gleaming white, highly polished statues of beautiful Greek gods and goddesses. The lines are minimal. It's an ensemble arrangement, with more than one figure. Canova excelled in mini-dramas like these, where the characters' understated gestures speak volumes about their emotions. It's sober and restrained, with just the right touch of Romantic sentiment.

Though the statue is perfectly balanced, the composition is complex. The center is a circle, formed by Psyche's reaching arms, which frames their two faces. It's also the center of an X, where the diagonal line of Cupid's wing and body crosses the diagonal line of Cupid's other wing and Psyche's body.

The statue is interesting from every angle—in fact, Canova fitted it with a handle, to rotate the base 360 degrees and spare the idle rich from having to walk around it. From the back, you can see story-telling details like Psyche's jar and Cupid's arrows. Their derrières are smooth and seductive. The highly polished skin contrasts with their curly hair, rumpled robes, and the rough stone base.

But you always come back to the center: the lovers' two faces. Cupid cradles Psyche's body and gazes intently, not with lust but with tenderness and devotion. Psyche, still half-asleep, awakens to her lover's touch, and succumbs to him completely. The open space between them is as compelling as the figures themselves. In fact, the very center of this statue is the electrically charged atmosphere between the lovers' anxious lips—an erotic synapse.

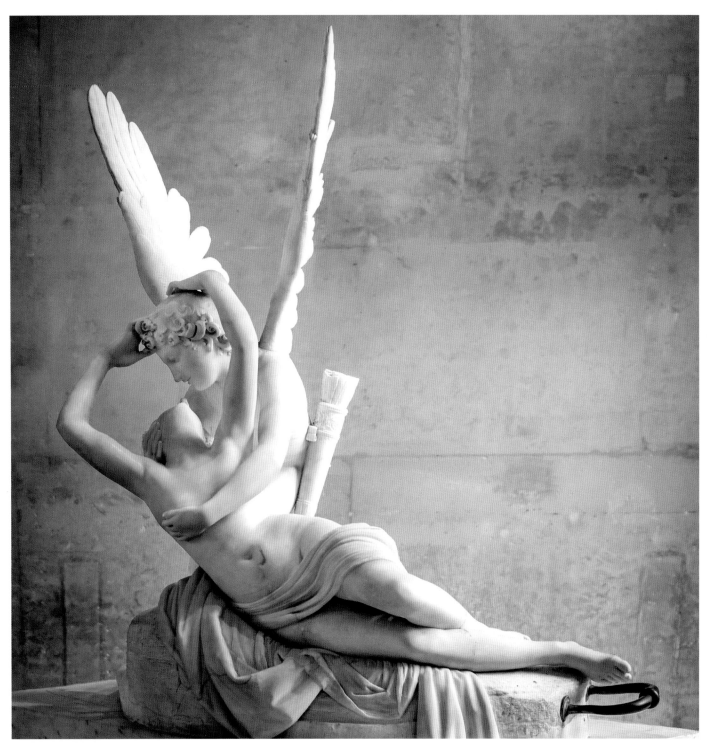

Psyche Revived by Cupid's Kiss (1793), Antonio Canova, Louvre Museum, Paris

INGRES' *LA GRANDE ODALISQUE*

Take a classical Greek statue, turn her around, lay her down, stick a hash pipe next to her, and you have *La Grande Odalisque*. But while it's a typical study of a female nude in the tradition of the ancient *Venus de Milo* or Titian's *Venus of Urbino,* Ingres gives her a thoroughly exotic setting—as an "odalisque," or harem girl.

She waits to serve her sultan, cloistered in her world of pleasure. She lounges across a plush bed, propped up on pillows, resting on silk sheets and furs. This sex slave is clearly pampered, judging by the rich turban on her head, pearls, gold bracelet, and the jeweled brooch tossed casually on the bed. She passes her days smoking, fanning herself with her peacock fan, and waiting. Then the door opens, we walk in . . . and she turns to look.

The odalisque was a common theme for 19th-century painters. (Might this fantasy of exotic sex have also represented the tempting assets awaiting Europeans in their overseas colonies? Hmmm.)

Artistically, Ingres was creating a vision of pure aesthetic beauty. Using clean, sculptural lines, Ingres accentuates the S-curve of her body. Her naked flesh fills the canvas, wrapping around a diagonal axis from lower right to upper left. Ingres' smooth brushwork gives her porcelain skin a polished sheen. The bunched-up sheets set off her smooth skin. You can practically feel the texture of the velvety curtains and silken sheets.

The colors are cool—blue, gold, and white. Notice how little background there is: the room is dark, and even her left cheek and leg are in shadow. This emphasizes the sinuous horizontal line of her cardboard-cutout silhouette.

When the painting debuted, critics savaged it. They focused on the odalisque's monstrously imperfect body. Her spine has three vertebrae too many. Her head's too small, her right arm too long, and her left leg is in an impossible pose. Her fingers float like a sea anemone. But Ingres was tweaking reality to emphasize the woman's languid lines and pliant role. The aloof expression on her face was puzzling: Seductive? Curious? Or indifferent?

La Grande Odalisque was groundbreaking. It was rooted in the dominant style of the day—Neoclassicism. The painting has the restrained colors and pure lines of a classical Greek statue. But Ingres was also pushing boundaries. Instead of Neoclassical realism and rational proportions, Ingres took liberties for artistic effect. Instead of a pristine Greek goddess, Ingres delved into the exotic world of the Orient. With *La Grande Odalisque,* Ingres pointed the way toward a new, more emotional style—Romanticism. He created a sensuous atmosphere that appealed not just to the logic of the mind but also to the longings of the heart and the stirring of the senses.

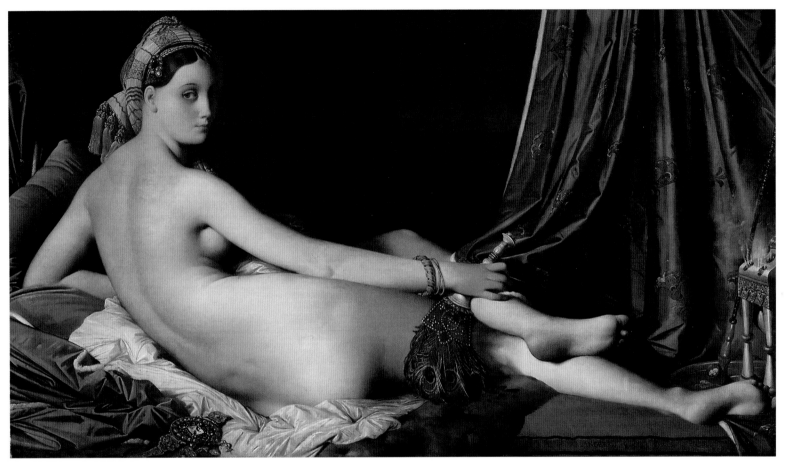

La Grande Odalisque (1814), Jean-Auguste-Dominique Ingres, Louvre Museum, Paris

GÉRICAULT'S *RAFT OF THE MEDUSA*

In 1816, the French ship *Medusa* went down off the coast of Africa, and the tragedy gripped the nation. Accounts poured in of the unspeakable hardships these French citizens suffered.

In Paris, the young artist Théodore Géricault began chronicling the tragic event. Like a method actor, he immersed himself in the project. He interviewed survivors and honed his craft sketching dead bodies in the morgue and the twisted faces of lunatics in asylums. He shaved his head and worked alone, wallowing in the very emotions he wanted to portray.

He captured the moment when all hope seemed lost.

Clinging to a raft in the midst of a storm-tossed sea is a tangle of bodies sprawled over each other. The scene is alive with agitated, ominous motion—the ripple of muscles, churning clouds, and choppy waves. The rickety raft is nearly swamped. The dark colors—dull green seas, dark brown raft, and ghostly flesh—are as drained of life as the survivors' spirits. On the right is a deathly green corpse dangling overboard. Of the 150 people who originally packed onto the raft, only these few remained. They floated in the open seas for almost two weeks—suffering unimaginable hardship and hunger, even resorting to cannibalism. The face of the old man on the left, cradling his dead son, says it all—it's hopeless.

But wait!

There's a stir in the crowd. Someone has spotted something. The bodies rise up in a pyramid of hope. The diagonal motion culminates in a waving flag. They wave frantically, trying to catch the attention of something on the horizon, their last desperate hope. It's a tiny ship—the ship that did finally rescue them and bring the 15 survivors home.

For months, Géricault worked feverishly on this giant canvas. When he emerged, it captured the traumatized mood of a French nation still in mourning. Géricault had also revolutionized art, paving the way for a bold new style—Romanticism. His contemporaries were still following the Neoclassical tradition of idealized gods and Greek-statues-on-canvas. Géricault shattered the mold, adding a gritty realism and super-ultra-mega-heightened emotion. What better story than this shipwreck to shock and awe the public? In the artistic war between hearts and minds, Géricault's Romantic style went straight to the heart. He used rippling movement, strong shadows, and powerful colors to catch us up in the excitement. If art controls your heartbeat, this is a masterpiece.

It also sounded another trumpet of the Romantic movement. Ultimately, it championed the godlike heroism of ordinary people who rise above their suffering to survive.

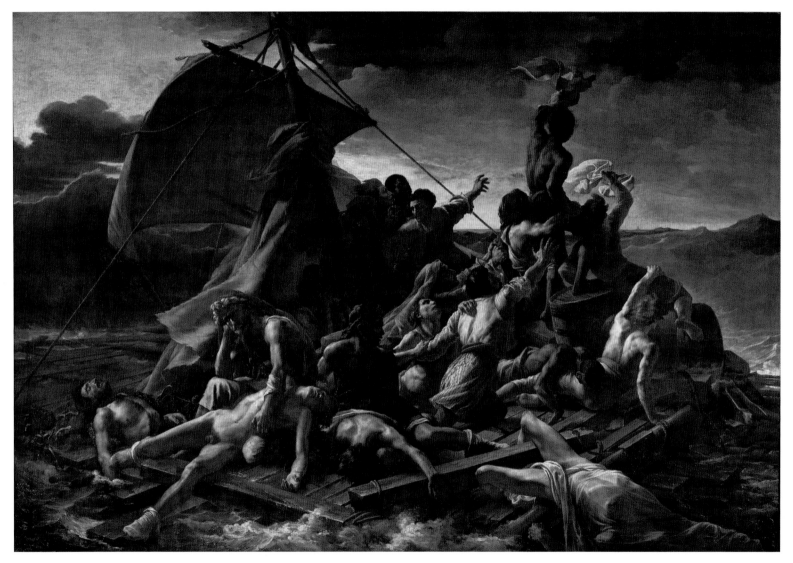

The Raft of the Medusa (1819), Théodore Géricault, Louvre Museum, Paris

GOYA'S *THIRD OF MAY*

As court painter to Spain's kings, Francisco de Goya (1746–1828) spent his career dutifully cranking out portraits and pretty pictures. But inside, he chafed at the arrogance of kings and tyrants, and eventually became a champion of the oppressed.

Goya's problem with authority came to the fore on one watershed day in Spain's history—the Third of May, 1808. France had invaded Spain. When the proud Spaniards confronted them on Madrid's main square, Puerta del Sol, the French brutally crushed the protest and started rounding up the ringleaders.

Goya's *Third of May* shows the reprisals. It's the middle of the night, and the rebels have been secretly dragged before a firing squad. They plead for mercy and get none. The soldiers are completely in charge, well-equipped, and well-organized. The rebels are a motley group of grubby workers, scattered and confused. It's a total mismatch, a war crime. The soldiers—a faceless machine of death—start cutting the men down with all the compassion of a lawnmower. The Spaniards topple into a mass grave. A kneeling man spreads his arms, Christ-like, and asks, "Why?" We can see the whole grim assembly line: those waiting their turn, the victims, the lifeless executed. Next.

If it wasn't for Goya, who would ever have known about these nobodies? Goya places a big lantern in the middle of the scene and literally shines a light on this atrocity for the whole world to see. It's a harsh prison-yard floodlight that focuses all the attention on this one man with his look of puzzled horror. The distorted features, the puddle of blood, the twisted bodies, the thick brushwork—all these were unheard of at the time. Goya helped lay the foundations for a shocking new style—Romanticism—that emphasized strong emotion over idealized beauty.

Eventually, the Spaniards drove the French out of their country. But Goya was left disillusioned. His work became increasingly dark. *The Third of May* has become a universal comment on the horror of war. Goya's unflinching black-ness foreshadowed both 20th-century Expressionism with its bleak cynicism and Surrealism with its troubling imagery. Pablo Picasso consulted *The Third of May* for his own painting of an atrocity in Spain, *Guernica*.

Because of Goya's artistic innovations and his social conscience, many consider him to be the last classical and the first modern painter. And thanks to Goya, even today we can remember these anonymous martyrs of freedom.

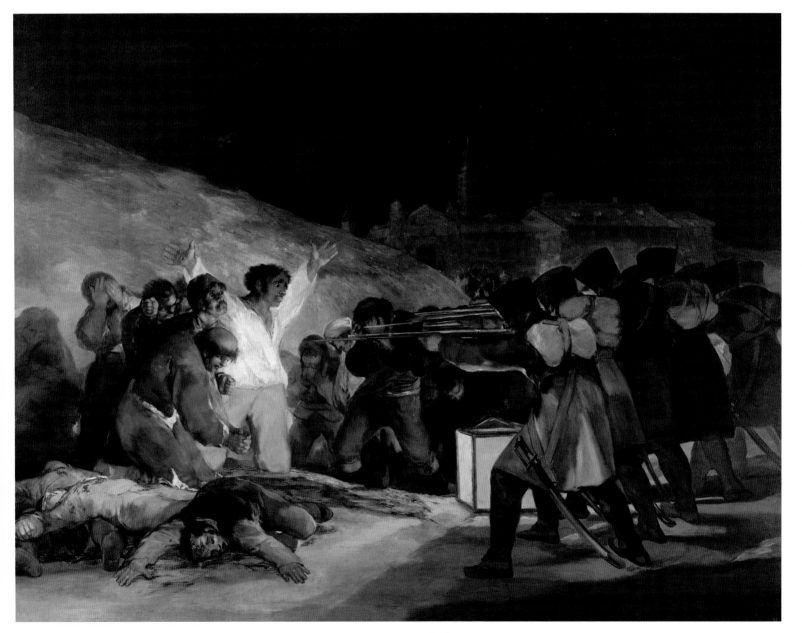

The Third of May, 1808 (1814), Francisco de Goya, Prado Museum, Madrid

GOYA'S TWO *MAJAS*

Two paintings of the same woman in the same pose—one clothed, one nude.

Why? Why two versions? What was Goya thinking? And above all, who is this mysterious woman?

The story begins in the late 1790s. The Prime Minister of Spain hired his good friend Goya to paint his teenage mistress—art he could enjoy privately, away from his wife.

Goya delivered a full-sized, full-frontal centerfold. The young woman reclines luxuriously across a bed, resting on big plush pillows. Her skin shines like porcelain, standing out from the icy-green couch, rumpled satin sheets, and frilly lace. The pose was clearly based on Venuses done by earlier masters like Titian and Velázquez.

But Goya's nude was shockingly frank. She raises her arms to fully display all her charms, smiles, and stares directly out without a hint of shame: "You like what you see?" At the center of the composition is what may be a first in the entire 20,000-year history of art: female pubic hair.

Goya then dashed off a second version, showing her wearing the flamboyant garb of a trendy working girl—a *"maja."* Viewed side by side, the clothed version made it clear that the nude was not an allegorical goddess but a real Spanish woman with her clothes off. The Minister could display the two paintings in a double frame: the *Clothed Maja* discreetly on top, until—*zoop!*—he pulled a cord to reveal the luscious nude hidden beneath.

Well, that's one historically plausible version of this convoluted tale. Another involves one of the most intriguing figures of the day: the Duchess of Alba. Goya knew the Duchess well. He visited her often. He painted her numerous times. Rumors flew that the two were having an affair. During that time, Goya sketched various female nudes that seem to be inspired by the Duchess. Goya even painted a portrait of the Duchess pointing at a phrase written across the canvas: *"solo Goya"*—"only Goya." In all these portraits, the Duchess reveals a distinct anatomy: delicate curves, hourglass figure, widely spaced breasts, rosy cheeks, and an intense gaze—all similar to those found in the *Maja*.

So is the *maja* the Duchess, the mistress, or just some anonymous model? The mystery is enhanced by the *maja*'s head, which seems tacked onto the body at an odd angle and looks like nobody in particular. Perhaps it was an alias, to disguise the woman's body lest someone recognize her identity.

Regardless of the paintings' origins, we know their scandalous fate. The paintings were confiscated by the puritanical Spanish Inquisition and labeled obscene. Goya was hauled before the tribunal and asked to explain himself. He apparently convinced them they were not pornography but art, and was released. Nevertheless, the *Majas* were considered scandalous in ultra-conservative Spain. They were locked away for a century, before they were first publicly displayed in 1901.

Only then could Goya's masterpiece be fully appreciated. He'd delicately balanced the aesthetic traditions of earlier masters, while anticipating the new and more shocking art of the modern world to come.

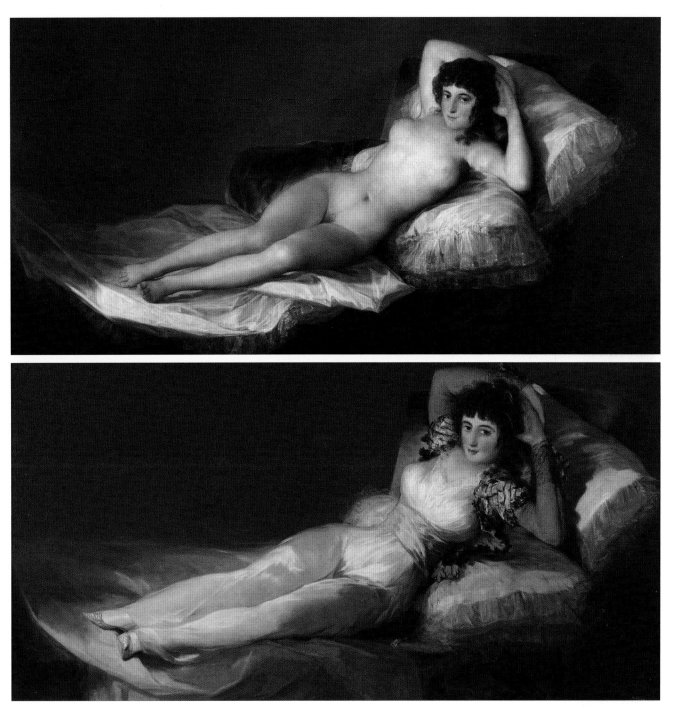

Nude Maja and *Clothed Maja* (c. 1800), Francisco de Goya, Prado Museum, Madrid

GOYA'S BLACK PAINTINGS: *SATURN DEVOURING HIS SON*

You can't unsee this image of a crazed, scraggly old man cannibalizing his own child. His eyes bulge as he opens his mouth wide to take another bite. He's already ripped off the head, and blood oozes out the top as he squeezes the corpse.

This is one of a dozen of Goya's late-in-life "black paintings"—dark in color and in mood. They were created when the seventy-something artist—having lived a controversial life in a troubled time—retired to an isolated farmhouse. He was deaf, depressed, worried his liberal ideas would get him arrested, prone to nervous breakdowns, and terrified that he was descending completely into madness. He began to paint his walls—living room, dining room, bedroom—with nightmarish scenes. There are craggy old men and cackling crones. Crowds of people huddle together amid bleak landscapes. Two giants face off, buried up to their knees, and flail at each other with clubs. A coven of skeletons swirls in a Black Sabbath frenzy around a Satanic goat-headed priest.

Of all Goya's "black paintings," the most disturbing image of all is this one, *Saturn*. According to the ancient myth, the king of the gods—afraid that his children would overthrow him—ate them. (Baby Zeus survived to eventually rule.) The king crouches like a subhuman creature in the darkness. His face is a mask of paranoia, as if he can't eat fast enough to save his precious throne. Goya creates an eerie atmosphere—the black background and blotchy brown body, highlighted with the deathly pale corpse and bright-red gore. Goya pulls no punches, managing to make the already horrifying subject even more haunting.

What did these "black paintings" mean? Nobody knows for sure. Goya painted them for his own home, did not give them titles, and wrote nothing about them.

It may be he was simply following the custom of the day of decorating his country home. But instead of happy peasants sampling cherries, Goya painted his dining room with an ogre devouring his kids. (Black humor? Whatever it was, the painting brings new meaning to the term "child's portion.")

Others think Goya was venting his inner demons. He'd once been a dutiful court painter for the Spanish king, but became disillusioned by the corruption. So Saturn could represent a cruel tyrant feeding on his own people. Or Saturn (a.k.a. Cronus, or "Time") may be an allegory of how time devours us all. The painting of the dueling giants could be the never-ending cycle of wars plaguing his home country. And the witches' ritual could be mocking the repressive Spanish Inquisition, who'd persecuted him personally. Whatever they mean, these black paintings are the final testament left by a dying, bitter genius with a bleak outlook on the human condition.

After Goya's death, the murals—painted in oils on plaster walls—were discovered, transferred onto canvas, and displayed to the public. Startling scenes such as these were unheard of, foreshadowing a more hard-edged modern world. A century before his time, Goya painted what he felt, and in the process, raised ugly truthfulness to the level of high art.

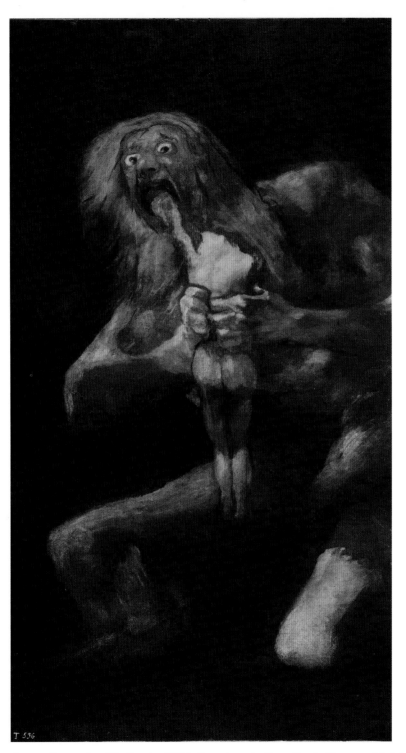

Saturn Devouring His Son (c. 1823), Francisco de Goya, Prado Museum, Madrid

PRE-RAPHAELITES AND *THE LADY OF SHALOTT*

This woman's haunting face makes it clear right away that—despite the sumptuous beauty of this painting—it doesn't tell a happy tale. The Lady of Shalott knows she's floating down a river to her doom.

The English artist John William Waterhouse depicts the dramatic climax of a legendary tale. The Lady of Shalott had spent her whole life shut up in a castle near King Arthur's Camelot, forbidden to even look outside, upon pain of death. She could only observe the world indirectly through the reflection in her mirror. But one day, the handsome knight Lancelot rode by. She was so smitten that she broke the rules and looked directly at him. Now she's followed his tracks and boarded a boat, releasing the mooring chain, as she sets off into the unknown to find her beloved, whatever the cost.

The riverside landscape—the reeds, the inky water, the darkening atmosphere, even birds in flight—evokes the melancholy beauty of the moment. Ms. Shalott burns brightly, her white gown and red hair radiating from the dark background. Waterhouse focused on evocative details, like the Lady's wispy hair, pearl necklace, lightly rumpled dress, and cupped hand. For the Lady's face, he painted his own wife. The colors—reds, greens, and blues—are bright, clear, and luminous, glowing like stained-glass windows.

The whole scene looks medieval, yet it was painted during an Industrial Age when Britain was leading the world in new technologies like electricity and trains. While Victorian Britain sped forward, its artists looked to the past. Waterhouse was inspired by a group of British artists called the "Pre-Raphaelite Brotherhood," who reveled in painting medieval damsels and legendary lovers with heartbreaking beauty.

The Pre-Raphaelites hated overacting. So—even in the face of great tragedy, high passions, and moral dilemmas—this Lady barely raises an eyebrow. But her surroundings speak volumes. Night is falling, foreshadowing her dark destiny. The first leaf of autumn has fallen, landing near her thigh. She brings the bright tapestry she wove in captivity, with scenes of the comforting world of illusion she once knew. Now she's guided only by a dim lantern on the prow, a small crucifix to fortify her faith, and three fragile candles—only one of which still burns.

Victorians of all ages knew this Romantic legend (which was also a best-selling poem by Tennyson). Everyone could read their own meaning into the painting: The Lady has chosen to leave her safe-but-deluded existence to pursue truth. She's following her heart, despite the dangers. She's taking the risk to find intimacy, love, and sex even at the expense of losing herself in the process. The expression on her face shows a mix of fear, hope, vulnerability, and a realization that—whatever comes—this is her destiny.

She lets the chain go. Then, "like some bold seer in a trance," wrote Tennyson, she goes "down the river's dim expanse." In the legend, the Lady of Shalott's boat headed downstream and washed ashore at Camelot, where Lancelot saw it and mourned for her. She had succumbed to the curse of seeing the world as it is.

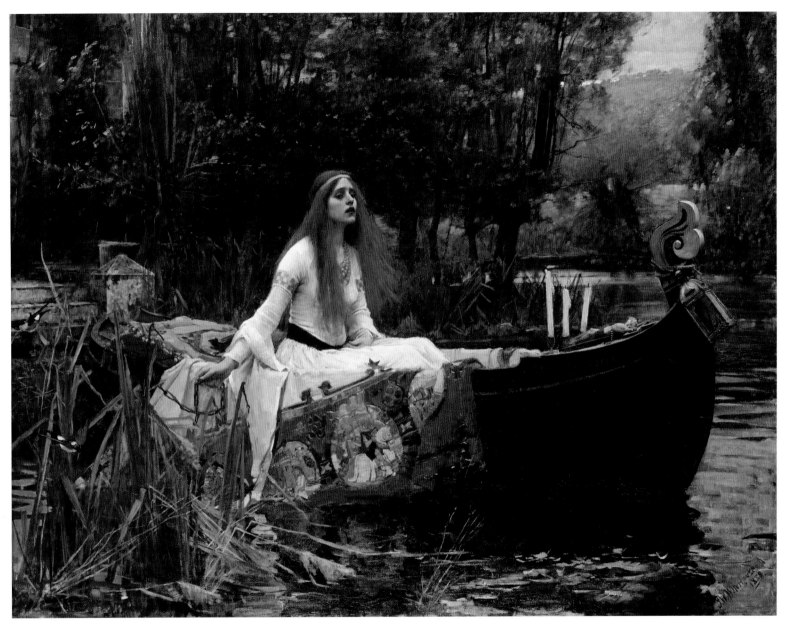

The Lady of Shalott (1888), John William Waterhouse, Tate Britain, London

NEUSCHWANSTEIN, THE CASTLE OF "MAD" KING LUDWIG

A fairy-tale castle in a stunning alpine setting, with a lush interior and all the latest conveniences . . . and they call the man who built it "mad"!

Neuschwanstein Castle—with its fanciful turrets and rustic stonework—looks like it dates from the Middle Ages, but it's barely older than the Eiffel Tower. It was the dream of "Mad" King Ludwig II of Bavaria. As a boy, climbing the hills above his summer home, Ludwig fantasized about building a castle there "in the authentic style of the old German knights." When he gained power at age 18, he began to turn his dreams into stone, creating a private getaway from the politics in Munich that Ludwig hated—a place to dream.

The location was unmatched—perched high on a rocky ledge, with a backdrop of snow-tipped mountains and glassy alpine lakes.

Ludwig's "architect" was a theater set-designer specializing in medieval fables. The actual construction (1869–1886) was executed by high-tech engineers using the latest techniques. Hundreds of tons of stone were hefted up with Industrial Age steam power. The castle core was a skeleton of modern iron and brick faced with medieval-looking white limestone, trimmed with gray sandstone. The result was a mash-up of a thousand years of medieval architecture . . . neo-medieval: Romanesque arched windows, castle-like crenellations, and prickly Gothic towers. It captured the spirit of 19th-century Romantics nostalgic for a pre-Industrial past.

Inside, it was lavish. Ludwig's extravagant throne room emphasized his royal status, with golden mosaics of the Christian kings Ludwig emulated. The floor, with its two-million-stone mosaic, features an encyclopedia of animals and plants. Overhead hangs a huge chandelier shaped like an emperor's crown.

The king's personal rooms, though incredibly ornate, are actually small and cozy. Ludwig's canopied bed is elaborately carved with a forest of Gothic spires. Ludwig enjoyed his own chapel, water piped in from the Alps, and views of steep mountains and plunging waterfalls—fueling his Romantic soul with the wonders of nature. Ludwig even built an artificial grotto, dripping with stucco stalactites and a bubbling waterfall. The castle's grand finale is the Singers' Hall, a fancy ballroom. The entire castle came with state-of-the-art technology: electricity, running water, flush toilets, and even telephones.

Meanwhile, all of the rooms were decorated with paintings of valiant knights and lovely damsels, inspired by the Romantic operas of Ludwig's idol, Richard Wagner. There are Wagner's legendary lovers, troubadours, Holy Grails, and especially Ludwig's favorite animal—swans. Ludwig's swan-like castle came to be called Neu-schwan-stein—"New swan stone."

Ludwig lived in his castle for a mere 172 days before the fantasy of Neuschwanstein came to an abrupt end. Fed up with Ludwig's expensive Romantic excesses, his political rivals burst into his bedroom and arrested him. Two days later, Ludwig—only 40 years old—drowned mysteriously in a Bavarian lake (murder? suicide?).

Within six weeks of his death, tourists were lining up to see the "mad" king's "folly." Today, Ludwig's cost has been recouped a hundredfold and huge crowds from all over flock to see Europe's most popular castle.

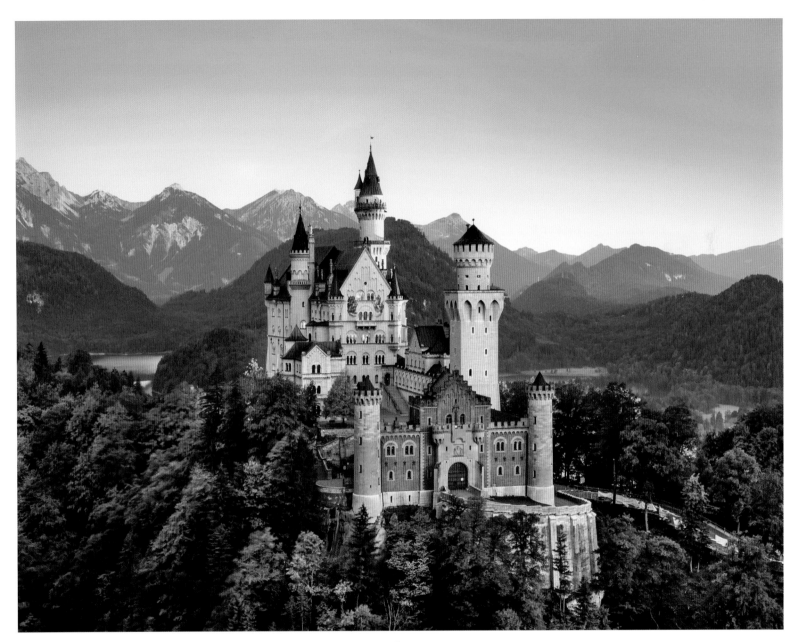

Neuschwanstein Castle (1869–1886), King Ludwig II, Bavaria, Germany

THE EIFFEL TOWER

Delicate and graceful when seen from afar, the Eiffel Tower is massive—even a bit scary—close up. You don't appreciate its size until you walk toward it; like a mountain, it seems so close but takes forever to reach.

It's crowded, expensive, and there are probably better views in Paris, but visiting this 1,063-foot-tall ornament is unforgettable. There are three observation platforms, at roughly 200, 400, and 900 feet. Although being on the windy top of the Eiffel Tower is a thrill, the view is better from the second level, where you can more clearly see Paris' monuments.

The Eiffel Tower was created for the Paris World's Fair in 1889, a grand celebration of the centennial of the French Revolution. Bridge-builder Gustave Eiffel won the contest to build the fair's centerpiece by beating out rival proposals such as a giant guillotine.

The tower was a massive project, employing innovations of the Industrial Age—including mass production, cutting-edge technology, and capitalist funding.

Eiffel deserved to have the tower named for him. He designed it, oversaw its entire construction, and personally financed it. His factory produced the iron beams, and his workers built it, using cranes and other gear designed by Eiffel himself. The tower went up like an 18,000-piece erector set, made of 15-foot iron beams held together with 2.5 million rivets. Facing a deadline for the exposition, Eiffel brought in the project on time and under budget.

A little over two years after construction began, the last beam was riveted. On May 15, 1889, a red, white, and blue beacon was lit on the top, the World's Fair began, and the tower carried its first astounded visitors to the top.

The tower demonstrated to the world that France was a superpower, with the wealth, knowledge, and can-do spirit to erect the tallest structure on the planet. It was built on a strict timetable and planned completely in advance, with almost no leftover parts. The original plan was to construct it, celebrate this Industrial Age triumph, and then dismantle the tower as systematically as it was built. But it was kept by popular demand. And today it's the most visited monument in the modern world.

To a generation hooked on technology, the tower was the marvel of the age, a symbol of progress and human ingenuity. The I-beam and T-square practicality of this icon of modern efficiency inspired similar buildings across Europe. But it also helped inspire a free-spirited movement that preferred organic curves and motifs from nature to right angles and rivets: Art Nouveau.

However imposing it may be by day, the tower is an awesome thing to behold at twilight, when it becomes engorged with light, and virile Paris lies back and lets night be on top. When darkness fully envelops the city, the tower seems to climax with a spectacular light show at the top of each hour.

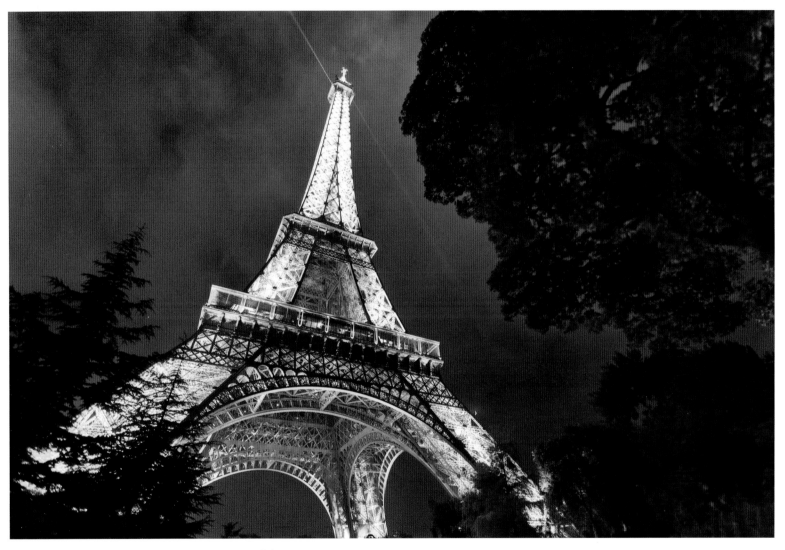

Eiffel Tower (1887–1889), Gustave Eiffel, Paris

MUCHA'S ART NOUVEAU POSTERS

It's Paris, the day after Christmas, 1894. Alphonse Mucha is a humble Czech immigrant scratching out a meager existence in a print shop. Suddenly, a once-in-a-lifetime offer comes up. Sarah Bernhardt—perhaps the most famous theater actress who has ever lived—needs a poster for her new play, and she needs it now. In just a week, working under intense pressure, the unknown artist Mucha cranked out this poster.

Mucha depicted Sarah—then 50 years old—as she would appear in her role, as a fresh-faced young maiden. She wears a royal robe and carries a palm branch as she parades in to rescue her lover in the play's climactic final scene. Mucha's poster design was simple. He put the title at the top, the name of the theater at the bottom, and dedicated the rest to the person that everyone was coming to see: the producer-director-star of the play, Sarah Bernhardt. The poster was unusually tall, allowing the divine Sarah to appear life-size.

The posters were plastered all over town by New Year's Day. Immediately, Parisians started stealing the posters for themselves, and it was clear Mucha was on to something. Almost literally, Mucha became an overnight

Gismonda (1894), Alphonse Mucha

sensation. Bernhardt signed him to a six-year contract, and suddenly he was the most in-demand artist in town.

The *Gismonda* poster set the tone for Mucha's signature style: willowy maidens with flowing hair, wearing long elegant gowns, posed amid flowery pastel designs, and backed with a halo-like circle. Such elements reached their peak of beauty in his evocative poster of Princess Hyacinth, which far outlived the cheesy ballet it was made for.

These posters were lithographs, a printing process popularized in late-19th-century Paris. Once Mucha made a single design, he could churn out hundreds of cheap (but exquisite) four-color posters.

Mucha's posters led to commissions for all kinds of consumer products. Soon his pastel pretties appeared on tobacco tins, magazine covers, calendars, wallpaper, postcards, and ad campaigns hawking everything from biscuits to beer.

Mucha's slinky, florid, and organic style helped define what became known as Art Nouveau. As Europe eased into a new (*nouveau*) century, it embraced a new (*nouveau*) art. Artists rejected the rigid art of the Industrial Age (which loves a straight line), and embraced nature (which abhors a straight line). Mucha was inspired by curves—the curves of plants and curvaceous women. Mucha almost literally wrote the book on Art Nouveau when he published a collection of prints that inspired budding artists.

In 1900, Paris held a big World Exposition that showcased Mucha's work and soon his new style was spread all over the world. Everywhere there were

Princess Hyacinth (1911), Alphonse Mucha, Mucha Museum, Prague

ironwork street lamps that bend like flower stems, dining rooms paneled with leafy garlands, and Tiffany's flower-petal stained-glass lamps.

Much of Mucha's work was mass-produced and intended as throwaway advertising, but it was soon accepted as high art. In our own age, think of how movie posters, album covers, and concert promos decorate more dorm rooms than any other artwork. The gap separating "pop culture" and just plain "culture" has blurred. And Mucha's poster may have started it.

SAGRADA FAMÍLIA BASILICA

Antoni Gaudí's most awe-inspiring work is this unfinished, super-sized basilica. With its cake-in-the-rain facade and otherworldly spires, the basilica has become the icon of Barcelona.

Birth of Jesus, detail of Nativity Facade

Construction began over a century ago (1883) and is still ongoing. The only section finished by Gaudí himself is the Nativity Facade. The four 330-foot towers soar upward, morph into round honeycomb spires, and taper to a point, tipped with colorful ceramic "stars."

Gaudí's Nativity Facade gives a glimpse at how grand this structure will be. The four spires are just a fraction of this mega-church. When finished, the church will have four similar towers on each side, plus five taller towers dedicated to the Evangelists and Mary. And in the very center will stand the 560-foot Jesus tower—the tallest in the world—topped with an electric cross shining like a spiritual lighthouse. The grand Nativity Facade (where tourists enter today) will become a mere side entrance. The huge church will accommodate 8,000 worshippers surrounded by a forest of sequoia-sized columns. With light filtering in, dappling the nave with stained-glass color, a thousand choristers will sing.

The Nativity Facade exemplifies Gaudí's unmistakable style. It's incredibly ornate, made from stone that ripples like frosting, blurring the architectural lines. The sculpted surface is crawling with life: people, animals, birds, trees, and weird bugs. Two massive columns flanking the entrance playfully rest on the backs of two cute little turtles. Gaudí's religious vision was infused with a love of nature. "Nothing is invented," he said, "it's written in nature." The church grows organically from the ground, blossoming to heaven.

(continued)

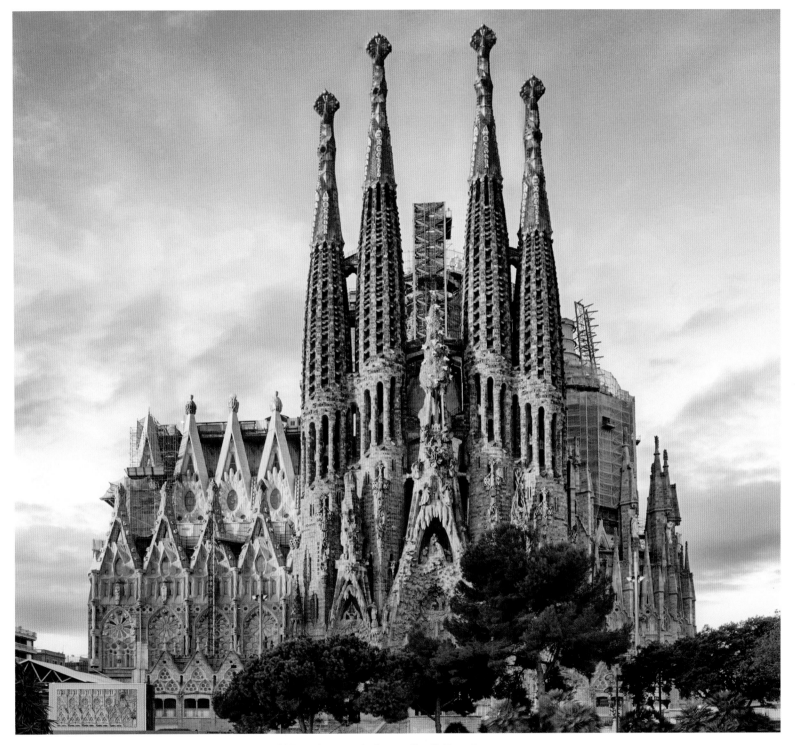

Sagrada Família with Nativity Facade (1883 until present), Antoni Gaudí, Barcelona

As a deeply religious man, Gaudí's architectural starting point was Gothic: spires, "flamboyant" ornamentation, pointed arches, and Christian themes. The Nativity Facade, dedicated to Christ's birth, features statues of Mary, Joseph, and Baby Jesus—the "Holy Family" (or *Sagrada Família*) for whom the church is named.

Gaudí mixed in his trademark "Modernist" (or Art Nouveau) elements: color, curves, and a clip-art collage of fanciful symbols celebrating Barcelona's glorious history. He pioneered many of the latest high-tech construction techniques, including parabolic arches, like those spanning the facade's midsection. He molded concrete to ripple like waves and enlivened it with glass and tile. His vision: a church that would be both practical and beautiful.

Gaudí labored over Sagrada Família for 43 years. As with Gothic cathedrals of old, he knew it would require many generations to complete. The Nativity Facade was Gaudí's template to guide future architects. But he also encouraged his successors to follow their own muses. After Gaudí's death, construction continued in fits and starts, halted by war and stagnation.

Today, the project enjoys renewed life. The site—funded in part by admissions from daily hordes of visitors—bristles with cranking cranes, prickly rebar, scaffolding, and engineers from around the world, trained in the latest technology. More than a century after Gaudí began, they're still at it. It's a testament to the generations of architects, sculptors, stonecutters, fund-raisers, and donors who became captivated by Gaudí's astonishing vision, and are determined to incarnate it in stone. The hoped-for date of completion? The centenary of Gaudí's death: 2026. I'll be there.

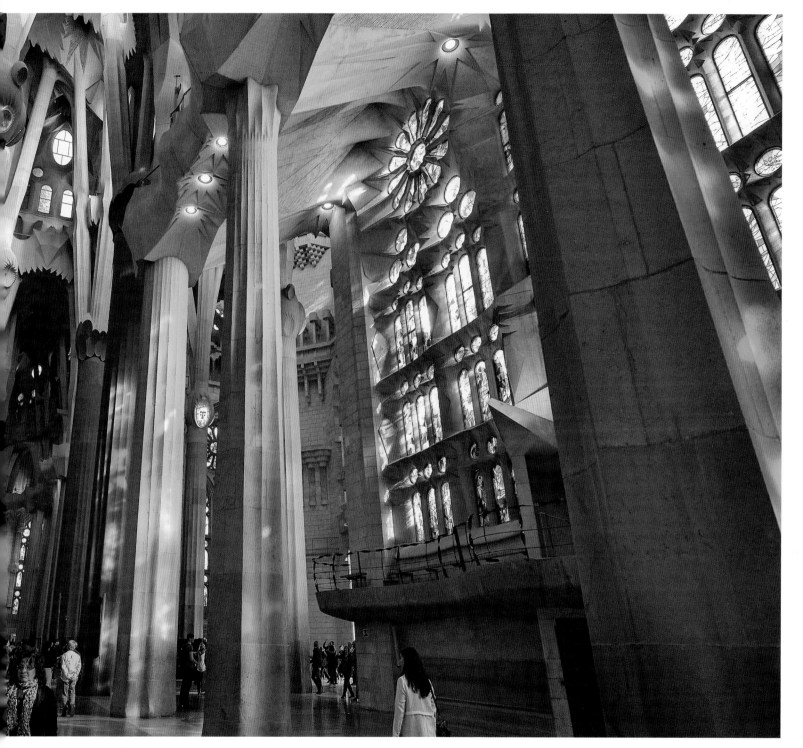

Interior of Sagrada Família (1883 until present), Antoni Gaudí, Barcelona

MANET'S *LUNCHEON ON THE GRASS*

Two well-dressed men and a naked woman have a picnic in the park like it's no big deal. The two men chat while the woman looks out nonchalantly at the viewer. In the background, another woman has stripped down to her slip to wade in the stream.

When the painting debuted in Paris in 1863, it caused a scandal. The shocked public wondered: What are these scantily clad women doing with these men? And what will they be doing after the last baguette is eaten?

The painting also shocked art critics. They could clearly see that Manet was riffing off works by the old masters. But instead of mythological Venuses and idealized nudes, Manet was replacing them with real people in a contemporary setting. The pile of discarded clothes (lower left) says this is not a classical nude but an undressed woman. And, with the fully dressed dandies, their nude companion looks even more naked. This isn't a goddess but a real woman—in fact, the model was Manet's friend and fellow painter. By putting everyday people in a traditional work of art, Manet seemed to be mocking the classics. In fact, he was replacing soft-core porn with hard-core art.

The *Luncheon* reflected the reality of 19th-century Paris. On the one hand, it was the belle époque, or "beautiful age," a time of prosperity, art, beauty, and joie de vivre. But Manet wanted to capture a grittier side. Behind its gilded and gas-lit exterior, Paris was a city of smoke-belching factories, inner-city slums, and revolution in the streets. A counterculture simmered.

Manet sketched in cafés, train stations, and busy Paris streets. He rejected the saccharine goddesses and tried to depict the real life of real people. The style was called Realism.

This is a Realist's take on the classics. Manet rejected the smooth brushwork of traditional art schools that gave everything a gauzy Vaseline-on-the-lens beauty. This woman's skin is pale and harshly lit. Manet used sharp outlines and a strong contrast of colors: white skin, black clothes, green grass.

The painting was purposely clumsy. The leaves are messy, the patches of paint stand out, and the woman in the background is unnaturally large. Manet was calling attention to the fact that this is a painting—a pile of pigment on a flat surface. It was a tiny first step toward that very modern idea that eventually became abstract art.

Manet's *Luncheon* was flatly rejected by Paris' establishment art show, the Salon. Unbowed, Manet exhibited it in the "Salon of the Refused." His daring attracted the next generation of artists. Like Manet, these young artists also chafed against middle-class tastes, rejected conformity, and refused to follow the traditional career path. They rallied behind Manet for his courage and innovations. Manet boldly opened the door for Monet, Renoir, and others, as they went on to found their own revolutionary movement—Impressionism.

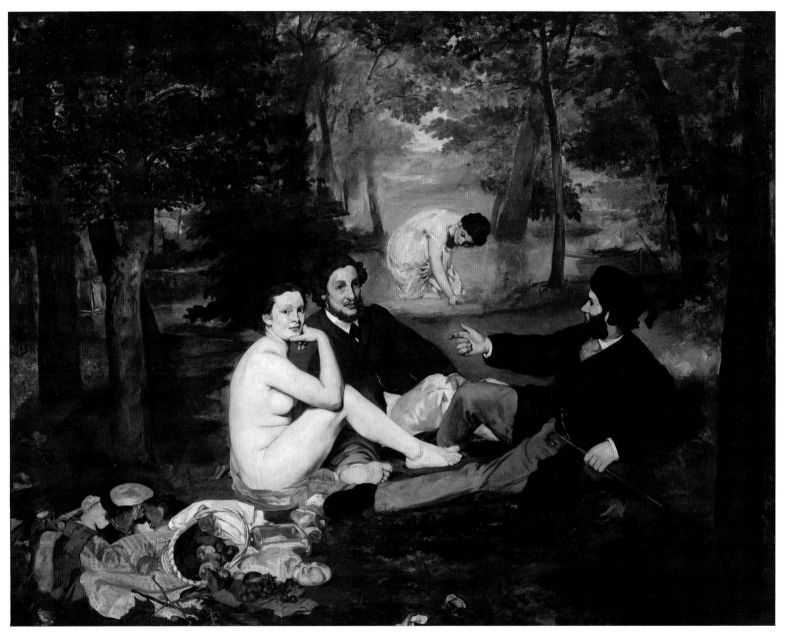

Luncheon on the Grass (1863), Edouard Manet, Orsay Museum, Paris

RENOIR'S *DANCE AT THE MOULIN DE LA GALETTE*

On Sunday afternoons, working-class Parisians would dress up and head for the bucolic hill overlooking Paris called Montmartre. They'd gather in outdoor cafés to dance, drink, and eat little crêpes (called *galettes*) until dark. Renoir would go there, too, to paint the common Parisians living and loving in the afternoon sun.

This painting captures the joyful beauty of France's belle époque, when Paris was a global center of prosperity, technology, opera, ballet, and high fashion. Artists flocked there to catch the magic on canvas.

In Renoir's glowing scene, the sunlight filters through the trees, creating a kaleidoscope of colors, like a 19th-century disco ball throwing darts of light onto the dancers. Renoir conveys the dappled light with quick blobs of yellow paint. The light speckles the ground, the men's jackets, and the sun-dappled straw hats. You can almost smell the fragrant powder on the ladies' faces. The painting glows with bright colors. Even the shadows on the ground, which should be gray or black, are colored a warm blue. The paint is thin and translucent, and the outlines are soft, so the figures blend seamlessly with the background. Like a photographer who uses a slow shutter speed to show motion, Renoir paints a waltzing blur.

Along with his good friend Claude Monet, Renoir embraced Impressionism. Stifled by the stuffy atmosphere of the conventional art scene in Paris, they took as their motto, "Out of the studio and into the open air." They grabbed their berets and scarves (and their newly invented tubes of premixed paint) and set up their easels right on the spot—on riverbanks, hillsides, cafés . . . or in the fields of Montmartre. Gods, goddesses, nymphs, and fantasy scenes were out. Common people in their everyday lives were in. The result? Light! Color! Vibrations! You don't hang an Impressionist canvas—you tether it.

Renoir features Impressionism's trademark bright colors, easygoing open-air scenes, spontaneity, broad brushstrokes, and the play of light. He made this canvas shimmer with a simple but revolutionary technique. Look at the dancing woman to the left, in a "pink" dress. If you look real close, you'd see that the dress is actually a messy patchwork of individual brushstrokes of different colored paint. But as you back up . . . *Voilà!* The colors blend in the eye. So while your eye is saying "pink," your subconscious is shouting, "Red! White! Gray! Blue! Yes!"

Renoir always painted things that were unabashedly pretty—happy scenes of rosy-cheeked women, rendered in a warm, inviting style. As Renoir liked to say, "There are enough ugly things in life."

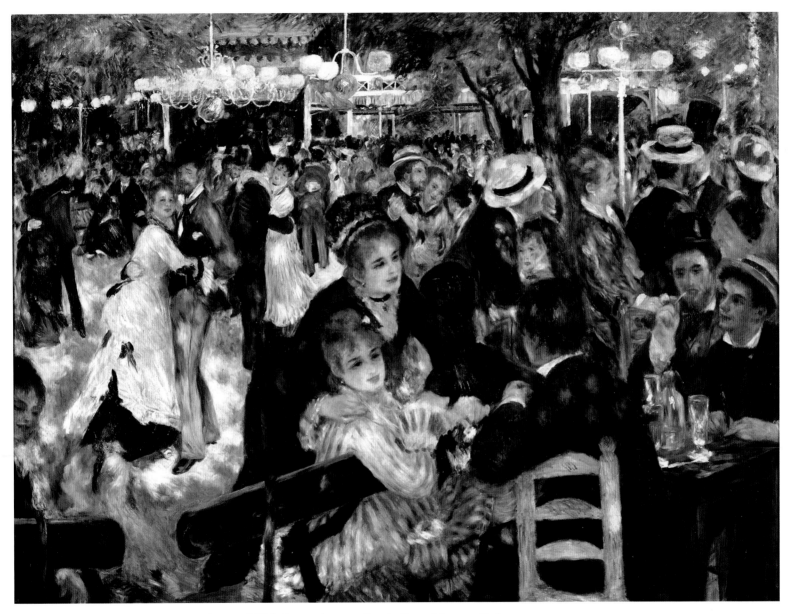

Dance at the Moulin de la Galette (1876), Pierre-Auguste Renoir, Orsay Museum, Paris

DEGAS' *THE DANCE CLASS*

It's a hot summer day in Paris, and the ballerinas are bored, tired of rehearsing. They fan themselves, slump wearily, and tug at their itchy costumes. One dancer plops herself on the piano and scratches her back.

Edgar Degas gives a behind-the-scenes peek at the prestigious Paris Opera's dance company. We're standing at one end of a long rehearsal room, made to seem even longer by the unnaturally receding floorboards and unnaturally small background dancers. In the middle stands Paris' greatest choreographer (and Degas' friend), putting the girls through their paces while beating time with his cane.

This painting was done during a crucial transition time in Degas' life, from privileged art student to avant-garde working artist. Degas was a rich kid who got the best classical-style art training money could buy. He adored the pure lines and cool colors taught in art school. He gained success and a good reputation within the art establishment of Paris, and then . . . he met the Impressionists. He hung out with these outcasts, discussing art, love, and life in the cheap cafés and bars of Montmartre. Degas began to apply the meticulous drawing skills he'd once used for grandiose classical myths to a new subject: everyday Parisian life.

He sketched women at work, making dresses or ironing clothes. Of all his workers, he especially loved professional dancers like these. (Half his paintings featured dancers.) His focus was not so much the onstage glamour as the backstage drudgery required to make this elegant art.

Degas loved the unposed "snapshot" effect, a technique he'd learned from that newfangled invention, the camera. Click! Degas catches these dancers off guard, seen from an odd angle. Some are taking a break and chatting with friends. The girl in the foreground strikes an ungraceful flatfooted pose, while her friend screws her body up, reaching to find that elusive itchy spot. A little dog wanders around aimlessly. For an art-buying public used to glorified goddesses and heroic dramas, this kind of real-life authenticity was truly radical.

Degas is regarded as an Impressionist, and there are elements of that style here. It's a spontaneous "impression" of a single moment. The halo of the tutus captures the play of reflected light. And look at that bright green bow. In the Impressionist style, Degas slopped paint onto her dress and didn't even say, *"Excusez-moi."*

Still, Degas kept his distance from other Impressionists. He looked down on open-air painting, preferring to work in the studio. He rarely painted landscapes, focusing instead on people. And he created his figures not as a mosaic of colorful brushstrokes, but with a more classic technique—outline filled in with color.

In his career, Degas embodied the evolution of 19th-century art—from Classical to Realism to Impressionism. He exalted the everyday and gave dignity to ordinary people.

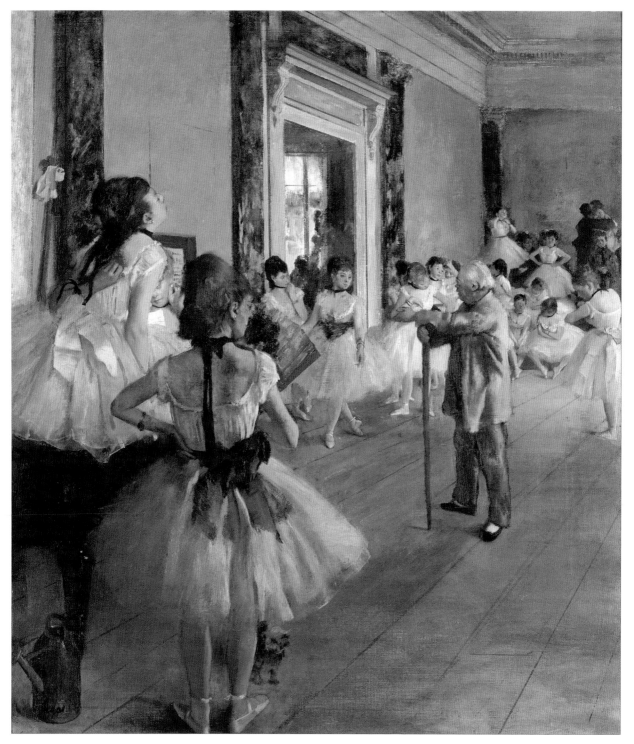

The Dance Class (1874), Edgar Degas, Orsay Museum, Paris

MONET'S ROUEN CATHEDRAL SERIES

Claude Monet is the father of Impressionism. In the 1860s, as if "out of the studio" was his artistic declaration of independence, he began painting landscapes in the open air. But his true subject was not the farms, fields, and flowers, it was . . . light.

Monet took a scientific approach. He studied optics and pigments to know just the right colors he needed to reproduce the shimmering quality of reflected light. The key was to wait until the light was just right—at the "golden hour," to use a modern photographer's term.

Then he'd work furiously, creating a fleeting "impression" of the scene. In fact, it was one of Monet's canvases of an "impression" at sunrise that gave the movement its name. His goal was not painting physical things—he was painting studies in color and light.

Monet is known for his series of works on the same subject: in this case, the Cathedral of Rouen at different times of day.

He used the classic Impressionist process. Monet went to Rouen, rented a room across from the cathedral, set up his easel . . . and waited. His goal, as he put it, was to catch "a series of differing impressions" of the cathedral facade. He had several canvases going at once. Each one was dedicated to a different set of light conditions: "in the morning," "in gray weather," "morning sun," "full sunlight," and so on. In all, he painted 30 versions of the same cathedral from the same angle. Seen together, they're like a time-lapse series showing the sun passing slowly across the sky, creating different-colored light and shadows.

As Monet zeroed in on the play of colors and light, the physical subject—the cathedral—began to dissolve. In fact, in the painter's mind, the cathedral was no longer the subject . . . it's now only a rack upon which to hang the light and color.

Later artists would take things even further . . . boldly throwing away the rack itself, and leaving nothing but abstract patterns of colorful paint. For that reason, the "father of Impressionism" is also known as the "father of modern art."

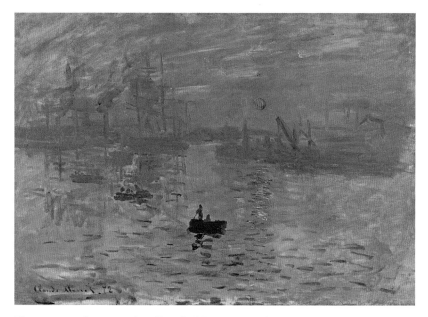

The painting that started it all, called *Impression: Sunrise*

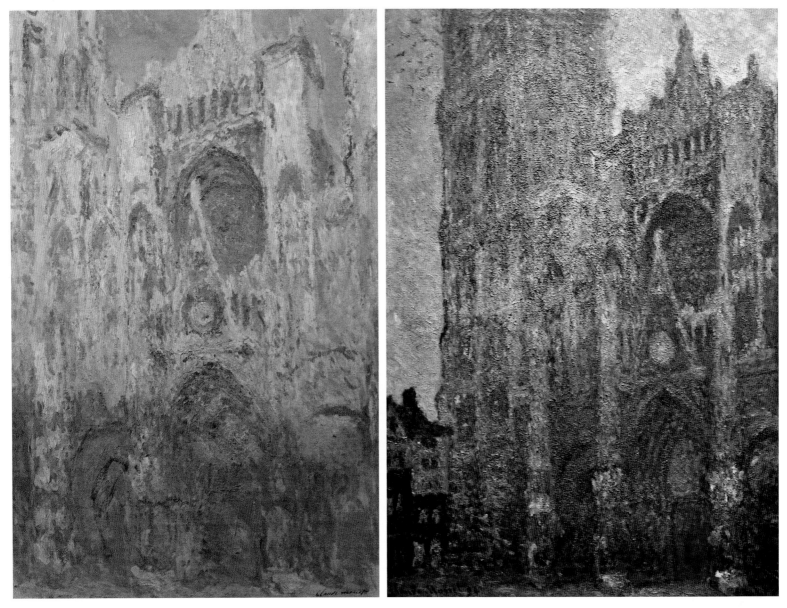

The Cathedral of Rouen (1894), Claude Monet, left: Marmottan Museum, Paris; right: Museum of Fine Arts, Rouen

MONET'S *WATER LILIES*

Monet's *Water Lilies* float serenely in two pond-shaped rooms in a Paris museum. Painted on eight mammoth curved panels, they immerse you in Monet's world. It's like taking a stroll in the gardens at Monet's home, enjoying his tranquil pond dotted with colorful water lilies.

Monet shows the pond at different times of day. Panning slowly around the museum's hall, you can watch the scene turn from predawn darkness to clear morning light to lavender late afternoon to the glorious golden sunset.

Get close to see how Monet worked. Each lily is a tangled Impressionist smudge composed of several different-colored brushstrokes—green, red, white, lavender, blue. Only when you back up do the colors resolve into a single "pink" flower on a "green" lily pad. Monet wanted the vibrant colors to keep firing your synapses.

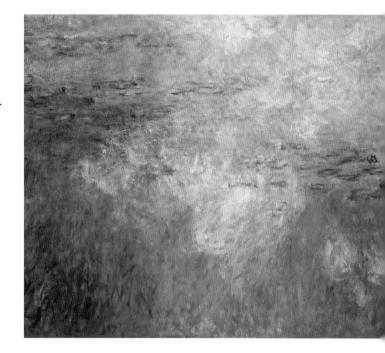

Now step farther back to take in the whole picture. Only then do you see that the true subject is not really the famous water lilies but the changing reflections on the pond's surface. The lilies float among sun-kissed clouds and blue sky reflected in the water. It's the intermingling of the classical elements—earth (the lilies), air (the sky), fire (sunlight), and water—the primordial soup of life.

The canvases at the Orangerie Museum are snapshots of Monet's

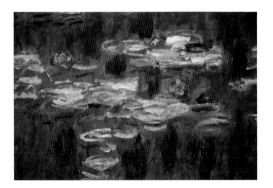

Water Lilies: Green Reflections (detail)

garden. In 1883, middle-aged Monet, along with his wife and eight kids, settled into a farmhouse in Giverny, near Paris. He turned Giverny into a garden paradise. Monet landscaped like he painted—filling the "blank canvas" with "brushstrokes" of shrubs and colorful flowers. He planted a garden with rose trellises, built a Japanese bridge, and made an artificial pond stocked with water lilies (*nymphéas* in French). Then Monet picked up his brush and painted it all—the bridge, trellises, pond—creating hundreds of canvases that brighten museums around the world. His favorite subject of all was the water lilies.

In 1914, Monet, now in his seventies, began a water-lily project on a massive scale. It would involve huge

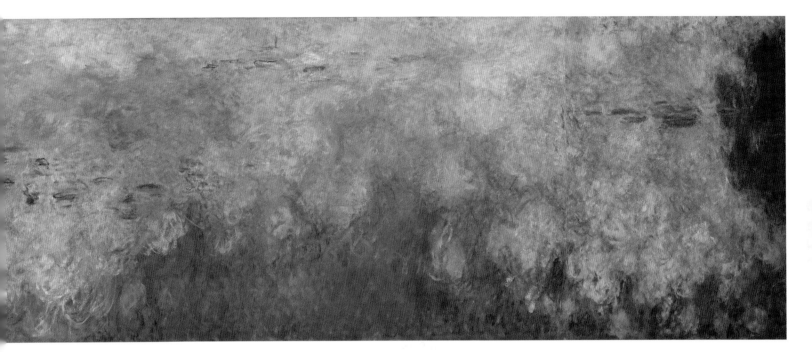

canvases—up to 6 feet tall and 55 feet long—to hang in purpose-built rooms at the Orangerie. Monet worked at Giverny, in a special studio with skylights and wheeled easels to accommodate the big canvases. He worked on several canvases at once, moving (with the sun) from one to the next to capture the pond at different times of day. For 12 years, Monet labored obsessively, even while he—the greatest "visionary," literally, of his generation—was slowly going blind.

Like Beethoven did when going deaf, Monet wrote his final symphonies on a monumental scale. Altogether, Monet painted 1,950 square feet of canvas. In the final paintings, he cropped the scene ever closer, until there's no reference point for the viewer—no shoreline, no horizon, no sense of what's up or down . . . leaving you immersed in the experience. The last canvas shows darkness descending on the pond—painted by an 80-year-old man in the twilight of his life.

Monet never lived to see the canvases in their intended space. But in 1927, the *Water Lilies* were hung as Monet had instructed, in this specially built space to enhance the immersive experience. He'd created what many have called the first modern "art installation."

Water Lilies: The Clouds (1914–1926), Claude Monet, Orangerie Museum, Paris

RODIN'S *THINKER*

Leaning slightly forward, tense and compact, every muscle working toward producing that one great thought, man contemplates his fate. (No constipation jokes, please.)

The Thinker is primal. He's naked, sitting on a rock. He could be a caveman, a Renaissance man, a modern man, or Everyman. Unlike most depictions of thinkers as effete scholars, this guy's a linebacker who's realizing there's more to life than frat parties. It's the first man evolving beyond his animal nature to think the first thought. It's anyone who's ever worked hard to reinvent himself or to make something new or better. Said Rodin: "It is a statue of myself."

This larger-than-life statue—made of bronze, not marble—is typical of Rodin's dynamic work process. *The Thinker* began life as a thought in Rodin's fertile mind. He made sketches. Then he molded a two-foot-tall version of it out of plaster. He conceived it to be just one figure out of 180 in a huge 20-foot-tall wall of figures depicting Dante's Hell. Rodin dubbed this statue "The Poet," as it would represent Dante himself pondering the fate of the troubled souls.

The small-scale *Thinker* intrigued Rodin so much that he decided to give it the full treatment on an epic scale. Though Rodin occasionally chiseled in marble, most of his statues were done in bronze. Rodin began by making a full-size statue out of plaster. This was covered with wax, then a form-fitting plaster mold. Then he poured molten bronze into the narrow space between the mold and the model. After it cooled and hardened, he removed the mold, and—*voilà!*—Rodin had a hollow bronze statue ready to be polished.

Using the same model, Rodin could produce multiple copies. That's why—though the original bronze *Thinker* stands in Paris—there are some 28 other authorized versions around the world. Rodin so identified with this figure that he chose a copy of it to stand atop his own grave.

The Thinker is a fine example of Rodin's favorite subject—the human body. He depicted people in poses that express their inner emotions. His statues are classics that make ordinary people seem noble. Rodin's statues are always moving restlessly. Even the famous *Thinker* is moving; though he's plopped down solidly, his mind is a million miles away.

Rodin loved the "unfinished" look. *The Thinker*'s bronze surface is alive, rippling with frosting-like gouges that reflect the light, so the figure never comes fully to rest in your eye. Combining Impressionist surfaces like this with classical solidity, Rodin became the greatest sculptor since Michelangelo. With a stable base in the classical sculpting tradition, he launched art into the 20th century.

The Thinker has come to symbolize the creative power of the mind. Once inspired with a single thought, anything is possible. It's been said that all of Rodin's work shows the struggle of mind over matter, and of brute creatures emerging from the mud and evolving into a species of thinkers. Hmmm.

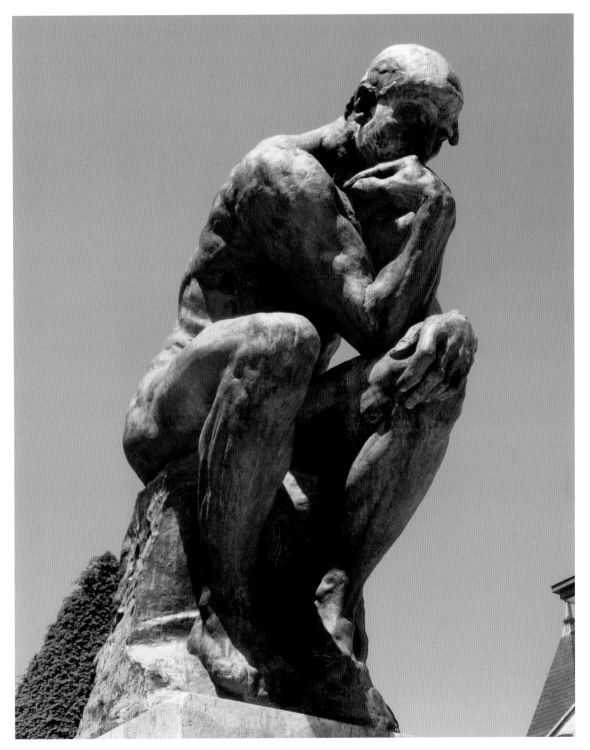

The Thinker (1904), Auguste Rodin, Rodin Museum, Paris

VAN GOGH'S LIFE IN PAINTINGS

Vincent Van Gogh's life is as compelling as his art. You can trace his life's journey through his paintings, as he restlessly roamed Europe in search of his calling.

His story begins in Holland. (Van Gogh was Dutch, and he pronounced his name not like the French "van GO" but like the Dutch "van-HOCK.") Vincent was a pastor's son from a small town. He spent his youth helping poor peasants and coal miners. His first paintings—of gray skies and crude peasants—are as unsophisticated as the rural Dutch world he called home.

In 1886, he moved to Paris, where he hung out with the bohemians in Montmartre. He drank cheap wine and absinthe, and caroused with his neighbor Toulouse-Lautrec. He learned the Impressionist technique, but he added his own twist to it: thicker brushstrokes, more striking colors, and wavy black lines, to evoke deeper emotions and a sense of mystery.

At 35 years old, with his career in art seemingly going nowhere, the Dutchman left dizzying Paris. He traveled to the south of France, and it was a revelation.

Sunshine! Rolling fields! Friendly people! Day after day, he set up his canvas in the open air, and—for the next two years—cranked out masterpieces. He feverishly painted the landscape, the farms, the simple workers, the cypress trees, the house where he lived, the bars where he drank, the postman he befriended, and the starry nights over the Rhône River. He also painted his own tiny room, where he lived, a Dutchman among the French, an artist living alone on his solitary path.

(continued)

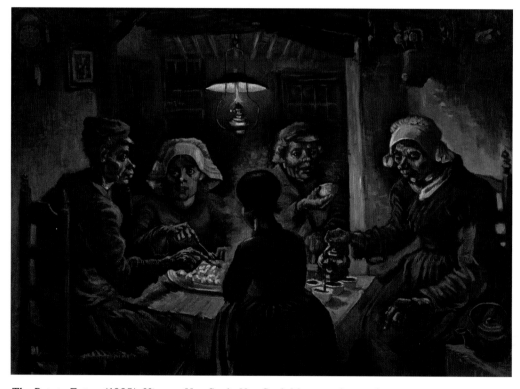

The Potato Eaters (1885), Vincent Van Gogh, Van Gogh Museum, Amsterdam

Terrace of a Café on Montmartre (1886), Vincent Van Gogh, Orsay Museum, Paris

The Bedroom (1888), Vincent Van Gogh, Van Gogh Museum, Amsterdam

Café Terrace at Night (1888), Kröller-Müller Museum, Netherlands

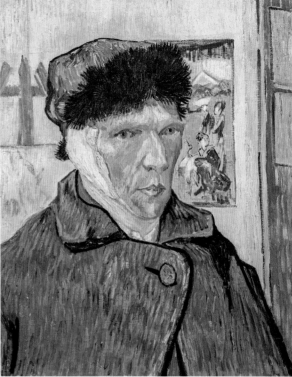

Self-Portrait with Bandaged Ear (1889), Courtauld Gallery, London

Vincent dreamed of making Arles a magnet for fellow artists. He persuaded Paul Gauguin to join him there. At first, the two got along well, but within a few months, their relationship deteriorated. It culminated in an event that would change Vincent's life—and art—forever.

On the night of December 23, 1888, Vincent van Gogh went ballistic. He and his friend Gauguin had been out drinking, as usual. Drunk, self-doubting, clinically insane, and enraged by Gauguin's smug superiority, he waved a knife in Gauguin's face, and later that night cut off a piece of his own ear.

The local paper reported it like this: "At 11:30 p.m., Vincent Vaugogh (sic), painter from Holland, appeared at the brothel at no. 1, asked for Rachel, and gave her his cut-off earlobe, saying, 'Treasure this precious object.' Then he vanished."

Vincent woke up the next morning at home with his head wrapped in a bloody towel and his earlobe missing. Gauguin had hightailed it back to Paris, and the locals were persuading the mad Dutchman to get help.

One week later, Vincent was in the local hospital. They let him paint as part of his therapy, and the result is one of his most remarkable self-portraits. He shows himself in front of the blank canvas, trying to paint himself. He's wearing a fur cap and a heavy overcoat—it's winter. He still has the bandage over his ear. He painted with his trademark thick brushstrokes and clashing colors, but—amid the swirling turbulence—there's a calm at the

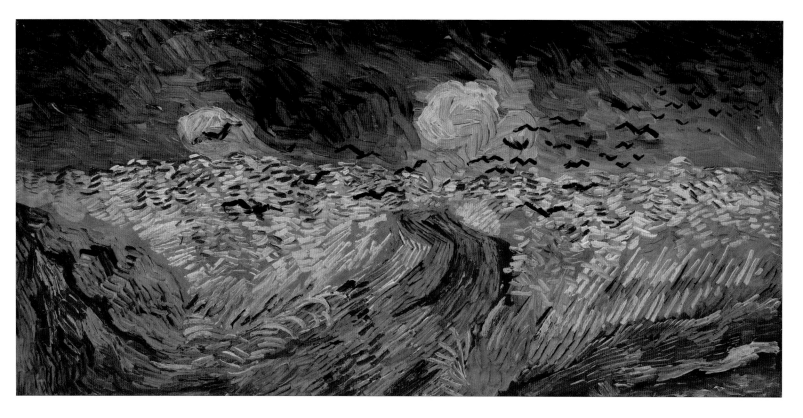

Wheatfield with Crows (1890), Vincent Van Gogh, Van Gogh Museum, Amsterdam

center of the storm . . . the eyes. His gaze is steady, like he's looking at himself in the mirror and taking stock of himself. Like, what did I just do? And what kind of crazy stuff is coming next?

After a year in the hospital (where he produced more than 100 paintings), Vincent traveled to Auvers-sur-Oise (a pleasant town north of Paris) to enter the care of a doctor. He was advised to throw himself into his work as a remedy for his illness. Vincent spent the last 70 days of his life in this little town, knocking out a masterpiece each day. Alcohol-free, he did some of his wildest work. With thick, swirling brushstrokes and surreal colors, he made his placid surroundings throb with restless energy.

Then, on July 27, 1890, Vincent wandered into a nearby wheat field and shot himself. No one knows why. He died of his injuries two days later.

Vincent Van Gone.

But he has certainly lived on in the world of art. The obscure artist who sold only one painting during his lifetime became one of the most influential. His intense colors influenced the Fauves, and his thick paints were adopted by the Expressionists. But most of all, it was his very personal approach to art that would serve to inspire generations of artists of all fields to follow their passions.

MUNCH'S *THE SCREAM*

On a lonely bridge, an emaciated figure (man? woman? fetus?) claps his hands to his face, opens his mouth and eyes wide, and . . . screams. The sound swirls up through his whole body and bleeds out his terrified skull, echoing until it melts into a blood-red sky. We can "hear" this soundless scream in the wavy lines that oscillate like sound waves.

In this famous work, Edvard Munch captured the anxiety of modern life. In fact, it's angst literally personified.

While some see this as a man screaming, others think he's covering his ears to avoid hearing a scream. Or it's both, like hearing some infernal, never-ending noise—the voices in your head—until you just want to scream.

Munch (pronounced "moonk") said it was inspired by an actual event. While walking with friends, he was suddenly overcome with the sensation that all of nature was forever screaming. In the painting, the two other men walk on, seemingly oblivious to the noise only he can hear. Munch communicated this inner sensation with snaking lines and shrieking colors. He enhanced the thick soup of paint by mixing in pastels.

Norway's long, dark winters and social isolation have produced many gloomy artists, but none gloomier than Munch. Many see the screaming figure as autobiographical. It's the scream of a man who'd seen his mother and sister die young, failed in love, drank too much, flew into rages, heard voices in his head, failed in the art world, and ended up living alone surrounded only by his "children"—hundreds of unsold paintings.

The Scream is actually quite different from Munch's other work, where he followed traditional Nordic themes of doom and gloom in a realistic style. Like the Norwegian Romantics, he saw nature as charged from within by an awe-inspiring life force.

But *The Scream* was groundbreaking. Where others captured terror on canvas with realistically gruesome events (hunger, disease, murder), Munch did it by distorting an everyday scene. He bends and twists it into a landscape of unexplained terror. Any sense of normal 3-D depth created by the bridge gets compressed into a claustrophobic wall of swirling colors.

Just five years after painting *The Scream,* Munch suffered a nervous breakdown and entered a mental clinic. He emerged less troubled . . . and less creative. His later paintings were brighter, but less daring. He labeled *The Scream* "the work of a madman."

But this innovative painting rippled out, like the echoes of a scream. By fusing the bold colors of Fauvism, the curved lines of Art Nouveau, and the emotional intensity of Van Gogh, Munch had pointed the way to a new style—Expressionism. Later artists used such lurid colors, distorted figures, and troubled imagery to "express" their inner turmoil and the angst of the modern world.

The Scream even entered pop culture. The horrified face was used in ads, Halloween masks, and emojis. In many ways, we have Munch to thank for the end of pretty, realistic paintings, and the emergence of the distorted, confrontational, and often ugly style we call modern art.

Modern art?!! "No-o-o-o-o-o-o-o-o-o-o-o-o-o!"

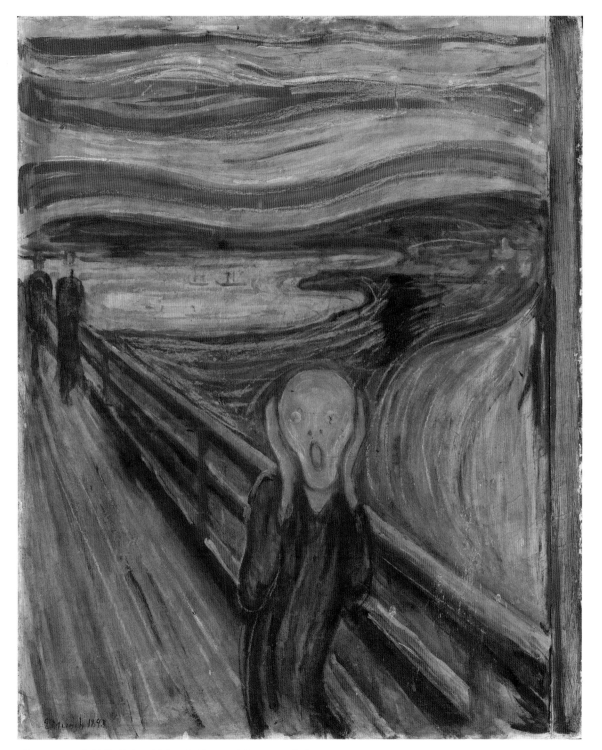

The Scream (1893), Edvard Munch, National Museum, Oslo

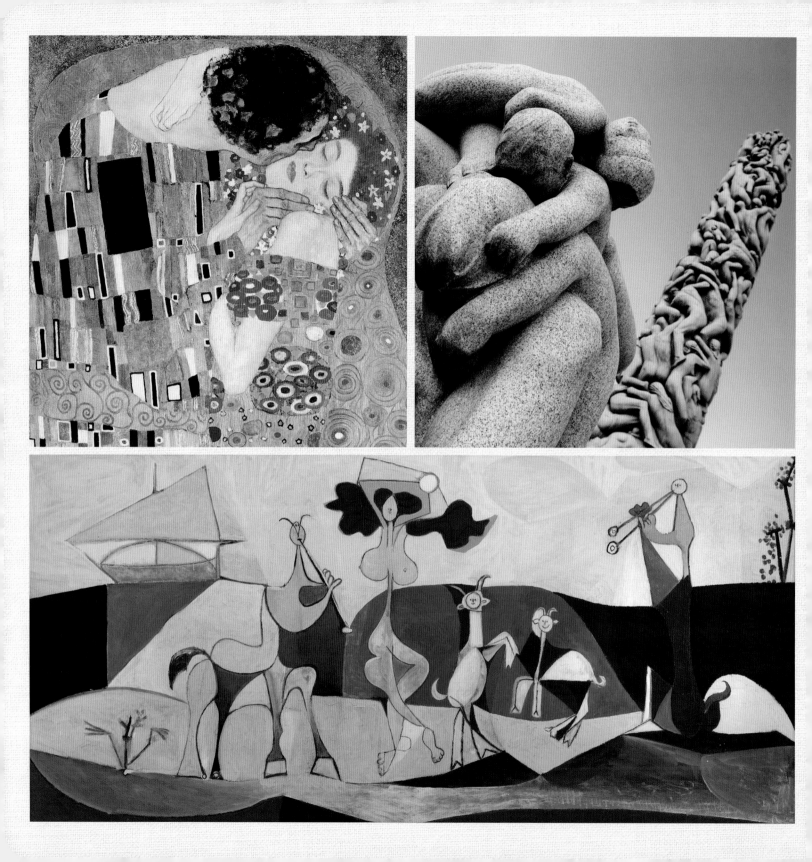

20TH CENTURY

Some people hate modern art.

Why is it so bizarre? Why doesn't it look like the real world? Better to ask: Why is the modern world so bizarre? In the 20th century, the world was shattered by war and accelerated by technology. The art reflects the chaotic turbulence of that century of change.

With the camera, realistic art was obsolete. With mass production, handmade art became an economic dinosaur. Artists turned to art that was not functional or realistic, but could be appreciated for its personal message, technique, and hidden meanings. They stressed originality and innovation over sheer beauty.

The art world shattered into dozens of styles and "isms." The Fauves used bright colors and simplified lines to capture pure beauty. Expressionists distorted reality to express angst. Abstract artists employed nothing but colors and shapes to convey their ideas and emotions. Cubists shattered reality into geometric shards (perfect for capturing the chaos of war, for example). And Surrealists jumbled reality in a blender and served it hot on a canvas, as a kind of snapshot of their inner landscape.

While the styles have changed, some themes have endured since cavemen were carving fertility figures 20,000 years ago. The constant seems to be the human form as the perfect symbol of the world at large. Since the beginning of time, artists have been showing us romantic love, family, joy, beauty, suffering, and hope springing eternal . . . the human condition.

KLIMT'S *THE KISS*

A couple kneels on the edge of a grassy precipice. The man bends down to kiss the woman on the cheek. Their bodies intertwine: He cups her face in his hands; she presses against him and wraps one arm around his neck while touching her other hand to his. The two lovers are wrapped up in the colorful gold-and-jeweled cloak of bliss. It's just the two of them, lost in the golden glow of the moment.

The Austrian painter Gustav Klimt was channeling the erotic spirit of turn-of-the-century Vienna. The city was wealthy and sophisticated, but also the capital of a fading Old World empire—making it a splendid laboratory of decadence and hedonism. To Klimt, all art was erotic art. He loved painting alluring women and embracing couples. (Some suggest the man in *The Kiss* is Klimt himself.) Though he gained a bad-boy reputation for wallowing in the degenerate side of sensuality, Klimt made *The Kiss* all about sweetness: the innocent affection of two people in love.

Klimt's technique reinforces *The Kiss*' romantic side. He used real gold and silver (along with traditional oil paints) to give it the radiant glow of desire. He emphasizes the man's masculinity with a robe of sturdy geometrical shapes, while the woman is all flowery femininity. The couple comes together in a harmony of color. The shimmering patterns on the robes—flowers, vines, swirls, and rectangles—are similar to what Art Nouveau interior decorators were putting on chairs, dishes, and bedroom walls in sumptuous Viennese apartments. Klimt sets the whole scene of *The Kiss* inside a perfectly square frame, enclosing the lovers in a world of their own.

The Kiss stands on the cusp between traditional 19th-century art and 20th-century Modernism. On the one hand, it's a pretty realistic scene of two people. But there's no background giving it 3-D depth, and the whole scene flattens out into a 2-D cardboard-cutout of patterns and colors—foreshadowing abstract art.

But *The Kiss* is about passion, not analysis. The couple glows with an inner radiance, lost in a world full of pollen and pistils. The only thing that emerges from this 2-D pattern of paint is the woman's face. She turns out, and we can see her reaction: Her eyes close, her cheeks flush, a faint smile paints her lips, and she squirms in pleasure, as she succumbs to the pleasure of *The Kiss*.

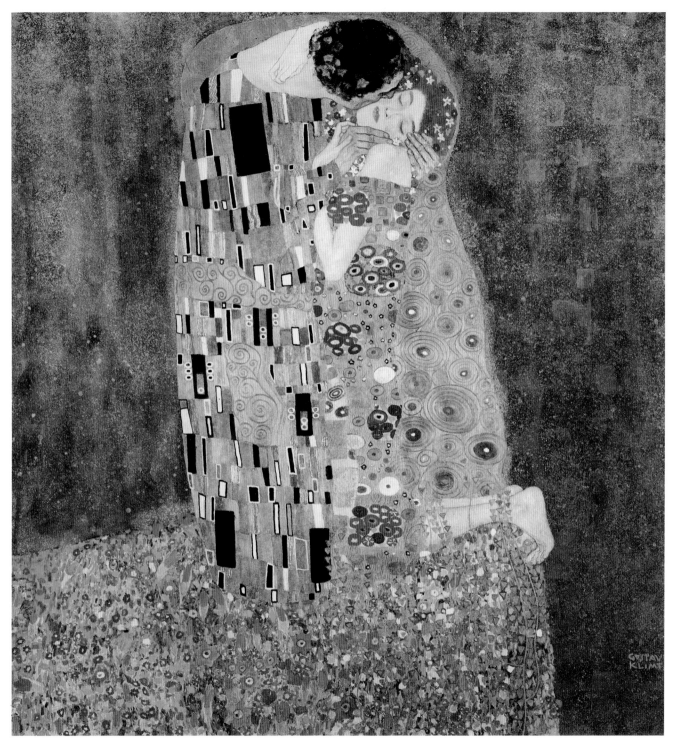

The Kiss (1908), Gustav Klimt, Belvedere Palace, Vienna

MATISSE'S *THE DANCE*

Five people strip naked, join hands, and go ring-around-the-rosy, creating an infectious air of uninhibited freedom. They dip their heads, lift their legs, and circle with abandon, lost in the beat of the music, dancing like no one's watching. Their bodies burn an intense red, charged from within by the life force. In the frenzy of movement, the woman in front trips and falls forward, but her partner reaches back to grab her, keeping the circle spinning.

The scene is primal, wild—a pagan bacchanal. Henri Matisse was one of the notorious artists labeled the Fauves—"wild beasts." Inspired by African masks and voodoo dolls, they tried to inject a bit of the jungle into the stuffy European scene. The result? Modern art that looked primitive. These dancers have masklike faces and crudely drawn bodies. The colors clash unnaturally—bright red dancers on a blue-and-green background.

The painting is not intended to be realistic. The blue "sky" in the background is just as close as the green "hill" in the foreground, so any illusion of 3-D depth gets flattened into a 2-D wall of color. Traditionally, the canvas was like a window you looked "through" to see the real world stretching off into the distance. But with Matisse, you look "at" the canvas, like wallpaper. *Voilà!* What was a crudely drawn scene now becomes a sophisticated pattern of colors and shapes.

Matisse simplifies. Two lines make a butt. An oval is a stomach, and a breast is a U with a dot in it. Matisse, the master of leaving things out, could suggest an entire body with just a few curvy lines . . . and let your imagination fill in the rest.

The painting's power is not in its realism but in the rhythmic pattern and emotionally charged colors. The undulating line that joins the dancers creates a hypnotic pattern. This simple design radiates mojo.

The Dance is a landmark in the evolution of modern art. Matisse combined the emotionally charged colors of Van Gogh, the primitive figures of Gauguin, and Cezanne's simplified forms, then suggested what would come next: purely abstract art.

Matisse painted *The Dance* at the same time Picasso was pioneering Cubism and Stravinsky was composing his tribal-sounding *Rite of Spring*. Some see Matisse's painting as a pantheistic celebration of the pagan cosmos—blue sky, green earth, and fiery humans—coming together in the most primal form of human expression: dance. From the cradle of primitivism, modern art was being born.

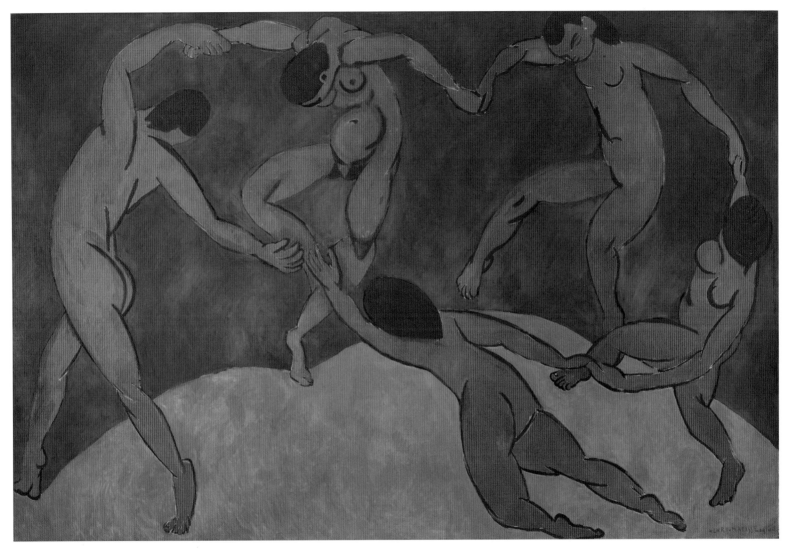

The Dance (1910), Henri Matisse, The Hermitage, St. Petersburg

PICASSO'S MANY STYLES

Pablo Picasso was the most famous and—OK, I'll say it—the greatest artist of the 20th century. Always exploring, he became the master of many styles (Cubism, Surrealism, and so on) and of many media (painting, sculpture, and so on). But he always managed to make everything he touched look unmistakably like "a Picasso."

Picasso's teenage works are stunningly realistic and show mature insight into the people he painted. At 19, the Spaniard moved from Barcelona to Paris, the center of the art world. He painted beggars and social outcasts, showing the empathy of a man who was himself a lonely outsider. These works mark his Blue Period, so-called because their dominant color matches their melancholy mood.

Picasso was jolted out of his Blue Period (early 1900s) by the avant-garde trends bubbling around him. Artists were rejecting traditional 3-D, attracted to the "flat" look of primitive art. Picasso began playing with the building blocks of line and color. At his Montmartre studio in Paris, he and his neighbor Georges Braque worked together, in poverty so dire they often didn't know where their next bottle of wine was coming from. They emerged with a new way to portray the world, where the painting looks as though it was built with blocks. It came to be called Cubism.

It was as if Picasso had shattered a glass statue, picked up the pieces, and glued them onto a canvas. The subjects—a "seated nude," a "girl with mandolin," a "bottle of rum"—are somewhat recognizable (with the help of the titles), but they're built with geometric shards (or "cubes"). The cubes overlap, so the subject and foreground are woven together, and the subject dissolves into a flat pattern. A Cubist painting is a kind of Mercator projection, where the round world is sliced up like an orange peel and then laid as flat as possible. You can see the front and the back at the same time.

(continued)

Science and Charity (1897), Pablo Picasso, Picasso Museum, Barcelona

Motherhood (1903), Pablo Picasso, Picasso Museum, Barcelona

Seated Nude (1909), Pablo Picasso, Tate Modern, London

Having revolutionized the art world before he was 30, Picasso just kept changing with the times. He turned to "cubes" that were more colorful, curved, and flatter, like paper cutouts (what's called Synthetic Cubism). After he married and had kids, he entered a classical period (the 1920s) of more realistic, full-bodied women and children. As his relationships with women deteriorated, he vented his sexual demons by twisting the female body into grotesque balloon-animal shapes (Surrealism). Throughout his life, Picasso's favorite subject was people. The anatomy might be jumbled, but it's all there.

In the 1930s, Picasso used the whole range of his styles to create his monumental mural *Guernica*. He distorted reality just enough to capture the horror of war.

Picasso spent the final years of his life on the French Riviera, consorting with women half his age. He made pottery and collages, and built statues out of wood, wire, and everyday household objects. These kinds of multimedia works have become so standard today that we forget how revolutionary they were when Picasso invented them. He also painted sunny, childlike pictures of birds, goats, fish, and frolicking beach-goers. His simple doves became an international symbol of peace.

Picasso celebrated the freedom to be playful in his art by saying, "It took me four years to paint like Raphael, but a lifetime to paint like a child."

Two Women Running on the Beach (1922), Pablo Picasso, Picasso Museum, Paris

The Pigeons (1957), Pablo Picasso, Picasso Museum, Barcelona

PICASSO'S MANY WOMEN

Pablo Picasso has been portrayed many ways: staggering genius, abusive womanizer, psychological explorer . . . or maybe all of the above. His portraits of women over the years are a kind of snapshot not only of them, but also of his own emotional state as he evolved as an artist and as a man.

Start with the first great female presence in his life—his mother. Pablo was born in Spain (with all the classic *machismo* that came with it). He was 15 when he painted his mother. It's very tender, showing her in a thoughtful pose, in a sheer and delicate white dress. It's almost photorealistic, a style Picasso mastered completely before turning to his later abstract stuff. Check out the way he signed this portrait: "Ruiz Picasso." Eventually, he'd drop the surname of his overbearing father—Ruiz—and keep the name of his saintly mother—Picasso.

Next, we fast-forward to Paris, where Picasso lived for the next 40 years. Here he became famous, hanging out with other expatriates from around the globe, from Hemingway to Gertrude Stein to Igor Stravinsky. Over the years, Picasso had many wives, mistresses, and girlfriends. He often painted one girlfriend in particular, Dora Maar, who was a well-known photographer. She was the one who took those famous photos of Picasso in his studio while he was working on *Guernica*. In the portrait called *The Weeping Woman*, Dora is shown with tears streaming down her face. No wonder. Here she is in love with an egomaniac, who's still married, and who even refuses to give up his other mistress.

In Picasso's last years, he moved to the French Riviera. This is the Picasso many people think of—older, dressed in rolled-up white pants and a striped shirt, and hanging with his Riviera neighbors Henri Matisse and Marc Chagall. In Antibes, Picasso painted yet another of his mistresses. He called it *La Joie de Vivre*—the joy of life. The painting is a Greek myth come to life, featuring dancing nymphs. It's easy to imagine that the old goat playing the flute is Picasso himself, now in his sixties. In the center stands a beautiful woman less than half his age—his latest mistress, the painter Françoise Gilot. This painting sums up the joie de vivre of Picasso's last years—sunny, lighthearted, playful. While he fathered his last child at the age of 69, he was still creating art when he died at 91.

All his life, through all his stylistic changes, Picasso painted the human form, and almost all of those were women he knew. They were his muses. It seemed that each time he fell in love, the result was a new breakthrough in art history. Picasso was a great lover, and a great lover of art. As he put it: "It is your work in life that is the ultimate seduction."

Portrait of the Artist's Mother (1896), Pablo Picasso, Picasso Museum, Barcelona

The Weeping Woman (1937), Pablo Picasso, Tate Modern, London

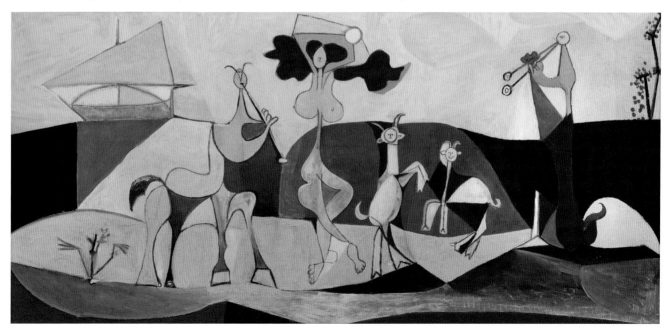

La Joie de Vivre (1946), Pablo Picasso, Picasso Museum, Antibes, France

PICASSO'S *GUERNICA*

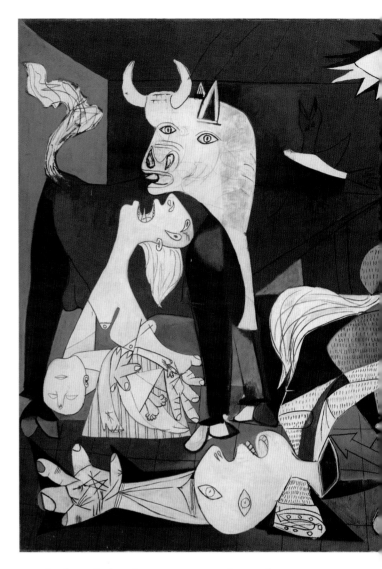

This monumental canvas—more than 25 feet wide—is not only a piece of art but a piece of history, capturing the horror of modern war in a modern style.

It depicts a specific event. On April 26, 1937, Guernica—a Basque market town in northern Spain—was the target of the world's first saturation aerial-bombing raid on civilians. Spain was in the midst of the bitter Spanish Civil War (1936–1939), which pitted its democratically elected government against the fascist general Francisco Franco. To quell the defiant Basques, Franco gave permission to his fascist confederate Adolf Hitler to use the town as a guinea pig to try out Germany's new air force. The raid leveled the town, causing destruction that was unheard of at the time (though by 1944, it would be commonplace).

News of the bombing reached Pablo Picasso, a Spaniard living in Paris. Horrified at what was happening back in his home country, Picasso immediately set to work sketching scenes of the destruction as he imagined it . . .

The bombs are falling, shattering the quiet village. A woman howls up at the sky, horses scream, and a man falls to the ground and dies. A bull—a symbol of Spain—ponders it all, watching over a mother and her dead baby . . . a modern pietà.

Picasso's abstract, Cubist style reinforces the message. It's like he'd picked up the bomb-shattered shards and pasted them onto a canvas. The black-and-white tones are as gritty as the newspaper photos that reported the bombing, creating a depressing, sickening mood.

Picasso chose universal symbols, making the work a commentary on all wars. The horse with the spear in its back symbolizes humanity succumbing to brute force. The fallen rider's arm is severed and his sword is broken, more symbols of defeat. The bull, normally a proud symbol of strength, is impotent and frightened. The scared dove of peace can do nothing but cry. The whole scene is lit from above by the stark light of a bare bulb. Picasso's painting threw a light on the brutality of Hitler and Franco. And, suddenly, the whole world was watching.

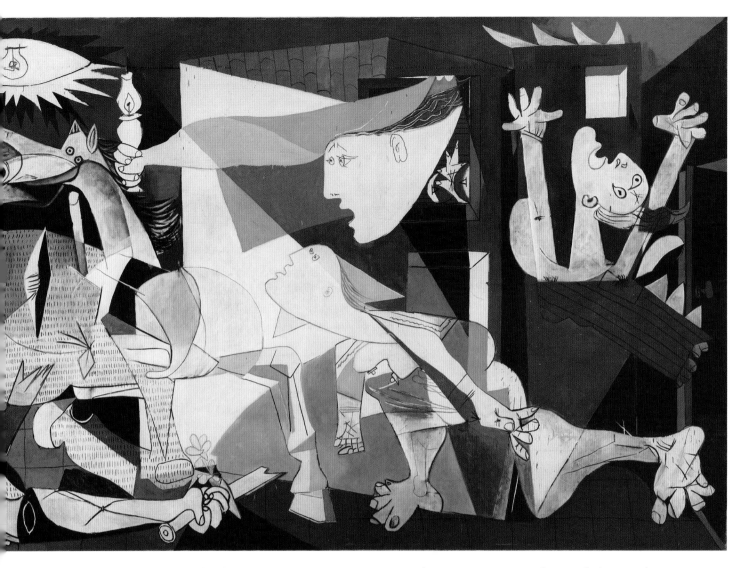

The painting debuted at the 1937 Paris exposition and caused an immediate sensation. For the first time, the world could see the destructive force of the rising fascist movement—a prelude to World War II.

Eventually, Franco won Spain's civil war and ended up ruling the country with an iron fist for the next 36 years. Picasso vowed never to return to Franco's Spain. So *Guernica* was displayed in New York until Franco's death (in 1975), when it ended its decades of exile.

Picasso's masterpiece now stands in Madrid as Spain's national piece of art.

With each passing year, the canvas seems more and more prophetic—honoring not just the thousands who died in Guernica, but the 500,000 victims of Spain's bitter civil war, the 55 million of World War II, and the countless others of recent wars. Picasso put a human face on what we now call "collateral damage."

Guernica (1937), Pablo Picasso, Centro de Arte Reina Sofia, Madrid

CHAGALL'S *NEWLYWEDS*

From the title, it's not hard to get the gist of this playful painting. A couple has just gotten married (see the two tiny figures on the far left). Then the groom changes into a spiffy purple suit and whisks his bride off to the wedding reception at the Eiffel Tower (rising blue in the background). There, musicians serenade them, a naked lady catches the wedding bouquet, a six-foot rooster shows up, and . . . well, things get a little crazy, as weddings can.

Though the imagery is bizarre and very personal, it was Chagall's way of telling his life story in his paintings.

The happy couple—floating with the lighter-than-air bliss of love—is Chagall himself and his wife Bella. She was the love of his life and his inspiration, and he painted her many times. "In both art and life," Chagall once said, "anything is possible, as long as there is love." Flying lovers became Chagall's trademark, suggesting how the thrill of love can carry you away from the gravity of mundane cares and into a magical realm of infinite possibility.

The ramshackle village (lower right) is Chagall's humble hometown in Russia, which he remembered fondly for its simple earthy pleasures (represented by the smiling goat at the top). He had strong Jewish roots, as seen in symbols like the candlestick (lower right), the Torah student (top) and the couple getting married under the traditional Jewish canopy (left). Chagall's signature fiddler-on-the-roof motifs helped form the world's image of turn-of-the-century European Judaism.

In 1910, 22-year-old Chagall was introduced to the second love of his life: the city of Paris (represented by the Tower and the modern skyline beneath). There he soaked up the latest avant-garde trends—Cubist shards, Fauvist colors, and the jumbled symbols of Surrealism—and fused them into his unique style. Lovers are weightless with bliss. Animals smile and wink. Musicians, poets, peasants, and dreamers ignore gravity, tumbling in slow-motion circles high above the rooftops. The colors are deep, dark, and earthy—a pool of mystery with figures bleeding through below the surface. (Chagall explained that his early poverty forced him to paint over used canvases, inspiring the overlapping images.) The unearthly colors create a mystical ambience. To Chagall, humans loving each other mirrored God's love of creation.

Note the date when this painting was done: 1938–1939. Chagall's exhilarating years in Paris with Bella were about to end. Nazis soon occupied Paris, driving the Chagalls into exile. The Holocaust decimated their beloved heritage. Then Bella suddenly took sick and died. For a time, Chagall stopped painting completely.

But at war's end, Chagall settled down on the sunny French Riviera. He gained worldwide acclaim, doing large-scale murals and stained glass. He combined Jewish, Christian, and secular imagery to celebrate cross-cultural brotherhood. And he fell in love again with a woman who gave him a second wind. Time and again, he returned to painting his favorite theme: two lovers, arm-in-arm, floating in dreamy bliss over the rooftops of the everyday world.

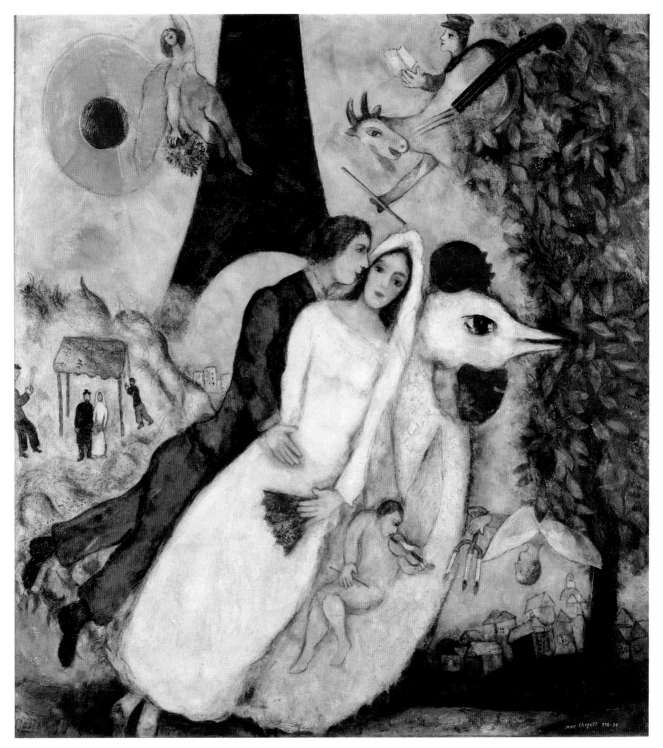

Newlyweds on the Eiffel Tower (1939), Marc Chagall, Pompidou Center, Paris

VIGELAND'S *MONOLITH OF LIFE*

In a park in Oslo—where children play, couples embrace, and old people reflect—you'll find nearly 200 statues of people engaged in those same primal human activities. It's a lifetime of work by Norway's greatest sculptor, Gustav Vigeland.

In 1921, Vigeland struck a deal with the city. In return for a great studio and state support, he'd spend his creative life beautifying Oslo with this sculpture garden. From 1924 until his death in 1943 he worked on-site, designing 192 bronze and granite statue groupings—600 figures in all, each unique.

Vigeland's sturdy humans capture universal themes of the cycle of life—birth, childhood, romance, struggle, childrearing, growing old, and death. His statues laugh, cry, jump for joy, and hug each other in sorrow. The bittersweet range of human experience was sculpted by a man who'd seen it all himself: love, failed marriages, children, broken homes, war, death—a man who did not age gracefully.

For generations, the people of Oslo have made Vigeland's timeless people a part of their own lives. The park is treated with respect: no police, no fences—and no graffiti. Vigeland created an in situ experience that is at once majestic, hands-on, entertaining, and deeply moving.

Vigeland was inspired by Rodin's naked, restless, intertwined statues. Like Rodin, Vigeland explored the yin-yang relationship of men and women. Also like Rodin, Vigeland did not personally carve most of his statues. Rather, he made models that were executed by a workshop of assistants.

Strolling the park, you'll cross a 300-foot-long bridge lined with statues, including the famous *Angry Boy*. He stomps his feet, clenches his fists, and screams—just like two-year-olds have since the beginning of time. (It's said Vigeland gave a boy chocolate and then took it away to get this reaction.) Next comes a huge fountain, where water—the source of life—cascades around the statues. Vigeland consciously placed his figures amid the park's landscaping to show how mankind is intimately bound up with nature.

The most striking thing about these statues is they're all so darn naked. This isn't the soft-focus beauty of nubile nymphs, but the stark reality of penises, scrotums, vulvas, breasts, and butts. These people are naked Homo sapiens.

In the center of the park, high on a hill, is the *Monolith*, a 46-foot granite pillar surrounded by 36 free-standing statues. Here, Vigeland explores a lifetime of human relationships. A mother bends over to care for her kids. Two lovers nestle nose to nose. A father counsels his son. An old man cradles his emaciated wife.

Vigeland's final great work was the *Monolith* itself. It was carved from a single 180-ton block of granite, and took three sculptors 14 years to carve. The pillar teems with life, a tangle of bodies. More than 120 figures—men, women, old, young—scramble over and around each other as they spiral up toward the top. What are they trying to reach? Success? Happiness? Mere survival? God? Vigeland never said. But whatever it is that drives the human race to aspire to better things, it's clear that we're all tied up in it together.

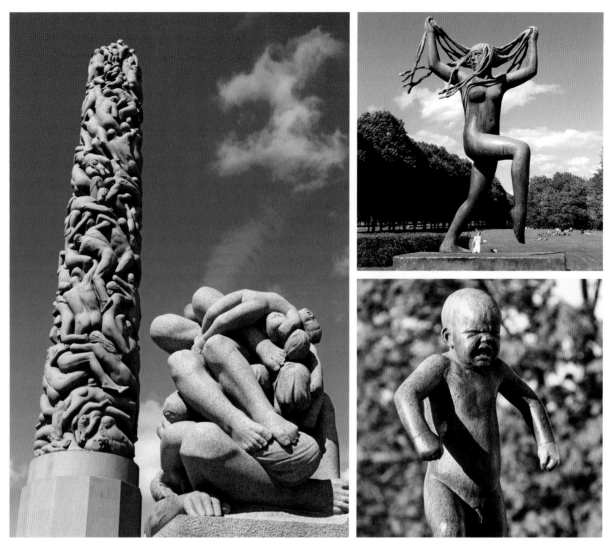

Monolith of Life, *Dancing Young Woman*, and *Angry Boy* (1924–1943), Gustav Vigeland, Vigeland Park, Oslo

CONGRATULATIONS!

You've completed your grand tour of Europe's art.

We hope you've enjoyed these 100 masterpieces. Art connects us with our past and it points the way to a better future. As if tumbling together in Vigeland's *Monolith*, art reminds us that we're all in this together.

Perhaps the artists in this book will inspire you to add more creativity to your own life. Or to visit Europe and enjoy its wonderful art in person. Whether you're traveling or just letting art take you away . . . bon voyage!

RICK STEVES' TV CLIPS ON FEATURED ART

Each masterpiece listed below is featured in a short TV clip on my free Classroom Europe website. To view the clips, go to classroom.ricksteves.com, type the clip number into the search bar, then watch the three- to five-minute clip. In some cases, longer clips contain related topics—just scan the script, then slide the dot to the point where you'd like to begin.

If you enjoy reading about the art, we hope you'll enjoy these TV clips as well.

PREHISTORY
PREHISTORIC CAVE PAINTINGS OF LASCAUX
CLIP: 502.2 (keyword: Prehistory). TITLE: Prehistoric Cave Paintings in France's Dordogne

ANCIENT GREECE
ARTEMISION BRONZE—ZEUS OR POSEIDON
CLIP: 508.2 (keyword: Athens). TITLE: Athens' National Archaeological Museum: Art Treasures of Ancient Greece

THE PARTHENON
CLIP: 508.1 (keyword: Parthenon). TITLE: Athens' Acropolis, Parthenon, and Agora

ELGIN MARBLES—THE PARTHENON SCULPTURES
CLIP: 305.2 (keyword: British Museum). TITLE: The British Museum's Ancient Collection

VENUS DE MILO
CLIP: 706.4 (keyword: Louvre). TITLE: Paris' Louvre, Europe's Greatest Collection of Art

WINGED VICTORY OF SAMOTHRACE
CLIP: 706.4 (keyword: Louvre). TITLE: Paris' Louvre, Europe's Greatest Collection of Art

ANCIENT ROME

ROMAN SHE-WOLF STATUE
CLIP: 701.2 (keyword: Forum). TITLE: The Birth of Ancient Rome and the Forum

ROMAN COLOSSEUM
CLIP: 701.3 (keyword: Colosseum). TITLE: The Ancient Colosseum in Rome

ROMAN PANTHEON
CLIP: 701.4 (keyword: Pantheon). TITLE: Ancient Rome's Pantheon

RAVENNA'S MOSAICS
CLIP: 808.4 (keyword: Ravenna). TITLE: Ravenna, Italy: Exquisite Byzantine Mosaics

MEDIEVAL ERA

BOOK OF KELLS—*CHRIST ENTHRONED*
CLIP: 208.2 (keyword: Kells). TITLE: Medieval Ireland, Book of Kells, and St. Patrick

IMPERIAL CROWN OF THE HOLY ROMAN EMPIRE
CLIP: 409.3 (keyword: Habsburgs). TITLE: The Habsburgs, Austria's Royal Family

FLORENCE BAPTISTERY'S HELL
CLIP: 704.3 (keyword: Florence Cathedral). TITLE: The Florence Cathedral, Brunelleschi's Dome, and Ghiberti's Doors

VENICE'S ST. MARK'S
CLIP: 710.3 (keyword: St Marks). TITLE: Venice and St. Mark's Basilica

VENICE'S BRONZE HORSES
CLIP: 710.3 (keyword: St Marks). TITLE: Venice and St. Mark's Basilica

BAYEUX TAPESTRY
CLIP: 303.2 (keyword: Tapestry). TITLE: Bayeux Tapestry in Normandy

Filming *Rick Steves' Europe* in Rothenburg, Germany

THE ALHAMBRA
CLIP: 605.1 (keyword: Alhambra). TITLE: Granada: Alhambra, Islamic Moors, and Reconquista

DUCCIO'S *MADONNA*
CLIP: 704.5 (keyword: Uffizi). TITLE: The Uffizi Gallery: The Best Paintings of the Florentine Renaissance

GIOTTO'S SCROVEGNI CHAPEL
CLIP: 808.2 (keyword: Giotto). TITLE: Frescoes by Giotto in Padova's Scrovegni Chapel

PARIS' NOTRE-DAME CATHEDRAL
CLIP: 306.1 (keyword: City of Light). TITLE: Paris: France's City of Light

SAINTE-CHAPELLE
CLIP: 707.2 (keyword: Sainte). TITLE: Paris' Sainte-Chapelle, the Most Exquisite Gothic Chapel

FRA ANGELICO'S *ANNUNCIATION*
CLIP: 704.4 (keyword: San Marco). TITLE: Florence's Monastery of San Marco, Starring Fra Angelico and Savonarola

CHARTRES CATHEDRAL'S STATUES
CLIP: 804.3 (keyword: Chartres). TITLE: Chartres, Possibly Europe's Greatest Gothic Cathedral

CHARTRES CATHEDRAL'S STAINED GLASS
CLIP: 804.CRF (keyword: Malcolm). TITLE: Chartres Cathedral with Malcolm Miller

THE LADY AND THE UNICORN TAPESTRIES
CLIP: 707.1 (keyword: Unicorn). TITLE: Paris' Cluny Museum: The Unicorn Tapestries

RENAISSANCE

GHIBERTI'S BRONZE DOORS
CLIP: 704.3 (keyword: Florence Cathedral). TITLE: The Florence Cathedral, Brunelleschi's Dome, and Ghiberti's Doors

BRUNELLESCHI'S DOME
CLIP: 704.3 (keyword: Florence Cathedral). TITLE: The Florence Cathedral, Brunelleschi's Dome, and Ghiberti's Doors

BOTTICELLI'S *SPRING*
CLIP: 704.5 (keyword: Uffizi). TITLE: The Uffizi Gallery: The Best Paintings of the Florentine Renaissance

BOTTICELLI'S *BIRTH OF VENUS*
CLIP: 704.5 (keyword: Uffizi). TITLE: The Uffizi Gallery: The Best Paintings of the Florentine Renaissance

LEONARDO'S *LAST SUPPER*
CLIP: 406.2 (keyword: Leonardo). TITLE: Leonardo da Vinci in Milan: "The Last Supper"

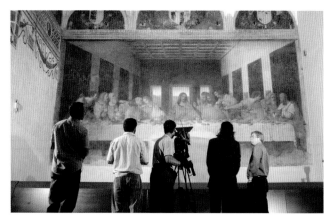

Filming Leonardo's *Last Supper*

LEONARDO'S *MONA LISA*
CLIP: 706.4 (keyword: Mona Lisa). TITLE: Paris' Louvre, Europe's Greatest Collection of Art

BOSCH'S *GARDEN OF EARTHLY DELIGHTS*
CLIP: 301.6 (keyword: Prado). TITLE: Madrid's Prado Museum

MICHELANGELO'S *DAVID*
CLIP: 704.2 (keyword: David). TITLE: Michelangelo's "David"

MICHELANGELO'S FLORENCE *PIETÀ*
CLIP: 704.1 (keyword: Florentine). TITLE: The Florentine Renaissance

EL GRECO'S *BURIAL OF COUNT ORGAZ*
CLIP: 302.2 (keyword: Greco). TITLE: El Greco in Toledo

RIEMENSCHNEIDER'S ALTAR OF THE HOLY BLOOD
CLIP: 212.3 (keyword: Rothenburg). TITLE: Germany's Medieval Walled Town of Rothenburg

BAROQUE ERA

REMBRANDT'S *NIGHT WATCH*
CLIP: 809.1 (keyword: Rijk). TITLE: Amsterdam's Rijksmuseum and Rembrandt

VERMEER'S *KITCHEN MAID*
CLIP: 809.1 (keyword: Rijk). TITLE: Amsterdam's Rijksmuseum and Rembrandt

BERNINI'S *APOLLO AND DAPHNE*
CLIP: 702.2 (keyword: Bernini). TITLE: Rome's Borghese Gallery and Bernini Statues

VELÁZQUEZ'S *LAS MENINAS*
CLIP: 301.6 (keyword: Prado). TITLE: Madrid's Prado Museum

ST. PETER'S BASILICA
CLIP: 504.1 (keyword: Vatican). TITLE: Vatican City, a Tiny Country with a Billion Citizens

PALACE OF VERSAILLES
CLIP: 804.1 (keyword: Versailles). TITLE: France's Palace of Versailles and Louis XIV

19TH CENTURY

ARC DE TRIOMPHE
CLIP: 706.3 (keyword: Napoleon). TITLE: Paris, the French Revolution, and Napoleon

DAVID'S *CORONATION OF NAPOLEON*
CLIP: 706.4 (keyword: Louvre). TITLE: Paris' Louvre, Europe's Greatest Collection of Art

GERICAULT'S *RAFT OF THE MEDUSA*
CLIP: 706.4 (keyword: Louvre). TITLE: Paris' Louvre, Europe's Greatest Collection of Art

GOYA'S *THIRD OF MAY 1808*
CLIP: 301.6 (keyword: Prado). TITLE: Madrid's Prado Museum

NEUSCHWANSTEIN, THE CASTLE OF "MAD" KING LUDWIG
CLIP: 213.4 (keyword: Ludwig). TITLE: Neuschwanstein: "Mad" King Ludwig's Castle in Bavaria

THE EIFFEL TOWER
CLIP: 306.1 (keyword: Eiffel). TITLE: Paris: France's City of Light

MUCHA'S ART NOUVEAU POSTERS
CLIP: 811.3 (keyword: Mucha). TITLE: Prague's Art Nouveau, Mucha, and the "Slav Epic"

SAGRADA FAMÍLIA BASILICA
CLIP: 503.3 (keyword: Sagrada). TITLE: Modernisme and Gaudí: Art Nouveau in Barcelona

MANET'S *LUNCHEON ON THE GRASS*
CLIP: 306.3 (keyword: Orsay). TITLE: The Orsay Museum and Impressionism in Paris

MONET'S *WATER LILIES*
CLIP: 707.3 (keyword: Monet). TITLE: Monet at the Orangerie, Impressionism in Paris

RODIN'S *THINKER*
CLIP: 707.4 (keyword: Rodin). TITLE: Paris' Rodin Museum: Impressionism in Stone

VAN GOGH'S LIFE IN PAINTINGS
CLIP: 809.3 (keyword: Gogh). TITLE: Amsterdam's Van Gogh Museum

MUNCH'S *THE SCREAM*
CLIP: 607.3 (keyword: Scream). TITLE: Norwegian Psyche in Its Art: Romantic Art, Munch's "Scream," and Vigeland Sculptures

20TH CENTURY

KLIMT'S *THE KISS*
CLIP: 506.4 (keyword: Kiss). TITLE: Vienna's Belvedere Palace, Jugendstil, Gustav Klimt

PICASSO'S MANY STYLES
CLIP: 503.2 (keyword: Picasso Barcelona). TITLE: Barcelona's Picasso Museum

PICASSO'S MANY WOMEN
CLIP: 309.3 (keyword: Picasso Antibes). TITLE: Picasso in Antibes, France

PICASSO'S *GUERNICA*
CLIP: 301.5 (keyword: Fallen). TITLE: Spain's Civil War: The Valley of the Fallen and Picasso's "Guernica"

CHAGALL'S *NEWLYWEDS*
CLIP: 309.2 (keyword: Chagall). TITLE: Chagall in Nice and Zurich

VIGELAND'S *MONOLITH OF LIFE*
CLIP: 607.CRF (keyword: Vigeland). TITLE: Oslo: Vigeland's Many Statues

THUMBNAIL GUIDE TO ARTISTS AND ARCHITECTS

BERNINI, GIOVANNI LORENZO, 1598–1680
Sculptor and architect, dramatic Roman Baroque

BOSCH, HIERONYMUS, c. 1450–1516
Dutch painter, crowded, bizarre scenes

BOTTICELLI, SANDRO, c. 1445–1510
Delicate Renaissance paintings in Florence

BRUNELLESCHI, FILIPPO, 1377–1446
First great Renaissance architect, renowned for Florence dome

CANALETTO, 1697–1768
Photorealistic Venetian overviews

CANOVA, ANTONIO, 1757–1822
Italian sculptor of cool, white Neoclassical statues

CARAVAGGIO, 1571–1610
Shocking ultra-realistic Italian painter, used stark lighting and down-to-earth models

CHAGALL, MARC, 1887–1985
Russian-French-Jewish artist, magical realism, painting and stained glass, fiddlers on roofs

CRIVELLI, CARLO, 1430–1495
Italian Renaissance painter with Gothic style

DAVID, JACQUES-LOUIS, 1748–1825
French Neoclassical chronicler of heroic Napoleonic era

DEGAS, EDGAR, 1834–1917
French painter of candid Impressionist snapshots, often of dancers

DELACROIX, EUGÈNE, 1798–1863
French artist who captured colorful, emotional, exotic Romanticism in paint

DONATELLO, 1386–1466
Early Italian Renaissance sculptor of bronze, wood, and marble

DUCCIO, 1255–1319
Sienese Gothic artist, gilded religious scenes hinting at 3-D

DÜRER, ALBRECHT, 1471–1528
Renaissance wood-carver with German detail, "Michelangelo of the North"

EIFFEL, GUSTAVE, 1832–1923
French master builder of bridges and monumental monuments

FRA ANGELICO, c. 1395–1455
Renaissance artistry and medieval piety in Florence

GAUDÍ, ANTONI, 1852–1926
Modernista Spanish architect known for organic, wavy, and fanciful design

GÉRICAULT, THÉODORE, 1791–1824
Dramatic Romantic French painter

GHIBERTI, LORENZO, 1378–1455
Florentine Renaissance artist renowned for Gates of Paradise

GIOTTO, c. 1267–1337
Proto-Renaissance Italian painter (depicting emotion and 3-D) in medieval times

GOYA, FRANCISCO, 1746–1828
Spanish painter's three stages: frilly court painter, political rebel, dark stage

GRECO, EL, 1541–1614
Greek-born Spaniard who painted spiritual scenes depicting elongated bodies

GRÜNEWALD, MATTHIAS, c. 1470–1528
Visionary German painter

INGRES, JEAN-AUGUSTE-DOMINIQUE, 1780–1867
French Neoclassical painter

KLIMT, GUSTAV, 1862–1918
Vienna Secession artist depicting erotic, gilded women

LEONARDO DA VINCI, 1452–1519
A well-rounded Renaissance genius who also painted

LUDWIG, "MAD" KING, 1845–1886
Royal Bavarian builder of fanciful castles

MANET, EDOUARD, 1832–1883
French painter, forerunner of Impressionist rebels

MASACCIO, 1401–1428
Early Italian Renaissance painter with 3-D mastery

MATISSE, HENRI, 1869–1954
French painter of decorative "wallpaper," bright colors, simple scenes

MICHELANGELO, 1475–1564
Earth's greatest sculptor and one of its greatest painters

MONET, CLAUDE, 1840–1926
Father of Impressionism

MUCHA, ALPHONSE, 1860–1939
Art Nouveau Czech painter known for posters and *Slav Epic*

MUNCH, EDVARD, 1863–1944
Norwegian Expressionist famous for *The Scream*

MURILLO, BARTOLOMÉ, 1617–1682
Spanish artist who painted sweet Catholic images

PICASSO, PABLO, 1881–1973
Spanish master of many modern styles, especially Cubism

RAPHAEL, 1483–1520
Epitome of the Renaissance: balance, realism, beauty

RIEMENSCHNEIDER, TILMAN, 1460–1531
German sculptor of carved-wood altarpieces

REMBRANDT, 1606–1669
Greatest Dutch painter, brown canvases, dramatic lighting

RENOIR, PIERRE-AUGUSTE, 1841–1919
French painter, Impressionist style, idealized beauty, pastels

RIGUAD, HYACINTHE, 1659–1743
French Baroque painter of royal portraits

RODIN, AUGUSTE, 1840–1917
French sculptor, classical statues with rough "Impressionist" finish

RUBENS, PETER PAUL, 1577–1640
Flemish painter of Baroque, fleshy women, violent scenes

TITIAN, c. 1490–1576
Greatest Venetian Renaissance painter

VAN EYCK, JAN, c. 1395–1441
Northern painter, exquisite detail

VAN GOGH, VINCENT, 1853–1890
Dutch painter, Impressionist style plus emotion

VELÁZQUEZ, DIEGO, 1599–1660
Objective Spanish court portraits with remarkable detail

VERMEER, JAN, 1632–1675
Quiet Dutch art highlighting everyday details

VIGELAND, GUSTAV, 1869–1943
Prolific Norwegian sculptor of life-cycle art

WATERHOUSE, JOHN WILLIAM, 1849–1917
English artist, Pre-Raphaelite, medieval focus on damsels in distress

WESTERN ART AT A GLANCE
FROM PREHISTORY TO THE PRESENT

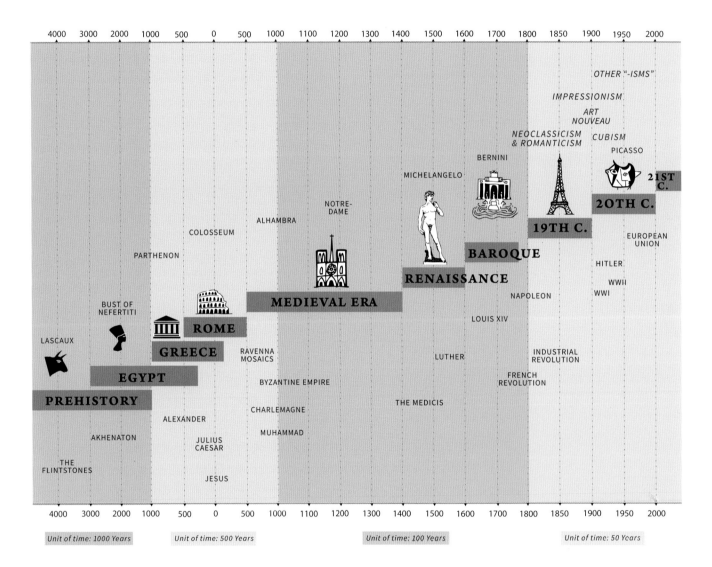

| 4000 | 3000 | 2000 | 1000 | 500 | 0 | 500 | 1000 | 1100 | 1200 | 1300 | 1400 | 1500 | 1600 | 1700 | 1800 | 1850 | 1900 | 1950 | 2000 |

OTHER "-ISMS"

IMPRESSIONISM

ART NOUVEAU

NEOCLASSICISM & ROMANTICISM

CUBISM

PICASSO

BERNINI

MICHELANGELO

NOTRE-DAME

ALHAMBRA

COLOSSEUM

21ST C.

20TH C.

19TH C.

EUROPEAN UNION

PARTHENON

BAROQUE

HITLER

WWII
WWI

RENAISSANCE

NAPOLEON

MEDIEVAL ERA

LOUIS XIV

BUST OF NEFERTITI

ROME

RAVENNA MOSAICS

LUTHER

INDUSTRIAL REVOLUTION

LASCAUX

GREECE

EGYPT

BYZANTINE EMPIRE

FRENCH REVOLUTION

PREHISTORY

THE MEDICIS

ALEXANDER

CHARLEMAGNE

AKHENATON

JULIUS CAESAR

MUHAMMAD

THE FLINTSTONES

JESUS

| 4000 | 3000 | 2000 | 1000 | 500 | 0 | 500 | 1000 | 1100 | 1200 | 1300 | 1400 | 1500 | 1600 | 1700 | 1800 | 1850 | 1900 | 1950 | 2000 |

Unit of time: 1000 Years Unit of time: 500 Years Unit of time: 100 Years Unit of time: 50 Years

PREHISTORY

Early Homo sapiens made small figurines, generally of women, perhaps symbolizing fertility. Cave paintings depicted realistic-looking animals, possibly ritualistic icons or a hunter's wish list.

ANCIENT EGYPT

Egyptian statues and paintings preserved Egyptian souls in the afterlife. Egypt's huge impact on Greece and Rome made it a bedrock of European culture.

ANCIENT GREECE

Greek statues captured the nobility and beauty of the idealized human form. Greeks built temples with massive columns and crossbeams, topped with triangular pediments. While Classical Greek art was all about balance and harmony, later Hellenistic art was more dramatic.

ANCIENT ROME

As conquerors, the Romans built on a grand scale—colosseums, triumphal arches, public baths, aqueducts, and roads. Though they used pragmatic arches and concrete, they decorated with Greek-style statues and architecture, keeping Greek culture alive.

MEDIEVAL ERA

After Rome fell, Europe stagnated during its Dark Ages, but rebounded in the High Middle Ages. Art served the Church, with countless paintings and statues of Mary, Jesus, and the saints, evoking Europeans' deep Christian faith. Tall Gothic churches with large stained-glass windows took the place of dim Romanesque churches.

RENAISSANCE

In this "rebirth" of Greece and Rome, artists remastered 3-D realism and rediscovered the beauty of the human body. Architects used Greek columns and Roman arches and domes. Secular art (art for art's sake) became increasingly common, and artists gained respect and were no longer anonymous.

BAROQUE ERA

The bold style of Baroque is big, colorful, dramatic, and emotional. Featuring exaggerated beauty and violence, Baroque specialized in Greek gods, myths, fleshy nudes, and pudgy winged babies. The Catholic Church and "divinely ordained" kings favored Baroque grandeur to impress commoners.

19TH CENTURY

As Europe modernized and democratized, three major art movements emerged. Neoclassical art echoed the simple lines of classical Rome—reacting against Baroque excess. Romantic art employed drama to champion individuals and nations—reacting against the Neoclassical and Industrial Age. And Impressionists painted everyday scenes dappled with light.

20TH CENTURY

Modern art became as chaotic as the times. Anything goes: distorting reality (Surrealism and Expressionism), primitive vibrancy (Fauvism), colorful patterns (abstract art and Cubism), and multimedia mixes. Art engaged the viewer with much to ponder, allowing multiple interpretations. Its legacy is that artists today feel freer than ever to ignore the "rules" and simply . . . create.

BACKSTAGE AT THE AWARDS CEREMONY

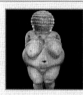 What an honor making the top 100. And I'm the first!

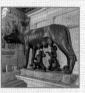 You mean the fattest.

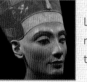 Ladies, remember, there are many types of beauty. There's timeless beauty like me . . .

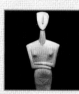 . . . balanced beauty like me . . .

 . . . art that's dramatic and thrilling . . .

 . . . and art that's dis-arming.

 Ha ha, very funny. Why is it that everyone else can have fun, while I get stuck with the kids?

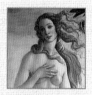 Well, I was stuck at church for what seemed like centuries. That was worse.

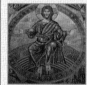 I'll be the judge of that. What I do know is that nothing in the medieval world can compare with the realistic beauty of Renaissance art.

 Yes, I'm so gorgeous, I symbolize the birth of a whole new age.

 Nice hair. Can I borrow your blow dryer?

 I symbolize how Renaissance man slew the medieval giant of superstition.

 Hey, I thought I symbolized that—slaying Goliath with my sword of knowledge.

 No, Goliath died of laughter looking at your hat.

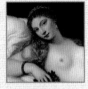 If anyone symbolizes the Renaissance, it's me—the most ravishing creature of all time!

 You?! (Must . . . not . . . laugh . . .)

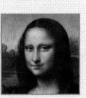 Regardless, as I gaze into the future, I can see that we in the Renaissance set the tone for the more human art that followed.

 Oui, but zee Baroque art ees *magnifique!* Fit for a king, simply divine.

 My choice for the best work of art of the 19th century is . . . me. And I'll crown myself, thank you.

 Not so fast, Emp. Now we have art that's made for the common people.

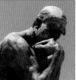 Hmmmm . . . let me think about that.

 It's art for the dancers . . .

 . . . for the lovers . . .

 . . . and for the gourmets.

 Let's hear it for the artists—both those who made this list and those who didn't.

 Yes, let's *ear* it for the artists! And thanks to those who take the time to appreciate our work, too.

 Art—it takes us back, it lights our way, it gives a voice to each age, and it helps charge the human spirit.

Yes, but 100 was more than enough. ENOUGH!!!

AUTHORS

RICK STEVES

Since 1973, Rick has spent about four months a year exploring Europe. His mission: to empower Americans to have European trips that are fun, affordable, and culturally

broadening. Rick produces a best-selling guidebook series, a public television series, and a public radio show, and organizes small-group tours that take over 30,000 travelers to Europe annually. He does all of this with the help of more than 100 well-traveled staff members at Rick Steves' Europe in Edmonds, WA (near Seattle). When not on the road, Rick is active in his church and with advocacy groups focused on economic and social justice, drug policy reform, and ending hunger. To recharge, Rick plays piano, relaxes at his family cabin in the Cascade Mountains, and spends time with his son Andy and daughter Jackie. Find out more about Rick at www.ricksteves.com and on Facebook.

GENE OPENSHAW

Gene has co-authored more than a dozen *Rick Steves* books, specializing in writing walks and tours of Europe's cities, museums, and cultural sights. He also contributes to Rick's

public television series, produces audio tours on Europe, and is a regular guest on Rick's public radio show. Outside of the travel world, Gene has co-authored *The Seattle Joke Book*. As a composer, Gene has written a full-length opera called *Matter,* a violin sonata, and dozens of songs. He lives near Seattle with his daughter, enjoys giving presentations on art and history, and roots for the Mariners in good times and bad.

INDEX

PHOTO CREDITS

5, 6 top left © Rick Steves' Europe (www.ricksteves.com); 6 top right © Artokoloro Quint Lox Limited / Alamy Stock Photo; 6 bottom left © Rick Steves' Europe (www.ricksteves.com); 6 bottom right © Oscar Elias / Alamy Stock Photo; 9 left © Zoltan Tarlacz | Dreamstime.com; 9 right © Peter M. Wilson / Alamy Stock Photo; 10 top © Bokstaz | Dreamstime.com; 10 bottom © classicpaintings / Alamy Stock Photo; 11 left © GL Archive / Alamy Stock Photo; 11 top right © World History Archive / Alamy Stock Photo; 11 bottom right Photo by Dennis Jarvis from Halifax, Canada; 13 © Suse Schulz | Dreamstime.com; 15 © Anna Bartosch-Carlile / Alamy Stock Photo; 16 top left, top right, bottom left, bottom right © Rick Steves' Europe (www.ricksteves.com); 19 © PRISMA ARCHIVO / Alamy Stock Photo; 21 © EmmePi Images / Alamy Stock Photo; 23 © Ivan Bastien | Dreamstime.com; 24, 25 © Dominic Arizona Bonuccelli (www.azfoto.com); 26-27 © Rick Steves' Europe (www.ricksteves.com); 29 © Jonghyunkim | Dreamstime.com; 31 © Dominic Arizona Bonuccelli (www.azfoto.com); 33 © Roman Milert | Dreamstime.com; 35 © Rick Steves' Europe (www.ricksteves.com); 36 top left, 36 top right, 36 bottom left © Dominic Arizona Bonuccelli (www.azfoto.com); 36 bottom right © Rakonjac Srdjan | Dreamstime.com; 39 © Dominic Arizona Bonuccelli (www.azfoto.com); 40-41 © Beatrice Preve | Dreamstime.com; 43, 45 top © Dominic Arizona Bonuccelli (www.azfoto.com); 45 bottom © Rick Steves' Europe (www.ricksteves.com); 46-47 © Rakonjac Srdjan | Dreamstime.com; 48-49 © Tinamou | Dreamstime.com; 50 top left © Dominic Arizona Bonuccelli (www.azfoto.com); 50 top right © Heritage Image Partnership Ltd / Alamy Stock Photo; 50 bottom left, 50 bottom right © Dominic Arizona Bonuccelli (www.azfoto.com); 52 © The Print Collector / Alamy Stock Photo; 53 © Album / Alamy Stock Photo; 54 © Rick Steves' Europe (www.ricksteves.com); 55 © Alexandre Fagundes De Fagundes | Dreamstime.com; 57 © volkerpreusser / Alamy Stock Photo; 58 left © Chlodvig | Dreamstime.com; 58-59 © Davide Montalenti | Dreamstime.com; 60 © Rick Steves' Europe (www.ricksteves.com); 61 © The Picture Art Collection / Alamy Stock Photo; 62 left © Ihsan Gercelman | Dreamstime.com; 62-63 © Scaliger | Dreamstime.com; 64 left © Rick Steves' Europe (www.ricksteves.com); 64-65 © Dominic Arizona Bonuccelli (www.azfoto.com); 66 © Lestertairpolling | Dreamstime.com; 67 © Dominic Arizona Bonuccelli (www.azfoto.com); 68 top, 68 middle, 68 bottom © City of Bayeux; 69 © FORGET Patrick / Alamy Stock Photo; 70 top, 70 middle, 70 bottom, 71 top, 71 middle, 71 bottom, 72 top, 72 middle, 72 bottom © City of Bayeux; 73 © Martin Bennett / Alamy Stock Photo; 74 left, 74-75 © Dominic Arizona Bonuccelli (www.azfoto.com); 76 left © Rick Steves' Europe (www.ricksteves.com); 76 right, 77 top © Dominic Arizona Bonuccelli (www.azfoto.com); 77 bottom © Rick Steves' Europe (www.ricksteves.com); 79 © Heritage Image Partnership Ltd / Alamy Stock Photo; 80 © Rick Steves' Europe (www.ricksteves.com); 81 © Ciaobucarest | Dreamstime.com; 83 top left © Anyaivanova | Dreamstime.com; 83 top right © Tomas1111 | Dreamstime.com; 83 bottom left © Maksim Bogdanets | Dreamstime.com; 83 bottom right © Gualberto Becerra | Dreamstime.com; 85 © Dominic Arizona Bonuccelli (www.azfoto.com); 87 © Adam Eastland / Alamy Stock Photo; 88 top © Radu Razvan Gheorghe | Dreamstime.com; 88 bottom © Gautier Willaume | Dreamstime.com; 89 © Philippehalle | Dreamstime.com; 90 © Jorisvo | Dreamstime.com; 91 © Ingrid Klimbek-lebedev | Dreamstime.com; 92, 93 © Pictures Now / Alamy Stock Photo; 94 © Danita Delimont / Alamy Stock Photo; 95 © Heritage Image Partnership Ltd / Alamy Stock Photo; 96 top left Public Domain via Wikimedia Commons; 96 top right © Rick Steves' Europe (www.ricksteves.com); 96 bottom left © Heritage Image Partnership Ltd / Alamy Stock Photo; 96 bottom right Public Domain via Wikimedia Commons; 99 top left, 99 top right © Album / Alamy Stock Photo; 99 bottom left © Sphraner | Dreamstime.com; 99 bottom right © Zatletic | Dreamstime.com; 101 © Dominic Arizona Bonuccelli (www.azfoto.com); 103 © Album / Alamy Stock Photo; 105 © Peter

Barritt / Alamy Stock Photo; 106, 107 left © Rick Steves' Europe (www.ricksteves.com); 107 middle © Peter Vrábel | Dreamstime.com; 107 right © Wieslaw Jarek | Dreamstime.com; 108, 109 © Rick Steves' Europe (www.ricksteves.com); 111 Public Domain via Wikimedia Commons; 113 © World History Archive / Alamy Stock Photo, 115 © Rick Steves' Europe (www.ricksteves.com), 116 © Nikolai Sorokin | Dreamstime.com, 117 © GL Archive / Alamy Stock Photo; 118-119, 120 top © Masterpics / Alamy Stock Photo; 120 bottom © PRISMA ARCHIVO / Alamy Stock Photo, 121 © Album / Alamy Stock Photo; 123, 124 © Rick Steves' Europe (www.ricksteves.com); 125 © Prakich Treetasayuth | Dreamstime.com, 126 © Marsana | Dreamstime.com; 127, 128-129, 130 © Dominic Arizona Bonuccelli (www.azfoto.com); 131 © Claudio Balducelli | Dreamstime.com; 133 © Pivariz | Dreamstime.com; 134,135 Public Domain via Wikimedia Commons; 137 © Heritage Image Partnership Ltd / Alamy Stock Photo; 138, 139 © Marsana | Dreamstime.com; 141 © World History Archive / Alamy Stock Photo; 142, 143 © Albert Knapp / Alamy Stock Photo; 144 © Album / Alamy Stock Photo; 145, 147 Public Domain via Wikimedia Commons; 149 © IanDagnall Computing / Alamy Stock Photo; 150 left, 150-151 © imageBROKER / Alamy Stock Photo; 153, 154-155 © Heritage Image Partnership Ltd / Alamy Stock Photo; 156 top left © Rijksmuseum, Amsterdam; 156 top right © Rick Steves' Europe (www.ricksteves.com); 156 bottom left © Heritage Image Partnership Ltd / Alamy Stock Photo; 156 bottom right © Meunierd | Dreamstime.com; 159, 161 left © Rijksmuseum, Amsterdam; 161 right © Pictures Now / Alamy Stock Photo; 163, 165 © Rijksmuseum, Amsterdam; 166 © Heritage Image Partnership Ltd / Alamy Stock Photo; 167 © Pjgibson | Dreamstime.com; 169 © classicpaintings / Alamy Stock Photo; 170 top, 170 bottom © Rick Steves' Europe (www.ricksteves.com); 171 © Natalia Volkova | Dreamstime.com; 173 © classicpaintings / Alamy Stock Photo; 175 © Alinari / Art Resource, NY; 177 © Sir John Soane's Museum, London; 179 © Heritage Image Partnership Ltd / Alamy Stock Photo; 180-181 182, 183 © Dominic Arizona Bonuccelli (www.azfoto.com); 185 © classicpaintings / Alamy Stock Photo; 186 left © Vitaly Edush | Dreamstime.com; 186-187 © Filip Fuxa | Dreamstime.com;

188-189 © Chon Kit Leong | Dreamstime.com; 191 © Masterpics / Alamy Stock Photo; 192 top left © GL Archive / Alamy Stock Photo; 192 top right © Asier Villafranca | Dreamstime.com; 192 bottom left © FineArt / Alamy Stock Photo; 192 bottom right © PAINTING / Alamy Stock Photo; 195 Photo by Dennis Jarvis from Halifax, Canada; 197 © Svetoslav Iliev | Dreamstime.com; 199 © GL Archive / Alamy Stock Photo; 201 © Asier Villafranca | Dreamstime.com; 203 © Masterpics / Alamy Stock Photo; 205 © Heritage Image Partnership Ltd / Alamy Stock Photo; 207 © Niday Picture Library / Alamy Stock Photo; 209 top, 209 bottom © Album / Alamy Stock Photo; 211 © The Picture Art Collection / Alamy Stock Photo; 213 © PAINTING / Alamy Stock Photo; 215 © Vojtaheroutcom | Dreamstime.com; 217 © Dominic Arizona Bonuccelli (www.azfoto.com); 218 © Artokoloro Quint Lox Limited / Alamy Stock Photo; 219 © The Protected Art Archive / Alamy Stock Photo; 220 © Rick Steves' Europe (www.ricksteves.com); 221 © Tomas1111 | Dreamstime.com; 222-223 © Thecriss | Dreamstime.com; 225 © GL Archive / Alamy Stock Photo; 227 © FineArt / Alamy Stock Photo; 229 Public Domain via Wikimedia Commons; 230 © Heritage Image Partnership Ltd / Alamy Stock Photo; 231 left © Art Library / Alamy Stock Photo; 231 right © Peter Horree / Alamy Stock Photo; 232 left © Peter Barritt / Alamy Stock Photo; 232-233 © Heritage Image Partnership Ltd / Alamy Stock Photo; 235 © Alisonh29 | Dreamstime.com; 236 © The Artchives / Alamy Stock Photo; 237 top © Peter Horree / Alamy Stock Photo; 237 bottom © Peter Barritt / Alamy Stock Photo; 238 left © World History Archive / Alamy Stock Photo; 238 right © Heritage Image Partnership Ltd / Alamy Stock Photo; 239 © The Artchives / Alamy Stock Photo; 241 © Nasjonalmuseet for kunst, arkitektur og design/The National Museum of Art, Architecture and Design; 242 top left © PAINTING / Alamy Stock Photo; 242 top right © Tyler Olson | Dreamstime.com; 242 bottom © 2019 Estate of Pablo Picasso / Artists Rights Society (ARS), New York; 245 © PAINTING / Alamy Stock Photo; 247 © 2019 Succession H. Matisse / Artists Rights Society (ARS), New York. Photograph © The State Hermitage Museum / photo by Vladimir Terebenin; 248 © 2019 Estate of Pablo Picasso / Artists Rights Society (ARS), New York; 249 left, 249 right ©

APPENDIX

COVER

Avalon Travel

Hachette Book Group

1700 Fourth Street

Berkeley, CA 94710

Printed in China by RRD, Shenzhen

First Edition.

First printing November 2019.

ISBN 978-1-64171-223-1

For the latest on Rick's talks, guidebooks, tours, public television series, and public radio show, contact Rick Steves' Europe, 130 Fourth Avenue North, Edmonds, WA 98020, tel. 425/771-8303, www.ricksteves.com, rick@ricksteves.com.

Rick Steves' Europe

SPECIAL PUBLICATIONS MANAGER: Risa Laib

ART DIRECTOR: Rhonda Pelikan

GRAPHIC CONTENT DIRECTOR: Sandra Hundacker

MAPS & GRAPHICS: David C. Hoerlein

PHOTO EDITOR: Rich Sorensen

Avalon Travel

SENIOR EDITOR AND SERIES MANAGER: Madhu Prasher

EDITORS: Jamie Andrade, Sierra Machado

COPY EDITOR: Maggie Ryan

PROOFREADER: Elizabeth Jang

PRODUCTION & TYPESETTING: Megan Jones Design, Jane Musser

COVER DESIGN: Gopa & Ted2

INTERIOR DESIGN: Megan Jones Design

Locations of Europe's Top Art

Atlantic Ocean

PORTUGAL

MOROCCO